Frida Kahlo

Edited by
Emma Dexter
and
Tanya Barson

With contributions
Gannit Ankori
Oriana Baddeley
Christina Burrus
Raquel Tibol

First published 2005 by order of the Tate Trustees
by Tate Publishing, a division of Tate Enterprises Ltd,
Millbank, London SW1P 4RG
www.tate.org.uk/publishing

on the occasion of the exhibition
Frida Kahlo
at Tate Modern
9 June – 9 October 2005

Exhibition sponsored by HSBC

British Library Cataloguing in Publication Data
A catalogue record for this book is available
from the British Library

ISBN 1 85437 586 5 (paperback)
ISBN 1 85437 567 9 (hardback)

Distributed in the United States and Canada
by Harry N. Abrams, Inc., New York

Library of Congress Cataloging in Publication Data
Library of Congress Control Number: 2005923370

Designed by Studio Myerscough
Printed in Great Britain by Westerham Press Limited

Cover: *Self-Portrait with Monkey* 1938 (detail, pl.33)
Frontispiece: *Self-Portrait as a Tehuana* or
Diego on My Mind 1943 (detail, pl.42)

Contributors

EMMA DEXTER is a Curator at Tate Modern

TANYA BARSON is a Curator at Tate Liverpool

GANNIT ANKORI is Associate Professor of Art History
at the Hebrew University of Jerusalem, and Research
Associate and visiting Faculty at Harvard University
Divinity School, Women's Studies in Religion Program
for 2005–2006

ORIANA BADDELEY is a Professor at Camberwell
College of Arts and Deputy Director of TrAIN,
the University of the Arts London Research Centre
for Transnational Arts, Identity and Nation

CHRISTINA BURRUS is an independant curator

RAQUEL TIBOL is a writer and art critic, and has
published numerous books on Latin American art

Editors' Note

We have done everything we can to ensure that the
information contained here is accurate. However, this
publication brings together a variety of historical and
contemporary perspectives on Frida Kahlo, and on
Mexican history and culture. Scholars and experts
may hold differing opinions and current research
continues to reveal previously unknown details and
facts, contributing to the wealth of narratives. This is
part of the challenge and fascination of working on
Kahlo, who herself participated in this myth-making
process.

Contents

Sponsor's Foreword

HSBC is delighted to sponsor this exhibition of Frida Kahlo – the first major display of her work in the UK for over twenty years.

HSBC has major operations in Mexico and the UK and it is therefore particularly fitting for us to help bring the internationally acclaimed work of one of Mexico's most revered artists to London.

Frida Kahlo was a woman ahead of her times. Her work is a testimony of her most personal experiences: pain, suffering, happiness, love, and her distinctive self-portraits and visionary paintings influenced and inspired some of the world's greatest artists, including Picasso and the Surrealists. This exhibition brings together some of her most important works, including some that have never been seen before in the UK.

This sponsorship has an added dimension that is particularly significant for HSBC, both as a long-term supporter of the arts and as the world's local bank. Running concurrently with this exhibition in London is a display of Tate's collection of works by sculptor Henry Moore in Mexico's Museo Dolores Olmedo Patiño; a cultural exchange that is making world-famous artworks accessible to new audiences on opposite sides of the globe.

I hope you enjoy this retrospective of Frida Kahlo, and the insight it provides into one of history's most remarkable female painters.

Stephen Green
Chief Executive, HSBC Holdings Plc

Foreword

Frida Kahlo has become one of the most celebrated artists of the twentieth century, and Tate Modern is proud to have dedicated this exhibition to such a remarkable artist. Kahlo was a supreme image-maker, forging a poignant yet magical realism from her personal and political experiences, and drawing on such diverse influences as anatomy and psychoanalysis, Aztec myth and Mexican art and popular crafts.

The exhibition focuses closely upon Kahlo the artist, demonstrating the tremendous ambition and scope of her work, as she moves seamlessly between portraiture, still life, narrative painting, and her late spiritual and cosmological works. The exhibition delineates the momentous cultural and political milieu in which she lived, the key friendships and relationships that sustained her, and her passionate life-long engagement with her native Mexico. We believe that this exhibition, the first monographic exhibition dedicated to a Latin American artist at Tate, will give visitors a rare opportunity to enjoy the full range of her artistic achievement, and to grasp the scale of her cultural significance. Kahlo continues to fascinate and attract new audiences with her mix of politics, humour and introspection, or as André Breton described it, the unique combination of 'candour and insolence … cruelty and humour' in her work.

This is a very special exhibition which requires a particularly generous commitment from our sponsor HSBC, both in the UK and in Mexico. We are delighted that HSBC responded to our challenge by sponsoring an arts event at Tate for the very first time. We are extremely grateful to Stephen Green, Group Chief Executive and John Studzinski, Co-Head of Corporate, Investment Banking and Markets, for their enthusiasm and vision, supporting not only the Kahlo exhibition at Tate Modern but the Henry Moore and Mexico exhibition taking place at the Museo Dolores Olmedo Patiño, Mexico City, during summer 2005. In addition, the Mexico Tourism Board has given us invaluable support, led by Manuel Diaz-Cebrian, Regional Director for Europe. We are also grateful to the Department of Culture, Media and Sport and the Museums, Libraries and Archives Council for granting government indemnity to the exhibition.

We would like to thank all those in Mexico who supported and encouraged this project right from the outset, most particularly Sari Bermúdez, President of the National Council for Culture and the Arts, and all her colleagues at CONACULTA/INBA, especially Jaime Nualart, Alberto Fierro, Saúl Juarez, Denise Muñoz and Gabriela López for all their help and advice. We are deeply indebted to Javier A. Oropeza y Segura at Instituto Nacional de Bellas Artes y Literatura and José Luis Pérez Arredondo from Banco de México for ensuring that the Kahlo estate fully supported all aspects of this exhibition.

We also have a very special debt of gratitude to Carlos Phillips Olmedo from the Museo Dolores Olmedo Patiño, for his immediate, enthusiastic and sustained contribution to the exhibition, as well as Luis-Martín Lozano, Armando Colina and Víctor Acuña for their encouragement from the outset. We have also relied upon the goodwill and active participation of Ramis Barquet, Mary-Anne Martin and Robert Littman who have given us invaluable assistance. We also want to thank all our helpers and supporters here in London particularly His Excellency Mr Juan José Bremer the Mexican Ambassador in London, and Ignacio Durán Loera, Minister for Cultural Affairs, Embassy of Mexico for all their kind help in the preparation for the show, as well as particularly affectionate thanks to Patricia Zietz who has been such a close personal supporter of this exhibition at Tate.

Kahlo produced only about 150 oil paintings, so her works are both rare and precious. We are deeply grateful to the many private owners, mostly in Mexico and the United States who have parted with such treasured objects on this occasion. In addition, we appreciate the generosity of the museum directors and trustees who have entrusted their Kahlo paintings to us, knowing how keenly a work by Kahlo is missed by any institution.

This exhibition has been fortunate in having the imaginative and energetic curators Emma Dexter and Tanya Barson to conceive and lead the exhibition as well as write for and edit the catalogue with flair and passion. They have been assisted with great care and professionalism by Assistant Curator Cliff Lauson in the delivery of the show. In their acknowledgements overleaf, the curators express their thanks to all those who have helped in so many ways to make this extraordinary exhibition possible.

The catalogue, beautifully designed by Studio Myerscough, benefits from the excellent contributions that provide such a range of viewpoints on Kahlo's oeuvre. We are grateful to Gannit Ankori, Oriana Baddeley, Christina Burrus and Raquel Tibol for their enlightening and stimulating texts. In addition we would like to thank Judith Severne for project managing the publication with skill and real dedication, and Fernando Gutiérrez from Pentagram for his eye-catching Communications and Marketing design concept.

Kahlo's images are impossible to forget, and while her life and work has become known around the world to millions, this exhibition gives visitors a rare but welcome opportunity to experience her paintings at first hand. We warmly invite our visitors, sponsors, colleagues and friends to experience this truly memorable exhibition at Tate Modern.

Vicente Todolí
Director, Tate Modern

Curators' Acknowledgements

We would like to extend our warmest thanks to all those who gave us both hospitality, as well as enormous help and encouragement on our visits to Mexico and the United States, most notably Carlos Phillips Olmedo and his wife Guadalupe, María Eugenia de Lara Rangel and all the other charming and helpful staff at the Museum Dolores Olmedo Patiño. Our gratitude goes out to the irrepressible and tireless Ramis Barquet, and the many others who have given us advice and encouragement, including Armando Colina and Víctor Acuña, Robert Littman, Mary-Anne Martin, Salomon Grimberg, Luis-Martín Lozano, Manuel Arango, Álvaro Fernández, Margarita Garza Sada, Rodolfo Gómez, Olivier Debroise, Juan Coronel Rivera, Manuel and María Reyero, Hilda Trujillo Soto, Guadalupe Ayala from the Mexico Tourism Board, London, and Circe Henestrosa at the British Council in Mexico. We owe a special debt of gratitude to Raquel Tibol, not just for her essay and help at the initial stages of our research, but also for the excellent informal advice and information on Mexican history and politics she has so kindly given us.

We would also like to mention all those whose actions and words have helped us greatly, including Marcel Fleiss, Federica Simon, Brooke Alexander, James Corcoran, Cuauhtémoc Medina, Magda Carranza de Akle, Sandra Weisenthal de Galewicz, Jorge Contreras, Teresa Arcq, Mariana Pérez Amor and Alejandra R. De Yturbe, Carlos Monsiváis, Rina Lazo, Ricardo Pérez Escamilla, Teresa del Conde, Susan Grilo Arana, Laura González Matute, Benjamin Doller, Kirsten Hammer, Carmen Melián, Laura Pacheco, Virgilio Garza, Ana Sokoloff, Mario Paloschi and Martina Fuga from Artemesia, James Oles, Dawn Ades, and Víctor Zamudio-Taylor, for their pro-active and kind help in bringing this exhibition to fruition. We would also like to thank William Parry from HSBC for his hard work and commitment to the project.

We are very grateful to Victoria Sowerby, Carlos Córdova, Jimena Gorráez-Belmar, Lorcan O'Neill, Angela Becker, Shari Goldsmidt, and Demetra Prattas for their hard work and professionalism which has helped greatly with various aspects of the exhibition.

An exhibition and catalogue such as this requires enormous team work and dedication throughout Tate. We would particularly like to thank our colleagues in Tate Publishing who have produced such a beautiful and informative publication for their attention to detail and professionalism, especially Judith Severne, Sarah Tucker, Alessandra Serri, and Rebecca Fortey, with advice and encouragement from Celia Clear and Roger Thorp.

At Tate Modern we extend our warm appreciation to the Director Vicente Todolí for his decisive and passionate engagement with all aspects of the project both large and small and to Sheena Wagstaff, Head of Exhibitions, for her insightful and encouraging input throughout. We also owe a great deal to Cliff Lauson, Assistant Curator, who has contributed tirelessly, and with good-humoured acuity, to all aspects of the exhibition and to Nickos Gogolos, Stephen Mellor and Phil Monk who have dealt superbly with the considerable technical, registrarial and contractual demands of the show. Helping with both catalogue research and administration were interns Ana María Flores, Emily Gaynor, Kathleen Madden, Alejandra Aguado, Elisa Ferrero and Lucy Havard.

An exhibition of this complexity requires the tireless input and expertise of our colleagues across the institution and therefore we are very grateful to Amanda Cropper, Fiona Parker and Andrea Nixon from Development; Jane Burton, Simon Bolitho, Sandy Goldberg, Gillian Wilson and Helena Pérez from Interpretation; Will Gompertz, Nadine Thompson, Ruth Findlay, Jennifer Lea, Emma Clifton, and Caroline Priest from Communications; Jacqueline Hill and Lucy Hillary from Tate Legal; Brad McDonald and Emily Paget from External Events; Adrian Hardwicke and Mary Taylor from Visitor Services and Art Handling; Dominic Willsdon, Stuart Comer and Sophie Howarth from Public Events; Tim Green, Calvin Winner and Matthew Flintham from Conservation; Jo Matthews, Frances Croxford, Rosey Blackmore and Emma Woodiwiss from Tate Enterprises, not forgetting the invaluable input of our colleagues Jan Debbaut, Matthew Gale, Frances Morris, Jennifer Mundy, Catherine Clement, Renee Pfister, Richard Hamilton, Kerstin Knepper, Rebecca Lancaster and Paul McAree. We would also like to thank Toby Treves for curating the Henry Moore and Mexico exhibition, which has enabled so many Kahlo works to be released from the Museo Dolores Olmedo Patiño, and all those who have supported his efforts. Last but not least we would like to thank Tate Director Nicholas Serota for the many ways in which he has encouraged and assisted this project.

We have met and worked alongside many remarkable people while working on this exhibition and hope to continue the dialogue and friendship that it has engendered after the exhibition. It seems appropriate to leave the last word to Frida, who wrote these words on the invitation to her exhibition in 1953:

These canvases I've painted
I did with my own hands;
they wait for you upon the walls
to please you as I planned.

Emma Dexter and Tanya Barson

fig.1 (opposite)
Self-Portrait 'The Frame' 1937–8
Oil on aluminium and glass 28.5 x 21 cm
Centre Georges Pompidou, Paris,
Musée national d'art moderne. Centre de création industrielle

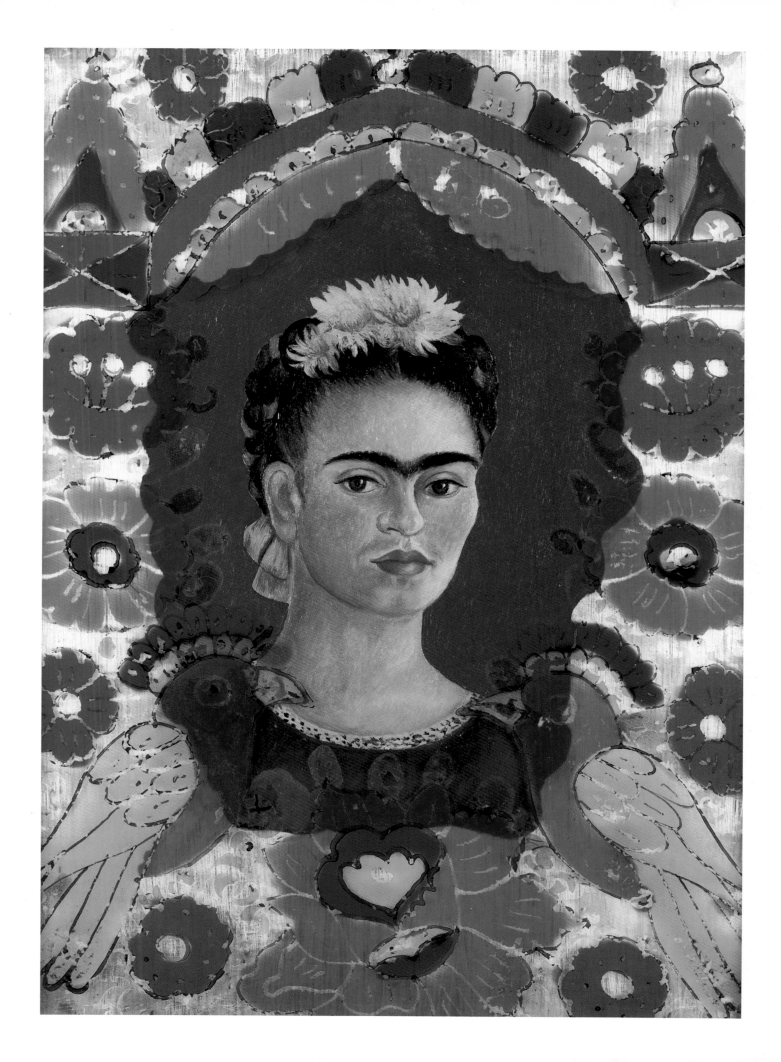

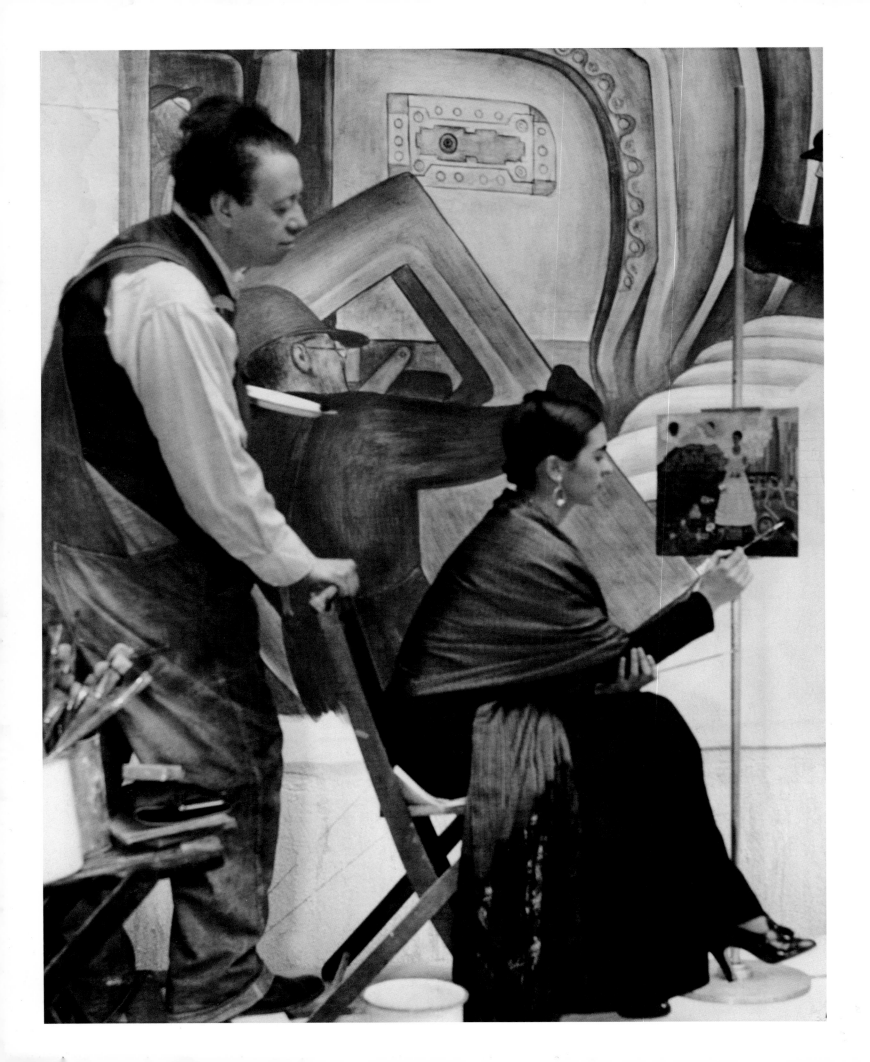

fig.2
Diego Rivera and Frida Kahlo:
Kahlo with *Self-Portrait on
the Borderline between Mexico
and the United States* 1932,
in front of Rivera's mural
Detroit Industry 1932,
Detroit Institute of Arts
Photographer unknown
Courtesy of Throckmorton
Fine Arts, Inc., New York

The Universal Dialectics
of Frida Kahlo

Emma Dexter

I've done my paintings well … and they have a message of pain in them, but
I think they'll interest a few people. They're not revolutionary, so why do I keep
on believing they're combative? *Frida Kahlo, 1953, as told to Raquel Tibol*[1]

The personal is political. This phrase is most commonly linked to the feminist
movement of the 1960s and 1970s, whose exponents employed it as a means
of exposing the structure of oppressive patriarchy hidden beneath everyday life.
But decades before this, Frida Kahlo had achieved a remarkable synthesis of the
personal and political, through the total output of fewer than 150 paintings that she
created during her short lifetime. Her works ranged from those expressing intense
introspection, to sophisticated mappings of the newly democratic Mexico's search
for a national identity, to extraordinarily ambitious canvases dealing with global
human history and metaphysics. Recent art-historical interest in her work, which
has chimed with the feminist art history movement, has tended to focus on its
autobiographical and confessional aspects at the expense of the political. As
Joan Borsa describes it:

> The critical reception of her exploration of subjectivity and personal history
> has all too frequently denied or de-emphasized the politics involved in
> examining one's own location, inheritances and social conditions … Critical
> responses continue to gloss over Kahlo's reworking of the personal, ignoring
> or minimizing her interrogation of sexuality, sexual difference, marginality,
> cultural identity, female subjectivity, politics and power.[2]

Or as Oriana Baddeley and Valerie Fraser have expressed it, what has been
overlooked has been her 'active role in the formulation of a language of art
which questioned neo-colonial cultural values'.[3] Claudia Schaefer quotes Fredric
Jameson to suggest that her paintings can be seen as '"private allegories"
of "the embattled situation of the *public* third-world culture and society"'.[4]
　　　Just as it could be said that all of Kahlo's works, even her still lifes, bear
traces of the self-portrait, one could also say that to a greater or lesser extent,
all of Kahlo's works are political. These political messages can be found across
the range of her oeuvre – from humble still lifes of fruits and vegetables, which
are in fact an expression of pride in Mexican produce and identity, to paintings
which delineate the power relationship between Mexico and the US, to a series
of works in which her broken body mirrors the shattered dreams and promises
of Mexican liberation and revolution.

fig.3
All-Seeing Eye! 1934
Pencil on paper
21 x 30.5 cm
Juan Rafael Coronel Rivera.
Promised donation to
the Museo Nacional
de Arte, Mexico City

fig.4
Frida Kahlo, Mexico 1941
Photograph by
Emmy Lou Packard
Courtesy Throckmorton
Fine Arts, Inc., New York

figs.5 and b (right)
Frida Kahlo with
Lucienne Bloch
Exquisite Corpse c.1932
Pencil on paper
each 21.5 x 13.5 cm
Private collection

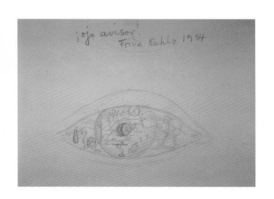

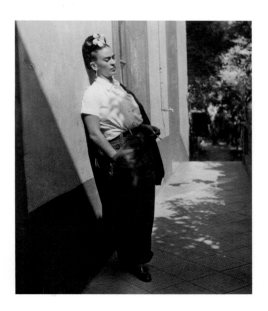

As we explore Kahlo's works, the extent to which they are packed with opposites, with dualisms and paradox, is striking. Amongst the myriad possible sources for this world view one could put forward her personal and family history, her sexuality, political and national allegiances, her delicate understanding of herself as a female, postcolonial Mexican artist, or her use of Aztec modes of thought and philosophy which allowed her to create a symbolic imagery from a simultaneity of apparent opposites: life and death, male and female, light and dark, ancient and modern. Aztec culture and religion was steeped in dualism and multiple layers of meaning, its deities often enjoy numerous apparently contradictory qualities and attributes, most notably for Kahlo, the goddess Coatlicue, who represented life as well as death with her necklace of skulls resting on her bare breast.[5] Kahlo it seems, innately as well as intellectually, was drawn to seeing life as a series of dialectical struggles, which in her last years, under the influence of Eastern religions such as Buddhism, Taoism and Hinduism, developed into a more complex philosophy of the oneness of the universe, where dialectics are superseded by harmony, by Yin and Yang in balance, and by the circularity of all deeds within a Karmic system of cosmic justice.[6] Many of those dialectics are reflected in the emergent Mexico itself, caught 'between tradition and change, between national and supranational interests, between the individual and the collectivity'.[7] Rivera himself recognised this quality in Frida: 'The recurring self-portrait never resembles another and is more and more like Frida, changeable and permanent, like universal dialectics'.[8] Even the *Cadavre Exquis* drawings (figs.5a, b), so often used as an example of Kahlo's surrealist tendencies, could just as well reflect her perception of the finely balanced, complementary and interrelated nature of gender, based on the dualistic and holistic cast of Aztec and Eastern philosophical modes of thought.

Perhaps the earliest evidence of Kahlo's interest in the exploration of the dialectical can be found in the family photographs, in which, at the age of nineteen, she dressed as a man, precociously acting out a combination of both genders simultaneously. Throughout her life, Kahlo consciously played with various roles and guises using hair, clothes and jewellery. She see-sawed between different politically coded forms of dress: the exaggerated frills and flounces of the Tehuana costume (the unique style of dress from the region of Tehuantepec

where women were reputedly economically and socially dominant), the wearing of a crossed shawl in the style of the female fighters or *soldaderas* of the Revolution, or the adoption of men's apparel. All these choices of dress must have seemed starkly eccentric when most women of her class would have dressed in the coquettishly modish style adopted by her younger sister Cristina. But Kahlo turned herself through her dress into 'a Mexican artefact', as well as indulging her love of 'masquerade and a taste both for the archaic and the ornamental'.[9] No doubt she enjoyed the political ironies inherent in the response to her Tehuana-style dress in the United States, where children apparently followed her in the street, asking the way to the circus. By dressing as a Tehuana in the heart of New York, Mexico City or Paris, Kahlo's dress was a sign of solidarity with the ordinary oppressed of Mexico, and it was also a sign of 'recognizable national tradition in the face of a changing world of social, political, and economic modernization'.[10] Her complex family and ethnic background, resulting from a devoutly Catholic mother born of Mexican-Spanish and Indian parentage, and a German father, must have added further to her sense of oppositions and balances, since she looked simultaneously towards Europe and the Americas in the search for her roots. This is illustrated in the painting *My Grandparents, My Parents, and I (Family Tree)* 1936 (pl.18), in which she plants herself in the courtyard of the family home in Coyoacán, flanked by portraits of her family, her Mexican maternal side hovering over the land, and her European paternal grandparents floating over the sea. Kahlo knew that her own lineage perfectly matched the mixed or Mestizo culture of colonial Mexico – 'both Indian and European, baroque, syncretic, unsatisfied'.[11]

Mexico

Kahlo's art was also formed by the remarkable times in which she lived. She was born in 1907, at the intersection of two very different worlds, when autocratic rule was about to be forcibly terminated by the uprisings that became the Mexican Revolution. It was the end of a nineteenth-century Mexico dominated by a small elite that had based its administrative structures on European models, under the dictatorship of Porfirio Díaz, in which conditions for the peasants (*campesinos*) and Indians had worsened, common lands had been forcibly privatised, enforced modernisation had led to increasing poverty and landlessness and the wealth of the country was concentrated in a tiny section of society. Kahlo's personal experience of these times had a very great influence on her attitudes, her politics and her art. Most importantly it is the contradictions, tensions and disparities of that historical and cultural moment that are played out in the work. Post-revolutionary Mexico was squeezed between its desire for modernisation and technological advance, represented by the capitalist ideology of its powerful and dominant northern neighbour, the United States, and the desire to reconnect with its own indigenous traditions and accomplishments. Schaefer describes this ideal of integration as being always visible in Kahlo's works.[12]

Kahlo's devotion to the ideals of the Mexican Revolution can never be in doubt. It is said that she even changed the date of her birth from 1907 to 1910 to coincide with its start. From 1910 to 1920 Mexico went through a bloody and unstable period of interfactional strife, which must have had a profound effect on the young Frida, who witnessed fighting in the streets outside her home in 1914, when Emiliano Zapata laid siege to Mexico City. Throughout her life she was dedicated to the notion of a people's revolution, to Marxism and later to Stalinism. Her family suffered financial hardship during the revolutionary period and afterwards, but in general she lived in moderate comfort throughout her life. Despite this, she always identified with the poor, the peasantry and the underdog, and not with bourgeois society. As Mexico became a modern industrialised nation, and Mexico City a fulcrum for the latest ideas and social principles in the 1920s,

fig.6
Country Girl 1925
Watercolour and pencil
on paper 23 x 14 cm
Government of the State of
Tlaxcala, Instituto Tlaxcalteca
de Cultura, Museo de Arte
de Tlaxcala

Kahlo never lost her emotional attachment to the Indian and oppressed Mexico, as opposed to the tiny European-oriented elite, either before or after the Revolution.

During the post-revolutionary era of a single-party state – the National Revolutionary Party – when land reforms for the peasantry were slow in coming, other improvements, such as public education, national health policies and improved communications, did lead to rapid change and improvement for many. And, as Carlos Fuentes argues: 'Whatever its political failures, the Mexican Revolution was a cultural success. It revealed a nation to itself.'[13] The Revolution encouraged a new spirit in Mexican nationalism, fostering a pride in and acknowledgement of indigenous arts, crafts and native and historical traditions, known as 'indigenism'. As a well-educated and clever young woman – one of only thirty-five girls out of a total of two thousand students entering the highly competitive National Preparatory School – Kahlo was part of an intellectual and politically radical elite who embraced the concept of indigenism and looked to a pre-Columbian Mexican past for the roots of the new nation and as a bulwark to European cultural imperialism and later on, the dominance of the United States.

The cultural policies of the Mexican Revolution reflected a dual aspect of influence: looking simultaneously to Europe and the Western tradition as well as developing indigenist policies that drew on Mexico's past and folkloric present. As an aspiring young artist, Kahlo, along with her peers, saw Europe as her most powerful cultural referent. It was still felt that Europe offered important cultural lessons both historically and in terms of its avant-garde. Two of the principal architects of the cultural revolution completed their educations in Europe before returning home to contribute to the Revolution: the celebrated muralist Diego Rivera and the philosopher-politician José Vasconcelos. Rivera spent the years from 1907 to 1920 in Europe (with a brief return to Mexico in 1910), absorbing El Greco's influence in Spain, as well as post-Impressionism and Cubism in Paris. Vasconcelos was made Secretary of Public Education in 1921 and was responsible for an ambitious programme of school and library construction, as well as for initiating the printing of cheap editions of classic works by Homer, Euripides, Plato, Dante and Goethe, all of which were available to Kahlo.[14] Naturally, therefore, her earliest influences as a painter were European. In her letters to her boyfriend Alejandro Gómez Arias, she expresses her envy that he had seen in the flesh the works of Cranach and Bronzino. Lying in hospital she amuses herself by penning an announcement of the birth of her child, aptly named Leonardo. The early *Self-Portrait Wearing a Velvet Dress* 1926 (pl.4) is an obvious example of the influence of a Renaissance and near-Mannerist style.

The description above of the Mexican cultural revolution as a happy, romantic synthesis of European enlightenment traditions and pre-Columbian motifs and historical narratives, glides over all sorts of problematic questions of class and race, economics and elites. As Carlos Fuentes has pointed out, even Rivera's 'Mexican vision' was seen entirely though the prism of European art; he had 'discovered the epic thrill of Renaissance painting (particularly Uccello) and allied it to the nativist lines of Gauguin in Tahiti'.[15] The other great muralists, Fuentes goes on, were also 'more European than they cared to recognize. José Clemente Orozco was a German Expressionist and David Alfaro Siqueiros an Italian Futurist. Maya or Aztec artists they certainly were not, and could not be.' They fused recognised European forms and traditions with those of their untainted, pure Indian and pre-Columbian ancestors. All the artists of the Mexican Revolution had to work hard at their rootedness to Mexico; as Baddeley and Fraser have observed, in the troubled arena of national and racial identities, a shared love of Mother Earth and the national attributes of Mexico was the only real common thread that could bind these artists to each other and to their country.[16] Kahlo developed a particular visual and poetic language of roots, ribbons, and cracked earth to suggest her special relationship with Mexican soil.[17] Kahlo and Rivera connected themselves to Mexico, its land, people and history, by collecting traditional arts and crafts and creating

fig.7
Kahlo in her living room
at the Casa Azul, c.1940
Photograph by Bernard
G. Silberstein
Courtesy of Throckmorton
Fine Arts, Inc., New York

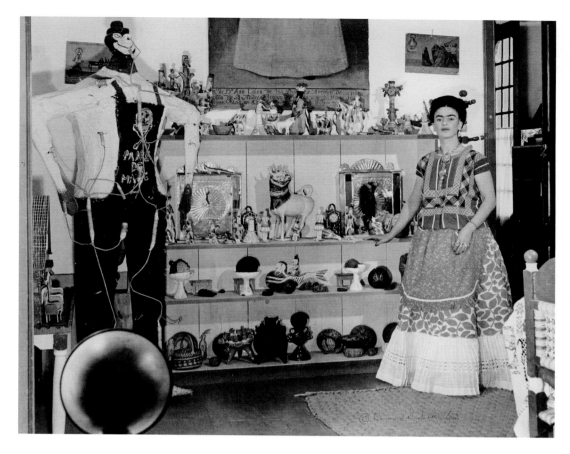

extraordinary buildings such as Rivera's private museum El Anahuacalli, which Kahlo described in 1949 as 'like an enormous cactus ... sober and elegant, strong and delicate, ancient and perennial. It shouts with the voices of centuries and days from its volcanic stone entrails: Mexico is alive! Like Coatlicue, it contains life and death; like the magnificent terrain from which it rises, it embraces the land with the tenacity of a living and permanent plant.'[18] Kahlo and Rivera filled their home the Casa Azul with objects that spoke of Mexico's history and traditions, they lived in and amongst objects that were the embodiment of the spirit of Mexico: 'retablos, modelled or decorated sweets, reed grass and glued paper, Judases, toys from a fair, profusely decorated furniture made of pine and fir; skeletons made of plaster, tin, cardboard, sugar.'[19] Kahlo described Rivera's collection of pre-Colombian treasures thus: 'His treasure is a collection of marvellous sculptures, jewels of indigenous art, living heart of the true Mexico.'[20]

The Mexican muralist movement was a call-to-arms by a group of male artists who were bent on the demolition of traditional easel painting, as well as creating a means of educating the illiterate masses about the glories of a hitherto obscured pre-Columbian past. The muralists wanted to sever the link between art and commodity, between painting and the bourgeoisie – creating an art that was genuinely for the people. Kahlo never attempted to ape their grandiloquent statements. While she agreed with the aims and the ambitions of the movement, and like them, of course, rejected abstraction, she chose to work within a more traditional trajectory. Having explored distinctly European-style figuration in her early works, she turned to the language of popular Mexican naive painting, a style that has immediate political connotations. This shift towards her native culture indicates a search for a style and content that would make sense in relation to the new nation of which she was to become such an important part. When Kahlo started to paint on tin in the early 1930s it was specifically in imitation of the naive painters of religious ex-votos of the eighteenth and nineteenth centuries (fig.9). These popular religious paintings, still being made today, are specially commissioned thank yous to God, a saint or the Virgin, for intercession or recovery from disaster, accident or illness. Kahlo was an avid collector of these

fig.8
The stairs of the Casa Azul
with Kahlo's collection
of *retablos* and *ex-votos*
on the walls
Photograph by Leo Matiz

fig.9 (right)
Ex-voto in Kahlo's collection
Courtesy of Museo Dolores
Olmedo Patiño,
Mexico City

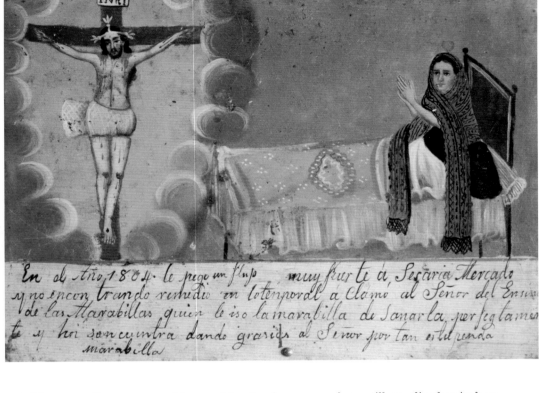

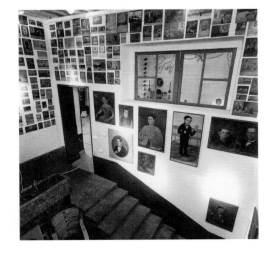

retablos or *milagros*, as evidenced by the large number still on display in her home the Casa Azul (fig.8). During the eighteenth and nineteenth centuries, tin became available as a cheap material, making these paintings accessible to the middle classes, and even to the poor. They always incorporate a text, which describes the circumstance of the deliverance illustrated above it. These popular images and their proliferation reveal how, in the particular cultural stew that is Mexico, the miraculous can seem a very real part of everyday life. While Kahlo herself was not devout, and through her political allegiances was actually antithetical to the Catholic church, these popular expressions of the miraculous, and the ever-present threat of death and injury, clearly represented a useful and appropriate vocabulary for her particular tastes. They provide the language for some of her most memorable images, particularly during the 1930s, when she was developing as an artist.

In *The Bus* 1929 (pl.7), she used this naive style to create a satirical picture of Mexican society, as it moved from an agrarian to a modern industrial future (both town and country are represented through the windows behind the passengers). Schaefer argues that *The Bus* articulates the complexities and contradictions of emergent Mexican modernity. The painting juxtaposes the pre-Columbian innocence of the barefoot peasant woman nursing her baby, with a young woman wearing European-style dress and the blue-eyed gringo carrying a bag of money on his lap. This depiction of a bus is the only time Kahlo comes close to referencing in paint her famous accident (there is one drawing from 1928). Schaefer points out how Kahlo's accident itself symbolically maps the cultural and economic collisions taking place in Mexico at that time: Kahlo's antiquated, wooden bus, used as a bridge between town and countryside, is struck by a tram, whose powerful structure and metal tramlines are quintessential symbols of modernising and capitalist developments in the new Mexico.[21]

When Kahlo reflects directly upon the revolution, the resulting painting has gender politics at its core. In *Pancho Villa and Adelita* 1927 (pl.5), Kahlo uses a semi-Futurist style known as Stridentism (*estridentismo*), the first flowering of a twentieth-century modernist avant-garde in Mexico. Two insets on the left and right of the painting present the conflicting and competing narratives of Mexico, with Kahlo placed at their nexus in the centre of the painting. The image

on the left shows revolutionary fighters, riding a train across Mexico, while the inset on the right depicts a modernist architectural construction. One reading of the painting is that it represents the aesthetic dilemma facing all radical Mexican artists, as to whether to choose the path of *Mexicanidad* and nationalist and socialist realism, or to pursue the path of international modernism.[22] Alternatively, the work can be viewed as a direct illustration of the tensions in post-revolutionary Mexico between tradition and the original ideals of the revolution, and the desire for modernity, cosmopolitanism and technological advance. But the title, containing the word *Adelita*, synonymous with the female revolutionary fighter, leads one to consider gender politics in post-revolutionary Mexico. Kahlo depicts herself as a free and modern woman, wearing an evening gown, two male figures nearby suggesting a bohemian café scene. This is further borne out by a preparatory drawing which clearly depicts a Cachuchas style café gathering, the artistic and literary group of which Kahlo was a member.[23] Against this depiction of a cosmopolitan Frida is juxtaposed the portrait of the revolutionary hero Pancho Villa whose portrait hangs on the wall behind Frida, and the clearly defined *soldaderas* or *Adelitas* in the left-hand panel. Kahlo must have been painfully aware by 1927 that the revolution had failed to deliver freedom for Mexico's female population. Prior to the revolution, women's lives had been tightly constrained by church, law and custom,[24] but as is often the case in war, the revolution offered the opportunity for change. Women took part on equal terms as fighters or *soldaderas* as well as playing the more traditional camp follower roles of cooks, washerwomen and prostitutes. But after the revolution, women's role and behaviour was circumscribed once again – for example, women did not obtain the vote in national politics until 1953. In addition, their heroic and essential role in the revolution was downplayed and romanticised after the conflict – the term *Adelita* was popularised by a popular song or *corrido* telling of a battlefield heroine who entered the fray for love of a soldier, rather than to fight for freedom. While Zapata admired and encouraged the *soldaderas*, Villa disliked them and is said to have forced them to withdraw from the firing line. In *Pancho Villa and Adelita*, Kahlo creates a multi-layered vision of competing aesthetics, philosophies, social histories and sexual politics within post-revolutionary Mexico. The work may even humorously make a connection between the *soldaderas* and Kahlo's role as a female intellectual in the male dominated milieu of the Cachuchas at the Preparatory School. Indeed, her very choice of such an ambitious political subject matter so early in her career was also a combative act, when the art world at that time would have considered flower studies or portraits more suitable to a woman's talents. As Schaefer so brilliantly points out, Kahlo went on in her oeuvre to create 'a dramatic and tragic parody of this cultural prescription for women's art'.[25]

Whatever residues of optimism remained after the bitter and violent interfactional struggles that characterised both the revolutionary and post-revolutionary periods, the 1930s and 1940s saw further disillusionment. The immediate energy of liberation was gone, and the country was beset both by its own disappointment in a failed utopia and by the powerful external economic forces of the Great Depression. Schaefer points out that Kahlo's extraordinary series of self-portrait busts, which she started in the late 1930s and worked on throughout the 1940s, coincided with Mexican society's loss of its revolutionary character and appreciation of the masses in favour of 'cultivating the individual bourgeois personality'[26] – most powerfully articulated via the burgeoning Mexican film industry and the personality cults created around particular stars. Schaefer suggests that Kahlo's mask-like self-portraits echo the contemporaneous fascination with the cinematic close-up of feminine beauty, as well as the mystique of female otherness expressed in film noir. These paintings helped to fix the iconic Kahlo image within a very public domain, being either sold or given as gifts to the rich and famous as well as to more modest friends and admirers, in the same way that her movie-star friends María Félix and Dolores del Río no doubt distributed signed photographs to their fans. In addition, these images lack the political and

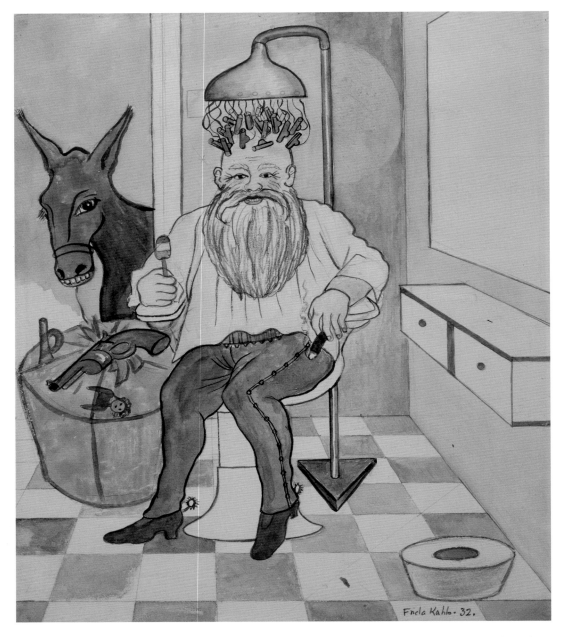

fig.10
Beauty Parlour (I)
or *The Perm* 1932
Watercolour and pencil
on paper 26 x 22 cm
Agustín Cristóbal,
courtesy of Galería Arvil,
Mexico City

personal honesty of the *retablo* paintings of the early 1930s – they are exercises in personal and political denial. They occur at the moment when the project of the revolution is losing its way – so Kahlo politely turns her gaze exclusively upon herself. They also occur around the time of her divorce and remarriage to Rivera, when Kahlo has to come to terms with the personal and economic realities of her relationship with her husband, and are an expression of her understanding of her need for personal and economic independence.

In a little-known drawing entitled *San Baba* or *Santa Claus c.*1932 (fig.11) of which there is another version entitled *Beauty Parlour (I)* or *The Perm* 1932 (fig.10), Kahlo takes a swipe with typical satirical humour at the bourgeois elements and forces holding back the reformist cause in post-revolutionary Mexico. Kahlo shows a cigar-smoking Father Christmas, which is in fact a portrait of the bearded cigar-smoking bourgeois revolutionary leader and one-time president Venustiano Carranza (1859–1920). *San Baba*, with its calendar displaying the date 5 December, perhaps conflates the feast of St Nicholas on 6 December with the constitutional congress in which Carranza participated in early December 1916, and which was one of his most important legacies, his 'gift' to the Mexican people. However, Kahlo's contempt is reserved for a conservative figure who did little for land reform, unleashed a reign of terror against his rivals, and was an ardent strike breaker. He was a desperate enemy of both Emiliano Zapata and

fig.11
San Baba or *Santa Claus* c.1932
Watercolour and pencil and
silver foil on paper 22 x 26 cm
Juan Rafael Coronel Rivera.
Promised donation to the
Museo Nacional de Arte,
Mexico City

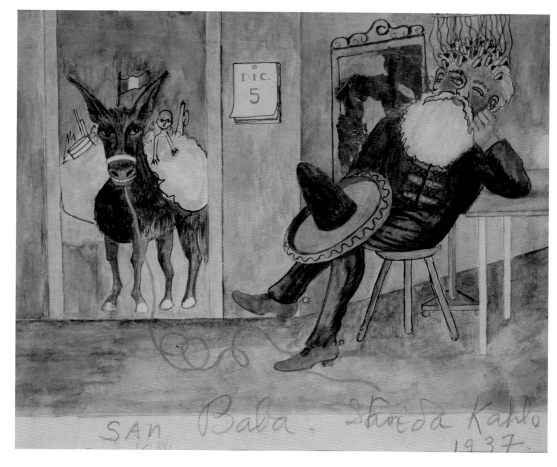

Pancho Villa who formed an alliance against him. Though he was murdered in
1920, San Baba or Carranza represents bourgeoisification and corruption in post-
revolutionary Mexico, meanings that are reinforced by the modern salon depicted
in *Beauty Parlour*, or his sucking of a lollipop in the colours of the Mexican flag.
San Baba (*baba* means stupid, dumb or decrepit when applied to people) has
been distracted from his task of 'delivering' to the people, by personal vanity, self-
interest and effeminacy. His patronising contempt for the Mexican people is
further delineated in the diminutive toy trumpets and guns he will distribute. The
drawing expresses Kahlo's frustration at seeing the forces of conservatism,
real-politik and individual private interests being reasserted in 1930s Mexico.[27]

The Problem with Surrealism

Kahlo's association with Surrealism arose more through accident than design.
It was due firstly to her manner of painting, which shares 'an interest in the
unconscious; disquieting, often inchoate imagery; and unorthodox subject matter'
characteristic of the second phrase of French Surrealism, as in the work of Dalí,
Magritte or Tanguy. But she also formally associated with the Surrealists, meeting
and impressing André Breton on his visit to Mexico in 1938, and travelling to
Paris in 1939 to participate in an exhibition he was planning, where she rubbed
shoulders with Picasso, Duchamp, Eluard, Ernst, Miró, Kandinsky and Tanguy.
Her first solo exhibition in 1938 took place at the Julien Levy Gallery in New York,
a gallery that specialised in introducing European Surrealism to the Americas,
and in 1940 she participated in the first Surrealist exhibition in Mexico, which
took place at the Galería de Arte Mexicano, Mexico City.
　　　　Breton came to Mexico in 1938 in search of 'the dialectical unity of art
and revolution'[28] sought by the Surrealists. The language he used to describe
Mexico clearly shows his breathless romantic idealisation of its land, history
and people. He described it as:

fig.12
René Magritte
The Spirit of Geometry 1937
Gouache on paper 37.5 x 29.2 cm
Tate, London. Presented by
the Hon. Ivor Montagu 1966

a country where the world's heart opens out, relieved of the oppressive feeling that nature everywhere is drab and unenterprising … where creation has been prodigal with undulations of the ground and species of plant-life [and where] the word INDEPENDENCE has continued to crackle beneath a blacksmith's giant bellows, sending up incomparable sparks into the sky. I had long been impatient to go there, to put to the test the idea I had formulated of the kind of art which our own era demanded, an art that would deliberately sacrifice the external model to the internal model, that would resolutely give perception precedence over representation.[29]

Breton was delighted to find a 'natural surrealism' taking place in Mexico: 'I was witnessing here at the other end of the earth, a spontaneous outpouring of our own questioning spirit: what irrational laws do we obey … which symbols and myths predominate in a particular conjunction of objects or web of happenings.' But there are many problems with the absorption of Mexican surrealists into Breton's Eurocentric project. Breton and the European Surrealists treated Mexican surrealists like *objets trouvés*,[30] seeing 'the inherent values of these traditional cultures as antidotes to the failure of Western industrialised society'.[31] Kahlo's absorption within Surrealism not only risks denying her a Latin American or culturally specific context for her work, but it also obscures its directly political content. When Breton describes her work he overlooks how nationality and postcolonial issues are represented in favour of readings based on gender, thereby launching the reading that has predominated to this day of Kahlo as an artist chiefly of women's experience.[32] This gender-specific reading is due in part to the Surrealist belief that women were closer to the unconscious than men. Tellingly Breton said of Kahlo's work that 'there is no art more exclusively feminine … by turns absolutely pure and absolutely pernicious', but in his obsession with its otherness and femininity he failed to grasp its fully rounded political power and ambition. He reflects on how 'the strange ecstasies of puberty and the mysteries of generation' are displayed by Kahlo with a mixture of 'candour and insolence' – again, qualities that are specifically associated with the feminine. Breton comes closest to a description of Kahlo's revolutionary credentials when he describes her art as 'a ribbon around a bomb',[33] but he never fully elaborates on this marvellous phrase. As a committed Third World cultural nationalist[34] and revolutionary, Kahlo should have been acknowledged for her unique contribution to melding the internal and external aspects of the surrealist revolution. As Fuentes puts it: 'The internal, oneiric, psychic revolution should be inseparable from the external, political, material, liberating revolution. The marriage of Marx and Freud.'[35]

Of course, Mexican modernists such as Kahlo and Rivera, both revolutionaries with an extraordinary cultural inheritance, were excellently placed to attempt the return to wholeness and unity that was at the root of Romanticism, Marxism and, later, Surrealism; they were major actors within a cultural and political revolution that was one of the century's great attempts to reverse or allay the horrors of alienation inflicted by capitalism and industrialisation. Laura Mulvey and Peter Wollen suggest that 'it was possible for political and artistic avant-gardes to overlap in Mexico in a way that they never could in Europe'.[36] But Breton could see in Kahlo's work only 'what was alien to the rational world of the white European male – madness, women, the exotic',[37] and it blinded him to the political and Mexican realities inherent in Kahlo's painting. If we compare René Magritte's *The Spirit of Geometry* (fig.12) with Kahlo's *My Nurse and I* (pl.17), both painted in 1937, they share similar concerns in terms of a psychoanalytical mapping of the mother/child relationship. Magritte's work is stripped of all other references save those details of hair, dress and drapes that suggest a stifling bourgeois domesticity, while Kahlo's image is packed with additional imagery and symbols that complicate the Freudian story at its centre, with a drama about the mother country, history, nature, culture and science, woven from such elements as the

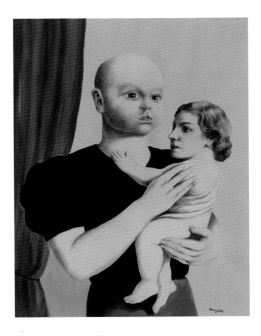

fig.13
George Grosz
Suicide 1916
Oil on canvas 100 x 77.5 cm
Tate, London. Purchased with
assistance from the National
Art Collections Fund 1976

fig.14
George Grosz
A Married Couple 1930
Watercolour on paper
66 x 47.3 cm
Tate, London. Presented
by the Contemporary
Art Society 1955

lush foliage, the masked pre-Columbian deity, and the anatomically drawn milk ducts. This painting demonstrates that what was mistaken for Surrealism was in fact part of the Latin American 'cultural stream, a spontaneous fusing of myth and fact, dream and vigil, reason and fantasy.'[38]

There is, of course, an element of neo-colonialism in the Surrealists' search for the renewing qualities of the exotic, and to designate Kahlo as a Surrealist overlooks the special qualities of a Latin American everyday reality described above. In addition, her use of Aztec, Olmec and Toltec imagery and myth was a political act, part of the movement of *Mexicanidad*, designed to deconstruct the mind-set of cultural inferiority that was the legacy of colonialism, just as much as it was due to her interest in themes and images of death, desire or the uncanny. Aztec culture was in fact part of a very recent past; its destruction had taken place in the sixteenth century, but its language – Nahuatl – was still being spoken, and many Indian practices and customs had remained or were being revived under the auspices of the Revolution.[39] For Kahlo, Aztec mythology provided an extraordinary primer for an unfettered world of cruelty, magic, desire and death. Salomon Grimberg, who has introduced us to the complex iconography of pre-Columbian culture, convincingly demonstrates, for instance, that not only is *The Little Deer* 1946 (pl.51) an extraordinary exploration of psychic alienation and gender confusion, but its symbolism is strongly indebted to pre-Columbian rites and rituals of rebirth and renewal, as well as to popular Mexican love songs of the 1930s and Hindu Karmic beliefs of reincarnation.[40] Kahlo's interest in popular Mexican religious painting – *ex-votos* and *retablos* – is a further alternative source for a specifically Mexican thinning of the interface between life and death, the ordinary and the miraculous. As described by Carlos Fuentes, the Surrealist Revolution delineated by Breton in Paris in the 1920s:

> was already the law of life and the imagination in Latin America. Pre-Columbian myth, Afro-American rites, the Baroque hunger for the object of desire, the masks of religious syncretism, gave Latin America its own patent for Surrealism with no need to submit, in the name of anti-Cartesian freedom of association, to very Cartesian rules on what dreams, intuitions, and prosody should properly be like.[41]

Interestingly, another European art movement of the 1920s could just as well be cited as the equivalent of Kahlo's brand of Mexican modernism in which the everyday and the fantastic are fused. 'Magical Realism' was a term coined by the German art critic Franz Roh in 1925 to describe the post-Expressionist works, now more commonly known as New Objectivity, of Christian Schad, George Grosz, Otto Dix and Franz Radziwill, in which a return to realism is inflected with formal freedoms won as a result of abstraction. It was the means of achieving a defamiliarisation of the familiar – a heightening and exaggeration of the everyday. Many correspondences may be identified with contemporaneous developments elsewhere, such as Italian Futurism, Russian Constructivism, American Precisionism and Argentine 'ultraism'. Interestingly, if we look at Grosz's *Suicide* 1916 (fig.13), alongside Kahlo's *The Suicide of Dorothy Hale* 1939 (pl.24), we see the same sort of unflinching analysis and refusal to shy away from the harsh realities of life. Even Grosz's *A Married Couple* 1930 (fig.14) is echoed in her gently satirical caricatures of Mexican society on the bus. In *A Few Small Nips* 1935 (pl.20), Kahlo again reveals an affinity with Grosz and Dix through the bitter irony of the title and the glaring horror of the image, based on a gory real-life murder story reported in the newspapers and reflecting the influence of the great satirical draftsman José Guadalupe Posada.

Roh pointed out the exaggerated clarity of line and colour inherent in Magical Realism, the flattened texture and perspective, and the return to human figures and furnishings, after the abstraction and kineticism of Expressionism. Ironically Magical Realism as a European art-historical term fell by the wayside,

but was reborn in the 1950s when applied to the emergence of the fantastic
as a powerful element in Latin American literature. According to Schaefer:

> The disjunction in post-revolutionary Mexico between pre-Columbian historical
> and cultural tradition, modern European ideas (among them Surrealism itself),
> and a pact with mass consumption on an international level falls squarely into
> the category of the criteria suggested by Fredric Jameson as basic to the
> production of magical realism. Jameson accurately proposes that magical
> realism 'depends on a content which betrays the overlap or the coexistence
> of precapitalist with nascent capitalist or technological features'.[42]

Even though the term Magical Realism is now regularly applied in relation to
the recent Latin American literary tradition of Gabriel García Márquez and Isabel
Allende, it is a useful term with which to denote a Latin American cultural sphere
in which politics, fantasy and subjectivity can freely interrelate, without the
implication of an indebtedness to European models. Some commentators
have seen Latin American Magical Realism as an attempt to fuse the union
of opposites: life and death, precolonial past with postindustrial present, Western
and indigenous. According to Ray Verzasconi and others, Magical Realism is
'an expression of the New World reality which at once combines the rational
elements of the European super-civilisation, and the irrational elements of
a primitive America'. Kahlo's own denial of a link with Surrealism also stresses
her connection to realism: 'They thought I was a Surrealist, but I wasn't. I never
painted dreams. I painted my own reality.'[43] On another occasion she commented:
'Some critics have tried to classify me as a Surrealist; but I do not consider myself
a Surrealist ... I detest Surrealism. To me it seems a manifestation of bourgeois
art. A deviation from the true art that the people hope for from the artist ...
I wish to be worthy, with my paintings.'[44]

The United States

In her mature work, which starts roughly in the 1930s, Kahlo used a language
of symbols to pack her images with layers of meaning, giving them an enormous
political range. The chief influence that allowed her to develop this mature style
is Mexican popular painting. This gives her the scale, the medium and the support,
as well as the slightly naive handling, and allows the use of symbols and attributes.
But far from developing a modern pastiche of naive and folkloric painting,
she invests this stylistic language with her own imagery, drawing on a variety
of sources, from the deeply personal to the rich heritage of pre-Columbian
image and myth.

Her work of this period enunciates Mexico's problematic relationship
with its northern neighbour, the United States. At the beginning of the nineteenth
century, Mexican territory extended as far north as Texas, as well as to parts
of California, New Mexico, Arizona, Colorado and Utah, lands that were
surrendered or sold as a result of the Mexican–American war of 1846–8. This
resulted in a 50 per cent diminution of Mexican territory, and climaxed in the
humiliating capture of Mexico City itself by the United States. Add to this American
economic involvement in the brutal and abrupt modernisation of the country
under Porfirio Díaz (the establishment of railways, roads and communication
networks) as well as outside ownership of the country's natural mineral resources,
and one can understand the long-standing roots of Kahlo's scepticism regarding
American industrial might. Her visit to the United States from 1930 to 1933 was
a personally traumatic period but during that time she developed a remarkable
visual language for representing neo-colonialist pressures on her society. This
complex relationship between the US and Mexico informs *Self-Portrait on the
Borderline between Mexico and the United States* 1932 (pl.13), in which Mexico

and the US seem to oppose yet balance each other along a dialectical scale, with Kahlo poised in the middle, rather like the figure of justice. Ostensibly a simple painting of the artist standing on the border, this tiny work is full of politically potent meaning that is still relevant today. The existing border was created in 1854, when the dictator Santa Ana sold a strip of land along the Rio Grande to the US for $10m. Thus for Kahlo this is no innocent dividing line of territories and cultures but is a potent symbol of loss, servitude to a powerful neighbour, and humiliation and disrespect for her nation. She succinctly demonstrates the predicament of the developing world in relation to the developed through her depiction of the onward march of an unfeeling and robotic technology, which heads in the direction of the earthy, undeveloped Mexican side of the painting. This mechanistic, Fordist world of the United States is juxtaposed with a pre-Columbian Mexico: an arid land strewn with figures, a pyramid, and with a symbol of its cultural dualism in the form of the sun and moon touching what looks like fingers of cloud, generating a streak of lightning. This natural electricity is echoed in the foreground, in the American lamps and other pieces of electrical hardware, which also echo the plants and flowers of Mexico on the other side of the painting. Kahlo's self-portrait is a feast of contradictions. Standing on a plinth, she wears a nineteenth-century European-style dress of pink flounces, her hair demurely plaited and raised in what can be described as the German fashion (a nod to her father's nationality). But she clearly debunks this image of demure, European womanhood with the addition of nipples subtly showing through the cloth of her dress, a cigarette in her hand, a Mexican necklace, and a Mexican flag. And while the surname engraved on the little plinth is her married name Rivera, she adopts her Mexican first name, Carmen. This painting is full of juxtapositions. As Baddeley and Fraser observe, the painting looks not only at the literal border between two geographical and territorial entities but also at the metaphorical border between different cultures, by juxtaposing 'the past versus the future, female nature versus masculine technology; growth versus exploitation; and in its very material presence, the traditions of fine art versus those of the popular'.[45]

Self-Portrait on the Borderline and other later paintings such as Moses 1945 (pl.69) owe a great deal to the muralist tradition and specifically to Rivera: the ambitious historical and cultural sweep of the painting, the symbolic depiction of an untainted and 'natural' Mexico, the dialectic of technology/the present versus nature/the past. But whereas Rivera dazzles with the accumulation of figures – creating vast friezes of humanity to represent the past, present and future of Mexico, the United States and mankind in general – Kahlo depicts no one but herself. And in this also lies part of her unique achievement, for here she plays out the drama of the individual caught in this cultural vice. By creating a self of great fascination and complexity, around which the political world revolves, she encourages the viewer to identify with the predicament she depicts, making the political dramas and messages in her work more accessible than the Socialist Realist tendency of the muralist movement. In this way Kahlo achieves the full interplay of the personal and the political, which is not just the mantra of feminist art practice, but also the key to all great political art and literature. Baddeley and Fraser suggest that her success in uniting popular art and the modernist avant-garde was due to this 'elision of the difference between the personal and the political which allowed her to identify her concerns as a woman with those of Mexico's peasantry'.[46] She fuses the directness and simplicity of Mexican popular art with sophisticated cultural references and uses her own self image as a means of representing the triumph of subjectivity.

It is interesting to compare this work with Rivera's Frozen Assets 1931 (fig.16), a fresco that depicts the US as a vast underground bank filled with a commodity: the frozen bodies of workers, lying under guard in cold storage beneath the skyscrapers of Manhattan. While Rivera provides no counterbalance, no alternative to his bleak and nightmarish vision, Kahlo chooses to keep all her oppositions in play, balancing them out across the width of the painting. Rivera's

fig.16
Diego Rivera
Frozen Assets 1931
Fresco on reinforced
steel with concrete
239 x 188 cm
Museo Dolores
Olmedo Patiño,
Mexico City

fig.17
Diego Rivera
Man at the Crossroads,
mural created for
the Rockefeller Centre,
New York 1933
This version repainted
in the Palace of Fine Arts,
Mexico City 1934

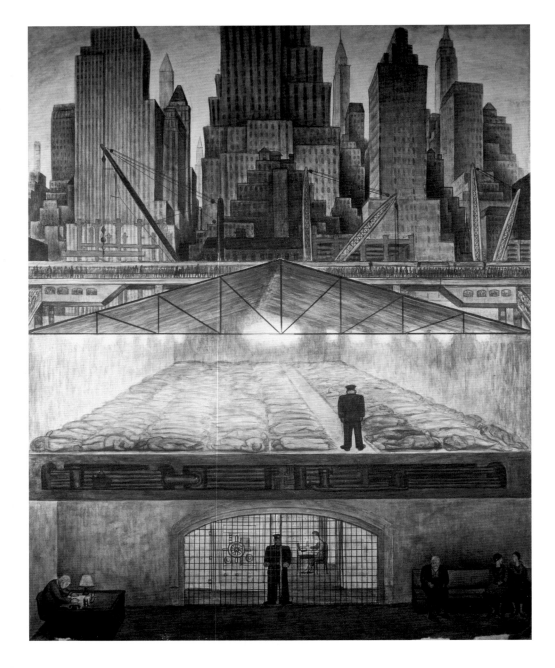

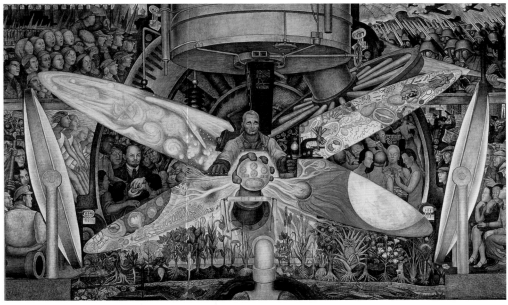

work is a *tour de force*, yet it lacks the humour and lightness of touch displayed by Kahlo's borderline observations.

After only one year of marriage, Kahlo accompanied her husband to the United States in 1930, where he was to complete numerous commissions in San Francisco, New York and Detroit over a four-year period. *My Dress Hangs There* 1933 (pl.14) is Kahlo's only collage and an eviscerating portrait of the United States during the Depression years. The tiny painting is crammed with motifs, jostling against each other, filling the picture plane as if it were a mural. Manhattan and the Statue of Liberty are depicted in the distance, but the foreground is filled with images of competing and contradictory scale, using what has been described as a 'primitive brand of Synthetic Cubism'.[47] Kahlo symbolises the empty utilitarianism and vapid escapism of US culture with a toilet bowl and a golfing trophy displayed on top of classical columns, while the huddled masses swarm like ants around the foreground of the painting. She represents herself and her Mexicanness through the empty Tehuana dress, which hangs in the centre. Other satirical elements include the church with a dollar sign emblazoned in its stained glass, or the steps up to the Grecian-temple-style bank, composed of a graph of sales figures. Both *My Dress Hangs There* and *Self-Portrait on the Borderline* are remarkable paintings for their political and cultural sophistication and ambition, especially considering that they were painted so early in Kahlo's career. She takes the huge sweep of vision and some of the formal devices used by her husband in works such as *Man at the Crossroads* 1933 (fig.17) but deploys them on a small scale, adopting the style of primitive painting to create works that continue to resonate with contemporary meaning to this day.

Still Life or the Life Force

In general Kahlo's still lifes are not as well known as her self-portraits or *retablo* paintings. Necessarily quieter in tone than her other more sensational or unusual works, they are nevertheless a fascinating and essential element in her oeuvre. In a sense they encapsulate many of the elements that define her work. Of course, the still life has always been a site for symbolic meaning within a Western art-historical context, originating in the seventeenth century as the vanitas painting that reminded viewers of their immanent mortality and the illusions of the material world. Kahlo's early admiration for Flemish painting such as Brueghel and Bosch strengthened her interest in symbols and embodiments of abstract concepts. Her still life output also reflects the development of her personal philosophy, moving from early paintings that dramatise the formation and consolidation of national and cultural identity, to works that express regenerative and sexual forces within nature, to canvases in which the human, the natural and the divine are melded into one, making the definition of the still life genre meaningless, as Kahlo creates a unifying vision of the wholeness of creation.

During the post-revolutionary cultural renaissance, as part of the search for *Mexicanidad*, previously undervalued or despised Mexican arts and crafts were re-evaluated and promoted as a source of national pride in public education programmes and progressive magazines dedicated to Mexican arts and crafts. In one of her earliest still lifes *Small Mexican Horse* 1927–8 (fig.18), what appears as a purely academic still life exercise, is in fact grounded in these revolutionary cultural policies. The watercolour depicts, alongside a Michoacán lacquer tray and other craft objects, a little figure of a revolutionary fighter on horseback made from a single palm leaf using the traditional *petate* technique.[48] *Small Mexican Horse* is therefore an embodiment of national identity and a rejection of European cultural values in favour of Mexico's poor and oppressed: fashioned through a newly rediscovered and appreciated traditional Mexican handcraft the fighter, his ammunition strapped to his waist, is a potent symbol of the struggle for liberation that would have still been fresh in the mind in 1927.

fig.18
Small Mexican Horse c.1928
Watercolour on paper 27 x 33 cm
Private collection, courtesy of
Galería Arvil, Mexico City

Window Display in a Street in Detroit 1931 (pl.56), a dispassionate yet wry description of the construction of US national identity, demonstrates further how Kahlo was well aware of the symbolic content of her still lifes. Based on a window display celebrating Independence Day (4 July was also the day that Kahlo suffered her miscarriage) the painting's dialectical balance exists in its depth, from front to back rather than side to side. The foreground depicts a constructed display of national pride and identity for public consumption, a frieze of patriotic symbols: a lion, a bust of George Washington, the American eagle, a white horse, and paper decorations and garlands. But she undercuts their potency via the vast background of the empty store, animated solely by the unused tools and materials lying around, an emptiness that reveals the artificiality and hollowness of the symbols in the foreground. Pointedly, a map of the US hangs on the back wall, another reminder of the former territorial glory that was once Mexico, and of all the lands that had been lost to this brazen, capitalist northern neighbour.

Fruits of the Earth 1938 (pl.57) at first sight appears to be a more conventional still life, following the tradition of Spanish and Dutch seventeenth-century works: a plate of fruits, vegetables and fungi depicted on a wooden table with a brooding El Greco sky behind. Here critics and commentators have found a wealth of allusions and hidden meanings that delineate the range of Kahlo's personal language: the obvious visual echoes of male and female genitalia, the bloody, wounded and sliced nopal fruits, which echo Kahlo's own wounded body, as well as being an expression of national pride and identity. Kahlo lays out the rich abundance of Mexican flora and fungi, framed by the plate. On the plain wooden table lie three maize cobs, often used as revolutionary symbols for land reform, or the peasantry, and still the staple diet of millions of Mexico's poor to this day.

By contrast, *Sun and Life* 1947 (pl.68), painted nine years later, only loosely earns the designation still life, being a plant study. It is part of a group of works created towards the end of Kahlo's career that defy any categorisation by genre, and which take a much more rounded view of life. An active, rudely fecund nature is depicted: the inner organs of the plants are quite unequivocally ejaculating male genitalia, while opening vulva and a lone foetus hidden in a plant interior seem to be weeping.

fig.19
Kahlo's studio at the Casa Azul,
with a portrait of Stalin,
left unfinished at her death
Photograph by Leo Matiz

Reconciliation

Kahlo's late works are notable for the inclusion of elements of iconography from Eastern religious beliefs combined with ancient Aztec folklore and religion. The third eye becomes a recurring motif in self-portraits and other images. Schaefer suggests that Kahlo's growing interest in 'myth, nature, cosmic forces, and popular tradition as sources of healing power'[49] is part of a disillusionment with the project of modern Mexico as, post-Cárdenas, the country turns towards foreign capital and technology as an answer to its problems, allowing bourgeois capitalism and private industry to re-emerge as powerful forces within the country. Kahlo's late work *Marxism Will Give Health to the Sick* 1954 (Museo Frida Kahlo, Mexico City), demonstrates her desire to fuse her interest in healing with the egalitarian socialist project that seemed all but dead in her native Mexico. Yet this painting is a rare example of an explicit fusing of the notion of healing, faith and the miraculous with identifiable political and ideological figures and lacks the dialectical tension inherent in her best and most complex work. Kahlo preferred to depict powerful political and social forces in generalised and dialectically balanced terms. *Moses* 1945 (pl.69) is a tiny painting packed with enormous historical and political meaning: massed ranks of humanity are joined by friezes of powerful and influential historical figures: Marx, Ghandi, Julius Caesar, Martin Luther, Hitler. In addition to flanks of Aztec mythological, Egyptian and Greco-Roman and Judaic imagery, the central panel depicts the birth of Moses in the form of a medical uterine transection, dominated by the formal poetry of various other rounded forms: the Sun as the overwhelming life force dominates the painting, while medallions mimic the microscope's view of the moment of conception. Kahlo created the work after reading Freud's essay *Moses and Monotheism*, describing her goal as to show that 'the reason people need to invent or imagine heroes and gods is because of their fear – fear of life and fear of death'.[50] The painting is a remarkable fusion of the tensions and forces that exerted themselves on Kahlo throughout her life, the articulation of which is at the core of her work: juxtaposing the individual and the collective mass, the competing narratives of world religions and cultures, ancient beliefs versus science and medicine. It also depicts race in terms of figures composed of individual blocks of contrasting colour. This is very different from the elevation of the *mestizo* as the universal race advocated and wished for by Vasconcelos, who first promulgated his vision of Christian and racial harmony in *The Cosmic Race*, published in 1925, his blueprint for a universal society based on Christian brotherhood. Kahlo always depicts race in terms of contrast and interrelation rather than homogeneity. In *The Two Fridas* 1939 (pl.28) she portrays one Indian, one European self, while in *Two Nudes in a Forest* 1939 (pl.27) a light-skinned and a darker-skinned woman caress. Kahlo's works always exist in this dialectical tension: 'Kahlo's art flourishes on the borderlines, in the spaces of contention and opposition among races, cultures and genders.'[51]

Kahlo's oeuvre always worked at 'reconstructing the mythic past of the nation',[52] but in her last works, the Mexican themes become less specific, assertive and 'combative' in favour of universal, spiritual and cosmological imagery fused from Aztec and Eastern religious elements. In *The Love-Embrace of the Universe, the Earth (Mexico), Me, Diego and Mr Xólotl* 1949 (pl.70), Frida holds an outsize infant Diego on her lap. The pair themselves are locked in the embrace of the Mexican Earth Mother whose breasts are dripping milk, and who is herself embraced by a cosmological goddess formed out of light and dark, sun and moon. The Mexican theme is further articulated through the cacti that radiate around the figures protectively, and the wounded Pedregal landscape which forms the breast of the goddess. Resting on the arm of the large goddess is Kahlo's pet dog Mr Xólotl, a source of multiple possible meanings: including the *nahual* or alter-ego of Quetzalcoatl, who was named Xólotl, or the ancient Chichimec warrior Xólotl seen as a precursor of the Aztecs.[53] Like the life/death giving goddess Coatlicue both Kahlo and the Earth Goddess have slashed necks,

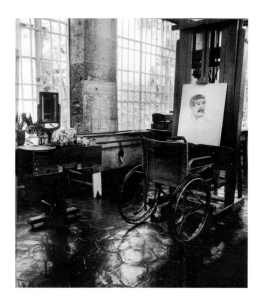

Kahlo's wound culminating in a fount of blood reminiscent of the starbursts of semen from the plants in *Flower of Life* 1943 (pl.67), and *Sun and Life*. Almost every figure or element of the painting represents the simultaneous presence of opposites: of life and death, light and dark, sun and moon, child and adult, male and female. These late works represent Kahlo's quest for harmony – both in her personal life and in a wider sphere. In her 'Portrait of Diego' she wrote, in 1949, 'For me, everything has a natural mixing together. Within my role, both difficult and obscure, as an ally of an extraordinary being, I have the compensation that a green dot has within a quantity of red: the compensation of *equilibrium*.'[54] As overt references to the political realm fall away, Kahlo combines self-portraiture with not simply the 'mythic nationalism'[55] of earlier works but with a cosmic Aztec nationalism in which Mexico is the embodiment of the forces of the universe. Kahlo may have lost faith with Mexican government and politics in the 1940s and 1950s, but she continued to use Mexico's landscape, plants, deities and customs as the means by which she uncovered the universal. As Rivera described her work/life in 1943: 'Frida's art is collective-individual. Her realism is so monumental that everything possesses universal dimensions, and, as a consequence, she paints the outside, the inside, and the very bottom of herself and the world'.[56] Schaefer adds: 'Kahlo's passionate desire to attain the paradise of a complete mental and physical body reflects the parallel search in Mexico for a utopian social body after the Revolution'. In *The Love-Embrace*, Kahlo achieves a harmony and equilibrium of sorts: she immortalises herself and Diego as revolutionary red surrounded by a sea of cosmic green.

Notes

1 Raquel Tibol, *Frida Kahlo: An Open Life*, trans. Elinor Randall, Albuquerque 1993, p.67.

2 Joan Borsa, 'Frida Kahlo: Marginalization and the Critical Female Subject', *Third Text*, Autumn 1990, no.12, p.26.

3 Oriana Baddeley and Valerie Fraser, *Drawing the Line: Art and Cultural Identity in Contemporary Latin America*, London 1989, p.92.

4 Claudia Schaefer, *Textured Lives: Women, Art, and Representation in Modern Mexico*, Tucson and London 1992, p.5.

5 Tibol 1993, p.149. Kahlo describes Rivera's El Anahuacalli museum as 'Like Coatlicue, it contains life and death'.

6 Salomon Grimberg, *Frida Kahlo: The Little Deer*, 1997, leaflet, Miami University, School of Fine Arts, p.4.

7 Schaefer 1992, p.6.

8 Quoted in Luis-Martín Lozano, 'Frida Kahlo, or the Will to Paint', in *Diego Rivera, Frida Kahlo*, exh. cat., Fondation Pierre Gianadda, Martigny 1998, p.233.

9 Laura Mulvey and Peter Wollen, 'Introduction', in *Frida Kahlo and Tina Modotti*, exh. cat, Whitechapel Art Gallery, London 1982, p.18.

10 Schaefer 1992, p.25.

11 Carlos Fuentes, 'Introduction', in *The Diary of Frida Kahlo: An Intimate Self-Portrait*, London 1995, p.9.

12 Schaefer 1992, p.6.

13 Fuentes 1995, p.9.

14 Helga Prignitz-Poda, *Frida*, New York 2004, p.15.

15 Fuentes, p.19.

16 Baddeley and Fraser 1989, p.17.

17 Ibid.

18 Tibol 1993, pp.148–9.

19 Ibid., p.163.

20 Ibid., p.147.

21 Schaefer 1992, p.36.

22 Luis-Martín Lozano, *Frida Kahlo*, Boston 2001, p.50.

23 The drawing is reproduced in Lozano 2001, p.45. See Hayden Herrera, *Frida: The Biography of Frida Kahlo*, New York 1983, pp.27–31 for the Cachuchas.

24 Under the Mexican Civil Code of 1884 while single women enjoyed almost the same rights as men, married women could not divorce, vote, draw up a contract or administer their personal property

25 Schaefer 1992, p.7.

26 Ibid., p.12.

27 I am indebted to Raquel Tibol for helping to decipher the iconography of these two drawings.

28 Mulvey and Wollen 1982, p.7.

29 Ibid., p.35.

30 Baddeley and Fraser 1989, p.93.

31 Lowery S. Sims quoted in Schaefer 1992, p.122.

32 André Breton, 'Frida Kahlo de Rivera' (1938), reprinted in Mulvey and Wollen 1982, pp.35–6.

33 Mulvey and Wollen 1982, p.36.

34 Janice Helland, 'Aztec Imagery in Frida Kahlo's Paintings', *Womens Art Journal*, Fall 1990/Winter 1991, p.12.

35 Fuentes 1995, p.17.

36 Mulvey and Wollen 1982, p.20.

37 Sarah M. Lowe, 'Essay' in *The Diary of Frida Kahlo* 1995, p.27.

38 Fuentes 1995, p.14.

39 Mulvey and Wollen 1982, p.20: 'Hence the artistic avant-garde, once the crucial decision had been taken to retreat from any move into abstraction, was able to use popular forms not as a means of facilitating communication but as a means of constructing a mythic past whose effectiveness could be felt in the present. Thereby it brought itself into line with the revolutionary impetus towards reconstructing the mythic past of the nation'.

40 Grimberg 1997.

41 Fuentes 1995, p.15.

42 Fredric Jameson, 'On Magical Realism in Film', *Critical Inquiry*, no.12, Winter 1986, p.311. Quoted in Schaefer 1992, p.11.

43 Herrera 1983, p.266.

44 Ibid., p.263.

45 Baddeley and Fraser 1989, p.94.

46 Ibid., p.122.

47 Hayden Herrera, *Frida Kahlo: The Paintings*, London 1991, p.101.

48 Lozano 1998, p.172.

49 Schaefer 1992, p.23.

50 Tibol 1993, p.72.

51 Schaefer 1992, p.29.

52 Mulvey and Wollen 1982, p.20.

53 Helland 1991, p.10.

54 Quoted in Schaefer 1992, p.27.

55 Mulvey and Wollen 1982, p.20. 'Although Kahlo was not herself a "history painter" like Rivera, avant-garde modernism, popular historicism and mythic nationalism all met in her favourite genre – self-portraiture. Popular forms made it possible for her to develop a type of self-portraiture that transcended the limits of the purely iconic or personal and allowed her to use narrative and allegory. In this way she created a mode of emblematic autobiography steeped in *mexicanidad*.'

56 Diego Rivera quoted in Lozano 1998, p.233.

Frida Kahlo:
The Fabric of her Art

Gannit Ankori

'Where is the "I"?' *Frida Kahlo, 1938*[1]

Before feminist thinkers formulated the slogan 'the personal is political' and long before 'identity politics' and postcolonial hybridities were theorised by scholars in academic circles, Frida Kahlo produced a body of work that brilliantly addressed these issues. Delving into her most intimate experiences, she explored her own identity. Yet, as she transfigured her 'lived experiences' into meticulously composed works of art, Kahlo embarked on a more ambitious ontological quest, which produced an innovative and multi-faceted poetics of identity.

In this essay I reject the implicit two-fold premise that has dominated much of the literature concerning Kahlo: first, that she was a 'naive' or 'spontaneous' artist, who simply '[painted] whatever passes through [her] head without any other considerations';[2] second, that her paintings are merely an illustration of her 'autobiography in paint'.[3] I will argue that Kahlo was anything but naive in her art-making praxis, and will demonstrate how she constructed her paintings with intent sophistication and careful 'considerations'. I will also show that while autobiographical components undoubtedly informed Kahlo's imagery, additional *non*-biographical sources – diverse, well-chosen and laden with significance – were deliberately interwoven with them, as weft interlaces with warp, to create the complex fabric that is the art of Frida Kahlo.

Between 1926, the year she painted her first self-portrait, and her untimely death in 1954, Kahlo produced over one hundred images that explore aspects of her complex identity in relation to her body, to her genealogy, to her childhood, to social structures, to national, religious and cultural contexts, and to nature.[4] Thus, she scrutinised her physical and psychological process of becoming and decomposing as it unfolded through time, imaging herself as a zygote, a foetus, a child, an adult and a disintegrating mortal being. Concurrently, she examined various social identities. She placed herself in traditional female roles, such as those of Wife and Mother. Exposing her failure to fit into usual social structures, she pursued numerous alternative options of Selfhood. Hence, in several paintings she assumed the identities of 'evil women' who personify forces that undermine the 'proper' social order, such as La Llorona and La Malinche. In her art she also expressed her sexual ambiguities, androgynous traits and homosexual tendencies. And finally, reflecting her profound affinity with nature and with Oriental concepts of being, Kahlo depicted herself as a hybrid creature, merging her human Self with plants, animals and other beings.

Given the limited scope of this essay, I will focus my discussion mainly on Kahlo's investigation of identity formation vis-à-vis social and gender roles. By examining several of Kahlo's major works, I will trace the artist's transition from her early self-depiction in a traditional conjugal role to her post-1932 espousal of subversive alternative 'Selves'.

fig.21
Frieda Kahlo and
Diego Rivera
1931
(pl.12)

fig.22
Jan van Eyck
Portrait of ?Giovanni
Arnolfini and his Wife
('The Arnolfini Portrait') 1434
Oil on wood 82.2 x 60 cm
National Gallery, London

Posing as La Mexicana: Diego's Little Wife who also Paints

Throughout her life, Kahlo was known first and foremost as the wife of the legendary Diego Rivera. In Mexico and in select artistic circles in New York and Paris, 'Frida' eventually gained recognition as a colourful personality in her own right. These twin roles – the role of wife and the role of flamboyant character – overshadowed her identity as a serious painter. To be sure, the artist herself was responsible – to a certain extent – for this attitude, for she was an expert at hiding behind masks and facades of her own construction. It is no coincidence that she was nicknamed by Rivera and by her closest friends *la gran ocultadora* – 'the great concealer'.

One of Kahlo's early paintings – a 1931 double portrait celebrating her marriage to Rivera – demonstrates how she initially constructed a normative female identity, imaging herself in the role of the demure Mexican wife (fig.21). In this work, Rivera is portrayed as the Great Artist, who holds the attributes of the painter – the palette and the brushes – in his right hand. Kahlo, on the other hand, holds onto her husband, thus defining herself *not* as a painter but as his spouse. Adorned with a red *rebozo* and jade Aztec beads, she displays herself as the paradigmatic Mexican woman – *La Mexicana*. Moreover, her manner of painting this work – note the stiff pose, awkward rendering of the feet, and affinity with colonial portraiture – emulates the style of an amateur painter. Kahlo thus conceals her sophistication behind a mask of naiveté and camouflages her position as a painter by espousing the subordinate role of the painter's doting wife. Ironically, though, even this pseudo-naive work is based on a well-known European precedent – Jan van Eyck's *Arnolfini Portrait* from the fifteenth century (fig.22). Kahlo kept a reproduction of this work in her studio, among numerous other books and documents that reflect her vast knowledge and erudition.[5]

The Failed Mother: Kahlo's 'Anti-Nativity' Scenes

Just one year after she signed and dated her marriage portrait, Kahlo experienced a series of events that transformed her life and her art significantly. Neither would ever follow the traditional path thereafter. Between the end of May and mid-September of 1932 – within a period of less than four months – she went through a succession of dramatic experiences.[6] Late in May she found out that she was pregnant. Contrary to popular myths, which claim that Kahlo's deepest desire was to have Rivera's child, her initial reaction was to abort the foetus, which she immediately tried to do with the aid of her doctor. The attempted abortion was unsuccessful and Kahlo reluctantly began to consider the possibility of having a baby, in spite of her fears and hesitations. On 4 July, however, a traumatic miscarriage brought both her pregnancy and her budding – if ambivalent – thoughts about having a child to an abrupt halt. The miscarriage was also a near-fatal experience, as Kahlo almost bled to death. Barely out of the Henry Ford Hospital in Detroit, the exhausted artist travelled to Mexico City, where her mother, Matilde Calderón, lay dying in hospital. On 15 September 1932, soon after Kahlo's arrival, her mother died.

These unmediated and dramatic encounters with the forces of life and death, maternity and mortality, experienced viscerally through the body – the artist's own fragile body, the ailing and moribund body of her mother, and the disintegrated body of her unborn child – determined the course that Kahlo's art was to follow. Two drawings, two paintings and Kahlo's only known lithograph allow us to follow her process of coping with the compounded traumata of 1932 and to observe her manner of transforming 'lived' personal experiences into works of art that are suffused with profound and wide-ranging social and political implications.

Kahlo is often cited as claiming that 'two accidents' had shaped her life. The first was the 1925 automobile crash that almost killed her and left her physically handicapped for the rest of her life (fig.24). 'The second accident', Kahlo is quoted as saying, 'was Diego'. The fact that the near-fatal automobile accident compelled

fig.23
*Self-Portrait,
9 July 1932* 1932
Pencil on paper
20.5 x 13.2 cm
Juan Rafael Coronel Rivera.
Promised donation to the
Museo Nacional de Arte,
Mexico City

fig.24
The Accident 1926
Pencil on paper 20 x 27 cm
Juan Rafael Coronel Rivera.
Promised donation to the
Museo Nacional de Arte,
Mexico City

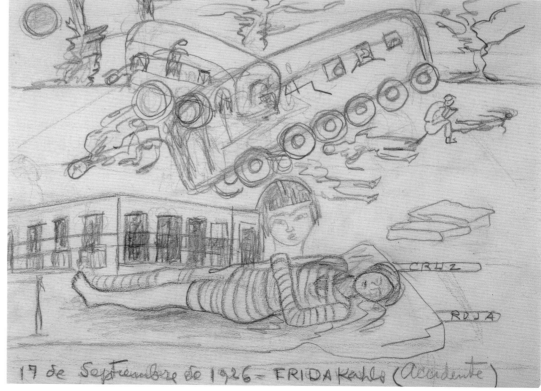

the eighteen-year-old Kahlo to abandon her plans to study medicine has been well-documented. Elsewhere, I have also examined the link between the accident and the essence of Kahlo's self-portraiture.[7] My suggestion here is that whereas Kahlo's tumultuous relationship with Rivera certainly shaped her life, it was after she had abandoned the traditional roles of Wife and Mother that she became the innovative and profound painter whom we know today.

Just five days after her miscarriage, Kahlo made a small pencil drawing (fig.23). In this work, dated 9 July, the artist's face appears puffy and round. Her gaze is a haunting, unfocused stare. Her hair is carefully gathered in a net and she seems to be wearing a loose-fitting hospital gown. At the bottom left-hand corner of the drawing an enlarged eye appears. By placing her eye outside her Self, Kahlo symbolically splits into viewer and object. This may be a visualisation of the psychological defence mechanism known as 'splitting', which Kahlo had previously employed to cope with life-threatening traumas.[8] Her attempt to illustrate her accident, for example, images this phenomenon even more clearly.[9]

The very next day (10 July 1932), Kahlo signed and dated a second drawing (fig.27). In this sketch (which became the basis for the oil painting *Henry Ford Hospital* completed shortly thereafter), she moved from direct self-portraiture to symbolic self-representation. The drawing shows a naked Kahlo upon a bed, her face almost expressionless, her eyeless sockets blank, and her hair neatly combed back. Her left hand touches (but does not grasp) five strings, which are attached to a corresponding number of elements symbolising the body parts that Kahlo believed were responsible for her miscarriage.[10] Of these, the images of a snail, a pelvic bone, a female abdomen, and an orchid are based on obstetrical illustrations of internal parts of the female anatomy. Lucienne Bloch, who was the artist's close friend at the time and an eye-witness to the events, recalled that when Kahlo was in the hospital, she asked to see the foetus she had lost. When this proved impossible, she requested illustrated medical books that would provide her with some understanding of what had happened to her body (see fig.25).[11] Images from these books continued to influence Kahlo's imagery for the rest of her life. The fifth object that she included in the drawing (and later in the oil painting) was a machine identified by Salomon Grimberg as part of an autoclave, a contraption used to sterilise medical utensils.[12] The autoclave's link to sterility probably relates to Kahlo's conceptualisation of her own infertility.

Kahlo made significant changes as she transformed the preparatory drawing into the painting *Henry Ford Hospital* (fig.26). These punctilious modifications negate any possibility that she was a 'spontaneous' painter. She altered the scene's industrial background, its spatial setting, colour scheme and scale. She also appended intentional art-historical allusions (engaging, for example, with the work of Charles Sheeler, Raoul Hausmann and Francis Picabia) to the biographical references and medical sources that had already appeared in the initial drawing.[13]

However, the most prominent new elements that Kahlo introduced into the oil painting are the oversized and centrally positioned foetus (attached to an additional sixth string); the copious uterine blood that profusely stains the white sheet; and Kahlo's dishevelled black hair and messy tears, which completely alter her original, vacuous demeanour. Thus in the final version of *Henry Ford Hospital*, Kahlo deliberately and significantly endowed herself with the attributes of La Llorona (the Weeping Woman).

Mexican folklore constructs La Llorona as an archetypal 'evil woman', antithetical to the normative Wife and Mother. Like them she is sexual and maternal, but hers is a deviant sexual energy and a moribund motherhood, which threaten the very foundations of the patriarchal order. There are numerous versions of the story of La Llorona, but several key elements dominate all the tales: she is first and foremost an unwed woman, abandoned by her lover; loss of love leads her to the brutal act of killing her own children in a frenzy of rage. A Mexican Medea, she becomes the epitome of uncontrolled non-conjugal sexuality, childlessness and madness, a social outcast denounced and feared by normal society.

fig.25
Diagram of pelvis, pl.62 in
Francis H. Ramsbotham,
*The Principles and Practice
of Obstetric Medicine and
Surgery in Reference to
the Process of Parturition*
(ed. William Keating,
Philadelphia, 1865), a copy
of which Kahlo owned.
Courtesy Wellcome Library,
London

fig.26
Henry Ford Hospital 1932
(pl.15)

fig.27
Henry Ford Hospital 1932
Pencil on paper 14 x 21 cm
Private collection

Clearly, then, *Henry Ford Hospital* is not simply a biographical account of Kahlo's miscarriage. The work evokes broader cultural and social ramifications through its innovative and revolutionary art-historical reversals and rupturing of taboos. It is constructed deliberately as an *anti-Nativity* scene. Indeed, Kahlo's naked body is decidedly *not* immaculate. Morever, unlike the chaste and virginal Madonna, Kahlo does not produce a child but rather the taboo uterine blood of La Llorona. *Henry Ford Hospital* is also original in its bold rejection of traditional female roles, reflecting Kahlo's personal understanding that she cannot fit into the roles of wife and mother. Furthermore, her attempt to explore other options of being – through the espousal of the identity of the marginalised Llorona – engages in a broader, proto-feminist discourse pertaining to the oppressive nature of gender roles in Mexican society.[14]

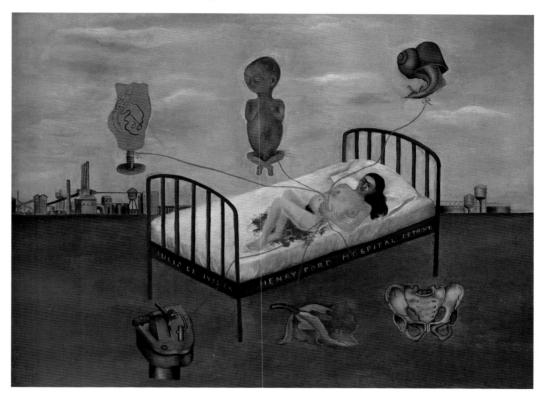

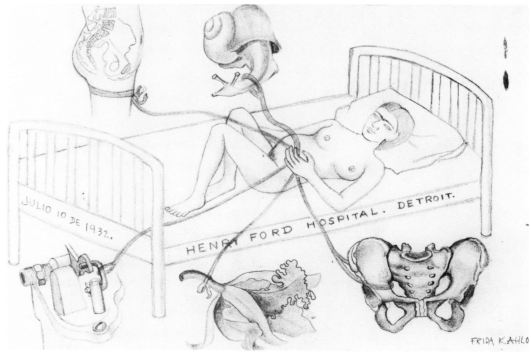

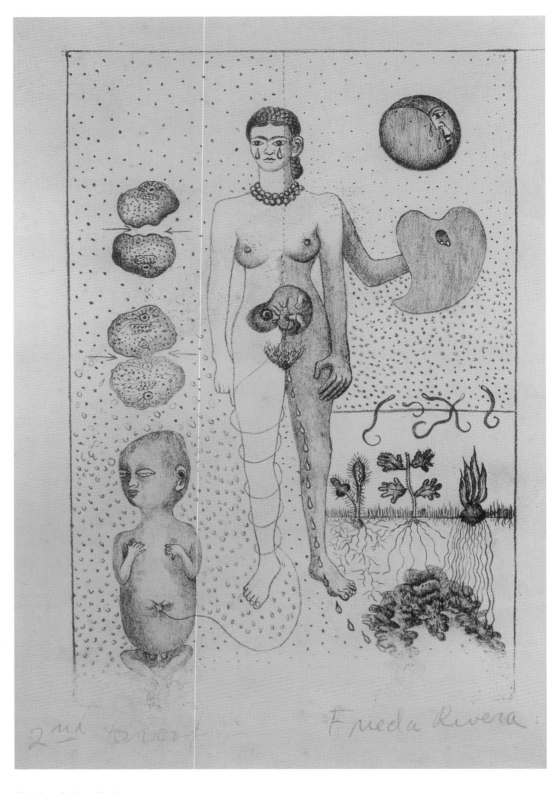

fig.28
Frida and the Miscarriage
1932
Lithograph on paper
31.5 x 23.5 cm
Museo Dolores Olmedo
Patiño, Mexico City

Birth of the Artist

Although it is possible that Kahlo never fully recovered from the trauma of her miscarriage, a lithograph that she completed on 11 August 1932 exhibits the beginning of a healing process and a transformation (fig.28). No longer passively lying in an alienated hospital bed, Kahlo literally and figuratively stands on her own two feet. No longer grieving with the wild tresses of the tearful Llorona, Kahlo has her hair carefully gathered in a net, as in her first post-miscarriage drawing. Even her blood flows in an orderly, controlled fashion. In fact, the blood drops and the tears become a stylised visual 'pattern' – as opposed to unruly or taboo bodily fluids – just as the artist's 'experiences' are transmuted into art. Both the composition and

Kahlo, its protagonist, are split in half. The left side of the work shows the fertile promise that did not materialise: from the foetus in Kahlo's uterus a delicate line, evoking an umbilical cord, encircles her right leg and is attached to the navel of a three-month-old male foetus.[15] Above this male foetus, two images of ovular cell division (carefully copied from scientific illustrations) are delineated. On the right side of the composition, an alternative scene of productivity is presented. Blood drops fall from Kahlo's vagina and fertilise the soil. They coagulate into strange, phallic-looking subterranean forms. Plants that resemble the human organs of the foetus, particularly his eyes, hands and genitals, sprout from this source. With their visible roots, they are based on images of Aztec depictions of medical herbs that Kahlo had in her library. Hence, they symbolise both fertility and healing. Sperm-like worms wriggle as Kahlo's blood contributes to the regeneration of the earth.

Above the realm of nature's fecundity, a third arm grows from Kahlo's left shoulder (reminiscent of Hindu or Buddhist imagery). In her newly acquired hand, Kahlo holds a painter's heart-shaped palette. This is the very same palette that Rivera had held in his hand in *Frieda Kahlo and Diego Rivera* (fig.21). In the 1931 painting, Kahlo presented herself as the doting wife of the Great Artist. Just one year later – a failed mother – she identifies herself as an artist in her own right. In the top-right corner of the work a weeping moon appears. The moon, a symbol of female menses and fertility, weeps for Kahlo's infertility. Kahlo too is weeping. But the two large symmetrical teardrops on her cheeks are stylised in such a way as to express a moderate sadness, no longer the frenzied grief of La Llorona. As she dons her bead necklaces, Kahlo is on her way to recovery. Acknowledging that part of her has failed, the part that could not produce a human offspring, she structures the other portion of her being as a productive entity, who participates in two realms of creativity: the fecundity of nature and the fertility of art.

fig.30
My Birth 1932
(pl.16)

Finally, Kahlo's lithograph is based on a genre of 'anatomical cosmologies' that inserts medical illustrations of the male and female bodies within cosmological settings. These elaborate compositions – which, like the lithograph, display internal and external aspects of the body – often include the sun and the moon, botanical illustrations and numerous additional images derived from scientific and mythic realms of human knowledge (fig.29).[16] In her lithograph, Kahlo rejects the standard cosmology in which Woman is subordinate to Man. Instead, she meticulously reconfigures an alternative scene in which the male partner – and the sun that is his symbol – are conspicuously absent. Kahlo images herself as an autonomous creative being, reborn as an artist.[17]

The first painting that Kahlo completed after her symbolic rebirth as an artist was *My Birth* 1932 (fig.30). Elsewhere, I have provided an exhaustive analysis and interpretation of this powerful work, stressing its biographical, psychological and cultural dimensions.[18] In the present context, I wish to emphasise the major transgressive innovations that find extreme expression in this painting. *My Birth* presents Kahlo's radical rejection of all artistic conventions of representation with regard to the female body in general and the body of the mother in particular. Hence, it is completely unlike Christian Nativity scenes; it is very different from the Aztec representation of the birth goddess Tlazolteotl, although it shares its frontal stance; and it is, of course, diametrically opposed to traditional renditions of the nude odalisque or bather.[19] In bold defiance, Kahlo copied a decontextualised obstetrical image of the nether parts of a female body, seen from a gynaecological perspective, into a carefully crafted and strictly symmetrical bedroom setting.[20] The shocking effect of the painting is enhanced by the fact that the artist covered the woman's head and positioned her exposed genitalia and uterine blood at the very centre of the composition. The startling image is immediately perceived as a forbidden sight: it explodes two deep-rooted taboos as it displays the 'unshowable' sexuality of the mother and her vaginal blood. In addition to this, Kahlo blasphemously links these 'impure' images with the holiest Christian icon, as she places a portrait of the immaculate Madonna directly above the taboo body.[21] *My Birth* relates to Kahlo's problematic relationship with her own mother.[22] But it also potently exposes the carnal, corporeal nature of Being that is repressed and hidden behind traditional cultural visualisations of the body.

To sum up, 1932 marked a pivotal turning point in the development of Kahlo's art on many different levels. First, it was at this juncture that she began her systematic search for Self. In a 1939 interview the artist explained that *My Birth* was the beginning of a larger quest, a project that entailed a visual reconstruction of her childhood years.[23] Her investigation into her psychological, genealogical and physical development produced nine powerful images, which comprise what I have called Kahlo's 'Childhood Series'.[24] Second, Kahlo's mode of deconstructing conventions of representation, which found extreme expression in *My Birth*, continued to dominate her art thereafter. For example, *My Nurse and I* 1937 (pl.17) reconfigured the Madonna and Child formula, hybridising it and enhancing its meaning by inserting Aztec, Surreal, medical, folkloric and popular religious components into the painting.[25] In Kahlo's revolutionary painting *What the Water Gave Me* 1938 (pl.26), she radically deconstructed the ubiquitous genre of the female bather, presenting herself in the mundane bath tub from an unprecedented vantage point that images the female protagonist as both subject and object. Moreover, the work visually theorises the Self as a set of diverse simultaneous entities: a fragmented physical being as well as a Cartesian Self who possesses thoughts, imagination and memories.[26] Finally, Kahlo's self-portrayal as La Llorona marked the first of many alternative identities that began to populate her oeuvre after her artistic 'rebirth' of 1932.

fig.31
The Dream or
Self-Portrait Dreaming (I)
1932
Pencil on paper 27 x 20 cm
Juan Rafael Coronel Rivera.
Promised donation to the
Museo Nacional de Arte,
Mexico City

fig.32
Antonio Ruíz
The Dream of the Malinche
1939
Oil on canvas 29.5 x 40 cm
Courtesy of Galería de
Arte Mexicano,
Mexico City

fig.33
The Dream 1940
(pl.25)

fig.34
Roots 1943
(pl.50)

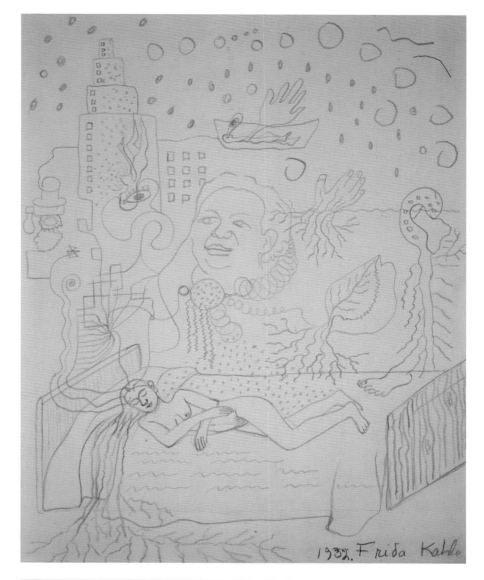

Imaging her other Selves

> Who was Frida Kahlo? It is not possible to find an exact answer. So contradictory
> and multiple was the personality of this woman, that it may be said that many
> Fridas existed. Perhaps none of them was the one she wanted to be.
> *Alejandro Gómez Arias*[27]

One of the alternative identities that Kahlo espoused was that of La Malinche.
The Indian translator and mistress of the Spanish conquistador Hernán Cortés,
La Malinche is one of the most notorious characters of Mexican lore. She is viewed
as a Mexican Eve, the sensuous woman who is responsible for 'the fall' (or the
conquest). In her role as the mother of Cortés's *mestizo* son, she is considered
a primary maternal being, the mother of all Mexicans.[28]

In *The Dream* of 1940 (fig.33) Kahlo links herself to La Malinche by connoting
Antonio Ruíz's 1932 painting *The Dream of the Malinche* (fig.32).[29] Like Ruíz's
protagonist, Kahlo portrays herself in passive slumber upon a bed. Both women
have dark tresses that fall similarly around their faces, both rest their heads
upon two pillows and both are covered by a blanket that metamorphoses into
'nature', evoking the archetypal link between Woman and the natural order, but
also suggesting an analogy between the conquest of the land and the sexual
violation of the Indian woman.

Whereas Ruíz's Malinche is transformed into a Mexican village, Kahlo's
body is associated with a thorny vine. The thorns denote the general theme
of pain, as well as a specific Christian allusion to suffering and martyrdom. The
leaves that Kahlo painted – each composed of five elongated pointed segments –
are based on a particular Mexican plant popularly called *Tripa de Judas* or 'Judas's
entrails'.[30] The name relates to the story of Judas's suicide that caused his intestines
to spill out, and was viewed as fitting punishment for his betrayal of Christ. Through
this intentional botanical allusion, Kahlo links her Malinche-Self to the skeletal
'Judas' figure that she painted on top of the bed. The two infamous characters
are associated with betrayal, suffering and death.

Kahlo's *Roots* 1943 (fig.34) is closely related both to *The Dream* and to
Ruíz's *The Dream of the Malinche*. In *Roots*, however, Kahlo's connection with nature
is even more pronounced. Rather than being covered with a blanket that turns
into nature, Kahlo literally metamorphoses into a plant-self. The uneven hole that
perforates her body, surrounded by the red fabric of her costume, resembles
an open wound. In the context of Kahlo's oeuvre, this image of an 'open wound'
relates to the vulgar Mexican term 'La Chingada', an epithet that characterises
La Malinche as 'forced open' – a 'screwed' or violated woman.[31]

The plant that sprouts from the hollow 'womb-less' body of the 'Chingada',
Kahlo has many leafless branches and bleeds profusely into the barren terrain.
It is significant that in this work the artist chose to link herself with a specific plant,
the *Calotropis procera*, also known as the Apple of Sodom. The prominent veins in
the large leaves of this plant contain a poisonous fluid that was used by the Indians
of Latin America to kill or commit suicide.[32] The popular name of the plant evokes
additional biblical connotations, linking its deadly botanical potential with the
theme of sexual misconduct associated with the city of Sodom. Kahlo's identification
with the stony earth and with the plant of death is further accentuated as she
transforms the lethal serum that courses through the veins of the leaves into
blood-red paint, with which she signs her own name upon the parched land.[33]

The Mask 1945 (fig.36) once again expresses Kahlo's emphatic – by now
obsessive – identification with the Malinche. In this unusual self-portrait, rather
than *depicting* her features, Kahlo completely *conceals* her face with a bright red
Malinche mask. Popular Malinche masks were traditionally scarlet, symbolising
the 'sexuality and … lasciviousness that led (La Malinche) to become Cortes's
mistress' on the one hand; and the 'violence and bloodshed that Malinche brought
upon her own people with the Conquest' on the other hand.[34] But the masked

fig.37
Self-Portrait Dedicated
to Dr Eloesser
1940
(pl.36)

fig.38
Félix Zarate
Portrait of Hermana Francisca
Leal y Bidrio 1840
(detail, fig.86 on p.71)

Kahlo-Malinche does not seem to be either sensuous or treacherous. Both she and the mask are crying. At the bottom left-hand corner of the painting, a cactus plant sheds tears as well. The cactus and the leaves that serve as a backdrop for this image have a brownish-green colour that makes them look dry and lifeless. Behind these plants, dark shadows reinforce the sombre mood.

Kahlo's self-depictions as the Malinche probably relate to her personal experiences of multiple betrayals.[35] But they also recast La Malinche – a central character of Mexican culture – as a tragic victim rather than an evil traitor. Indeed, Kahlo's revisionist view of the Indian woman seems to be more in keeping with the historical facts of La Malinche's life. La Malinche was born to an Aztec family of chiefs. Her father died when she was a small child and her mother remarried and had a son. Consequently, her mother sold her off to a group of traders. She was repeatedly sold and resold from tribe to tribe until she was finally 'given' to the Spanish Cortés. She was fourteen years old at the time. Her fluency in several Indian languages as well as in Spanish, her vast intelligence, and her proficient knowledge of the native cultures were clearly a great asset for the Spanish expedition. She was used and abused in other ways as well: after becoming Cortes's mistress and bearing him a son, he married her off to another Spanish man. She died at the age of twenty-four.

The unbridled passions of La Llorona and the sexual availability and hybrid fertility of La Malinche were constructed as destabilising forces that threatened the patriarchal order. At the other end of the social spectrum stood the non-sexual nun. Secluded and independent from men, she was considered another form of 'deviation' from the 'wife and mother' norm. In several self-portraits from the 1940s, Kahlo attempts to image herself as a Mexican nun. For example, in *Self-Portrait Dedicated to Dr Leo Eloesser* 1940 she wears the dull brown habit of a nun (fig.37). The colour symbolises mortification, mourning and humility. A crown of thorns encircles her neck and punctures her skin, making her bleed. Kahlo portrays herself from the neck down as an ascetic, engaged in *Imitatio Christi* self-mortification. The artist's head is crowned with flowers whose voluptuousness contrasts with the asceticism of her lower half. As Emmanuel Pernoud has suggested – this type of self-portrayal is modelled after well-known portraits of 'Crowned Nuns', a Mexican genre that was famous in Viceregal times.[36] The nun is usually portrayed bedecked with flowers on the day she takes the veil (fig.38). The sensuousness of her apparel contrasts with her future life in the convent. By adopting the symbolism of this genre, Kahlo constructs herself as a deeply divided being, split between sensuality and asceticism.[37]

The Androgynous Self

Kahlo did not only identify with female roles. Her art reveals a bold subversion of conventional gender divisions – way before her time. In *Self-Portrait with Cropped Hair* 1940 (fig.40) Kahlo depicts herself as an androgynous creature. This portrait is usually interpreted as the artist's direct reaction to Rivera's demand for a divorce. It is viewed as a reflection of her hurt feminine pride and her masochistic self-punishment following the breakdown of her marriage.[38] But the fact that in early photographs the nineteen-year-old Kahlo had already sported male garb (fig.39) indicates that although the divorce may have instigated this androgynous self-image, the work relates to more profound aspects of her identity.

By cropping her hair and by displaying the evidence of her actions, Kahlo created a complex symbolic image. *Self-Portrait with Cropped Hair* includes three distinct references to hair. First, two remnants of her braids appear in the work. Kahlo's left hand holds one cut plait upon her lap; a second braid is discarded near the foot of the chair. Kahlo's braided hair – beribboned or decorated with flowers – was a central feature of the exotic coiffures that helped construct her identity as *La Mexicana*. By lopping off her braids, Kahlo, the artist-protagonist, rejects her

fig.39
Kahlo wearing a man's suit,
7 February 1926
Detail from family photograph
by Guillermo Kahlo

fig.40
Self-Portrait with
Cropped Hair 1940
(pl.29)

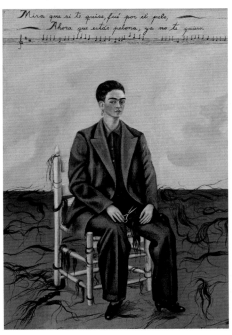

former identity as the traditional Mexican woman. In addition to the braids, wild strands of loose hair fill the entire scene. As they float in the air, litter the ground and writhe around the chair, these dark, animated tresses recall the attributes of Kahlo as La Llorona, exhibited for the first time in 1932. Kahlo's removal of her wild hair suggests an attempt to rid herself of the Llorona within her Being. A final allusion to hair appears at the top of the canvas, where – with brushstrokes that resemble hair in colour and texture – she inscribed the lyrics and music of a song. This verbal and musical statement, a product of culture, articulates the social convention that links female desirability with luxurious hair. A distinctly male voice utters a cruel rejection: 'Look, if I loved you it was for your hair, now that you are hairless, I don't love you anymore.' *Self-Portrait with Cropped Hair* presents Kahlo's unwillingness to accept various female roles. Her cut hair and masculine attire define her as an alternative, androgynous Self.

Hybrid Identities: Breaking the Boundaries between Self and Other

Through her art, Kahlo also explored non-Western ontological concepts. Initially referring to pre-Columbian beliefs, and later to Hindu and Oriental creeds, she explored her identity as a hybrid creature composed of human, animal and plant components. We see a progression in her work. Whereas in the 1930s she depicted herself *with* plants and animals, later, as her involvement with Oriental philosophy deepened, she showed herself *as* a plant or animal. For example, plants often comprise the background of her portraits and flowers often adorn her hair; but in *Roots* the plant actually becomes an integral part of Kahlo's Self. Similarly, beginning in 1937 she painted herself with various animals around her; by 1946 she imaged herself as an inseparable hybrid 'bird-being' or 'deer-being'.

Kahlo's most striking depiction of her animal-self appears in *The Little Deer* 1946 (fig.41).[39] At the very centre of the composition a hybrid creature, composed of Kahlo's head with the body, ears and antlers of a male deer, may be seen. The creature seems suspended in a small clearing among trees. Nine arrows pierce its body, creating bloody wounds. A broken branch lies on the ground; a body of water and lightning appear in the background. The work has been interpreted as related to Kahlo's suffering due to her failing health and to Rivera's cruelty. While this interpretation may be valid, it clearly does not embrace the full complexity of the painting, in which Kahlo not only images herself as a hybrid creature, but also constructs the entire composition to reflect her espousal of a hybrid multi-cultural world view and a new ontological perspective. The arrows that penetrate the deer's body clearly allude to Christian images of St Sebastian. Kahlo's choice to identify herself with a deer relates to a diverse array of Aztec sources: it alludes to the fact that the deer is a symbol of the right foot – which was Kahlo's ailing limb;[40] it also refers to Kahlo's attempt to change the date of her birth (marked in the Aztec calendar by the sign of Death) to the sign of the 'deer', and hence to alter her fate.[41] At the bottom of the painting she inscribed the word 'CARMA' (fig.42).[42] This Oriental reference reflects the artist's belief in reincarnation and helps us interpret the water and lightning that appear in the background of the painting: water is an Oriental symbol for the divine essence, and lightning stands for the option of reaching Nirvana-enlightenment. In Western thought, to have a concept of Self one must undergo a process of individuation that separates the Self from all others. According to Oriental thought, the human being must strive for the *opposite* of individuation. Merging with others, becoming an inseparable part of the fabric of life and thus attaining union with the one underlying force of being (*Atman*), is the goal of the enlightened.[43]

Through her creative oeuvre, Kahlo explored numerous concepts of Being, ranging from psychological inquiries that link identity formation with one's childhood years and body image, to social views of identity as the attempt to mould oneself into clearly articulated social models, to non-Western ontological notions, which

fig.41
The Little Deer 1946
(pl.51)

fig.42
The Little Deer 1946
(detail, pl.51)

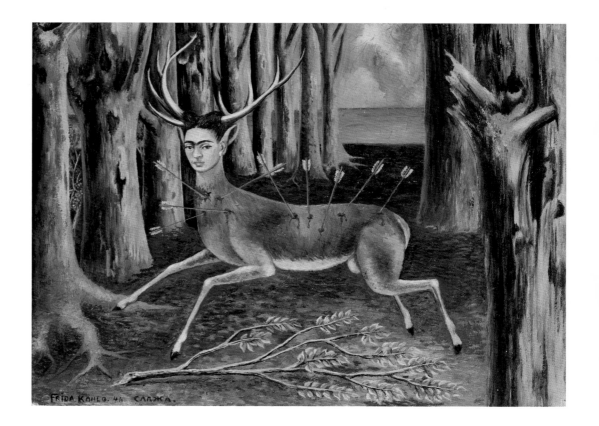

posit a Self that is undefined by contours and undifferentiated from all other creatures and objects. As she explored these issues, Kahlo exploded deep-seated taboos and boldly ruptured accepted boundaries and conventions of representation.

Kahlo's paintings coalesce into a visual discourse on identity, teaching us that identity is neither a static nor a monolithic 'given', but rather a complex construction and a shifting configuration. They also impress upon us the fact that the very attempt to conform to social roles or to limited gender divisions may be oppressive and detrimental to the Self. Hence, they suggest that being true to oneself may mean being many different Selves (sequentially or simultaneously). Furthermore, Kahlo's visualisations of hybridity – whether they relate to intermarriage, to the politics of miscegenation, or to cultural and religious hybridity – link her poetics of identity with current postcolonial theories, emphasising the innovative nature of her art and its profound relevance to our time.[44]

Frida Kahlo interwove a staggering array of complex visual and textual sources into the fabric of her art. While her oeuvre reveals a great deal about the life of the brilliant painter, its trajectory transcends biography and moves into the realm of ontological inquiry.

Notes

1 Frida Kahlo, quoted by Julien Levy in an interview with Hayden Herrera, 24 April 1977. I am grateful to Herrera, whose immense contribution to the study of Kahlo provides the foundation upon which we all stand, for sharing documents from her private archives with me. I also wish to acknowledge my debt and gratitude to the pioneering feminist texts of Linda Nochlin, John Berger, Laura Mulvey and Lynda Nead. Many thanks to Yve Alain Bois for his generous hospitality at Harvard University.

2 Frida Kahlo quoted in Bertram Wolfe, 'Rise of Another Rivera', *Vogue*, 1 November 1938, p.64.

3 Hayden Herrera, *Frida*, New York 1983, p.xii.

4 For a detailed analysis and full citation of references, see Gannit Ankori, *Imaging her Selves: Frida Kahlo's Poetics of Identity and Fragmentation*, Westport and London 2002. For a comprehensive study of Kahlo's genealogical identity, with particular emphasis on *My Grandparents, My Parents, and I*, see Gannit Ankori, 'The Hidden Frida: Covert Jewish Elements in the Art of Frida Kahlo', *Jewish Art*, vol.19/20, 1993/94, pp.224–47. Also see online exhibition: http://www.thejewishmuseum.org/kahlo, curated by Gannit Ankori.

5 I was extremely fortunate to have had the opportunity to conduct my research at La Casa Azul, Kahlo's Coyoacán home, in 1989, before the museum was renovated and the items 'rearranged'. My research, which included a systematic study of the books, papers, reproductions and photographs in Kahlo's studio library, revealed some of the significant sources that influenced her art. For more details, see Ankori 2002.

6 The main primary sources that help us understand these events are interviews with and the diary of Lucienne Bloch, who lived with Rivera and Kahlo in Detroit, and Kahlo's letters to her friend and confidante Dr Leo Eloesser. For complete references see Ankori 2002, pp.149–58.

7 Ankori 2002, pp.101–4.

8 Sigmund Freud, 'Splitting of the Ego in the Process of Defence', *The Standard Edition of the Complete Works of Sigmund Freud*, London 1964, vol.23, pp.273–8.

9 In the 17 September 1926 drawing, composed on the first anniversary of her accident, the wounded Kahlo lies upon a stretcher. A large, decapitated head, which bears Kahlo's distinct features, hovers above the bandaged body. It seems that at the time of the accident Kahlo's situation was so grave and life-threatening, that only by 'splitting' – that is, separating the physical Self from the conscious, 'thinking' Self – could she cope with such overwhelming sensations of pain, grief, anxiety and fear. See Ankori 2002, pp.101–4.

10 See Ankori 2002, pp.154–5.

11 Ibid. Lucienne Bloch's recollections are from four main sources: her diary (portions of which she read in interviews); transcripts of interviews from the 1960s conducted by Karen and David Crommie in preparation for their documentary film *The Life and Death of Frida Kahlo* (San Francisco 1966); Hayden Herrera's interview with Bloch (6 November 1978); my own telephone conversations with Bloch in the late 1980s.

12 Salomon Grimberg, private communication with the author. I thank Grimberg for his continued interest in my work.

13 For a detailed analysis see Ankori 2002, pp.155–7.

14 In her 1949 self-portrait, *Diego and I* (pl.47), Kahlo also seems to present herself as La Llorona (see Ankori 2002, pp.220–1).

15 The foetus that Kahlo painted inside her uterus is five weeks old, as was Kahlo's child when she attempted to abort it. The foetus on the left is three months old, reflecting the age of her unborn offspring when the miscarriage occurred. For additional details and illustrations of Kahlo's sources, see Ankori 2002, pp.158–9 and figs.38–41.

16 A detailed comparison was first presented in Gannit Ankori, 'Frida Kahlo: Anatomy, Theology and Art', *Gender, Health and Body: Changing Relationships*, International Conference at the Hebrew University of Jerusalem, Lafer Center for Gender Studies, 22–3 April 2001. For an accessible study of the links between anatomy and cosmology, see Martin Kemp and Marina Wallace, *Spectacular Bodies: The Art and Science of the Human Body from Leonardo to Now*, Berkeley, Los Angeles and London 2001.

17 At this point, it is instructive to diverge from the chronological framework of this essay and to briefly link Kahlo's 1932 lithograph with the monumental *The Two Fridas* of 1939 (pl.28). Both works were constructed as deliberate antitheses to Kahlo's previously discussed Marriage Portrait. In both, the 'husband' is conspicuously absent and Kahlo's sole companion is herself. Both works present Kahlo as a deeply divided being: the lithograph portrays her split in half, whereas *The Two Fridas* shows her doubled. Although *The Two Fridas* is usually viewed as the artist's direct reaction to her divorce, it clearly articulates a broader social message. As we decipher its meaning – from left to right as the photographs that document Kahlo's deliberate creative process reveal – Kahlo shows her *failed* attempt to follow the traditional track designated for the Mexican women of her time – from bride to mother. The newlywed bride in her white wedding gown (on the left) has blood near her groin that transforms into a flower, alluding to the term 'defloration'. The maternal figure on the right has an egg-shaped photograph of Rivera as a child near

her loins. In both roles Kahlo is alone in a stormy, arid setting. Her bleeding heart is exposed and vulnerable. She is a husbandless wife and a childless mother. The very attempt to fit into the traditional female roles and the failure to do so are shown to be wounding, self-dividing experiences. Finally, just as Kahlo's 1932 miscarriage transformed her into an artist, as the lithograph symbolically articulates, the ultimate failure of her marriage was also sublimated into art. The flowers that turn into blood refer to defloration; but the blood that metamorphoses into images of flowers upon Kahlo's white gown symbolises the artist's transformation of her pain into art.

18 Ankori 2002, pp.27–36.

19 See comparison, ibid. It is interesting to note that although it shares *My Birth*'s gynaecological vantage-point and emphasis on pubic hair, Gustave Courbet's *The Origin of the World* 1866 (Musée d'Orsay, Paris) (with which Kahlo was unfamiliar) produces a different affect from Kahlo's painting. This is because Courbet's work lacks the 'repulsive' aspect of Kahlo's image: it does not show either the taboo genitalia or the taboo uterine blood.

20 For visual comparisons, see Ankori 2002, figs.2, 3.

21 Kahlo subverts traditional notions of faith in other ways as well. She uses the format of the popular *retablo* devotional painting as the basis for her composition, but undermines its foundations by leaving the scroll at the bottom empty, thus rejecting the very option of divine intervention. See Ankori 2002, pp.28–9, 40.

22 As I have emphasised elsewhere, following the scholarship of Herrera and Grimberg: ibid., pp.27–36.

23 Frida Kahlo, quoted in Parker Lesley, 'Transcription of Notes Taken during Conversations with Frida Kahlo de Rivera and Diego Rivera', unpublished typescript, 27 May 1939.

24 For a full discussion of Kahlo's 'Childhood Series', see Ankori 2002, pp.61–92.

25 Ibid., pp.62–77.

26 See 'Re-visioning the Female Bather' in ibid., pp.123–34.

27 Alejandro Gómez Arias, 'Un Testimonio Sobre Frida Kahlo', in *Exposicion Nacional de Homenaje*, exh. cat., Mexico City 1977, n.p.

28 For a fuller discussion of La Malinche with citations of historical and cultural sources, see Ankori 2002, pp.87–9.

29 *The Dream* was based on additional sources: see ibid., pp.189–93.

30 This information appears in a book that I found in Kahlo's library: Luis G. Cabrera, *Plantas Curativas de México*, Mexico City 1936, p.245.

31 For a more profound and nuanced understanding of La Chingada in Mexican culture, see Octavio Paz, *The Labyrinth of Solitude,* New York 1985, pp.74–82.

32 Dan Palevitch and Zohara Yaniv, *Medicinal Plants of the Holy Land*, Tel Aviv, 1991 (in Hebrew), vol.2, pp.274–5.

33 *Roots* is based on additional sources that relate to aspects of Kahlo's mixed cultural 'roots'. It is a reversal of the biblical tale of Jacob's dream of fertility, offering Kahlo's dream of infertility instead. For a detailed analysis see Ankori 2002, pp.193–200.

34 Donald Cordry, *Mexican Masks*, Austin 1980, pp.38, 170.

35 Ankori 2002, pp.190–200.

36 Emmanuel Pernoud, 'Une Autobiographie Mystique', *Gazette des Beaux Arts*, ser. 6, no.101, January 1983, pp.43–8.

37 For a fuller discussion of Kahlo's 'Ascetic Self' see Ankori 2002, pp.203–22.

38 For a detailed account of the various interpretations of this work, with full citations of the sources, see 'The Androgynous Self' in ibid., pp.175–87.

39 See ibid., pp.242–8 and Salomon Grimberg, *Frida Kahlo: The Little Deer*, exh. cat., Miami University, Oxford, Ohio 1997.

40 Helga Prignitz-Poda, Salomon Grimberg and Andrea Kettenmann (eds.), *Frida Kahlo: Das Gesamtwerk*, Frankfurt 1988, p.257.

41 Although Kahlo was born on 6 July, she changed the day of her birth to 7 July. According to the complex Aztec calendar, day number 6 is marked by the sign of Death (*Miquiztli*). Day number 7 is marked by the sign of the deer (*Mazatl*). Being extremely fatalistic, Kahlo chose to align her fate with the sign of the deer. See Ankori 2002, p.244 and notes.

42 During the last decade of her life, Kahlo became immersed in Hinduism, Buddhism and Daoism. In her diary the words 'Carma' and 'Tao' and the Yin/Yang diagram appear frequently and her writings echo Oriental poetry and philosophy. Kahlo also portrayed herself as the Hindu goddess Parvati and as part of the fabric of life in drawings of interlaced and hybrid beings. See Gannit Ankori, *Frida Kahlo: Diary, Art, Life*, Ben Shemen 2003.

43 For a full discussion of the impact of Oriental thought on Kahlo's art and writings, see Ankori 2002, pp.223–48.

44 See note 4 above.

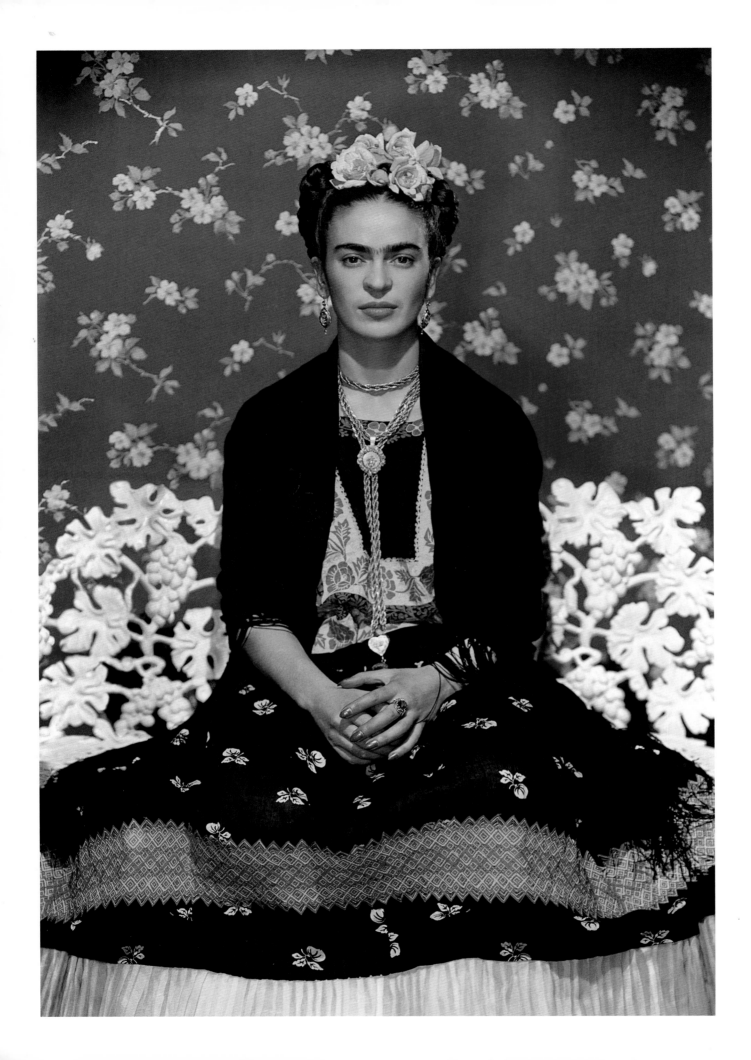

Reflecting on Kahlo: Mirrors, Masquerade and the Politics of Identification

Oriana Baddeley

So many words have been written about the life and work of Frida Kahlo that to contribute to this phenomenon seems somewhat indulgent. What more can be said? What aspect of her work and its reception has not been analysed and discussed from a diversity of perspectives and purposes?[1] The twenty-first-century Frida is both a star – a commercial property complete with fan clubs and merchandising – and an embodiment of the hopes and aspirations of a near-religious group of followers. This wild, hybrid Frida, a mixture of tragic bohemian, Virgin of Guadalupe, revolutionary heroine and Salma Hayek,[2] has taken such great hold on the public imagination that it tends to obscure the historically retrievable Kahlo.

The composite Frida has come to represent something far greater than the sum of her parts. The worship of this figure encompasses the desire for creative expression and for the subversion of social expectations of femininity. In a global marketplace her perceived relationship to fashion strikes a chord with a contemporary audience obsessed with the stylistic appropriation of sub-cultural norms. These aspects of her image have all contributed to her current status and have combined with the construction of Frida as the archetype of a cultural minority. A victim, crippled and abused, she is nonetheless a survivor who fights back.[3] The emphasis on physical and emotional pain has fitted seamlessly into her wider representational function as a minority radical, traditionally excluded from the pantheon of high art.

Exponents of the identity politics of the late twentieth century found in Frida the perfect example of both feminist and postcolonial debates. The juxtaposition of her aesthetic concerns with those of her husband Diego Rivera became a textbook example of the discussions around the gendering of public and private worlds.[4] The tough, aggressively masculine realm of the muralist Rivera, dealing with history and politics on an epic scale, was contrasted with the introspective, enclosed intimacy of Kahlo's small, emotion-laden paintings. Even their physical manifestation as a couple made the point, Rivera's height and girth looming above the delicate Frida (see pl.12).

Feminist arguments about the objectification of the female body within Western art history also found in Kahlo's appropriation of the self as subject the perfect antecedent for an aesthetic tactic used by popular contemporary artists such as Cindy Sherman. In tandem with this, the articulation within her work of the emotional turmoil caused by her often difficult relationship with her husband could be used to debate wider issues within sexual politics.

If the symbolic function of Kahlo within feminist art history was not enough, she also served to exemplify the Eurocentric nature of categorisations of art practice. Her interest in Mexican popular materials and techniques, and her rejection of the

traditions of the art academies gave her a special place in the search for a form of cultural expression that could represent values oppositional to those of traditional European high art.

These aspects of Kahlo's reputation and the issues that her work was seen to embody were raised to greater prominence by an international art world striving to embrace the social and political changes of postmodernism. Her reputation underwent an enormous transformation in the period between the publication of the seminal biography of Kahlo, Hayden Herrera's *Frida* in 1983,[5] and Salma Hayek's Hollywood biopic released in 2003.[6] The auction prices of her paintings rocketed during the 1980s and 1990s, with Kahlo breaking records for sale prices as both a female and a Latin-American artist.[7]

The phenomenon of Fridamania has spawned its own set of debates and cultural practices, but it is interesting to try to separate out the diverse strands of meaning implicit in responses to her work by a younger generation of Mexican artists. Julio Galán's *Pretty Little Tehuana Girl You Are Too Good To Be True* 1987 (fig.46) is a good case in point. In the vacant Frida evoked by the empty Tehuana dress, the overexposure of her work and its constant use to exemplify the nature of 'Mexican-ness' is ridiculed. The desire of the audience to 'see' and 'be' Frida is both pandered to and cheapened. Frida becomes a fairground identity, a reminder of the artificiality of the post-revolutionary myths of an authentic Mexico. To external audiences Kahlo had come to represent a type of creative expression perceived as uniquely Mexican, while within Mexico the emphasis on her work was increasingly becoming a tourist cliché.

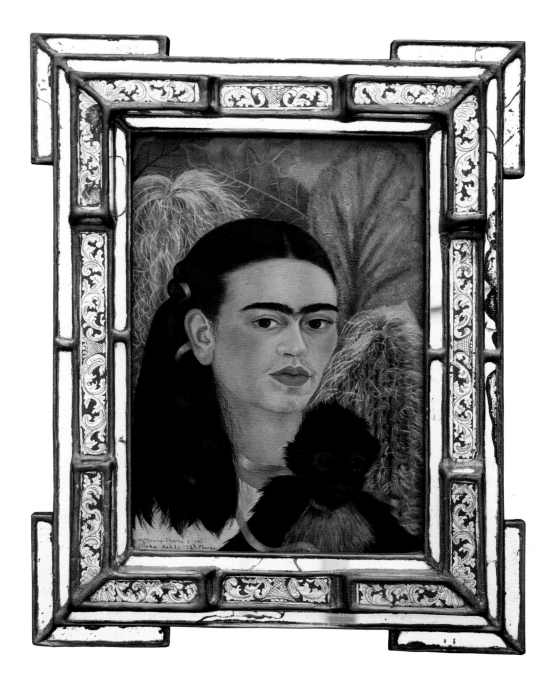

fig.47
Joe Bravo
Fridalupe 2002
Acrylic on flour tortilla
33 x 33 cm
Courtesy the artist

fig.48
Yasumasa Morimura
*An Inner Dialogue
with Frida Kahlo
(Hand-Shaped Earring)*
2001
Colour photograph,
edition of 10
120 x 95.9 cm
Courtesy the artist
and Luhring Augustine,
New York

fig.49 (right)
Fulang-Chang and I 1937
Oil on hardboard
39.9 x 27.9 cm;
Painted mirror frame
(added after 1939)
56.6 x 44.1 x 4.5 cm
The Museum of Modern Art,
New York

By the end of the twentieth century Kahlo's signature mono-brow had become recognisable to a mass audience outside of those interested in Mexican art history or Surrealism. Her self-portraits appeared on fashionable clothing and accessories. The face of Frida was used with the same regularity, and often with a shared symbolism, as images of Che Guevara or Bob Marley, so that her art and her appearance were forever confused in the public imagination. By buying into this Frida, the consumer can declare a nonspecific radicalism, an acceptable declaration of nonconformity. As one contemporary website sales line puts it: 'Give your vehicle the revolutionary spirit with a Frida Kahlo car window decal.'[8]

Devotion to this image of Frida is frequently linked with a similarly nonspecific patriotism among diasporic Chicano communities who have often raised her status to that of a religious icon. In Joe Bravo's *Fridalupe* 2002 (fig.47) Kahlo's features are imposed upon that of the Virgin of Guadalupe, painted onto a tortilla in a parody of the miraculous imprinting of the Virgin on the cloak of the Indian Juan Diego (to whom the Virgin of Guadalupe supposedly appeared in the sixteenth century to assure the salvation of the indigenous peoples of the Americas).[9] In form and content *Fridalupe* illustrates the extraordinary context within which many now view Kahlo's work as exemplifying Mexico itself.

fig.50
The Two Fridas 1939 (pl.28)

This construction of the trademarked Frida has coincided with a period dominated by the technological transformation of everyday life and the commodification of culture. The characteristics associated with Kahlo's work and popular image contradict and are in sharp contrast to the sleekly futuristic world of a new global digital era. In opposition to the touch-button aesthetic of the plasma-screen-dominated culture of the early twenty-first century, the Kahlo aesthetic is dependant on references to the handmade and the naive; it explores the limits of the decorative and is highly charged with emotional content. Work by Kahlo reminds the viewer of the physicality of creative practice, and while asserting the values of the craft object, simultaneously undermines ideas of consumerist pleasure.

Underlying our responses to Kahlo's art is a recognition of the projected Frida who stares out from the canvas. Here is a woman whom we think we know; her emotional ups and downs, her tastes for the unusual and symbolic, her complex love life, all remind us of elements of our own emotional lives. Her world is both known yet unknowable, like photographs of an aged parent with whom we can feel intimate yet separate. It is interesting to note that one of the most frequently reproduced of Kahlo's paintings, *Fulang-Chang and I* 1937 (fig.49), came literally to represent this process of identification.

During the 1990s, the self-portrait was hung in the Museum of Modern Art in New York alongside a mirror, mounted in a matching frame. The spectator of the work was confronted not only by the face of the artist but also by their own, a curatorial decision that emphasised the later theoretical interpretation of the work above that of its initial context. Within this installation Frida became a symbolic cipher onto which could be inscribed the outpouring of the viewers' soul. If the 1980s had seen an incorporation of Kahlo's work within the discourse of identity, by the end of the twentieth century Frida had come to represent a different set of concerns, a shift from the politics of identity to the politics of identification.

The current triumphant emergence of Frida as the most famous female artist in history has much to do with these cultural shifts, in particular within the United States, but it should not be overlooked that it also emerges from the mythologies explored by Kahlo herself. Her work revolved around a set of appropriations, from the popular traditions of Mexican folk art to the polemics of revolutionary nationalism. She consistently presented a complex subtext beneath a seemingly innocent surface. While much has been observed regarding the relationship of her work to the biographical details of her life, and the identifiable personal pain and suffering she undoubtedly experienced, less attention has been given to recognising the level of irony and sometimes straightforward playfulness that runs through her art.

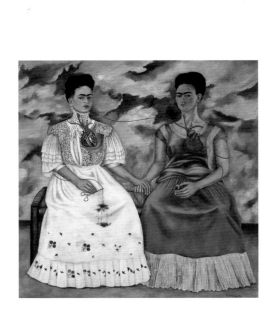

The retrospective sense of the tragic that is frequently imposed on Kahlo belies an underlying optimism and narrative within the works. Frida the martyred saint of mistreated womanhood often obscures recognition of the mocking and irreverent Kahlo described by her contemporaries.[10] Paintings that serve as illustrations of personal trauma have become more highly valued and are reproduced with far more regularity than works such as *My Dress Hangs There* 1933 (pl.14) with its more self-consciously metaphorical basis.

An exploration of these elements, however, is implicit in Yasumasa Morimura's *An Inner Dialogue with Frida Kahlo (Hand-Shaped Earring)* 2001 (fig.48). The commodification of the Frida phenomenon is highlighted by the *rebozo* that the barely recognisable Morimura wears, decorated with the Louis Vuitton logo. The point is even made by the acceptance of a Kahlo self-portrait as appropriate subject matter for the ironic parodies of dominant art-historical icons essential to the Japanese artist's work. The very characteristics that allowed a post-war generation of feminist artists to identify with Kahlo's work are undermined. For Morimura, Kahlo's work has lost its power to communicate directly; it has become a symbolic commodity reflecting what often appears to be a specifically North American fascination with icons of minority culture.

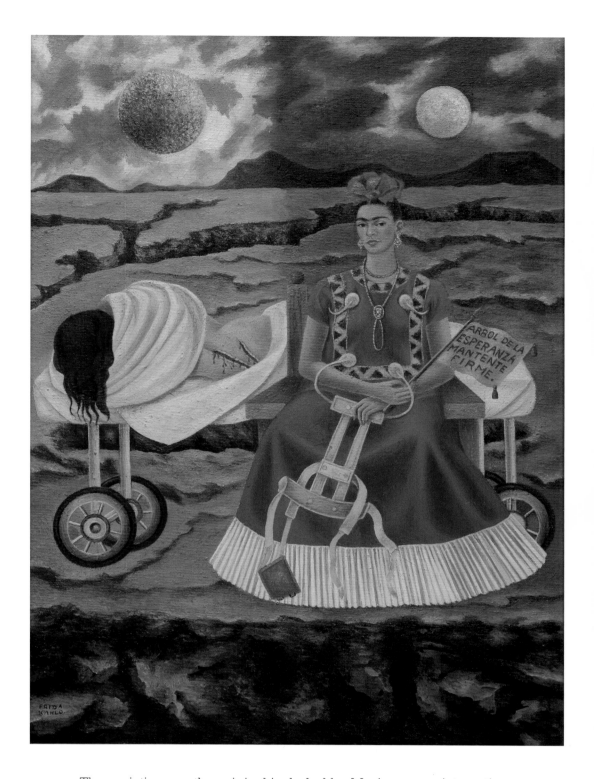

fig.51
Tree of Hope, Keep Firm
1946
Oil on hardboard 55.9 x 40.6 cm
Private collection

The variations on the original included by Morimura are interesting: they transform the hairstyle and floral decorations into that of a Japanese rather than Mexican prototype. As with Galán's work, it is the context of Frida worship that is attacked rather than the works themselves. In playing with the ideas of self-portraiture, cultural stereotyping and the commodification of ethnic identity, Morimura draws on many of the tactics used by Kahlo. The rawness of the self so often perceived within her work is as much a masquerade as Morimura's own tactic.

For Kahlo the personal became elided with the public sphere. Her body and experiences were used metaphorically to debate wider issues that were central to Mexican cultural politics. This is apparent in one of her best-known paintings, *The Two Fridas* (pl.28), originally painted in 1939 and exhibited at the International Exhibition of Surrealism held in Mexico City in 1940 (fig.98 on p.76).[11]

The scale of this work sets it outside of the usual frames of reference for a Kahlo painting. Made for a public audience and dealing more directly than usual with the interaction of Kahlo's private pains and a political ideology, it has none of the intimacy and quiet subversion of her small yet powerful works.

The Two Fridas is arguably the most famous of Kahlo's paintings not only because of its size but also due to its early purchase by the Institute of Fine Arts in Mexico. Since its creation it has remained a highly visible example of her work, and in the 1970s served to draw attention to the more obscure Kahlos. It is often used to refer to the pain experienced by the artist during her separation from Rivera, as the arrival of the divorce papers and the completion of the work coincided.[12] In the painting we are shown two almost life-size seated figures, both self-portraits of the artist. Neither figure appears to have more claim to be the real Frida than the other, yet the logic of this twinning is supported by the rhythm of the composition, which maintains a non-judgmental sense of balance.

Both Fridas sit stiffly, staring out at the audience with the usual mix of pride and despair contained within the expressive language of her self-portraits. These are aspects of self image that we know from earlier works, caught up in a clearly symbiotic relationship. On the viewer's left is the colonial Frida, her demure white lace dress decorated with spots of blood dripping from the vein held closed by the surgical scissors in her right hand. Her left hand is clasped over the hand of her other self, the Tehuana-clothed Mexican Frida. It is this Tehuana Frida that Diego purportedly loved, the colonial Frida his rejected wife.

In constructing this very public work, Kahlo refers to powerful mythologies of Mexican identity. Within the iconography of both her own art and that of post-revolutionary Mexican art in general, the unbowed Indian Mexico symbolised by the Tehuana woman represents the new positive future of a postcolonial state. In the later *Tree of Hope, Keep Firm* 1946 (fig.51) the red Tehuana costume literally represents hope for the injured Kahlo. The clear message is that through the adoption of a socialist and overtly anti-colonialist position, a healing of the pains of the past can become possible. In the use of the analogy between the self and the nation, Kahlo frequently characterises her own physical and emotional problems as symptomatic of the post-colonial condition. Mexico and her own body become merged, just as ideology and history are woven into the clothing within her paintings.

In this sense the European-style wedding gown and the Tehuana dress of *The Two Fridas* reflect ideological positions as much as the historical realities of Mexico's past. The twin Fridas are the embodiment of the conflict implicit in a *mestizo* culture, never truly European but never truly Indian. It is by means of political choice, represented in Kahlo's paintings through clothing,[13] that revolutionary change becomes possible. There is no more one true Frida than there is one true Mexico. This denial of absolute identity is the key to an understanding of Kahlo, her love of dressing up a rejection of the idea of the fixed or unchangeable. Knowledge and recognition of history can transform the present and in a sense, become the ultimate makeover.

In *My Dress Hangs There* the empty shell of the dress is suspended like a *piñata* above the urban sprawl of New York, meaningless without commitment and context. This is a painting of alienation, critical of the values of a capitalist industrial society. The desolateness of this particular work highlights the need felt by audiences to find hope within Kahlo's paintings. Without the empathetic body the dress is as empty a symbol as it is in the work of Galán.

It is likely that we will all keep looking for some special person hidden within the wider phenomenon that is Frida. It might be a person whom we want to be, or a person whom we know we will never be, but the desire for connection remains. What is wished for is probably the simplest yet most impossible of things: to have our own knowledge of this distant woman's painful secrets acknowledged through her reciprocal friendship or love, to release our own stories in an outpouring of empathy. Perhaps the marvel of Kahlo is that she can be constantly reinvented by different audiences, who find in her work what it is they are looking for.

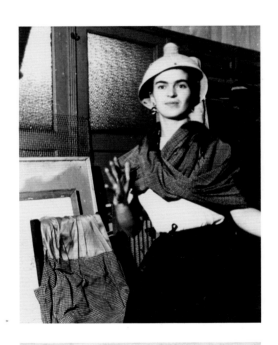

Do I look like a Javanese
dancer? It is only the
top of an electric lamp
that I have in my head.
la chicua
Crazy as always.

With the phenomenon that is Frida Kahlo it is hard to calculate at what point interest falls over into obsession or when theoretical analysis turns to sterile cultural stereotype. Just when it appears impossible to delve any deeper into the mythologies that surround this once-forgotten Mexican painter, we are given a new sense of intimacy; we find out yet more about our fantasy friend.

I have a small photograph of Kahlo taken in the 1930s and sent to her friend Clifford Wight,[14] in which she strikes a humorous pose for the camera. On the back she has written: 'Do I look like a Javanese dancer? It is only the top of an electric lamp that I have on my head' – confirmation that with Kahlo, things are not always as they appear.

Notes

1 This phenomena is described in Margaret A. Lindauer, *Devouring Frida: The Art History and Popular Celebrity of Frida Kahlo,* Hanover and London 1999.

2 A brief exploration of the many Frida websites is possibly the clearest illustration of this aspect of Kahlo's following. Out of over half a million entries on Google, particularly of interest in this respect are www.fridakahlo.it and www.fridakahlo.us.

3 See for example, Martha Zamora's *Frida Kahlo: The Brush of Anguish*, London 1990.

4 The exhibition and catalogue of the 1982 UK exhibition at the Whitechapel Art Gallery, London, set the tone for later work on Kahlo within the context of feminist and postcolonial studies: see Laura Mulvey and Peter Wollen, *Frida Kahlo and Tina Modotti*, exh. cat., Whitechapel Art Gallery, London 1982.

5 Hayden Herrera, *Frida: A Biography of Frida Kahlo*, Harper & Row 1983.

6 *Frida* (2002; Dir. Julie Taymor), starring Salma Hayek and Alfred Molina, Miramax.

7 www.artprice.com has a good guide to auction prices for Kahlo's work as does Mary Anne Martin's article 'Latin American Art Comes of Age' in *Leonard's Price Index of Latin American Art at Auction*, ed. Susan Theran 1999, Auction Index Inc.

8 The Frida decal at $12.99 is but one of many Frida products offered by companies such as www.fridakahlo.us, all of which offer their purchasers a chance to buy into a set of lifestyle choices through their association to the image and aesthetic appearance of Frida.

9 For an account of the role of the Virgin of Guadalupe in constructions of Mexican identity, see David Brading, *Mexican Phoenix: Our Lady of Guadalupe: Image and Tradition across Five Centuries*, Cambridge 2001, and her importance to migrant communities in the United States is described in Jeanette Rodriguez, *Our Lady of Guadalupe: Faith and Empowerment among Mexican-American Women*, Austin 1994.

10 The contrast between the letters written to friends and the diary writings of Kahlo suggest that her public and private personas were very different. The style of the 'irreverent Frida' is very much part of her response in correspondence to friends and loved ones where she frequently makes light of her physical and emotional traumas.

11 In late 1939 and the first weeks of 1940 Frida Kahlo produced two paintings for the International Exhibition of Surrealism held at Inés Amor's Galería de Arte Mexicano, Mexico City, *The Wounded Table* (now lost) and the large double self-portrait *The Two Fridas*. After its exhibition in Mexico City, *The Two Fridas* also featured in the show at the Museum of Modern Art, New York, *Twenty Centuries of Mexican Art* (1940).

12 Herrera 1983, p.277.

13 Oriana Baddeley '"Her Dress Hangs Here": De-Frocking the Kahlo Cult', *Oxford Art Journal,* vol.14, Winter 1991, pp.10–17b.

14 This photo was a gift from Connie Baker, the widow of Clifford Wight (one of Diego Rivera's assistants), whom I met while researching the influence of the Muralist in the UK for the Channel Four/Rear Window/Bandung Productions documentary *Marx on the Walls* (1991; dir. Ramsay Cameron). It had formed part of a collection of letters and memorabilia arising from Kahlo's correspondence with Clifford in the 1930s.

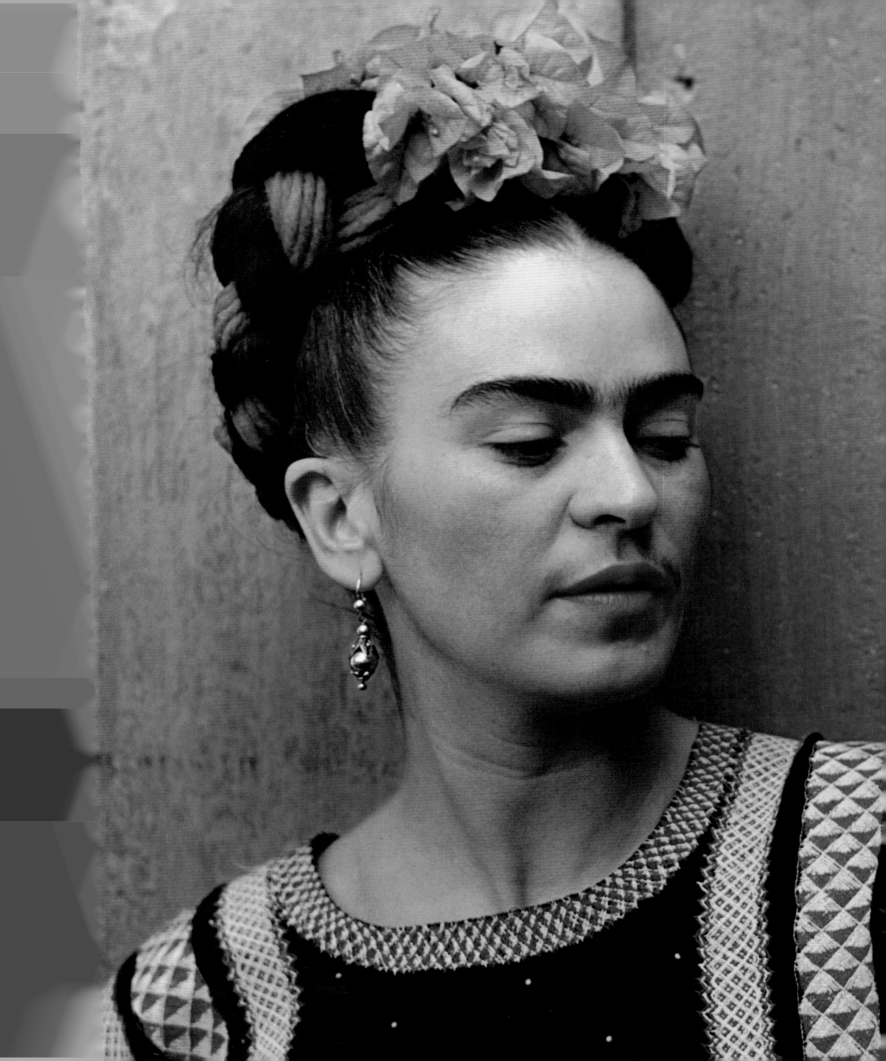

'All Art is at Once Surface and Symbol':[1] A Frida Kahlo Glossary

Tanya Barson

Over her career, Frida Kahlo built up a complex symbolic language, a repertoire of signs and emblems drawn from many diverse sources, which she gave a particularly personal and often highly idiosyncratic character. Her visual language is eclectic, encompassing European fine art traditions from Bosch and Brueghel to avant-garde movements such as Surrealism, Mexican colonial-era art, the Mexican avant-garde of her contemporaries (including her husband Diego Rivera), popular and folkloric Mexican art and culture, as well as belief systems as different as Catholicism, Eastern spirituality, Aztec culture and religion, ancient Egyptian belief, European philosophy, psychoanalysis and Communism. She often combines varied references together in a single image, speaking on multiple levels and creating an especially private and cryptic language. The following far from comprehensive glossary attempts to provide an insight into the breadth of Kahlo's work while addressing some of her key subjects, symbols, influences and sources.

fig.53
Nickolas Muray
Frida with Olmec Figurine 1939
Nicolas Muray Photo Archives

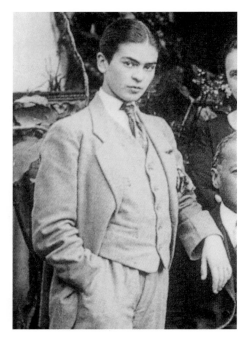

fig.54
Kahlo in men's clothes, 7 February 1926
Photograph by Guillermo Kahlo (detail)

Androgyny

Kahlo is first pictured dressed as a boy in several photographs taken by her father, Guillermo Kahlo, in 1926. In the context of otherwise conventional family photographs, she appears in a three-piece man's suit and tie and, in some, with a cane. She looks directly at the camera. Kahlo was known for her high-spirited pranks and friends have called this a 'joke', suggesting it was merely a superficial, youthful stunt. Her sophisticated understanding of dress as a language with which to construct and perform identity, however, suggests that she was aware that this was a more intensely subversive gesture. It was also a sign of her early desire to confront and subvert the strict gender roles assigned within Mexican society and to be involved in the active, public and professional spheres traditionally dominated by men. Her ambition to study medicine bears this out. Cross-dressing and androgynous looks were becoming chic at this time (though less so in Mexico City) but were also recognised

as symbolic of rebellious sexuality, women who wore male attire were known as 'amazons'. Kahlo's first homosexual encounter – when she was seduced by an older woman (possibly a teacher) at the age of thirteen – and her later affairs with various women, make her transvestism an expression of a defining experience and a fundamental aspect of her make-up and sexual persona. In many of her self-portrait paintings, including *Self-Portrait with Monkey* 1938 and *The Two Fridas* 1939 (pls.33, 28), Kahlo exaggerates her facial hair (moustache, side-burns and joined eyebrows), deliberately playing up the androgynous and earthy aspects of her natural yet unconventional beauty. In *The Two Fridas*, as well as *Itzcuintli Dog with Me* 1938 (pl.30) and *Me and My Parrots* 1941 (private collection), she highlights her broad shoulders and strong arms, a way perhaps of aligning herself with images of physically robust Tehuana women. Such paintings contrast directly with Kahlo's presentation of herself as diminutive and feminine in works like *Frieda Kahlo and Diego Rivera* 1931 (pl.12). *Self-Portrait with Cropped Hair* 1940 (pl.29) apparently encapsulates her sexual ambiguity and what Gannit Ankori has called her 'androgynous self'.[2] While she depicts herself at her most transvested and therefore transgendered, with her hair cut off in what is often reported as a gesture of retaliation for Diego's affairs and dressed in a man's suit, nevertheless she still wears her delicate earrings and the large suit dwarfs her physique. Furthermore, the painting alludes to the theme of castration – according to Freud the condition of women – through the positioning of the scissors in Kahlo's hand. Thus Kahlo's cross-dressing was not necessarily a denial of her gender, but a way to analyse and communicate her own complex gender predicament.

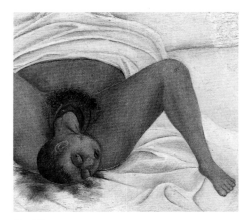

fig.55
My Birth 1932 (detail, pl.16)

Birth

The theme of birth is related in Kahlo's work first and foremost to her experiences of miscarriage and abortion, but it is also connected with ideas of fertility and the cycle of life and death. She was born Magdalena Carmen Frieda Kahlo y Calderón on 6 July 1907, the third daughter of Guillermo Kahlo and Matilde Calderón y Gonzalez. Kahlo depicted her own birth, not merely the fact but the event in process, in one of her most uncompromising paintings, *My Birth* 1932 (pl.16). Yet this is far from a straightforward image of birth. The painting was made following the traumatic miscarriage that she suffered on 4 July 1932 and was completed after her mother's death, which occurred on 15 September the same year. Thus, paradoxically, *My Birth* deals with two deaths. The child is identifiable as Kahlo through her distinctive eyebrows. The identity of the mother figure is obscured: she is covered, or shrouded, from the waist upwards and can therefore be seen as a dual portrait, representing both Kahlo's mother and herself. Like other paintings, such as *My Grandparents, My Parents, and I* 1936 (pl.18), *My Birth* embodies an examination of origins.[3] However, it can also be viewed as an image of self-birth or self-creation. *My Birth* addresses

the relationship between parent and child from multiple perspectives, and Kahlo puts herself in both roles. It confronts her often difficult relationship with a distant and devoutly Catholic mother whose death nevertheless devastated her; above the bed hangs an image of the Virgin as Mater Dolorosa, 'Our Lady of Sorrows'. Meanwhile, the painting also encapsulates Kahlo's own ambivalent view of motherhood, her failure to fulfil this role and her conflicting desires about having a child.[4] She also plays the part of clinical observer; sources for the work include obstetrical illustrations. After her miscarriage in 1932 Kahlo requested a book illustrating foetuses from the hospital medical staff in order to draw from it; in the end it was Diego who brought it to her.[5] By exposing the process of birth in the painting she confronts fundamental taboos governing the female body.[6] The painting has also been related to a sculpture of Tlazolteotl in childbirth, an Aztec goddess of fertility associated with concepts of filth and purification; she was also connected with disease, especially through sexual excess, and its cure.[7] Following her miscarriage Kahlo also painted *Henry Ford Hospital* 1932 (pl.15), an unfinished work called *Frida and the Caesarean* 1932 (Museo Frida Kahlo, Mexico City) and made the lithograph *Frida and the Miscarriage* 1932 (fig.28 on p.36). Diego later commented, with harsh candour, that the paintings Kahlo made in 1932 were 'much better than those she executed before losing her baby'.[8] Birth, death and resurrection are alluded to in the life cycle of the butterfly depicted in *Self-Portrait with Bonito* 1941 (pl.39). The butterfly is a symbol of the eternal soul in both Christian and Aztec belief.[9]

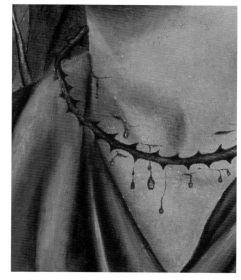

fig.56
Self-Portrait Dedicated to Dr Eloesser 1940 (detail, pl.36)

Blood

Kahlo's paintings are frequently bloody. The literal depiction of blood from open wounds represents actual physical harm and pain. Yet blood also implies metaphysical suffering, for instance in *Self-Portrait Dedicated to Dr Eloesser* 1940 (pl.36) and *Self-Portrait with Thorn Necklace and Hummingbird* 1940 (pl.37), where it issues from the wounds pierced in Kahlo's skin by a necklace of thorns. These works refer to religious rituals and images of Christ's Passion, identifying the sitter with innocent suffering. The sacred or bleeding heart is evoked in paintings such as *Memory* or *The Heart* 1937 and *The Two Fridas* 1939 (pls.19, 28). In such works Kahlo refers to Catholic imagery, both colonial Mexican and European in origin. In Catholic belief, blood is a symbol of life and redemption through Christ's sacrifice and red is therefore the symbolic colour of martyrdom.[10] Kahlo's works also evoke the Aztecs' belief that blood was man's most precious possession, a source of vital energy and nourishment for the gods and regeneration of the cosmos. In Aztec sacrifice the

human heart was removed and ritually burnt. In *A Few Small Nips* 1935 (pl.20) Kahlo projects the internal pain she felt following Rivera's affair with her sister Cristina onto an image of bloody murder. Uterine blood signifies her ambivalent attitudes towards womanhood, fertility and childbirth, as well as challenging an essential taboo relating to the female body.[11] Paintings like *Henry Ford Hospital* 1932 and *My Birth* 1932 (pls.15, 16) expose such taboos and preserve the profound ambivalence of abjection – a theme that recurs in later feminist and post-feminist art. In her still lifes, such as *Cactus Fruits* 1938 and *Fruits of the Earth* 1938 (pls.57, 56), Kahlo emphasises the analogy between fruits that have been cut open and the body by painting the ripe and juicy produce as if it were bleeding. More obliquely, in Kahlo's colour symbolism magenta signifies blood, thus red ribbons stand in for umbilical cords or family blood ties, red braids in Kahlo's hair additionally symbolise pain. Kahlo was deeply concerned with her heritage and the fact of her parents mixed blood: her mother was a Mexican *mestiza* and her father a German immigrant. This blood heritage is at the root of her split identification on the one hand with Mexican popular and indigenous culture and on the other with European culture. She felt at once bound to her nation and an outsider.

fig.57
A page from Kahlo's diary 1944–54
The caption reads: 'I am disintegration'
Museo Frida Kahlo, Mexico City

Body

Kahlo put her own body at the centre of her art. Through the presentation of her body she explored aspects of her autobiography, the construction of identity, female experience, gender boundaries and subverted stereotypical representations of women and their bodies in art. Her work appears as an early milestone in the enactment of the female artist's body in twentieth-century art and in advance of feminist theory, the discourse of the body, performance art and body art. Her painting works simultaneously to conceal and expose the true nature and specificity of her own body and the wider condition of women's bodies within social and aesthetic structures. Masking and masquerade became important tools within this dialectic. Kahlo's meticulous attention to dress and the presentation of her body (in her art and her life) constitutes

an all-inclusive project to probe the condition and boundaries of self and womanhood. Her painting has been viewed as an attempt to regain control over her broken body following a traffic accident in 1925, when she suffered serious injuries, to create an image of self and thus stabilise a fugitive grasp on identity. For this reason she represented her body as perpetually on the brink of disintegration. A drawing in Kahlo's diary of a female figure that is literally falling apart reveals this self image; she writes next to it: 'I am disintegration.'[12] The body is repeatedly revealed as wounded, *chingada*, a nucleus of pain and a place to inscribe internal suffering.

fig.58
What the Water Gave Me 1938
(detail, pl.26)

Bosch, Hieronymus

The influence of Hieronymus Bosch (1450–1516), a painter whom Kahlo admired and to whom she dedicated a page in her diary, can be seen most strongly in the dream imagery of *What the Water Gave Me* 1938 (pl.26). She called him a 'wonderful painter' and wrote that 'it disturbs me very much that there is so little known about this man of genius'.[13] Bosch's influence on Kahlo can also be seen in her depictions of metamorphosis, references to folklore and religion, the intricate detail of her compositions and her complicated symbolism and use of visual metaphor.

fig.59
Portrait of Alicia Galant 1927
(detail, pl.3)

Botticelli, Sandro

Kahlo's early work such as the *Self-Portrait Wearing a Velvet Dress* 1926 and *Portrait of Alicia Galant* 1927 (pls.4, 3) testify to the influence of Botticelli. While her fellow student and first love Alejandro Gómez Arias was in Europe he wrote to her about his visit to the Uffizi and the Italian girls who looked as though they were painted by Botticelli; *Self-Portrait Wearing a Velvet Dress* was made as a love token for him. Unlike her later paintings, or the contemporaneous *Portrait of Miguel N. Lira* 1927 (pl.6), the figures in these works have a graceful, sinuous quality, their elaborate silhouettes and elegant gestures recalling Botticelli's figures.[14] Her early works are also indebted to Leonardo, whom Kahlo admired, and to Mannerist masters such as Bronzino.[15]

Brueghel, Pieter (the Elder)

Kahlo called Brueghel (1525–69) 'my loved one' in her diary.[16] His paintings of peasant life struck a chord with her own identification with the Mexican peasantry or *la raza* (the people) and her pride in all things authentically Mexican.

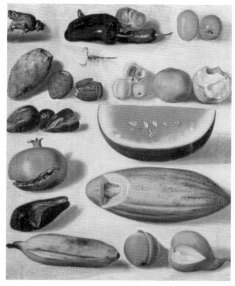

fig.60
Hermenegildo Bustos
Still Life with Fruit and Frog 1874
Oil on canvas 41 x 33.5 cm
Museo de la Alhondiga de Granaditas,
Guanajuato (INBA)

fig.61
Portrait of Miguel N. Lira 1927 (detail, pl.6)

Bustos, Hermenegildo

The paintings of the Mexican artist Hermenegildo Bustos (1832–1907) were an important influence on Kahlo's work. Bustos, like Kahlo, was mainly self-taught. He lived in isolation in Purísima del Rincón in the heart of the Mexican provinces and painted small-scale portraits, *ex-voto* or *retablo* paintings, portraits of *difuntitos* or 'dead angels', and still lifes. In the latter he painted Mexican fruits sliced open to reveal their interiors, as well as animals and objects. Kahlo's paintings *The Deceased Dimas Rosas Aged Three* 1937 and *Fruits of the Earth* 1938 (pls.11, 56) are among those influenced by Bustos. He was 'rediscovered' during the post-revolutionary era as part of a process of recuperating Mexican popular traditions and a search for 'authentic' embodiments of Mexican culture, to counteract the European-influenced academicism of nineteenth-century and Porfirian-era painting.[17]

Cachuchas

The Cachuchas were a group of Kahlo's friends from the Escuela Nacional Preparatoria (the prestigious National Preparatory School), named after the style of hats they wore. The group exemplified the ambitious, young Mexican bourgeoisie and created an environment of mutual intellectual stimulation. Easily bored, they had no tolerance for conservatism. However, they were known for their pranks and hell-raising, such as leading a donkey into a classroom, as much as for their intellectual pursuits and intelligence. Kahlo was one of the key participants in such exploits. Despite this background, the members of the group were later to become part of Mexico's elite. Alejandro Gómez Arias, who became a lawyer and political journalist, was the group's nominal leader and Kahlo's first love. The others members were Miguel N. Lira, who was a Stridentist poet and later became a lawyer, José Gómez Robleda, who was to become a professor of psychiatry at the university medical school, Manuel González Ramírez, who became a historian, writer and lawyer, Augustín Lira, Jesús Ríos y Valles, Alfonso Villa, Carmen Jaime and Kahlo herself.[18] The Cachuchas were the subject of some of her earliest paintings, including the work known as *Pacho Villa and Adelita* from before 1927 (pl.5), and *Portrait of Miguel N. Lira* 1927 (pl.6), which translates into visual images the essentials of *estridentismo* or Stridentism (a fusing of elements of Cubism, Futurism and the Neue Sachlichkeit). A lost work called *Cachuchas* also dating from before 1927 is known through a black and white photograph.

Cadavre exquis

The game of Cadavre exquis or Exquisite Corpse, invented by the Surrealists, was played by Kahlo and her friends. It involves drawing a section of a body on a piece of paper, which is folded and passed on to the next person, who adds a section without seeing the rest of the drawing. Only at the end is the image revealed to show a composite body. Two drawings made by Kahlo with her friend Lucienne Bloch include portraits of Kahlo and Rivera, reversing their genders and thus exploring, while also poking fun at, the boundaries of sexual identity (see fig.5a and b on p.12).

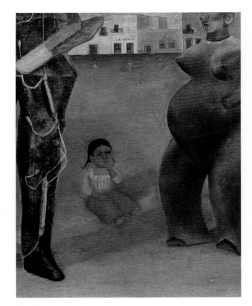

fig.62
Four Inhabitants of Mexico City 1938
(detail, pl.22)

Childhood

Kahlo believed that identity was determined by decisive experiences undergone during childhood. She was also deeply preoccupied with her cultural and biological heritage. These interests point to her deep-seated need to understand her own origins. She painted various child versions of herself, for instance in *My Nurse and I* 1937 (pl.17), *Four Inhabitants of Mexico City* 1938 (pl.22) and *They Ask for Planes and Only Get Straw Wings* 1938 (whereabouts unknown).[19] She also addressed the subject of her genealogy at the beginning and end of her career, in *My Grandparents, My Parents, and I* 1936 (pl.18) and the unfinished *Family Tree* 1950–4 (Museo Frida Kahlo, Mexico City). While the children she paints are self-portraits, they also stand in for the children she could not or did not have herself, as in *Girl with a Death Mask* 1938 (pl.21). Likewise, the doll in *Self-Portrait on the Bed* 1937 (pl.31) can also be viewed as a reference to Kahlo's unfulfilled desire for a child.

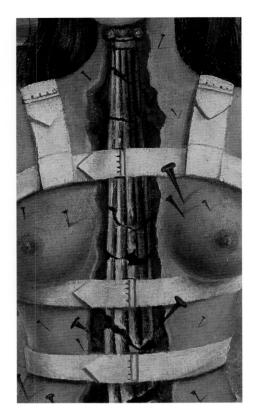

fig.63
The Broken Column 1944
(detail, pl.49)

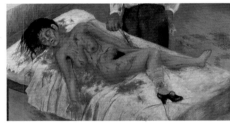

fig.64
A Few Small Nips 1935
(detail, pl.20)

Chingada

The term *chingada* embodies numerous interrelated meanings and concepts.[20] To be *chingada* means to be wounded, broken, torn open or deceived. The word derives from the verb for violation or sexual penetration and implies domination of the female by the male (you are either *chingado/a* : a recipient of abuse, or *chingón*: the active perpetrator of acts that put others in this position). It refers to the quintessential victim or status of victimhood. This state of passive capitulation results in a loss of identity and nothingness, and is intimately bound up with shame. It also refers to the experience or violation of conquest and therefore to a sense of national inferiority. It evokes European domination over indigenous culture, and women, thus linking the term to La Malinche. *Chingada* is associated with Mexican representations of maternity like La Llorona or the long-suffering mother. In contrast to the immaculate Virgin, *chingada* is the violated mother. Paintings such as *Memory* or *The Heart* 1937 (pl.19), *Remembrance of an Open Wound* 1938 (now lost) and *The Broken Column* 1944 (pl.49) represent Kahlo as *chingada*, wounded or torn open. *The Broken Column* also evokes images of Christ, both in the form of Ecco Homo or Man of Sorrows and representations of his flagellation tied to a column where the lashes 'cut into the divine flesh all the way to the bone'. In *A Few Small Nips* 1935 (pl.20) the female murder victim is *chingada*, stabbed repeatedly. Her nakedness is emphasised by the rumpled stocking and shoe she is still wearing. The painting symbolises the pain and sense of betrayal that Kahlo felt when she discovered Rivera's affair with her younger sister Cristina. Rivera himself evoked the imagery of this term when he described Kahlo as 'The only artist in the history of art who tore open her chest and heart to reveal the biological truth of her feelings.'[21]

Colour symbolism

In her diary Kahlo records the specific system of colour symbolism she devised and employed in her painting. Green symbolised 'good warm light'; solferino 'Aztec Tlapali [the Aztec or Nahuatl word for colour] old prickly-pear blood, the brightest and oldest'; brown 'colour of *mole* [a Mexican chile sauce], of leaves becoming earth'; yellow 'madness, sickness, fear. Part of the sun and of happiness'; cobalt blue 'electricity and purity. love'; black 'nothing is black – really nothing'; leaf green 'leaves, sadness, science, the whole of Germany is this colour'; greenish yellow 'more madness and mystery, all the ghosts wear clothes of this colour, or at least underwear'; dark green 'colour of bad news and good business'; navy blue 'distance. Tenderness can also be this blue'; magenta 'blood? Well who knows?'[22]

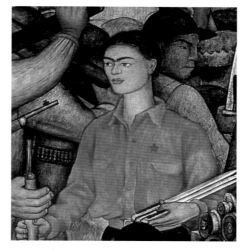

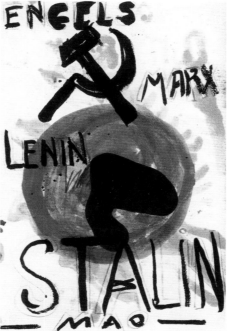

fig.65
Detail depicting Kahlo in
Diego Rivera's *The Arsenal*, panel from his mural cycle *Corrido of the Proletarian Revolution* 1928
Fresco 321 x 329 cm
Ministry of Education, Mexico City

fig.66
A page from Kahlo's diary, 1944–54
Museo Frida Kahlo, Mexico City

Communism

From early on Kahlo was active in politics and influenced by radical ideas. As a child she lived through the upheaval of the Revolution, which had a profound effect on her viewpoint. In 1927 she became a member of the Young Communist League, attending rallies and meetings. Alejandro Gómez Arias remembered her wearing sober black or red shirts with a hammer-and-sickle shaped badge and she is depicted in this way in Rivera's mural *Corrido of the Proletarian Revolution*, painted at the Ministry of Education in 1928.[23] Rivera had become a member of the Mexican Communist Party on his return from Europe in 1921. Many of the principal members of the Mexican Communist Party were also important artists, including muralists David Alfaro Siquieros, José Clemente Orozco and the photographer Tina Modotti. On 3 October 1929, not long after his marriage to Kahlo, Rivera was expelled from the Communist Party on the grounds of 'collaborating with the petit-bourgeois government of Mexico and of having accepted a commission to paint the stairway of the National Palace of Mexico'.[24] Kahlo chose to leave the party, too. Both applied to be readmitted in 1946; Kahlo was accepted in 1948 whilst Rivera had to wait until 1954. In the interim Rivera was involved in Trotskyite politics. Kahlo remained detached from this, though she did conduct a short-lived affair with Trotsky during his exile in Mexico, when he lived for a time in Kahlo's childhood home the Casa Azul. Unlike Rivera, who used his murals as a vehicle for his ideology, Kahlo's political beliefs did not find explicit expression in her work until the end of her life, by which time she was a devout Stalinist. In a few late works she addressed politics outright, including one of the last paintings she made, an unfinished portrait of Stalin (fig.19 on p.27). Her diary is full of references to her heroes Marx, Stalin and Mao, photographs of whom hung at the foot of her bed. Another work from the end of her life, titled *Marxism Will Give Health to the Sick* c.1954 (Museo Frida Kahlo, Mexico City), combines self-portraiture with political allegory.

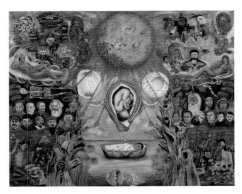

fig.67
Moses 1945
(pl.69)

fig.68
Fantasy (I) 1944
Pencil on paper 24 x 16 cm
Museo Dolores Olmedo Patiño, Mexico City

Corridos

Kahlo loved to hear and to sing *corridos*, folk songs, which she also wrote for friends and acquaintances or for special occasions. The invitation for her exhibition organised by Lola Álvarez Bravo in 1953, for example, was a *corrido* written by Kahlo.[25] The narrative style of *corridos* has been traced to pre-Columbian epic poetry as well as to Spanish verse. They were published as single-page sheets (the engraver José Guadalupe Posada illustrated many such broadsheets) or were passed on through oral performance. *Corridos* were a kind of musical newspaper: the subjects were important events, political and social conflicts, sensational crimes and tales of heroic outlaws. The form underwent a resurgence during the Revolution and became an expression of comradeship, identification with the people and ultimately an expression of national pride. Lines from a popular song or ballad in part inspired *The Little Deer* 1946 (pl.51); 'I am a poor little deer that lives in the mountains. / Since I am not very tame, I don't come down to drink water during the day. / At night, little by little, I come to your arms my love.'[26]

Cosmology

Kahlo's late work, including paintings such as *Moses* 1945 and *The Love-Embrace of the Universe* 1949 (pls.69, 70), as well as her diary and drawings, express her search for a system of belief and method for comprehending the world. Her earlier works had been defined by their references to Christianity on the one hand and Aztec beliefs on the other. In later life she broadened her frame of reference; though Christianity and Aztec religion continue to underpin much of her work, she began to combine various different religious, ideological and philosophical belief systems, most evidently in *Moses*. While the ideology of Marxism became increasingly important for Kahlo in later life, as her illness progressed this was tempered by an growing interest in Eastern mysticism, Hinduism and Buddhism. Various drawings, both in her diary and otherwise, include symbols from Eastern religion and mysticism such as the Third Eye motif and the Yin-Yang symbol, while the word 'Karma' appears in drawings and works such as *The Little Deer* 1946 (pl.51).

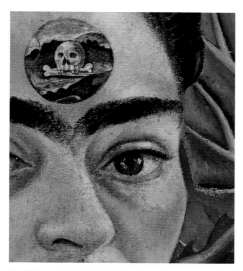

fig.69
Thinking About Death 1943
(detail, pl.43)

Death

Kahlo's early experiences of illness, including polio at the age of six – which left her with a deformed limb – and her accident, instilled in her a profound sense of her own mortality and the fragility of her body. Her father's epilepsy provided another experience of physical vulnerability. Meditations on death and the inevitability of mortality feature in much of her work. The death of her mother in 1932 and her father in 1941 were momentous events with which she dealt both directly and indirectly in her painting. In *Self-Portrait with Bonito* 1941 (pl.39), painted following the death of her father, Kahlo appears in simple black mourning clothes and with a black braid in her hair. In this circumstance of intense personal loss, and with the wider context of war in Europe, she maintains a sombre yet stoical gaze. A decade later, in 1951, she painted a portrait of her father that belongs to a tradition of painting commemorative images of the deceased. The painting is a *recuerdo*, a keepsake or momento mori. *The Suicide of Dorothy Hale* 1938–9 (pl.24) was commissioned for a similar purpose. It deals with the death of

a friend, yet in a frank and, to some of her contemporaries, shocking manner: Clare Luce Boothe, who commissioned the painting, returned it to Kahlo. *A Few Small Nips* 1935 (pl.20) portrays a brutal murder as reported in a newspaper story. *Thinking About Death* 1943 (pl.43) deals explicitly with Kahlo's preoccupation with mortality, suggesting that it is constantly in her thoughts. She was influenced by many different forms of funerary art and imagery, from Etruscan tomb sculpture, Aztec art relating to sacrifice and the afterlife, the symbols and objects of the Day of the Dead including Calavera skeletons, to the post-mortem portraiture of *difuntitos* (deceased children).

Difuntitos

One of the days in the festival known as the Day of the Dead is devoted to deceased children, or *difuntitos*. Related to this was the tradition of post-mortem portraiture depicting much-loved children dressed elaborately for burial, which had existed in Mexico since the colonial period. When a child died it would be painted dressed as a saint, wearing a crown and adorned with saintly attributes. These images, also called portraits of 'dead angels', were intended to encapsulate the child's innocence in the face of death and God, serving as memento mori. Hermenegildo Bustos was known for this sub-genre, and from the nineteenth century these portraits were also made as photographs. Kahlo painted one such image, *The Deceased Dimas Rosas Aged Three* 1937 (pl.11). Dimas is dressed as St Joseph, who was characterised by his love of children, and lies on a *petate* mat of woven palm leaves surrounded by flowers associated in Mexico with death.[27] The family

fig.70
Difuntitos painting on the wall over Kahlo's bed
Museo Frida Kahlo, Mexico City

fig.71
The Deceased Dimas Rosas Aged Three 1937 (detail, pl.11)

of the child were Indians from Ixtapalapa whom Rivera had used as models. By painting this work Kahlo made a gesture of solidarity towards the peasant family (though ultimately the painting was not destined for them), as well as situating herself within a populist Mexican aesthetic tradition and creating an image that expressed her empathy with the grief of losing a child.

fig.72
Diego and Frida 1929–1944 (II) 1944
(detail, pl.64)

fig.73
Frida Kahlo looking in mirror on the patio
of the Casa Azul, with two of her dogs c.1944
Photograph by Lola Álvarez Bravo
Courtesy of Throckmorton Fine Arts, Inc.,
New York

Dualism

Doubles, binary oppositions
and pairings occur frequently
in Kahlo's work and underpin
the symmetrical formal structure
of a number of her paintings. The
most central of these is, inevitably,
the partnership between herself
and Rivera, but this characteristic
dualism is also found in a series
of universal binaries that Kahlo
employs: male and female, life
and death, light and dark, sun
and moon, night and day, interior
and exterior, body and mind,
divine and mortal, Yin and Yang.
In *Diego and Frida 1929–1944 (II)*
1944 (pl.64) Kahlo paints half of her
own face and half of Rivera's joined
together, suggesting that neither
one is whole without the other.
Yet, although they are portrayed
as two halves of the same being,
the parts are uncomfortably
matched and therefore remain
distinct from one another. The
painting contains the sun and the
moon as signs of male and female
aspects and a conch and shell that
represent male and female sexual
organs; for Kahlo these shells
were symbols of love. The sun
and moon embody an ancient
dualism that can be traced back
to the pre-Aztec culture of
Teotihuacan – the ancient site is
dominated by the monumental
Sun and Moon pyramids – and
later Aztec symbolism. The
pyramids of Teotihuacan appear
most recognisably in the
background of *Portrait of Lucha
María, Girl from Tehuacán* 1942
(pl.52). The sun and moon recur
in Kahlo's paintings *Without Hope*
1945 (pl.53), *Tree of Hope, Keep
Firm* 1946 (fig.51 on p.51), and
The Love-Embrace of the Universe
1949 (pl.70). Kahlo was fascinated
by concepts of mirroring and
doubling. She had read Oscar
Wilde's gothic novel *The Picture
of Dorian Gray* (1891); and its
principal motif, a portrait that acts
as a signifier of the moral health
of the title character and becomes
progressively aged and decayed,
must have had a particular
resonance given the importance
of self-portraiture within Kahlo's
oeuvre, as would the theme of the
Doppelgänger or mirror image.[28]
Another source of Kahlo's interest
in the notion of a second self
was the Aztec belief in animal
counterparts or alter egos, and the
creatures with which Kahlo appears
in her paintings fulfil this role. In
The Two Fridas 1939 (pl.28),
created during her separation and
divorce from Rivera, she paints
herself twice over. On one side is
the 'Tehuana' Frida, representing
the woman that Diego loved. She
holds a miniature portrait of him in
her hand and her heart is whole.
On the other side is the unloved,
rejected Frida, dressed in a
colonial-style wedding dress. The
interior of her heart is exposed
and an artery drips blood into
her lap; the flowers on her dress
also turn to blood. And yet,
however different they appear,
the two 'Fridas' clasp hands and
are connected by an artery from
one heart to the other. For Kahlo,
psychical as well as physical
doubling is a recurring motif. *Tree
of Hope, Keep Firm* 1946 repre-
sents a prostrate Kahlo following
an operation, overlooked by a
guardian figure, both aspects of
herself. In *Two Nudes in a Forest*
1939 (pl.27), Kahlo paints two
women lying together that may,
similarly, represent two aspects of
a single nature rather than separate
individuals. In a broader sense
these two 'Eves', one with lighter
skin than the other, represent the
mixed racial origins of the Mexican
people. The painting also raises
the theme of homosexuality more
explicitly than anywhere else in
Kahlo's work. A splitting of the self
into mind and body, inner thoughts
and corporeal exterior, subject
and object is present in *What the
Water Gave Me* 1938 (pl.26). Kahlo
said the painting asked 'where is
the I?'.[29] Mirroring supports the
process of self perception as well
as threatening disintegration
through its illusory nature. Kahlo
repeatedly painted her mirror
image as a way of fixing her
identity, a precarious narcissism
that resulted paradoxically in
self-fragmentation.

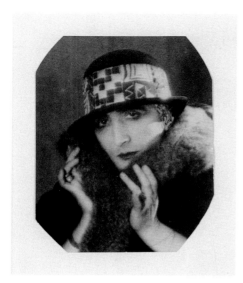

fig.74
Man Ray
Rrose Sélavy c.1924
Gelatin silver print 13.5 x 10.7 cm
Private collection

Duchamp, Marcel

Kahlo described Marcel Duchamp as 'The only one who has his feet on the earth among this whole bunch of coocoo, lunatic sons of bitches of the surrealists.'[30] She met him in Paris in 1939 and he helped to organise the exhibition of her work at Galerie Renou et Colle. Duchamp's alter-ego, for which he adopted the name Rrose Sélavy ('eros, c'est la vie' or 'eros, that's life'), is a crucial precursor to Kahlo's own blurring of gender and representation of herself in men's clothes in *Self-Portrait with Cropped Hair* 1940 (pl.29).

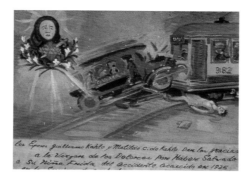

fig.75
Anon., with later additions by Frida Kahlo
Votive painting *c.*1943
19.1 x 24.1 cm
Private collection

Ex-Voto

Ex-voto or *retablo* paintings were made as a gesture of gratitude for salvation, a granted prayer or a disaster averted, and left as offerings in churches or at saint's shrines. They are generally painted on small-scale metal panels and depict both the incident (or several temporally distinct moments from it) and the Virgin or saint to which they are offered. Similar to these are the small metal *ex-voto* objects known as *milagros* or miracles, made in the form of crosses, sacred hearts or parts of the body (corresponding with those afflicted with illnesses which the offering aims to cure). Kahlo and Rivera possessed a large collection of *ex-voto* paintings ranging in date over several centuries. Although Kahlo never painted her accident, years later she did alter one of these paintings so that it depicted the scene of her own near death, changing the inscription to read as if written by her parents to give thanks. This gesture was laced with a typical mixture of irony, self-pity and pain; neither of her parents rushed to her bedside after her accident. Many of Kahlo's paintings, from the early 1930s especially, relate in size, format, architectural setting or spatial arrangement and style to these votive, folk objects. *Henry Ford Hospital* 1932, *My Birth* 1932

and *Self-Portrait with Portrait of Dr Farill* 1951 (pls.15, 16, 54) all employ elements that relate them to *retablo* paintings.

fig.76
A page from Kahlo's diary 1944–54
The caption reads: 'Feet what do I need them for if I have wings to fly? 1953'
Museo Frida Kahlo, Mexico City

Flight

Images of flight or flightlessness recur frequently in Kahlo's work and through her diary.[31] They reflect her concern for freedom of movement, her memory of being restricted and inhibited as a child by her deformed limb and her later experiences of confinement to hospital or home. In *They Asked for Airplanes and Only Get Straw Wings* 1938 (now lost), she painted herself as a child in Tehuana costume. She holds a model airplane and wears the wings referred to in the title, but these are attached to strings, like a marionette, and she is tethered to the ground. Following the amputation of her right leg below the knee in 1953, Kahlo wrote in her diary 'Feet what do I need them for if I have wings to fly?'[32]

Gender

The question of gender as it appears in Kahlo's work is rooted in Mexican cultural paradigms. The specific gender roles traditionally assigned in Mexican society are expressed through historical, religious and folkloric figures that, for women, include La Llorona, La Malinche, the Virgin (the Virgin of Guadalupe and the Mater Dolorosa), the wholesome Tehuana, and more generally the roles of wife, mother and *chingada*. Many of these symbols and stereotypes surface in Kahlo's work. Her expressions of her sexual ambiguity and her tendency to cross-dress attempted to explode the stereotypical roles assigned to women within a forcefully macho society. That she exaggerated such features as her eyebrows and moustache, and her broad shoulders and strong arms in her paintings contribute to a further blurring of gender as well as identifying her as a resilient Mexican *campesina*. Meanwhile, Rivera played out the roles of famous artist and, through his many affairs, virile male. Yet in her descriptions of Rivera, Kahlo highlighted his feminine or childlike qualities, his 'breasts' and curved belly.

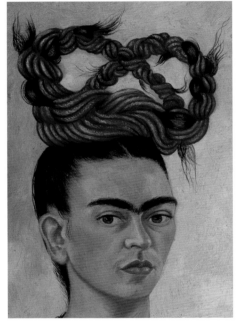

fig.77
Self-Portrait with Cropped Hair 1940
(detail, pl.29)

fig.78
Self-Portrait with Braid 1941
(detail, pl.38)

Hair

'Look if I loved you, it was for your hair. Now that you are bald, I don't love you any more.' So reads the inscription from a popular song on one of Kahlo's best-known works, *Self-Portrait with Cropped Hair* 1940 (pl.29). She made her hair an exterior expression of her emotions: her joy, her wounds and her grief. One of the most distinguishing features of her self-portraits is her long hair and elaborate hairstyles. However, this most feminine of attributes is incorporated by Kahlo into a system for conveying meaning and confronting traditional concepts of beauty. Her many-coloured braids and ribbons, the styles and accessories, all have specific connotations relating to the expression of her inner feelings. The colours of her ribbons are coded in their own right. Kahlo wore her hair long and dressed it in traditional styles to please Rivera. When she discovered his affair with her sister Cristina (which had begun in 1934) she cut off all her hair as an act of retaliation. *Self-Portrait with Cropped Hair* was painted at the time of their divorce; it is simultaneously a lament for a lost love, an accusation of betrayal and a self-flagellation in which Kahlo derides the love she once felt. Her cropped hair accentuates her androgynous appearance in this work. Following their remarriage Kahlo painted herself in *Self-Portrait with Braid* 1941 (pl.38) with the tresses of her hair apparently reattached with ribbons; the effect is one of visible restoration. In this way she refers to the permanent damage inflicted on herself and her relationship with Rivera.

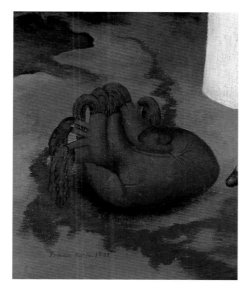

fig.79
Memory or *The Heart* 1937
(detail, pl.19)

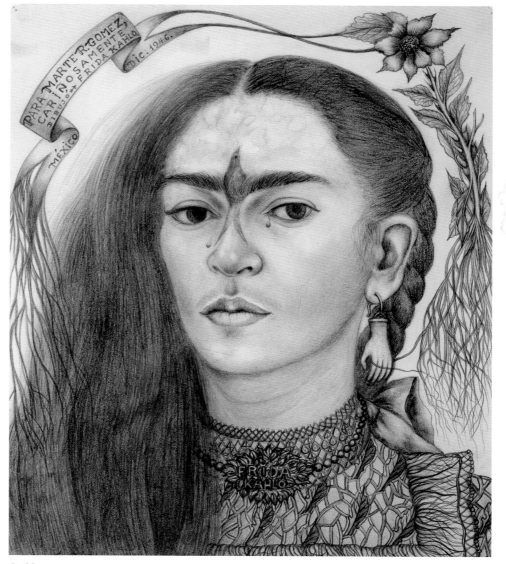

fig.80
Self-Portrait Dedicated to Marte R. Gómez 1946
Pencil on paper 38.5 x 32.5 cm
Private collection

Heart

The bleeding heart is one of the fundamental symbols of Catholicism. The heart is also intimately linked with Aztec ritual sacrifice. In *Memory* or *The Heart* 1937 (pl.19) Kahlo painted herself with a void where her heart should have appeared. An over-sized heart lies in the landscape beside her, creating rivers of blood. The painting has been linked with Kahlo's discovery of Rivera's affair with her younger sister Cristina. In *Self-Portrait with Portrait of Dr Farill* 1951 (pl.54) the artist's palette that Kahlo holds metamorphoses into a heart, while the brushes in her hand drip blood onto her lap.

Hummingbird (Huitzilopochtli)

In several works Kahlo identified herself with the hummingbird. In Mexico the hummingbird is understood as a talisman bringing luck in love, however, Kahlo uses it as a symbol to suggest her successive experiences of loss through love. In *Self-Portrait with Thorn Necklace and Hummingbird* 1941 (pl.37), she wears a dead hummingbird around her neck, thus reversing its traditional meaning to bad luck, injury and death. The painting was made following her remarriage to Rivera but was given to her former lover

Nickolas Muray. The frontal composition of the painting bears a strong relationship to the photographs that Muray had taken of Kahlo, but also gives it a hieratic grandeur and beauty. In 1946 she made a drawing in which her eyebrows transform into a hummingbird. In Aztec mythology the supreme god Huitzilopochtli, meaning the left-sided hummingbird or blue hummingbird on the left, guided the Aztecs on their epic journey to the site of Tenochtitlan (Mexico City). Huitzilopochtli, represented as a hummingbird or with the feathers of a hummingbird on his head, was the god of the sun and of war.[33]

fig.81
Kahlo and Diego Rivera with Judas figure
c.1929–34
Courtesy of Archivo Fotográfico,
CENIDIAP-INBA

Judas

Judas figures are life size, or larger, painted papier-mâché figures which have a network of fireworks attached to them; they are exploded during festivals at Easter or during the Day of the Dead. The figures are traditionally given the features of Judas but frequently they have also been made to look like dishonest politicians or criminals; blowing them up symbolises the defeat of evil and corruption.[34] Kahlo included a Judas in *Four Inhabitants of Mexico City* 1938 (pl.22) as one of the quartet of symbolic protagonists that represent the true spirit of Mexico; they act as companions or playmates to Kahlo, who is portrayed in the painting as a child. She kept such folk objects around her home, fixing them to her bed in the manner shown in *The*

Dream 1940 (pl.25). Gannit Ankori has identified the plant in this work as one named the Entrails of Judas suggesting the theme of betrayal.[35] In the painting *The Wounded Table* 1940 (now lost), a Judas is depicted as Kahlo's companion but also as an alter-ego with injuries that correspond to Kahlo's own. Judas figures embody the frailty and inevitable disintegration of the body.

fig.82
Self-portrait photograph by Guillermo Kahlo
(undated)

fig.83
Portrait of My Father 1952
Oil on canvas 62 x 48 cm
Museo Frida Kahlo, Mexico City

Kahlo, Guillermo

Kahlo's father Guillermo Kahlo (1872–1941) was born to Hungarian parents and brought up in Baden-Baden in Germany; he emigrated to Mexico in 1891 at the age of nineteen. He was a photographer who specialised in recording architectural views. Guillermo Kahlo suffered from epilepsy and, as a child, Kahlo had sometimes looked after him during his attacks. She shared

fig.84
Henry Ford Hospital 1932
(detail, pl.15)

a particular bond with her father, teasingly calling him 'Herr Kahlo' while he referred to her as 'Frida, lieber Frida' and said that of all his children 'she is the most like me'.[36] He was responsible for introducing Frida to German philosophy and literature, and stimulated her interest in nature, Mexican archaeology, as well as art and photography. Alejandro Gómez Arias recalled that Guillermo Kahlo had 'the typical library of an educated German of his time' and that a portrait of his hero, the philosopher Arthur Schopenhauer (1788–1860), presided over his photographic studio.[37] Kahlo's precise technique owes something to her father's personality and guidance. The Neue Sachlichkeit character of some of her works, especially her portraits of Miguel N. Lira (pl.6) and her patrons Marte R. Gómez and Eduardo Morillo Safa (figs.134, 136 on pp.211, 212), may be indebted to the Germanic side of her identity and her interest in German art. Rivera commented on how 'The German heritage of her father, the analytic constructor-destroyer and disillusioned sceptic – predominated, wiping out the Spanish-Indian influence of the mother.'[38]

La Llorona

La Llorona, 'the weeping woman' in Mexican folklore, murdered her own children when abandoned by her lover. She is thus at one and the same time a victim and the embodiment of evil and unnatural womanhood; she is also a symbol of madness. At the opening of the solo exhibition of Kahlo's work organised by Lola Álvarez Bravo in Mexico City in 1953 (the first such show in Mexico and the only one in Kahlo's lifetime) Kahlo requested that the folksong La Llorona be sung.[39] The words include the verse:

> Ay Llorona, Llorona!
> Lorona, take me to the sea
> To see if by crying,
> ay Llorona,
> I can weep my heart to
> sleep.[40]

Kahlo painted herself repeatedly as the weeping Llorona, but most explicitly in *Henry Ford Hospital* 1932, *Memory* or *The Heart* 1937 and *Diego and I* 1949 (pls.15, 19, 47). Her dishevelled hair, tears and exposed heart are attributes of the betrayed Llorona, who is sometimes conflated with La Malinche and is also associated with the Tehuana.[41]

La Malinche

La Malinche (*c.*1505–1529) was the indigenous Nahua mistress of the conquistador Hernán Cortés (1485–1547), and also acted as his translator.[42] Cortés overthrew the Aztec empire and claimed Mexico for Spain. As the woman who helped him forge alliances with various Indian nations against the Aztecs La Malinche was, and still is, reviled by Mexicans as a traitor. Furthermore she is a symbol of the 'duplicitous woman' and a condemnation that corresponds to the *chingada*. Since she gave birth to Cortés's child, a son, she is also seen as a symbol of the origin of the Mexican nation and of mixed-race *mestizo* culture, a side of Mexican history that is fraught with anxiety and an emblem of a nation that it not entirely comfortable with its dual origins. Her crimes are considered to be on a par with original sin and therefore at the root of all that is wrong with Mexico. She embodies the antithesis of *Mexicanidad*. La Malinche features in the murals of Diego Rivera and José Clemente Orozco, in the painting of Antonio Ruíz (known as 'El Corcito') and throughout Mexican literature. More than just a figure from history, she remains a constant in the Mexican imagination and a significant component of the nation's self-identity. She also gives her name to various insults; to be called a

Fig.85
The Mask 1945
(pl.48)

Masks

In Kahlo's work the construction of identity is closely connected with masquerade. She was known to Rivera and to friends as La Gran Ocultadura (the great concealer), a name she readily acknowledged in letters and in her diary. Through her work there is a constant oscillation between masking and unmasking, self-concealment and self-exposure, disguise and revelation. In paintings such as *Henry Ford Hospital* 1932 and *My Birth* 1932 (pls.15, 16), where Kahlo appears to offer extraordinary access into personal territory, there remain levels of disguise and camouflage in the obscure symbolism of the former and the shrouded figure featured in the latter. Masks feature as intimations of death in the two versions of *Girl with Death Mask (I)* painted in 1938 (pl.21; whereabouts of second version unknown). The masks these small paintings incorporate relate to both Aztec and Catholic rituals dealing with death, sacrifice and resurrection. In the bust-length self-portraits of the 1940s her impassive face and rigid gaze

malinchista is to be called a lover of foreigners, a traitor; to be named a 'son of La Malinche' is the equivalent of being labelled a bastard. For Kahlo, her own mixed heritage was a source of pride and independence, yet also anxiety. She sought to identify with her nation through her politics, work, clothing, behaviour and colloquial language; yet she also set out to distinguish herself as unique, revealing her conflicting need to belong while remaining an outsider. Kahlo was deeply concerned with her origins and heritage, and paintings such as *My Grandparents, My Parents, and I* 1936 (pl.18) that probe her genealogy testify to this. It is also clear that she identified with tainted heroines such as La Malinche and La Llorona, signing letters 'Frida, La Malinche' and painting herself in a Malinche mask.[43]

resist scrutiny. In one self-portrait painting, *The Mask* 1945 (pl.48), she wears a weeping Malinche mask, identifying herself with this anti-heroine and Mexican 'Eve'.[44] The emotion of the fake face perhaps conceals Kahlo's habitually inscrutable expression; thus, by adopting a mask, she paradoxically reveals more feeling than she does unmasked.

Mexicanidad

Mexicanidad refers to the sense of pride in being Mexican and the re-examination of national identity that was stimulated by the Mexican Revolution of 1910–20. While the Mexican muralists adopted this attitude as part of a broad political project, Kahlo turned herself and her art into a conspicuous and distinctly personal embodiment of Mexican culture and identity. One of the strongest themes running through her work is the construction of an identity rooted in the earth or land and strongly identified with the Mexican people. Although she was born in 1907, Kahlo later adopted 1910 as her date of birth to identify herself more closely with the rebirth of the nation through revolution. Her personal project manifested itself in her attire, through her choice of Tehuana costume, pre-Columbian jewellery and traditional hairstyles. In her painting, this stance is most evident in works such as *Four Inhabitants of Mexico City* 1938 (pl.22), in which she represents four archetypal figures drawn from Mexican customs, culture and folklore as her companions, and *Fruits of the Earth* 1938 (pl.56), a cornucopia of Mexican produce that demonstrates the richness of the land. Hayden Herrera has defined *Mexicanidad* as an ethic or as 'a style, a political stance, and a psychological support'.[45]

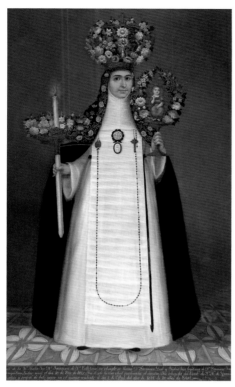

fig.86
Félix Zarate
Portrait of Hermana Francisca Leal y Bidrio 1840
Oil on canvas 200 x 117.7 cm
San Antonio Museum of Art

fig.87
Self-Portrait with Monkey 1938
(detail, pl.33)

Monjas Coronadas

Portraits of *monjas coronadas* or 'crowned nuns' were painted to mark the entry of a novice into a convent as the bride of Christ; the novitiate is usually depicted crowned and adorned with flowers. This tradition had existed in Mexican colonial painting for several centuries. Kahlo's self-portraits evoke such paintings, in particular in *Self-Portrait Dedicated to Dr Eloesser* 1940 and *Self-Portrait as a Tehuana* 1943 (pls.36, 42). The former portrait marked Kahlo's remarriage to Rivera, which they had agreed would be a celibate union.[46] Kahlo depicts herself with a diadem of flowers and a necklace of thorns, the latter referring to Imitatio Christi rituals practised by Mexican nuns.[47] Portraits of *monjas coronadas* were also painted to commemorate a nun on her death, indicating that perhaps Kahlo felt that the suppression of her desire for Rivera was a kind of death.

Monkey

Among the animals that Kahlo painted most frequently as her companions in her self-portraits are the small spider monkeys that she and Rivera kept as pets. These animal alter egos possess an almost human quality. Their particular proximity to Kahlo is emphasised by the ribbons she depicts connecting them to herself, symbolising a close bond, for instance in *Fulang-Chang and I* 1937, *Self-Portrait with Monkey* 1938 and *Self-Portrait with Monkey* 1940 (fig.49 on p.49, pls.33, 34). Such pets could also be interpreted as substitutes for the children that Kahlo was unable to have with Rivera. She was aware of the traditional meanings associated with monkeys and apes. Since the Middle Ages they have symbolised the devil, heresy and paganism, later coming to represent the fall of man, vice and the embodiment of lust. The monkey stands in as the agent of licentious temptation. It was also intended as a symbol cautioning against the danger of excessive love, referring most often to parental love where the child is smothered by the disproportionate attention of the parent. Additionally, they can symbolise flattery or blind love.[48] In the Christian tradition monkeys represented the base instincts of man, and artists whom Kahlo admired such as Brueghel and El Greco had employed monkeys in this way in their work. Chained monkeys denoted man caught by sin, as in Brueghel's *Two Monkeys* 1562 (Dahlem Museum, Berlin). In Mesoamerican culture monkeys represented sexual intercourse but in this context it was viewed as natural rather than sinful. Monkeys and apes are known for their tendency to imitate and so were also used to refer to the artist and the imitative arts of painting and sculpture. In *Moses* 1945 (pl.69) Kahlo includes apes to refer to Darwinian evolution.

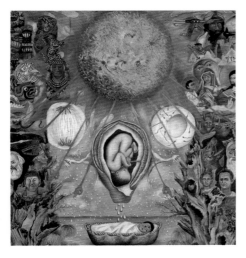

figs.88, 89
Moses 1945
(details, pl.69)

Moses

Kahlo painted *Moses* in 1945 (pl.69) after reading Sigmund Freud's essay *Moses and Monotheism* (1939).[49] The essay traces the roots of monotheistic belief back via Moses to the Egyptian pharaoh Amenhotep IV (Akhenaten)(reigned *c.*1363–36 BC) and his wife Nefertiti. The painting develops the subjects and ideas found in Freud's essay and combines these with other concerns introduced by Kahlo; she gave the painting the alternative title 'The Birth of the Hero' most probably in reference to Otto Rank's book *The Myth of the Birth of the Hero* (1909). Kahlo's painting, which reads like a mural although it is a small-scale *retablo*, depicts a pantheon of gods and historical figures either side of a representation of the Aten or sun disc as it was worshipped

by Akhenaten. The Aten is distinguishable by the hands at the end of each of the rays of the sun. Beneath the Aten is a womb and below that the infant Moses in a basket with a third eye on his forehead. Kahlo stated: 'I painted the Sun as the centre of all religions, as the first god and as the creator and producer of life.' The painting is divided, on either side of the sun, into two registers, which consist of images of gods in the upper section and portraits of 'heroes' below. On the left-hand side are Lightning, the Thunderbolt, Kukulcan and Gukumnatz – Mayan manifestations of the feathered serpent god – the Aztec gods Tlaloc, 'the magnificent Coatlicue, mother of all the gods', Quetzalcoatl, Tezcatlipoca, the Centéotl, the Chinese Dragon god and the Hindu Brahma; below this are Nefertiti, Marx, Paracelus, Epicurus, Freud, Buddha, Genghis Khan, Ghandi, Lenin and Stalin. On the right-hand side are the winged Assyrian bull, the Egyptian gods Amen, Osiris and Horus, alongside Zeus, Apollo, Venus, the Moon, Jehovah, the Virgin Mary, the Trinity and the Devil. Below this is Akenaten. Kahlo remarked 'I should have painted this figure with much more prominence than any other.' Alongside are Zarathustra (Zoroaster), Christ, Alexander the Great, Tamerlane, Caesar, Mohammed, Martin Luther, Napoleon and 'the lost child' Hitler.[50] In addition, in the lower part of the painting there are two scenes that allude to the evolutionary process and to the different human races. The painting seeks to represent a world view or all-encompassing cosmology through which to understand man's origins and systems of belief.

fig.90
Bust of Queen Nefertiti, Egyptian, 18th dynasty
Bode Museum, Berlin

Nefertiti

Kahlo identified Nefertiti (reigned 1353–36 BC) as an exemplary figure. She called her 'the marvellous Nefertiti, wife of Akhenaten', continuing, 'I imagine that besides having been extraordinarily beautiful, she must have been a "wild one" and a most intelligent collaborator with her husband.'[51] Nefertiti was the principal queen of pharaoh Amenhotep IV (Akhenaten), the heretic pharoah responsible for abolishing the polytheistic Egyptian religion to establish a new sun-worshipping religion. Nefertiti became much more than a consort, and in a break with tradition is depicted in Egyptian art on an equal footing with her husband as if she were co-regent. Kahlo's comment shows that she identified with Nefertiti and reveals her feelings about her own relationship with her husband Diego Rivera. It also demonstrates how she actively sought strong female role models. Her diary reveals the extent of her fascination with Nefertiti and ancient Egypt. In it she draws a number of imaginary characters that recall Nefertiti, Akhenaten, and Akhenaten's son Tutankhamen. She depicts Neferisis and an unnamed consort as well as their son Neferúnico and his brother Neferdós.[52]

fig.91
José Guadalupe Posada (1852–1913)
El crimen de la tragedia de Belen Galindo
Zinc engraving 11.2 x 11.5 cm
Posada collection, University of New Mexico

fig.92
Tlazolteotl
Aztec, early sixteenth century
Courtesy of Dumbarton Oaks, Washington, DC

Posada, José Guadalupe

The Mexican printmaker José Guadalupe Posada (1852–1913) was a master of popular engraving best known for his images of *calaveras* (costumed skeletons) and for creating characters such as the calavera Catrina, which became a distinctive part of the Day of the Dead celebrations. He contributed to numerous periodicals and created prints to illustrate sensationalist broadsheets, known as *corridos gráficos*, which contained cutting political and social commentary. Posada is remembered for his incisive portraits of Mexican society under the administration of the dictator Porfirio Díaz. He frequently depicted the more gruesome aspects of violent crime and death, as well as religious scenes, festivities, brawls, portraits of popular heroes and caricatures of politicians. Posada's influence on Kahlo can be discerned in works such as *A Few Small Nips* 1935 (pl.20).

Pre-Columbian Art

Kahlo's use of various pre-Columbian artefacts in her work can be interpreted as a way of asserting her Mexican, Aztec heritage and as an expression of national pride. She utilised pre-Columbian sculpture in her paintings both as a source for figure compositions and as motifs in their own right. *My Birth* 1932 (pl.16) was partly inspired by an Aztec sculpture of the goddess Tlazolteotl in the act of childbirth; both Kahlo's painting and the sculpture depict the process of birth midway through, rather than presenting a scene after the delivery, as occurs in traditional nativity scenes.[53] *My Nurse and I* 1937 (pl.17), portraying her Indian wet nurse, is indebted to a Jalisco figure of a nursing mother as well as to sculptures of the earth goddess and mother of the gods Coatlicue. Uniting the idea of birth and death, destruction and creation, Coatlicue was associated with women who died in childbirth, and is depicted with a mask-like face and pendulous breasts. Elsewhere Kahlo depicts Nayarit figures as her companions and alter egos, for example in *Four Inhabitants of Mexico City* 1938 (pl.22) and the lost painting *The Wounded Table* 1940. Diego Rivera was an avid collector of pre-Columbian art and artefacts and Kahlo accompanied him on many trips around Mexico during which they assembled an important collection of such works as well as of Mexican folk art and *retablo* paintings. Pre-Columbian sculptures, vessels and objects appear in many paintings by Kahlo, for instance *Self-Portrait with Small Monkey* 1945 or *Still Life* 1951 (pls.44, 59). In *Self-Portrait on the Borderline between Mexico and the United States* 1932 (pl.13), such objects help to set up an opposition between Mexico and the United States where the former is depicted as a civilisation with ancient roots and the latter appears as an industrialised, machine-age society. Kahlo frequently wore pre-Columbian bead necklaces, and painted herself wearing them, a further symbolic gesture that identified her with Mexico and its past. In a photograph by Nickolas Muray she is shown holding up an Olmec figurine in the palm of her hand (see fig.53 on p.55). Aztec illustrated codices were also an important inspiration for Kahlo; in *Self-Portrait on the Borderline* and the lithograph *Frida and the Miscarriage* 1932 (fig.28 on.p36) her depiction of plants, showing their root structures in cross-section, derives from such codices on Natural History.[54]

fig.94
Frieda Kahlo and Diego Rivera 1931
(detail, pl.12)

fig.93
Have Another One 1925
Watercolour and pencil on paper
17.5 x 24 cm
Government of the State of Tlaxcala,
Instituto Tlaxcalteca de Cultura,
Museo de Arte de Tlaxcala

Pulque

Pulque is an alcoholic drink made from the fermented sap of the maguey cactus, combined with the root of the 'pulque wood' bush, it was originally made and used by the Aztecs as a ritual drink. The Aztecs associated pulque with important magical power, but also with drunkenness, uninhibited states and sexual excess. The moon is a symbol of both the gods of pulque and the goddess Tlazolteotl, who symbolised heightened sexuality, femaleness and cycles of fertility.[55] The drink was sold in bars called Pulquerías. In an early watercolour from 1925 Kahlo depicted one such bar, calling it *Have Another One* (Echate L'Otra), while the bar named La Rosita that appears in *Four Inhabitants of Mexico City* 1938 (pl.22) identifies the scene as the town of Coyoacán where Kahlo grew up. La Rosita was located on the corner of Londres Street near Kahlo's house, the

Casa Azul. Rivera claimed that the paintings decorating these bars were the 'highest form of expression of Mexican culture' and one catalyst for the muralist movement.[56] Kahlo later oversaw the decoration of La Rosita with murals by her students from La Esmeralda art school, which were completed in 1943, announced through a Posada-style broadsheet and celebrated with a boisterous party.

Rivera, Diego

Kahlo stated that two accidents shaped her life: the first was the bus accident, the second was Diego Rivera (1886–1957). Frida married him on 21 August 1929; they divorced on 6 November 1939 and remarried on 8 December 1940. Kahlo first encountered Rivera at the National Preparatory School, where he was painting a mural in the auditorium. He was already the most famous artist in Mexico when they married, and one of the big three of the muralist movement, with José Clemente Orozco and David Alfaro Siquieros. Through Rivera, Kahlo met many avant-garde artists, writers and political figures. He was a prolific artist and a compulsive womaniser; for Kahlo the most devastating of his affairs was the one he conducted with her sister Cristina in the mid-1930s. He was the closest person to Kahlo and the one who understood her best. 'The work of Frida Kahlo shines like a diamond in the midst of many inferior jewels', he wrote. 'Frida's *retablos* do not look like *retablos*, not like anyone or anything else.'[57] A key influence on her work and career, he

fig.95
Fruits of the Earth 1938
(detail, p.56)

fig.96
Relief depicting Amenhotep IV (Akhenaten),
Nefertiti and their daughter Meritaten making
an offering to Aten
Egyptian, 18th Dynasty (*c*.1567–1320 BC)
Egyptian National Museum, Cairo

Still Life

Kahlo painted numerous still lifes throughout her career and they constitute one of the most important groups of works besides portraiture and self-portraiture. The fruits and vegetables she chose to paint in works such as *Fruits of the Earth* 1938 (pl.56), including *chayote*, nopal fruits (prickly pears) and corn cobs, are all native Mexican produce. The painting evokes the tradition of the cornucopia or horn of plenty, identifying the products that the world owes to Mexico and as such it is an expression of *Mexicanidad*. Artists such as Hermenegildo Bustos had employed this strategy in his still-life easel paintings and Rivera repeated it by including a list of Mexican produce in his murals at the Palacio Nacional. The corn cob has a political significance as an emblem of the Mexican peasantry and the revolution. The photographer Tina Modotti, one of Kahlo and Rivera's circle of friends, employed it in her photography in this way. Still-life paintings such as *Fruits of the Earth* also allude to the cycle of life. The fruits depicted are cut open to reveal fleshy interiors; they appear overripe or are beginning to wither. Many of the fruits resemble body parts and evoke a disturbing eroticism, suggesting the interrelation of sex and death. For Kahlo still life often functioned as a kind of indirect self-portraiture in which she projected her inner feelings through symbols and objects.

encouraged her to paint, to adopt popular Mexican forms and to cultivate her 'untrained' style. During their courtship and in the early years of their marriage, when Kahlo was still experimenting with styles, she painted a number of works that have distinctly Riveraesque qualities, among them *Portrait of Virginia* 1929 and *Portrait of Eva Frederick* 1931 (pls.10, 8). The brushwork and matt, fresco-like surface of the painting, the rounded volumes and facial types she favoured at this point, all bring her work closer to Rivera's style. Yet Kahlo did not pursue this style for long and soon adopted her own. Her small-scale, intricately detailed *retablo* paintings could not have been further from Rivera's murals and she concentrated on personal subject matter, eschewing the outright, emphatic politics of Rivera and his fellow muralists. She depicted Rivera frequently in her work, on a number of occasions giving him a third, 'all-seeing' eye in the centre of his forehead as a way to signify his special creative powers.

Sun Disc

The sun appears in Kahlo's work most frequently accompanied by the moon, symbolising oppositions such as male/female, night/day, light/dark. In two key paintings, she included representations of the sun disc alone: *Moses* 1945 and *Sun and Life* 1947 (pls.69, 68). In *Moses* the sun disc is represented as the Aten, the manifestation of the sun deity worshipped by the Egyptian pharaoh Amenhotep IV (Akhenaten). In this painting, Kahlo explained, the sun appears as 'the centre of all religions'.[58] The hands at the ends of the rays symbolise the sun's life-giving force. This depiction mirrors that of the ancient representations of the Aten from the city of Akhetaten at El Amarna, the capital of Akhenaten and Nefertiti. In *Sun and Life* the sun appears as a full, round face with a third eye, recalling Kahlo's representations of Rivera and which Gannit Ankori has interpreted as a depiction of Rivera as the Hindu god Siva.[59]

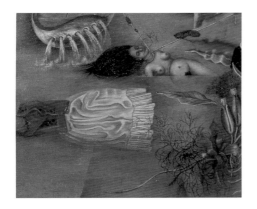

fig.97
What the Water Gave Me 1938
(detail, pl.26)

fig.98
Installation view, International Exhibition of
Surrealism 1940, at the Galería de Arte
Mexicano, Mexico City

Surrealism

Kahlo's work is often viewed as
Surrealist and attributed to the
manifestation of that movement
in Mexico. In 1938 Kahlo stated
'I never knew I was a Surrealist till
André Breton came to Mexico and
told me I was'. She continued,
'I paint always whatever passes
through my head, without any
other consideration'.[60] Breton

visited Mexico in 1938; for him
it was 'the Surrealist place par
excellence'.[61] He described Kahlo's
work as 'pure surreality, despite
the fact that it had been conceived
without any prior knowledge
whatsoever of the ideas motivating
the activities of my friends and
myself'.[62] However, Kahlo's denial
probably demonstrates her
ambivalence towards being
labelled, rather than her ignorance
of Surrealism before Breton's
arrival in Mexico. She cultivated
an image of herself as a self-taught
and naive artist with her roots in
popular art, but she had followed
developments in the European
and Mexican avant-gardes since
her school days at the

Preparatoria. When she was
offered her first solo exhibition
at the Julian Levy Gallery in New
York in 1938, Breton wrote the
catalogue essay, famously
describing her painting as 'a
ribbon around a bomb'.[63] He
singled out *What the Water Gave
Me* 1938 (pl.26) as the seminal
image of the exhibition. In 1939
Kahlo visited Paris, where she
was to have a second solo
exhibition, this time organised
by Breton, but she soon became
frustrated by the lack of progress
with the show. Duchamp stepped
in, ensuring that the exhibition
took place, but Kahlo was
alienated, at least from European
Surrealism, by her experience.
She summed up her opinion
of Paris and the Surrealists in
characteristically colourful
language, and in doing so
emphasised her distance from
that movement: 'I rather sit on the
floor of the market of Toluca
and sell tortillas, than to have
anything to do with those "artistic"
bitches of Paris.'[64] Even so, in
1940 she not only participated in
the International Exhibition of
Surrealism at the Galería de Arte
Mexicano in Mexico City, but made
two ambitious paintings especially
for it. These works, *The Two Fridas*
(pl.28) and the lost *The Wounded
Table*, were on a much larger scale,
thus deviating dramatically from her
practice both before and after the
exhibition. Her work in general
undoubtedly derived elements
from Surrealism, but she
never wholly subscribed to its
philosophy. In her work, she
knowingly included and adapted
Surrealistic aspects and devices,
but made them serve her own
independent purposes.

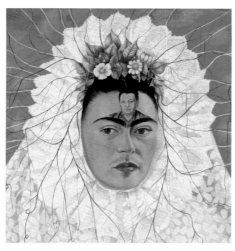

fig.99
Self-Portrait as a Tehuana or *Diego on My Mind*
1943
(detail, pl.42)

Tehuana

Tehuana is the generalised term that refers to the women of the Isthmus of Tehuantepec, a region towards the south-west of Mexico. The Tehuana costume worn by Kahlo became her trademark; it consisted of a brightly coloured, long skirt trimmed with a wide lace ruffle, a white underskirt and a *huipil* or short, low-cut blouse and heavy gold chain necklaces – traditionally the wearer's dowry or fortune displayed in jewellery. Even more distinctive is the head *huipil*, a headdress of starched, pleated lace. In 1938 André Breton described Kahlo as 'adorned like a fairy-tale princess, with magic spells at her finger-tips, an apparition in the flash of light of the quetzal bird which scatters opals among the rocks as it flies away.'[65] Kahlo knew that her costume, elaborate hairstyles and jewellery set her apart, whilst also serving to distract attention from her fragile, damaged body. In the United States some women tried to copy this style of dress; in 1933 Kahlo reported to a friend, 'some of the *gringachas* even imitate me and want to dress as "Mexicans", but the poor things look like turnips and the honest truth they just look absolutely dreadful,

which doesn't mean I look good myself, but at least I get by.'[66] Julien Levy, who gave Kahlo her first solo exhibition at his gallery in New York, recalled how on Fifth Avenue children followed her and asked 'Where is the circus?'[67] Kahlo wore Tehuana attire and kept her hair long in part to please Rivera, yet to wear the costume of the Tehuana was also a political and cultural statement. Although the Tehuana was already a popular symbolic figure during the nineteenth century, it was during the post-revolutionary period that Tehuana women came to represent an authentic and independent indigenous Mexican cultural heritage. José Vasconcelos, Minister of Education from 1921–4, and Sergei Eisenstein (who visited Mexico to make his film *¡Que Viva Mexico!*) praised the culture and Tehuana women. Vasconcelos had suggested to Rivera that he should travel to the region after the latter returned in 1921 from fourteen years in Europe, believing that it might prompt him towards a more genuinely national vision in his murals. Images of Tehuanas proliferated, as artists and photographers such as Adolfo

Best Maugard, Roberto Montenegro, Miguel Covarrubias, Rufino Tamayo, Manuel and Lola Álvarez Bravo, Bernice Kolko and Tina Modotti created interpretations of them. By wearing Tehuana costume, Kahlo was actively identifying with one of the central images of the post-revolutionary era – the courageous and indomitable Tehuana woman – as well as with a matriarchal culture. Tehuana society is structured so that women oversee trade while the men of the region do the physical work, a circumstance that caused Rivera to describe a society 'where Amazon women rule over bewitched men'.[68] This comment also alludes to the Tehuana's position as woman in the role of the 'Other'. The Tehuana embodies a complex mixture of myth, nostalgia, pure fantasy and idealism, an exotic foil for an urban Mexico 'unpolluted' by European influences, a popular figure in entertainment (featuring in operettas, *corridos* and films) and an embodiment of nationhood, *Mexicanidad* and femininity.[69]

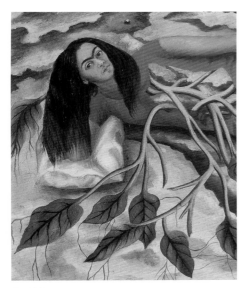

fig.100
Roots 1943
(detail, pl.50)

Vegetation

Kahlo employs vegetation in her paintings as a symbol of fertility and regeneration, and to emphasise the brief cycle of life. She also uses it as a sign of woman's proximity to nature and fecundity, but subverts this traditional association by introducing images of barren and sterile terrain. The fertility of nature and art is contrasted with Kahlo's failure to produce offspring. She alluded to her conception and birth in *My Grandparents, My Parents, and I* 1936 (pl.18) by including a plant in the process of fertilisation. Fertility is dealt with most explicitly in two flower paintings *Xochítl, Flower of Life* 1938 and *Flower of Life* 1944 (pls.66, 67), in which a flower is transformed into male and female genitalia in the act of love, and in *Sun and Life* 1947 (pl.68), where generative plant life encloses a foetus within its leaves. In her letters to Nickolas Muray, Kahlo refers to herself with the pet name Xochítl, which means flower in Nahuatl (the Aztec language) and is traditionally understood as a reminder that life is beautiful but brief. Aztec poets used plant imagery to reinforce this belief:

'We are as the grass in Spring. Our heart comes, it blooms and opens, our body causes some flowers to blossom, and then all withers.'[70] Within her bust-length self-portraits Kahlo used a wall of foliage as a background, forming a shallow, claustrophobic space. This contrasts the images in which she depicts herself in expansive, desolate landscapes, as in *Henry Ford Hospital* 1932, *The Two Fridas* 1939, *Roots* 1943 and *The Broken Column* 1944 (pls.15, 28, 50, 49). Kahlo frequently connected herself to the world of nature and the earth, for instance in *Roots*, where vines grow from a void in the centre of her body, though this is perhaps a poisonous plant that bleeds into the earth.[71] In *Self-Portrait as a Tehuana* or *Diego on My Mind* 1943 (pl.42) tendrils extend from the diadem of flowers she wears on her head. In *The Dream* 1940 (pl.25) the pattern of flora on the bedspread takes on a life of its own and grows towards her, surrounding her shoulders and head. Ripe fruits, frequently cut open, stand in for the body. Other natural produce denotes the fecundity of Mexico and the toil of peasant labourers. In *Girl with Death Mask* 1938 (pl.21), the child holds a *zempzúchil*, or marigold, an Aztec symbol of death that is used to decorate graves during the Day of the Dead.[72]

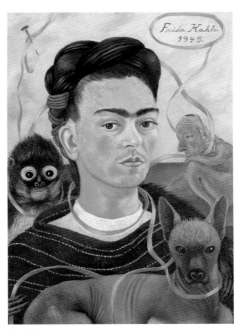

fig.101
Self-Portrait with Small Monkey 1945
(pl.44)

Xólotl (Xoloitzcuintli Dog)

Xótotl was the dog who accompanied the god Quetzalcóatl to the underworld (or Mictlan, 'place of the dead') as well as that god's animal aspect. Kahlo owned several dogs from the Xoloitzcuintli or Itzcuintli breed that is traceable back to the Aztecs, naming one Mr Xótotl. The Aztecs believed that Xoloitzcuintli dogs escorted the souls of the dead to the underworld, viewing them as guides and guardian figures. The dogs were bred for sacrifice and for domestic use. Aztec sculptures and vessels survive in the form of these hairless dogs and Kahlo included such objects in her paintings including *Still Life* 1951 (pl.59). Dogs of this breed appear as her companions in various paintings including *Itzcuintli Dog with Me* 1938 and *The Love-Embrace of the Universe, The Earth (Mexico), Me, Diego and Mr Xótotl* 1949 (pls.30, 70). Like the parrots and monkeys that Kahlo also painted in her self-portraits, these dogs relate to the Aztec concept of an animal alter-ego or *nahual*.

Selected Sources and Further Reading

In compiling this glossary I am particularly indebted to the work of Hayden Herrera and Gannit Ankori.

Gannit Ankori, *Imaging her Selves: Frida Kahlo's Poetics of Identity and Fragmentation*, London 2002 [Ankori 2002]

Salomon Grimberg, *Frida Kahlo*, Massachusetts 1997

Salomon Grimberg, *Frida Kahlo: The Little Deer*, Miami University, Oxford, Ohio 1997

Salomon Grimberg, 'Frida Kahlo's Still Lifes: "I paint flowers so they will not die"', *Women's Art Journal*, vol.25, no.2, Fall/Winter 2004–5, pp.25–30

Hayden Herrera, *Frida: A Biography of Frida Kahlo*, London (1983) 2003. [Herrera 2003]

The Diary of Frida Kahlo: An Intimate Self-Portrait, Introduction by Carlos Fuentes, Essay and Commentary by Sarah M. Lowe, London 1995.[*The Dairy of Frida Kahlo* 1995]

Sarah M. Lowe, *Frida Kahlo*, New York 1991.

Luis-Martín Lozano, *Frida Kahlo*, Boston, New York, London 2000 [Lozano 2000]

Eduardo Matos Moctezuma and Felipe Solís Olguín, *Aztecs*, Royal Academy of Arts, London, 2002 [Moctezuma and Olguín 2002]

Laura Mulvey and Peter Wollen, *Frida Kahlo and Tina Modotti*, exh.cat., Whitechapel Art Gallery, London, 1982 [Mulvey and Wollen 1982].

Helga Prignitz-Poda, Salomon Grimberg and Andrea Kettenmann, *Frida Kahlo: Das Gesamtwerk*, Frankfurt 1988

Helga Prignitz-Poda, *Frida Kahlo: The Painter and her Work*, Mosel and Munich 2004 [Prignitz-Poda 2004]

Raquel Tibol, *Frida by Frida*, Mexico City 2003 [Tibol 2003].

Michael C. Meyer and William H. Beezley (eds.), *The Oxford History of Mexico*, ed. Oxford and New York, 2000.

Notes

1 Oscar Wilde, *The Picture of Dorian Gray* (1891), Harmondsworth 2003, p.4. Gannit Ankori relates that Kahlo had read Wilde's novel several times and this was a favourite quote from the book, see Ankori 2002, p.10.
2 For a full discussion of androgyny and its relation to selfhood and sexual identity in Kahlo's work, see Ankori 2002, pp.175–87.
3 Ankori describes a search for origins as a key aspect of Kahlo's work through which she investigated not only her conception and birth but her mixed cultural and genealogical heritage: Ankori 2002, p.27, 43–57.
4 Gannit Ankori has convincingly argued that Kahlo's desires about having a child with Rivera were far from straightforward, that they were in fact profoundly ambivalent. See in particular, 'The Maternal Self', in Ankori 2002, pp.149–64.
5 Herrera 2003, p.142; Ankori 2002, p.154.
6 Ankori 2002, p.30.
7 Loa Traxler, 'Cat.320 Tlazolteotl', in Moctezuma and Olguín 2002, p.479.
8 Diego Rivera, quoted in Luis-Martín Lozano, 'The Esthetic Universe of Frida Kahlo' in Lozano 2000, p.89.
9 Ankori 2002, p.210, and Salomon Grimberg, *Self-Portrait with Bonito*, auction cat., Wolfe's Fine Art Auctioneers, 19 Sept. 1991 [unpag.]
10 James Hall, *Hall's Dictionary of Subjects and Symbols in Art*, London (1974) 1992, p.49.
11 Ankori 2002, p.30.
12 *The Diary of Frida Kahlo* 1995, pp.224–5.
13 Ibid., p.276.
14 In a letter to Alejandro Gómez Arias of 29 March 1927, Kahlo referred to *Self-Portrait Wearing a Velvet Dress* 1926 as 'your "Botticelli"', in Tibol 2003, p.51.
15 See in particular Lozano 2000, p.35.
16 *The Diary of Frida Kahlo* 1995, p.276.
17 Lozano 2000, p.99; see also *The Grove Encyclopedia of Latin American and Caribbean Art*, London 2000, p.135.
18 Herrera 2003, p.27.
19 Ankori has defined Kahlo's representations of herself as a child as a 'Childhood Series' manifesting her 'Child Self', one of an array of different selves Ankori argues Kahlo presented in her art. Ankori 2002, pp.61–92.
20 Both Hayden Herrera and Gannit Ankori apply the concept of the *chingada* as defined by Octavio Paz in *The Labyrinth Solitude* (1950) to Kahlo's work. See Herrera 2003, pp.180–1; Ankori 2002, pp.87–9, 113–16, 192–5.
21 Diego Rivera, 'Frida Kahlo and Mexican Art' (1943) repr. in Mulvey and Wollen 1982, p.37.
22 See both Herrera 2003, p.284, and *The Diary of Frida Kahlo* 1995, p.211.
23 Alejandro Gómez Arias quoted in Herrera 2003, p. 94.
24 Diego Rivera accusing himself at his own expulsion, quoted in Herrera 2003, p.102.
25 Herrera 2003, p.406.
26 Popular song quoted in Herrera 2003, p.358.
27 Lozano 2000, p.102.
28 See note 1.
29 Kahlo reported by Julian Levy in Ankori 2002, p.126.
30 Frida Kahlo, letter to Nickolas Muray, 16 February 1939, in Tibol 2003, p.171.
31 See Ankori 2002, pp.82–3.
32 *The Diary of Frida Kahlo* 1995, p.274.
33 Serge Gruzinski, *The Aztecs: Rise and Fall of an Empire*, London (1987) 1992, pp.20–1.
34 Prignitz-Poda 2004, p.36.
35 Ankori 2002, pp.193–4.
36 Herrera 2003, pp.13, 18.
37 Alejandro Gómez Arias, 'A Testimony to Frida Kahlo' (1977) reprinted in Mulvey and Wollen 1982, p.38.
38 Diego Rivera, quoted ibid., p.37.
39 Herrera 2003, p.408.
40 'La Llorona folksong reproduced in full in ' La Tehuana', *Artes de Mexico*, no.49, Mexico City 2000, p.96.
41 Ankori has interpreted Kahlo's paintings according to the symbolism of La Llorona, in Ankori 2002, in particular pp.157–9.
42 For a comprehensive discussion of La Malinche see Ankori 2002, pp.88–9, pp.189–95.
43 Ibid., pp.89, 195.
44 Ankori 2002, pp.88, 195.
45 Herrera 2003, p.219.
46 Ankori 2002, p.215.
47 See ibid., pp.203–8.
48 Helga Prignitz-Poda 2004, pp.40–1.
49 Frida Kahlo 'Speaking of One of My Paintings, of How, Starting from a Suggestion by José D. Lavín and a Text by Freud, I Made a Picture of Moses', in Tibol 2003, pp.255–60.
50 Ibid., pp.258–9.
51 Ibid., p.259.
52 *The Diary of Frida Kahlo* 1995, pp.220–1.
53 Ankori describes such paintings by Kahlo as anti-nativity scenes in direct opposition to establish tradition in Ankori 2002, pp.28–9, 158, 255.
54 Ankori 2002, p.159.
55 Eduardo Matos Moctezuma, 'Cat. 247 Pulque deity'. in Moctezuma and Olguín 2002, pp.261–2.
56 Diego Rivera quoted in Lozano 2000, p.99.
57 Diego Rivera, in Mulvey and Wollen 1982, p.37.
58 Kahlo, 'Speaking of One of My Paintings…' in Tibol 2003, p.257.
59 Ankori 2002, pp.226–35.
60 Frida Kahlo quoted in Herrera 2003, p.254.
61 André Breton quoted in Herrera 2003, p.226.
62 André Breton, 'Frida Kahlo de Rivera' (1938) repr. in Mulvey and Wollen 1982, p.35.
63 Ibid. p.36.
64 Frida Kahlo, letter to Nickolas Muray, Paris 16 February 1939, in Tibol 2003, p.171.
65 André Breton in Mulvey and Wollen 1982, p.35.
66 Frida Kahlo, letter to Isabel Campos, New York, 16 November 1933 in Tibol 2003, pp.115–6.
67 Julien Levy quoted in Herrera 2003, p.234.
68 Diego Rivera quoted in Aida Sierra, 'The Creation of a Symbol in 'La Tehuana', *Artes de Mexico*, no.49, Mexico City 2000, p.85.
69 For a detailed discussion see 'La Tehuana', *Artes de Mexico*, no.49, Mexico City 2000.
70 Quoted in Friedrich Katz, *The Ancient American Civilizations*, London 1997, p.161.
71 Ankori 2002, p.194.
72 Herrera 2003, p.221.

1
Urban Landscape c.1925
Oil on canvas 34.4 x 40.2 cm
Private collection, courtesy of
Galería Enrique Guerrero,
Mexico City

*Portrait of Alejandro Gómez
Arias* 1928
Oil on wood 61.5 x 41 cm
Private collection

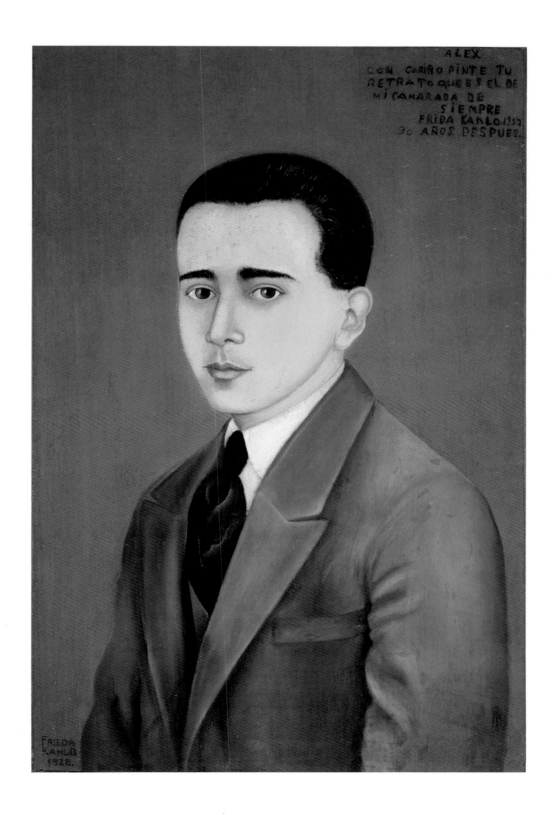

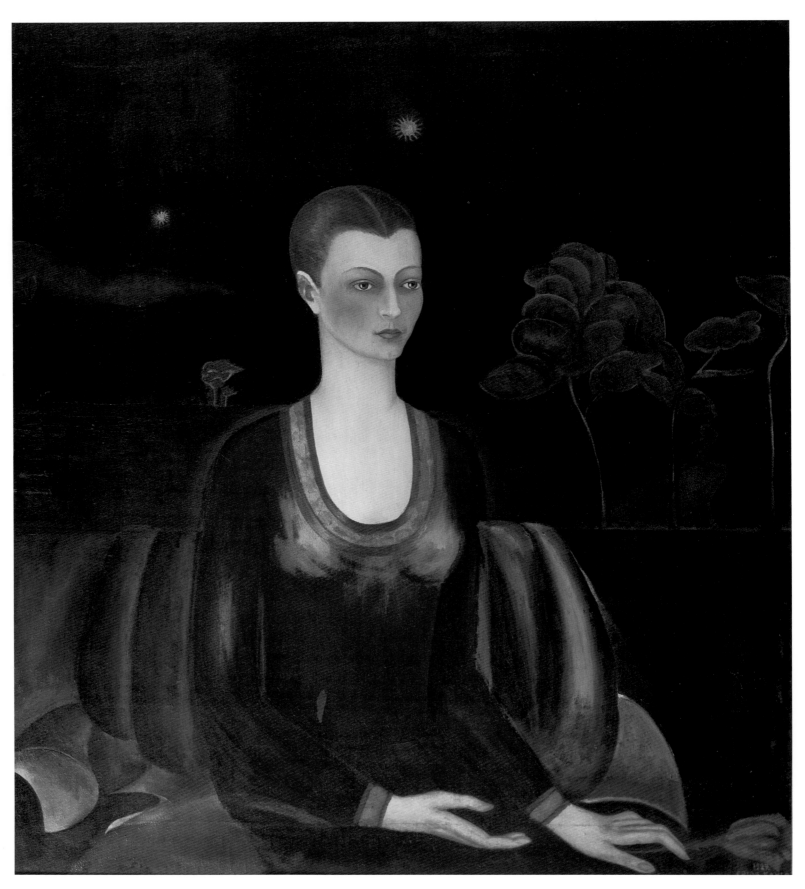

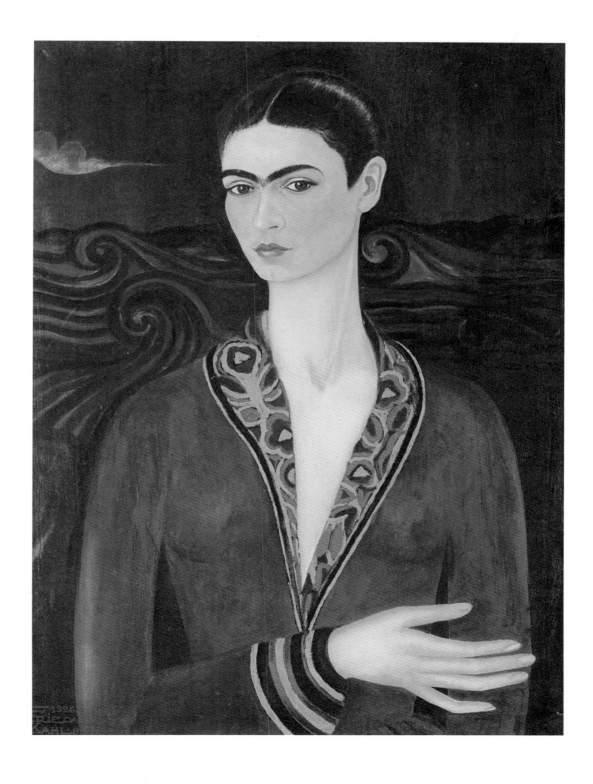

4
Self-Portrait Wearing a Velvet Dress 1926
Oil on canvas 79.7 x 59.9 cm
Private collection

5
Pancho Villa and Adelita
before 1927
Oil on canvas 65 x 45 cm
Government of the State of
Tlaxcala, Instituto Tlaxcalteca
de Cultura, Museo de Arte
de Tlaxcala

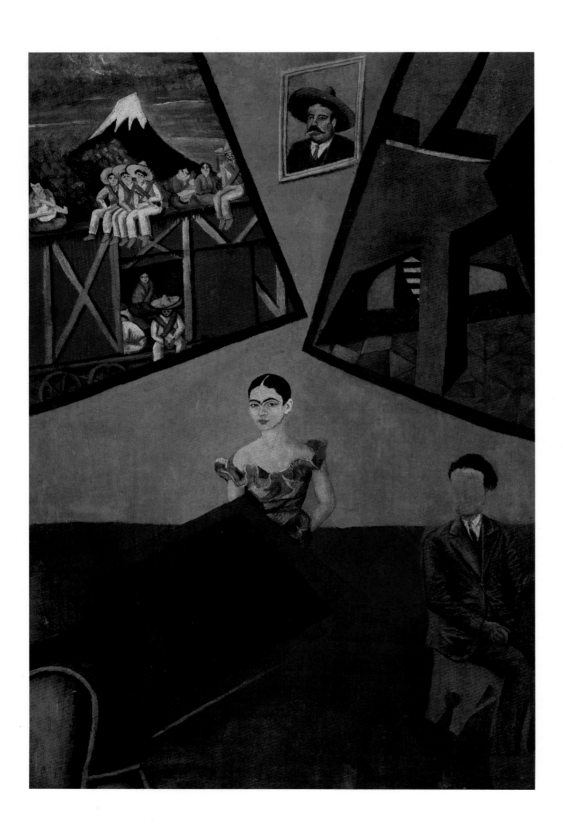

6
Portrait of Miguel N. Lira 1927
Oil on canvas 106 x 74 cm
Government of the State of
Tlaxcala, Instituto Tlaxcalteca
de la Cultura, Museo de Arte
de Tlaxcala

7
The Bus 1929
Oil on canvas 26 x 55.5 cm
Museo Dolores Olmedo Patiño,
Mexico City

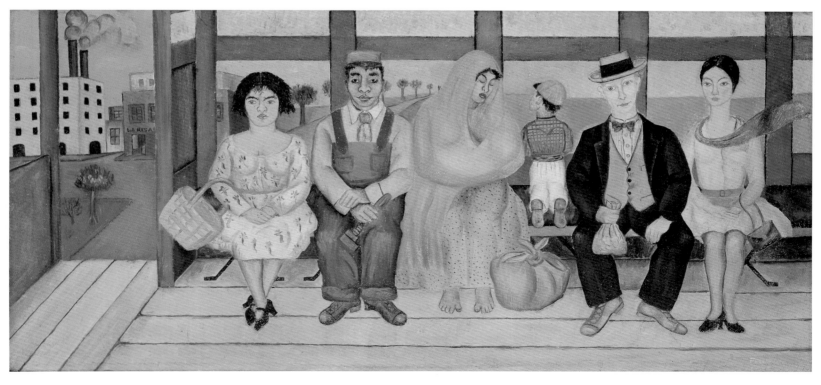

Portrait of Eva Frederick 1931
Oil on canvas 62 x 45 cm
Museo Dolores Olmedo Patiño,
Mexico City

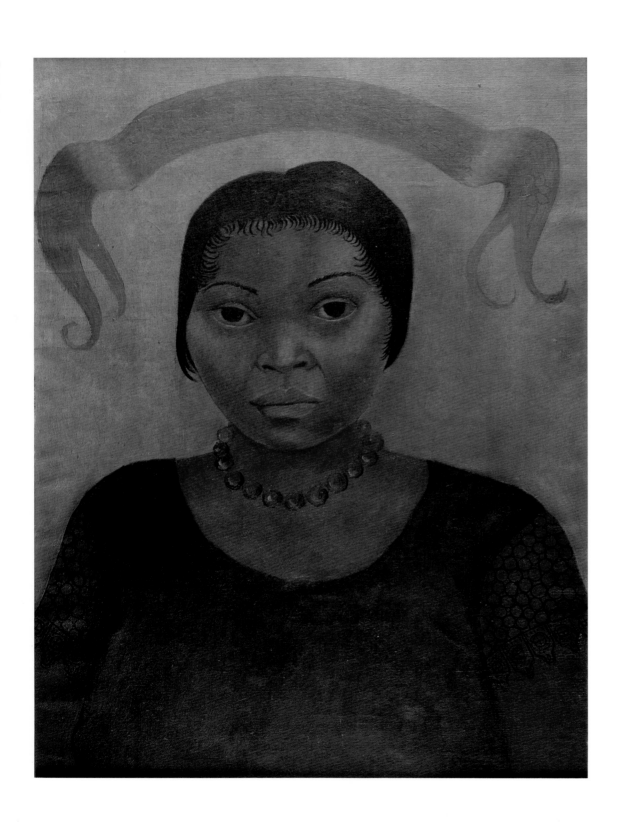

Portrait of Luther Burbank 1931
Oil on hardboard 85 x 61 cm
Museo Dolores Olmedo
Patiño, Mexico City

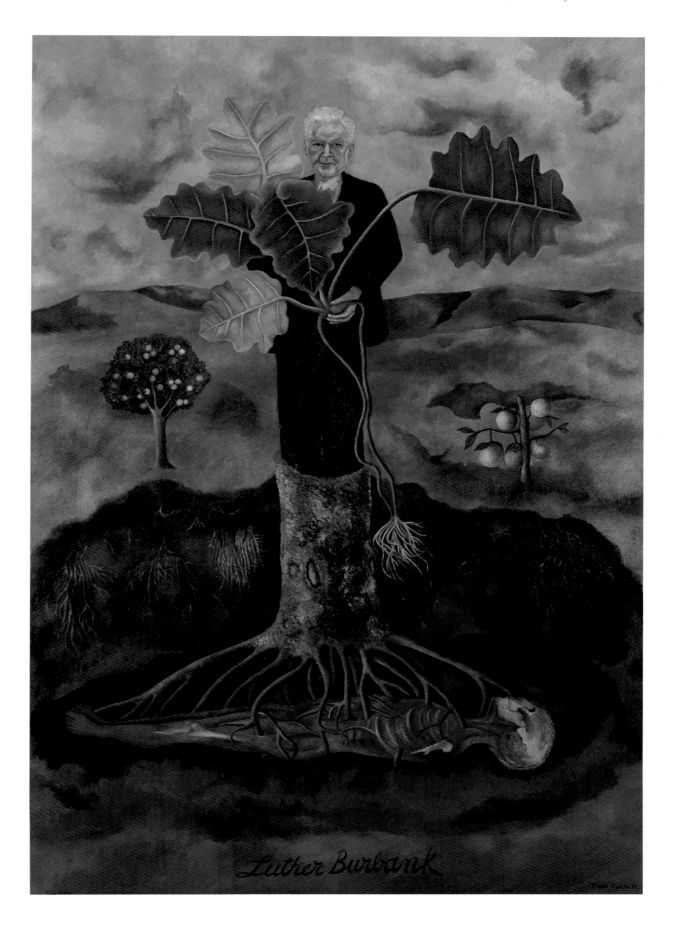

Luther Burbank

10
Portrait of Virginia 1929
Oil on hardboard 77 x 60 cm
Museo Dolores Olmedo Patiño,
Mexico City

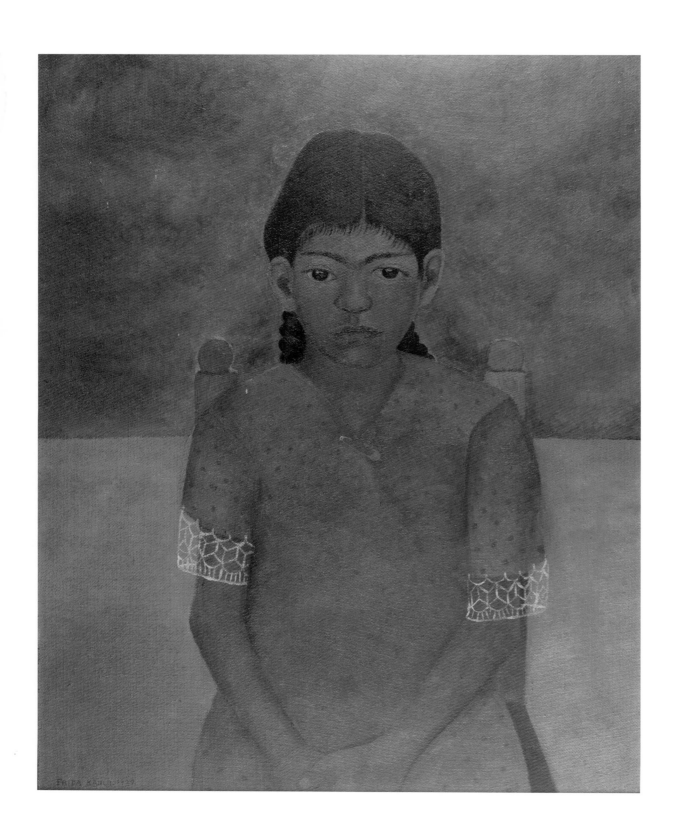

The Deceased Dimas Rosas
Aged Three 1937
Oil on hardboard
48 x 31.5 cm
Museo Dolores Olmedo
Patiño, Mexico City

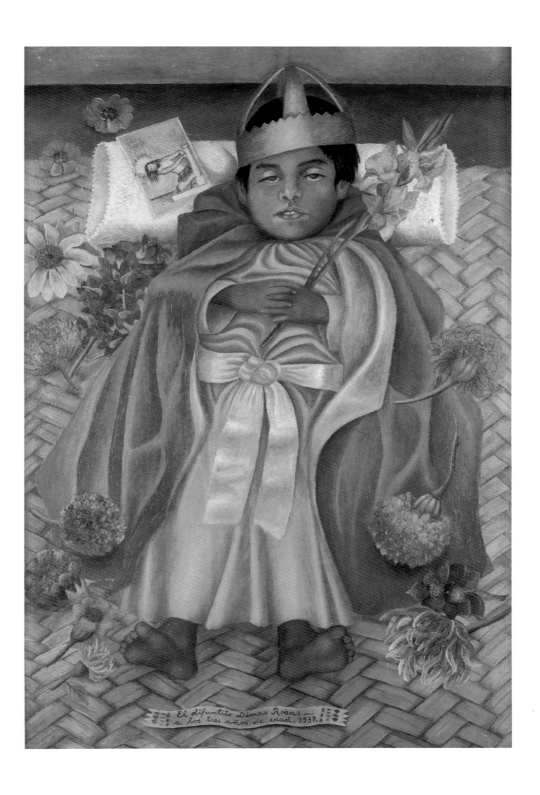

12
Frieda Kahlo and Diego Rivera 1931
Oil on canvas 100 x 78.7 cm
San Francisco Museum of
Modern Art. Albert M. Bender
Collection, Gift of Albert M. Bender

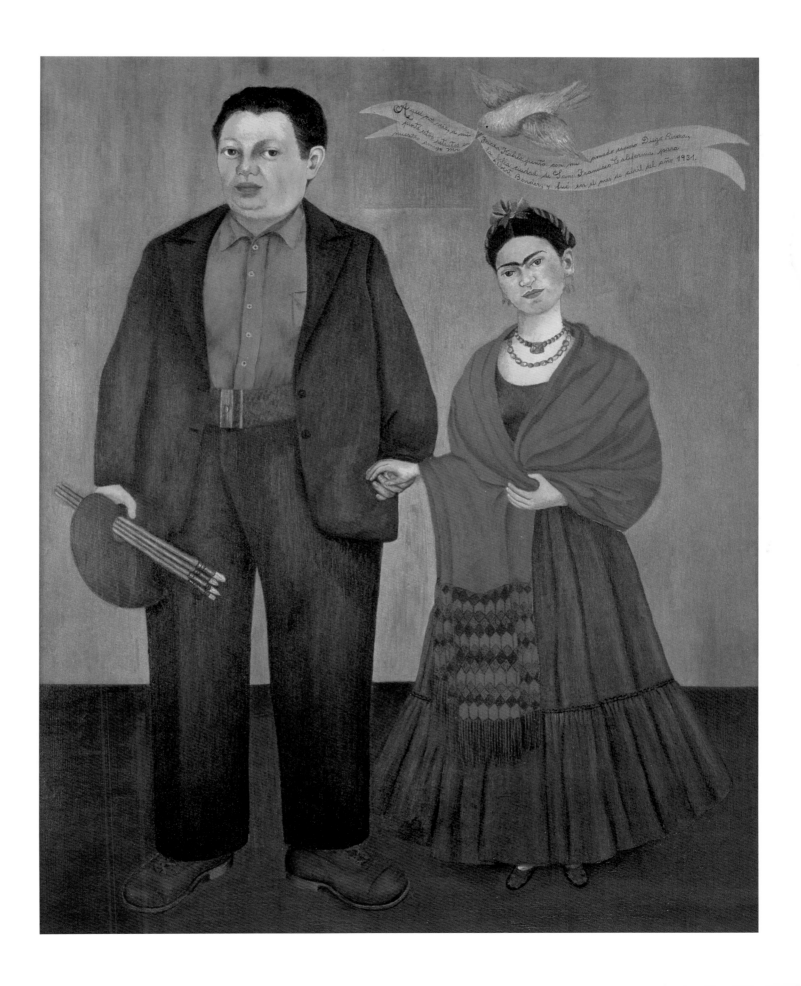

13

*Self-Portrait on the Borderline
between Mexico and the
United States* 1932
Oil on metal 31 x 35 cm
Manuel and Maria Reyero,
New York

*Self-Portrait on the Borderline
between Mexico and the
United States*

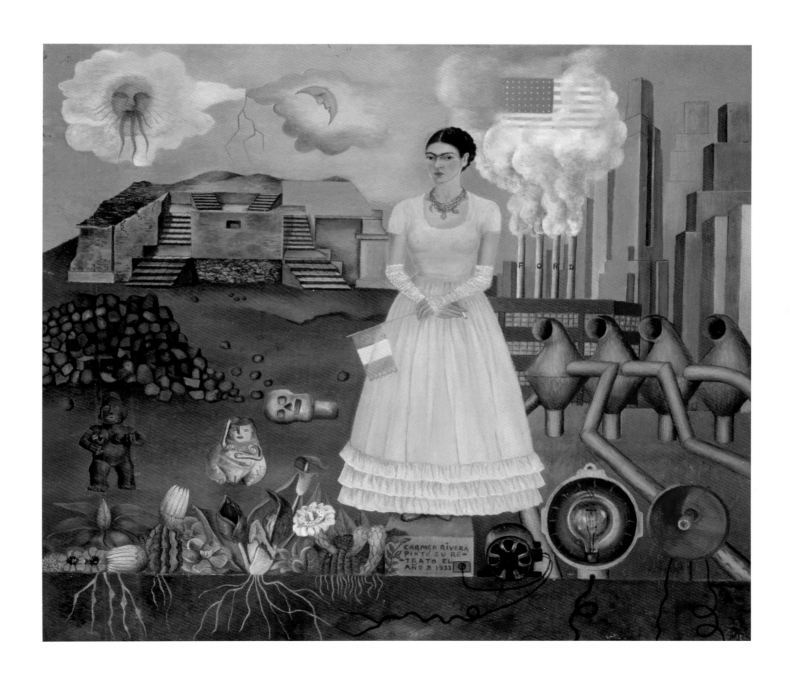

14
My Dress Hangs There 1933
Oil and collage on hardboard
46 x 50 cm
Private collection

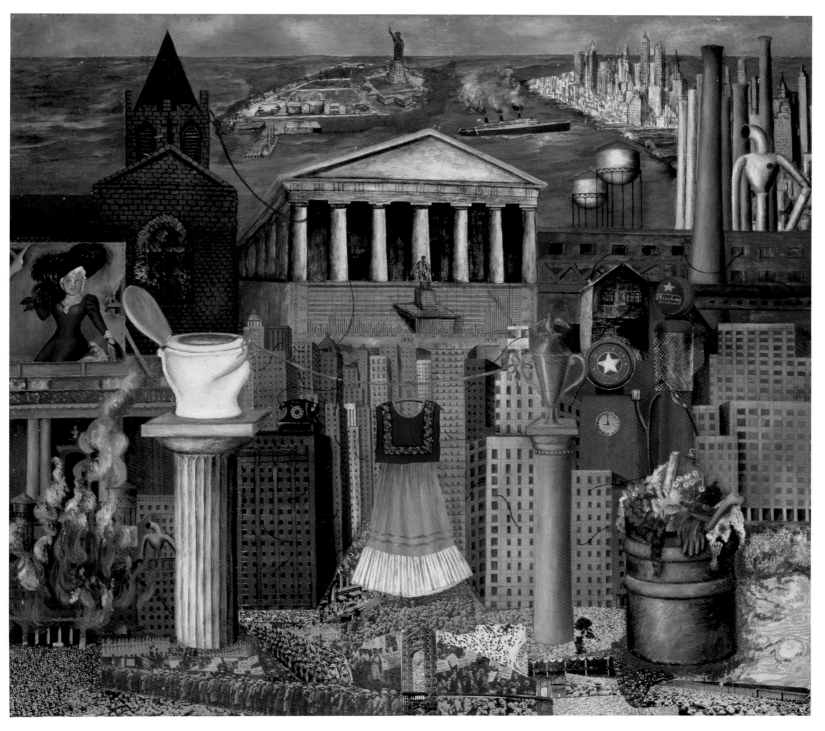

15
Henry Ford Hospital 1932
Oil on metal 30.5 x 38 cm
Museo Dolores Olmedo Patiño,
Mexico City

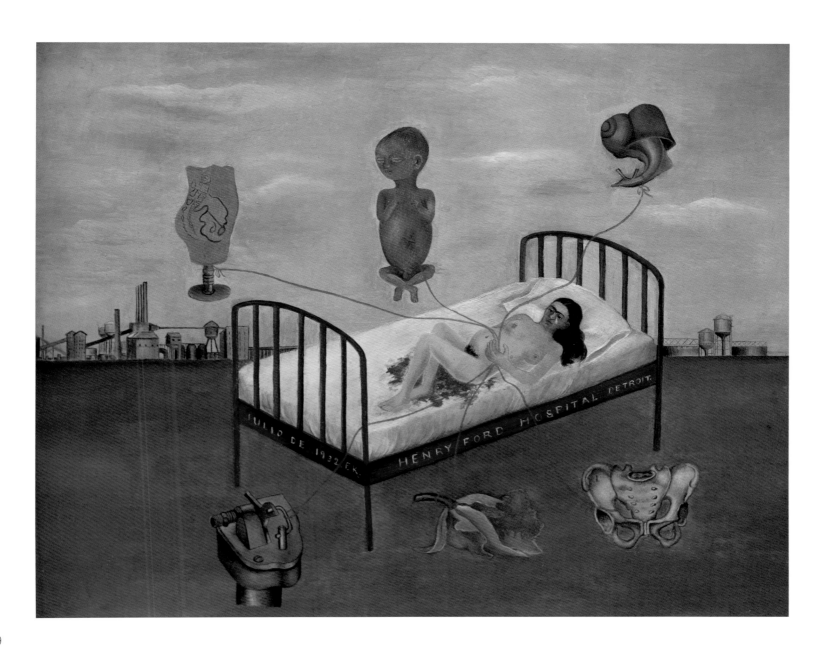

16
My Birth 1932
Oil on metal 30.5 x 35 cm
Madonna

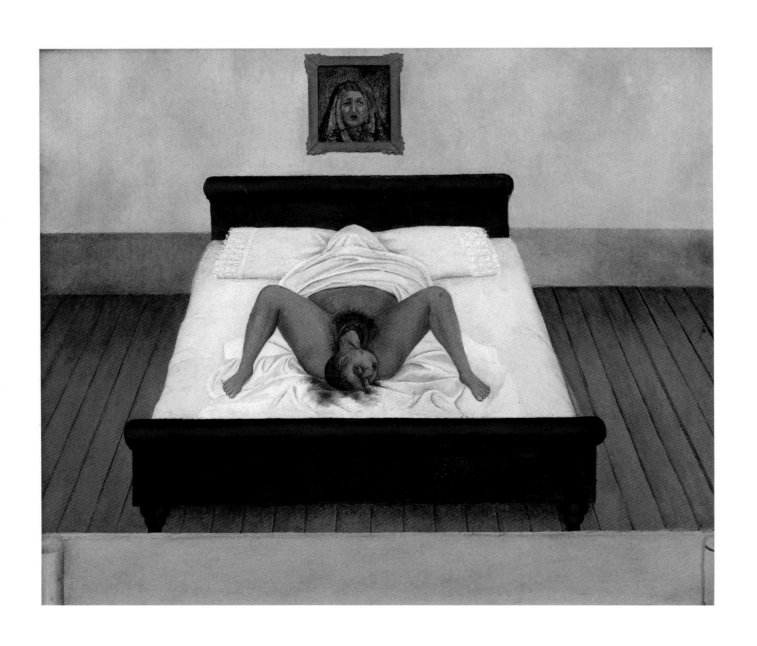

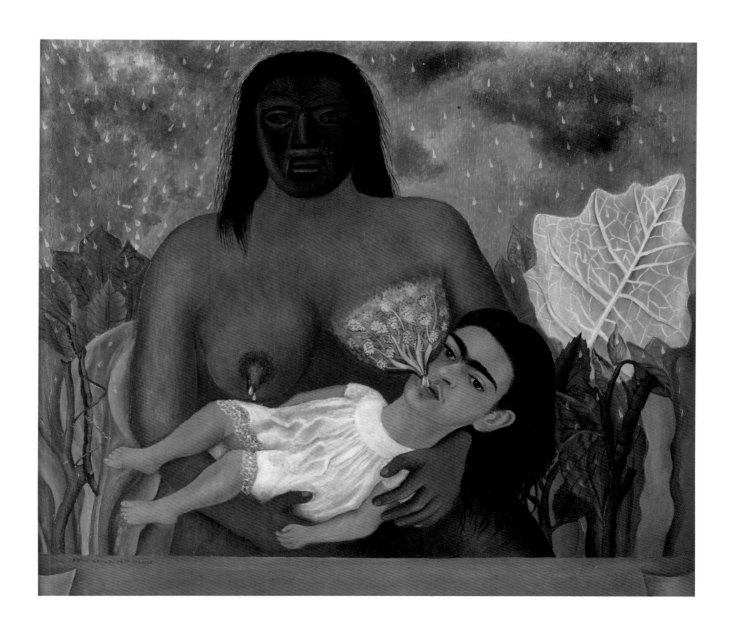

17
My Nurse and I 1937
Oil on metal
30.5 x 34.7 cm
Museo Dolores Olmedo
Patiño, Mexico City

18
My Grandparents, My Parents,
and I (Family Tree) 1936
Oil and tempera on metal
30.7 x 34.5 cm
The Museum of Modern Art,
New York. Gift of Allan Roos, M.D.,
and B. Mathieu Roos, 1976

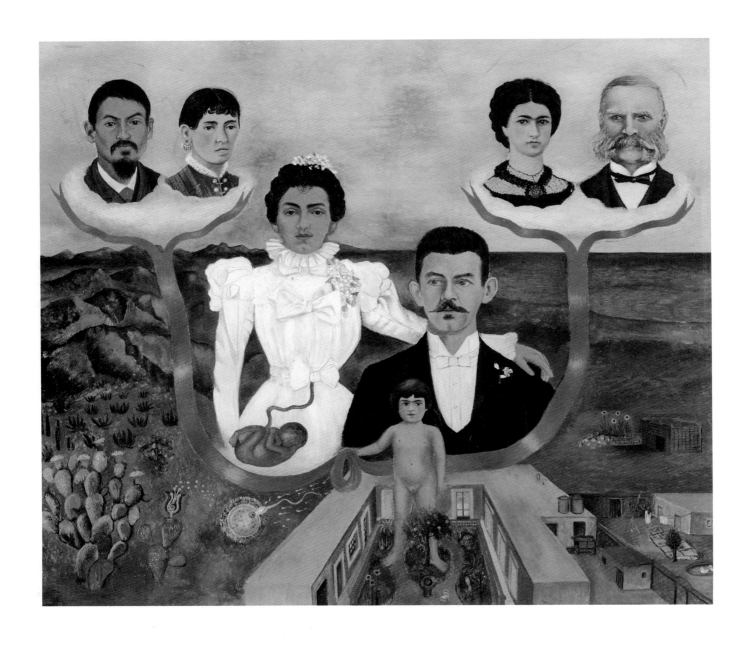

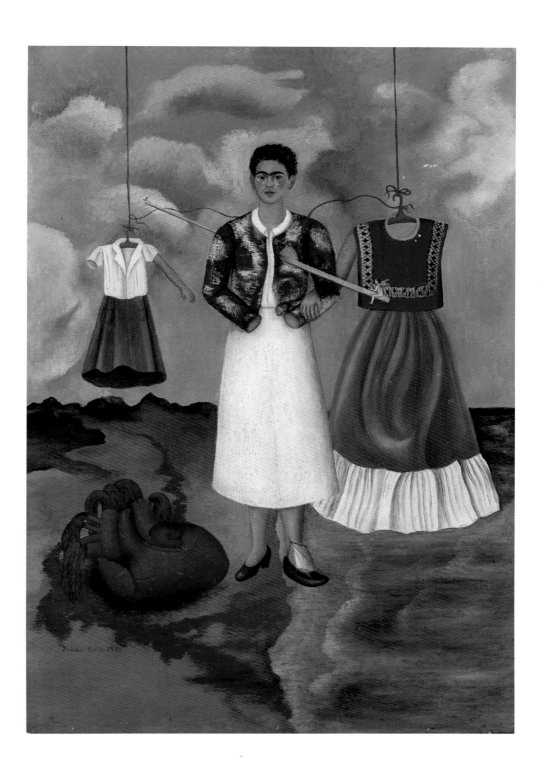

20
A Few Small Nips 1935
Oil on metal 30 x 40 cm
Museo Dolores Olmedo Patiño,
Mexico City

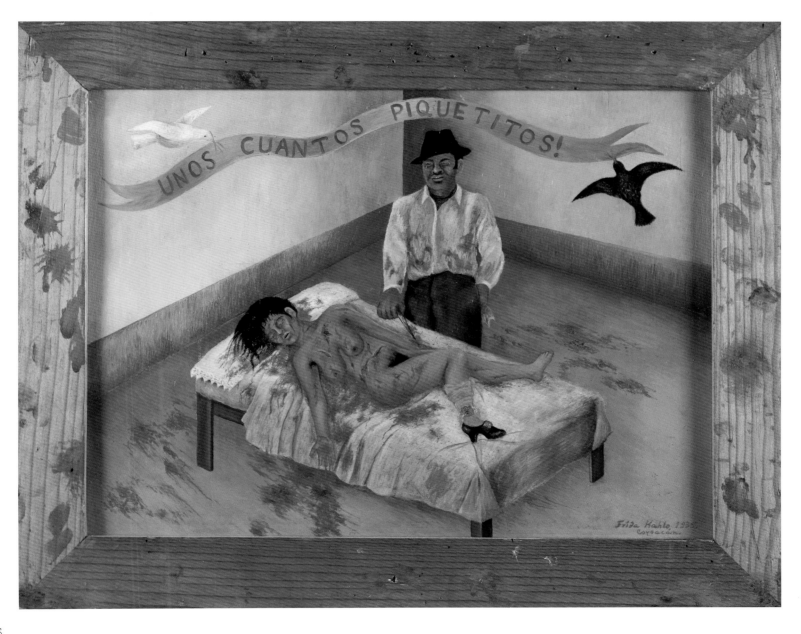

21
Girl with Death Mask (I) 1938
Oil on metal 14.9 x 11 cm
Nagoya City Art Museum

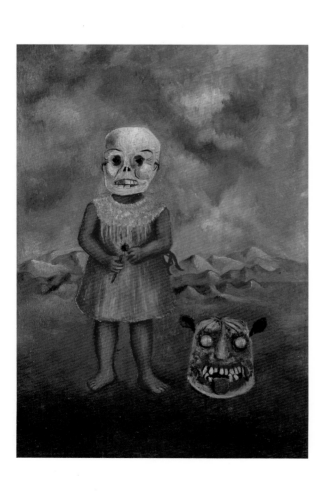

Four Inhabitants of Mexico City 1938
Oil on metal 32.4 x 47.6 cm
Private collection

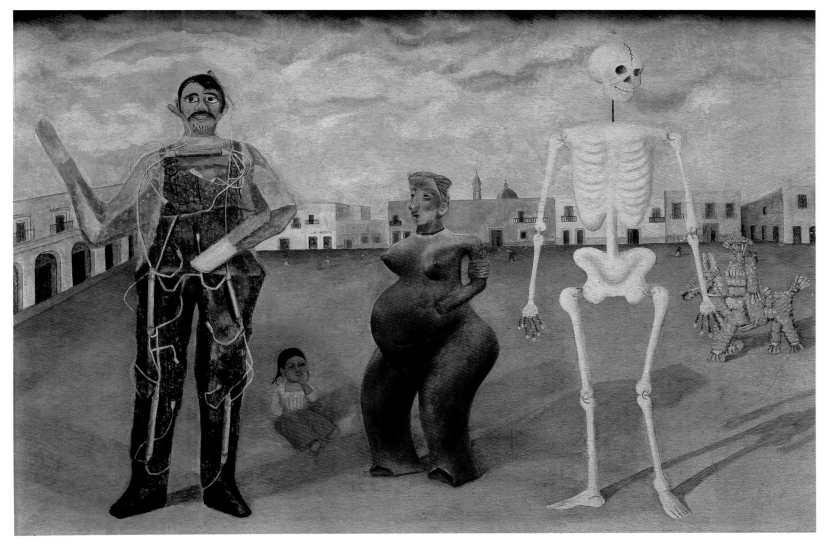

23
Self-Portrait *c.*1938
Oil on metal 12 x 7 cm
Private collection, courtesy of
Galerie 1900–2000, Paris

24
The Suicide of Dorothy Hale
1938–9
Oil on hardboard with
painted frame 50 x 40.6 cm
Phoenix Art Museum

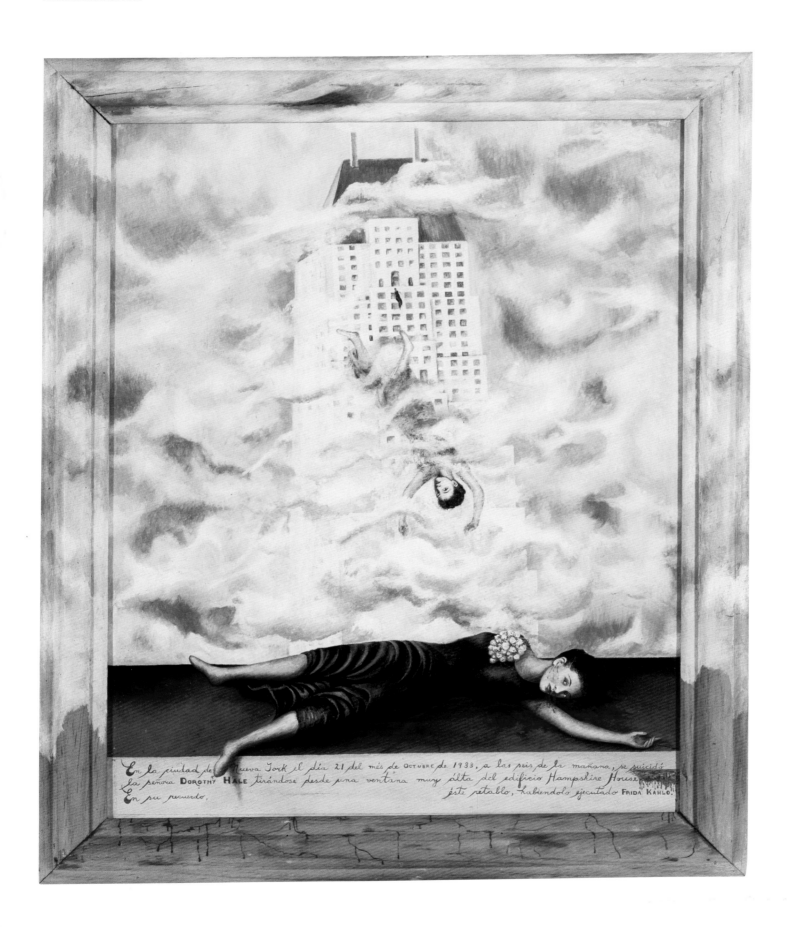

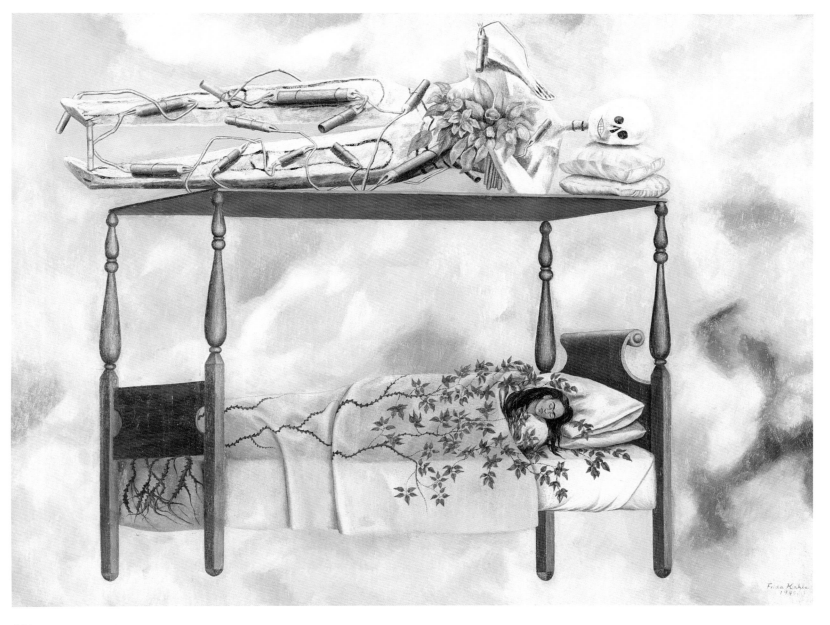

What I Saw in the Water or
What the Water Gave Me 1938
Oil on canvas 91 x 70.5 cm
Private collection

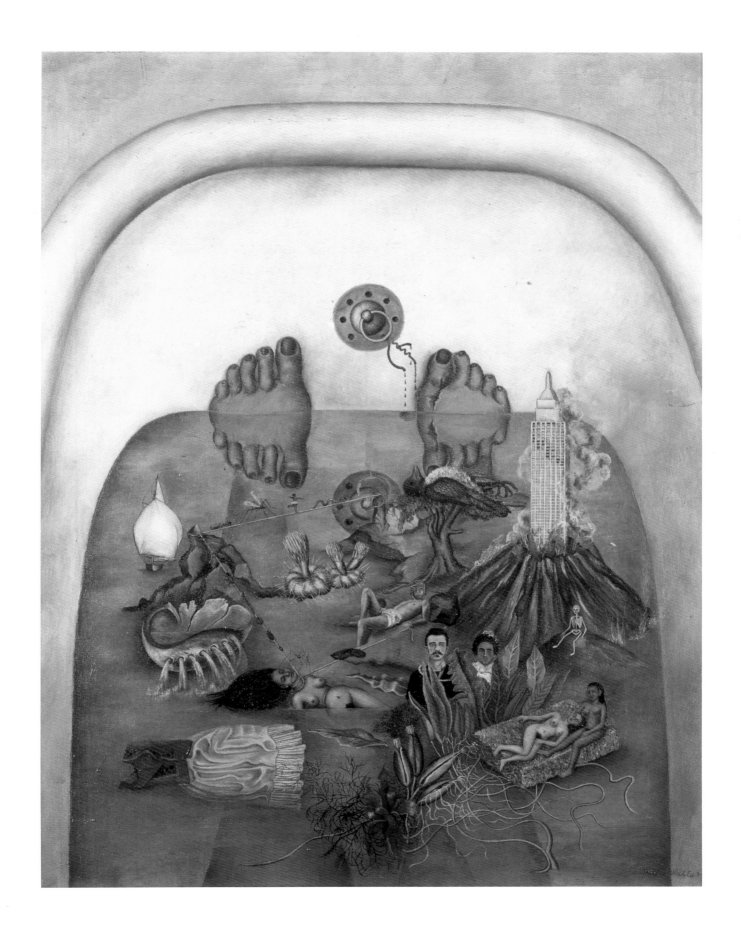

27
Two Nudes in a Forest 1939
Oil on metal 25 x 30.5 cm
Jon and Mary Shirley

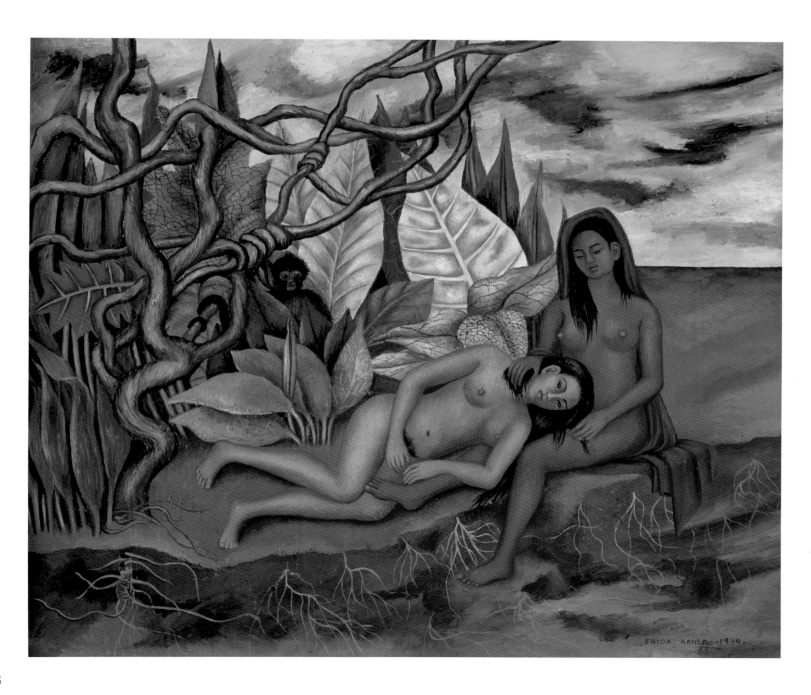

28
The Two Fridas 1939
Oil on canvas 173.5 x 173 cm
Museo de Arte Moderno,
CONACULTA-INBA, Mexico

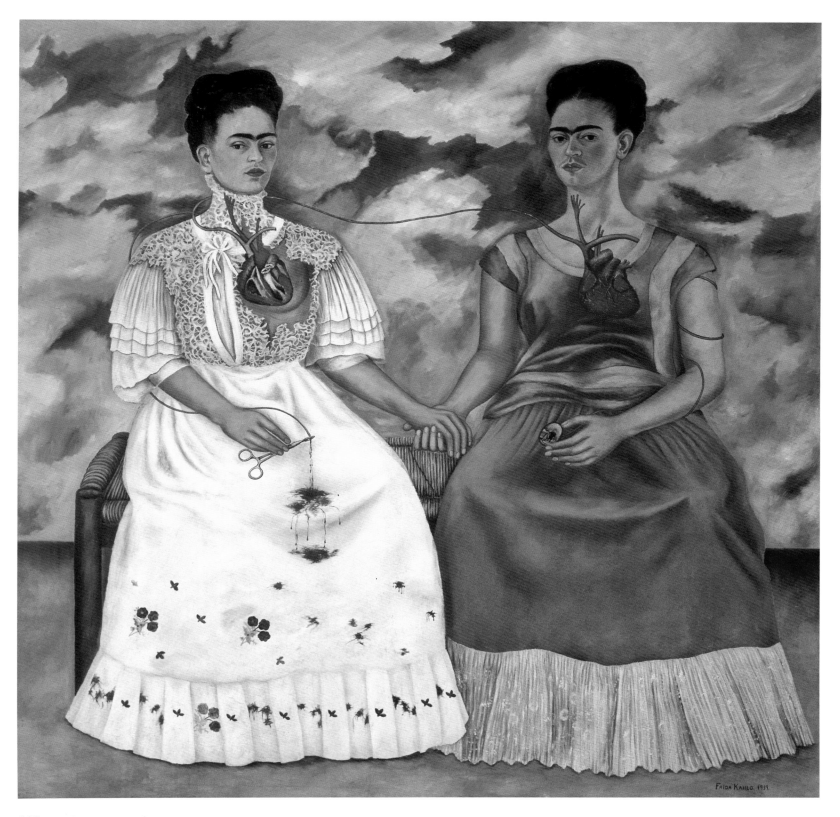

29
Self-Portrait with Cropped Hair
1940
Oil on canvas 40 x 28 cm
The Museum of Modern Art,
New York. Gift of Edgar
Kaufmann, Jr., 1943

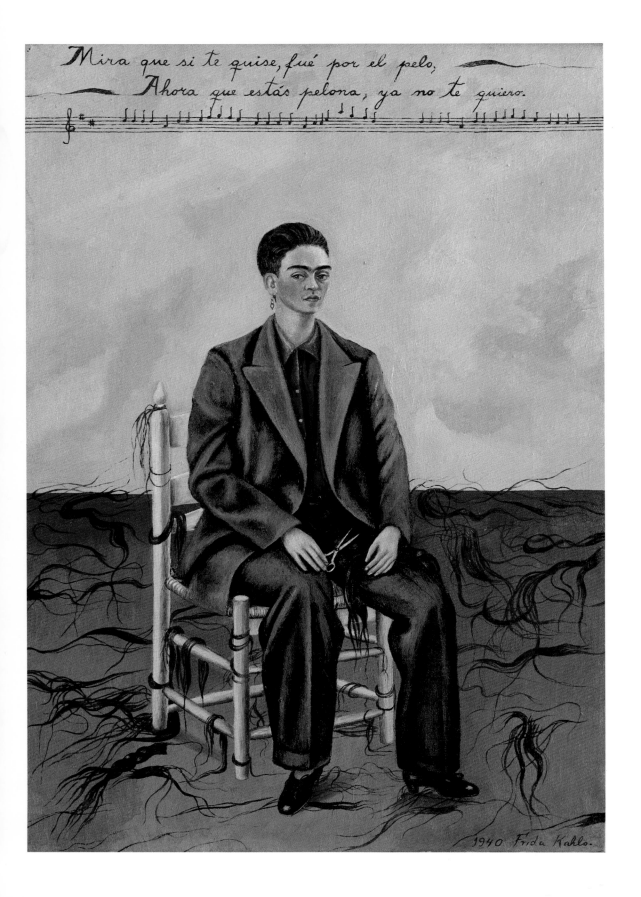

30
Itzcuintli Dog with Me c.1938
Oil on canvas 71 x 52 cm
Private collection

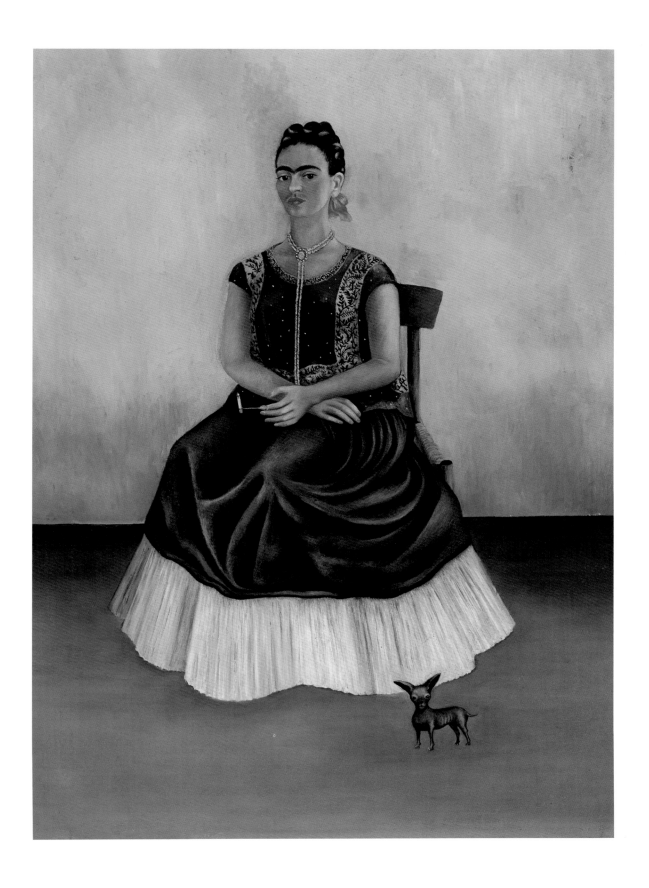

33
Self-Portrait with Monkey 1938
Oil on hardboard
40.6 x 30.5 cm
Albright-Knox Art Gallery,
Buffalo, New York. Bequest of
A. Conger Goodyear, 1966

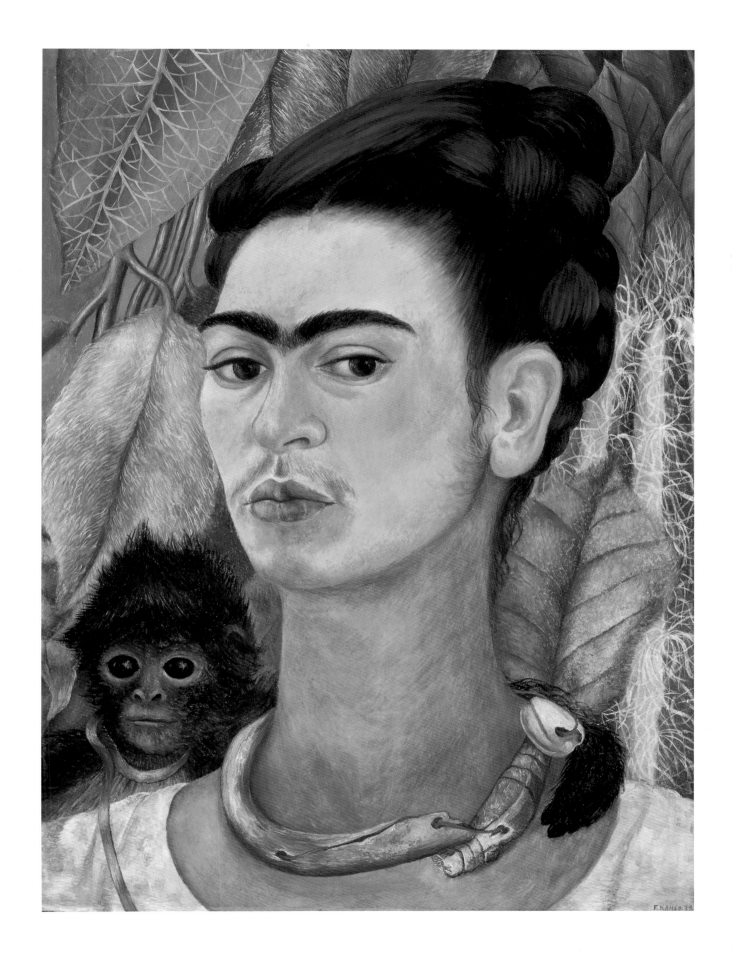

123

34
Self-Portrait with Monkey 1940
Oil on hardboard
55.2 x 43.5 cm
Madonna

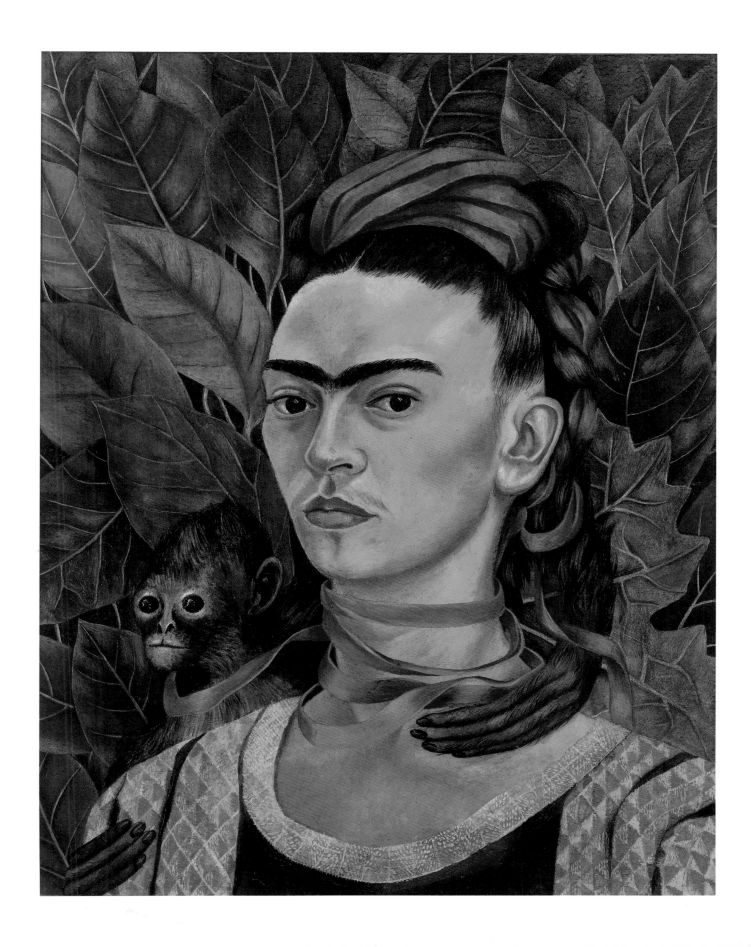

35
Self-Portrait 1940
Oil on hardboard 61 x 43 cm
Private collection, courtesy of
Mary-Anne Martin Fine Art,
New York

fig.102 (below)
DIEGO RIVERA (1886–1957)
Self-Portrait 1941
Oil on canvas 69.9 x 41.9
Private collection, courtesy of
Mary-Anne Martin Fine Art,
New York

These companion portraits
were commissioned by
Sigmund Firestone in 1939
after he visited the artists
in Mexico.

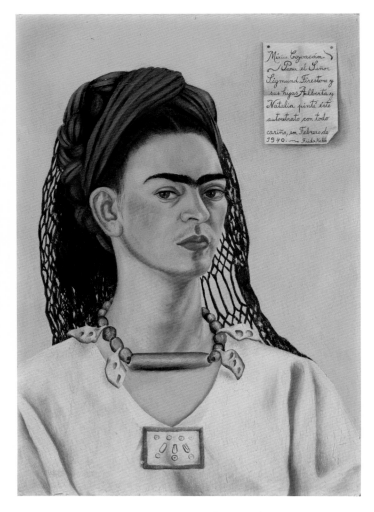

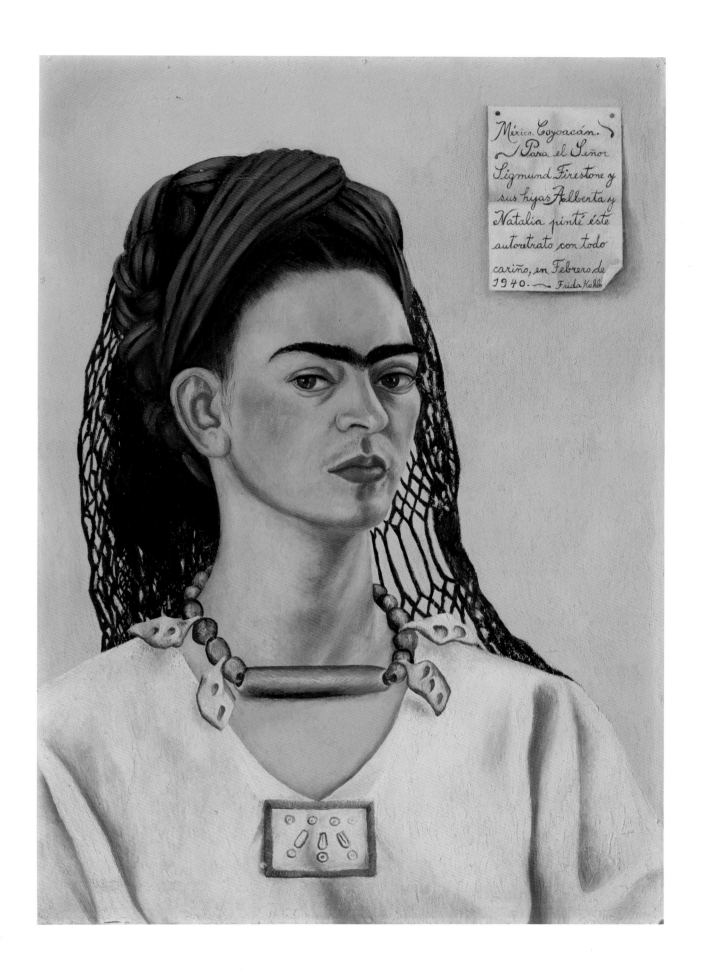

36
Self-Portrait Dedicated to
Dr Eloesser 1940
Oil on hardboard 59.5 x 40 cm
Private collection

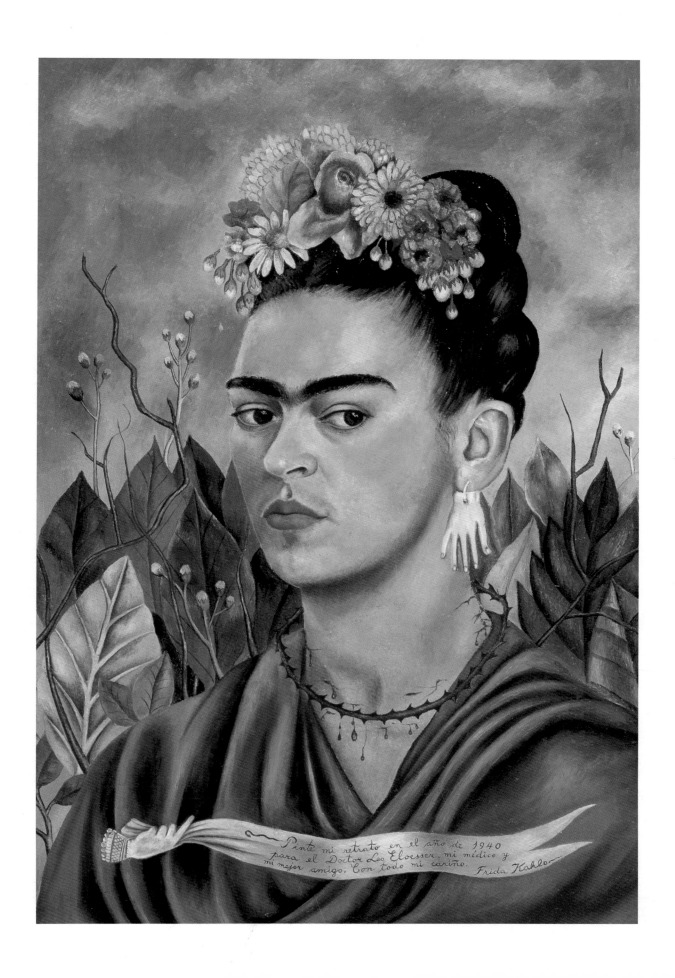

Pinté mi retrato en el año de 1940 para el Doctor Leo Eloesser, mi médico y mi mejor amigo. Con todo mi cariño. Frida Kahlo

37
*Self-Portrait with Thorn Necklace
and Hummingbird* 1940
Oil on canvas 63.5 x 49.5 cm
Harry Ransom Research Center
University of Texas at Austin.
Muray Collection

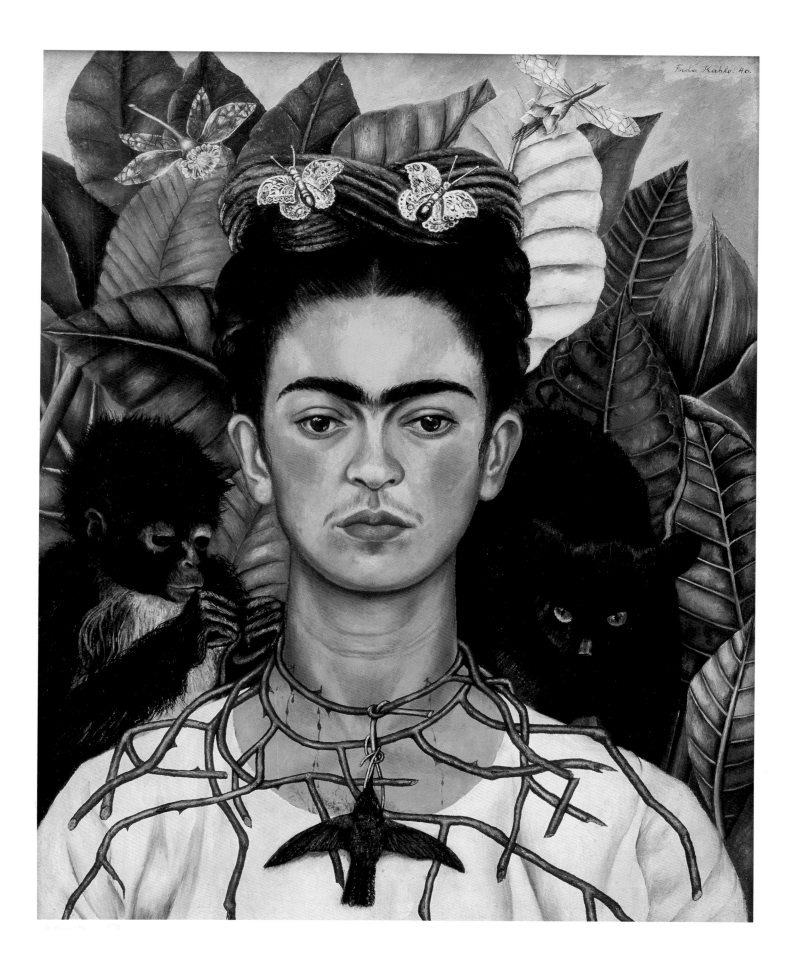

38
Self-Portrait with Braid 1941
Oil on hardboard 51 x 38.5 cm
The Jacques and Natasha Gelman
Collection of Modern and
Contemporary Mexican Art;
The Vergel Foundation;
Fundación Cultural Parque Morelos,
Cuernavaca; Costco/Comercial Mexicana

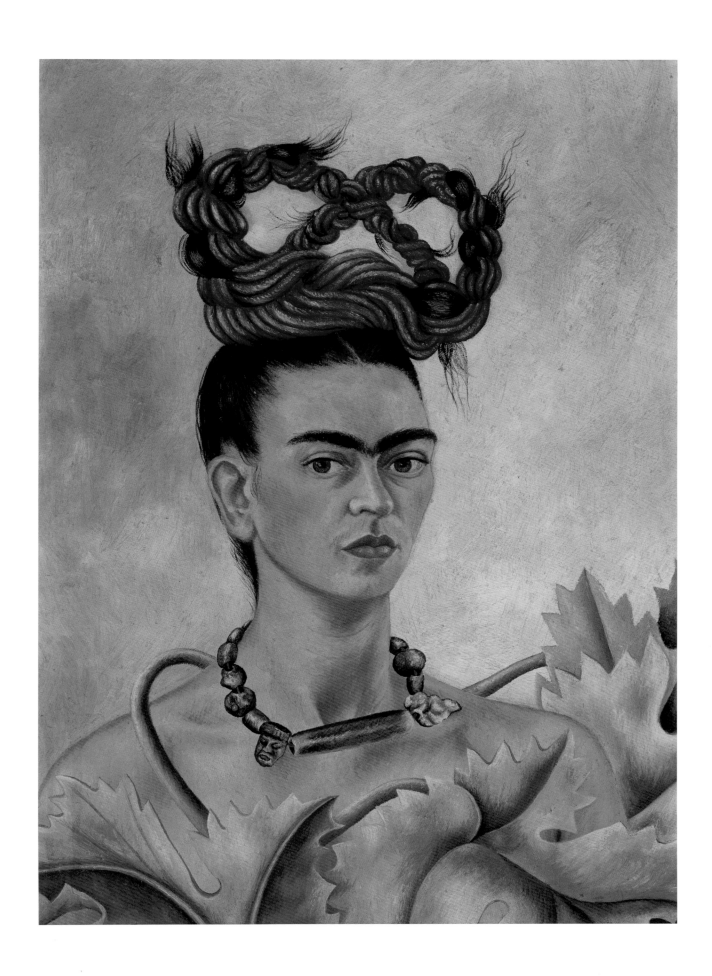

39
Self-Portrait with Bonito 1941
Oil on hardboard 55 x 43.5 cm
Private collection

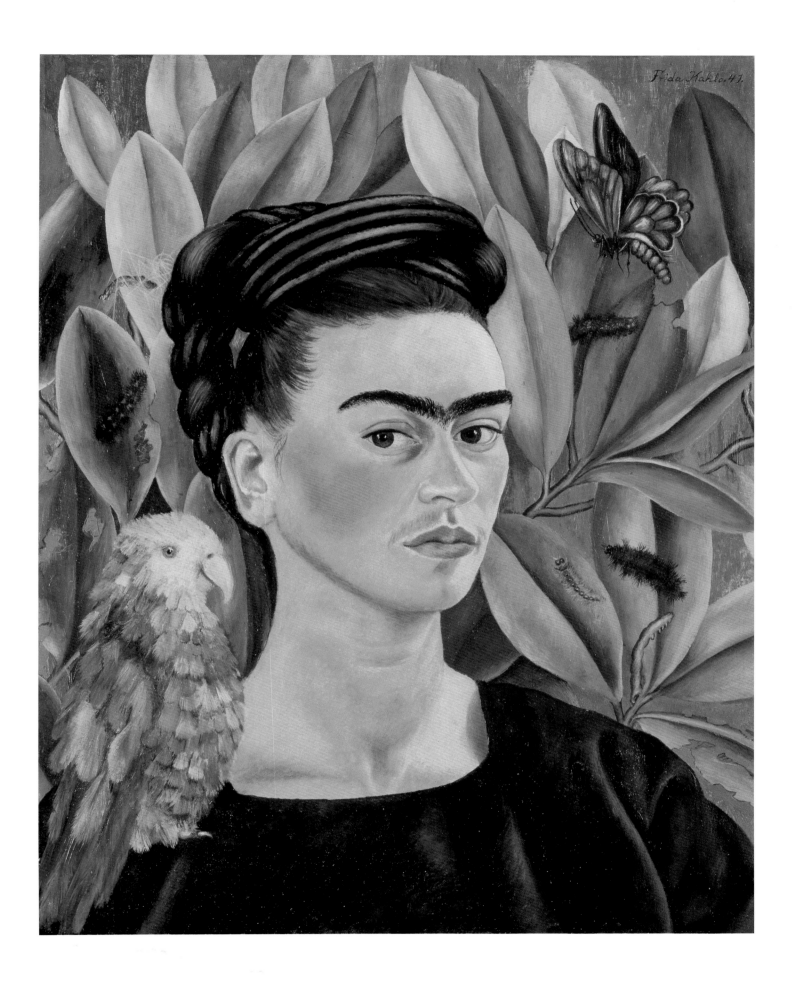

40
*Self-Portrait with Monkey
and Parrot* 1942
Oil on hardboard
54.6 x 43.2 cm
MALBA / Costantini Collection,
Buenos Aires

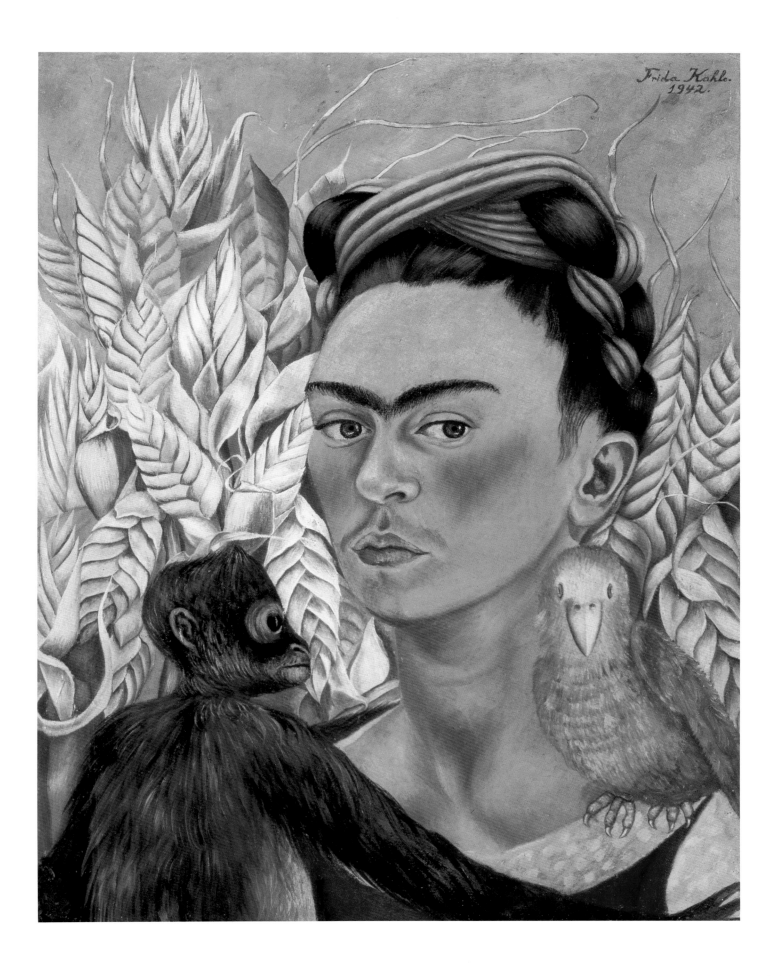

41
Self-Portrait with Monkeys 1943
Oil on canvas 81.5 x 63 cm
The Jacques and Natasha Gelman
Collection of Modern and
Contemporary Mexican Art;
The Vergel Foundation;
Fundación Cultural Parque Morelos,
Cuernavaca; Costco/Comercial Mexicana

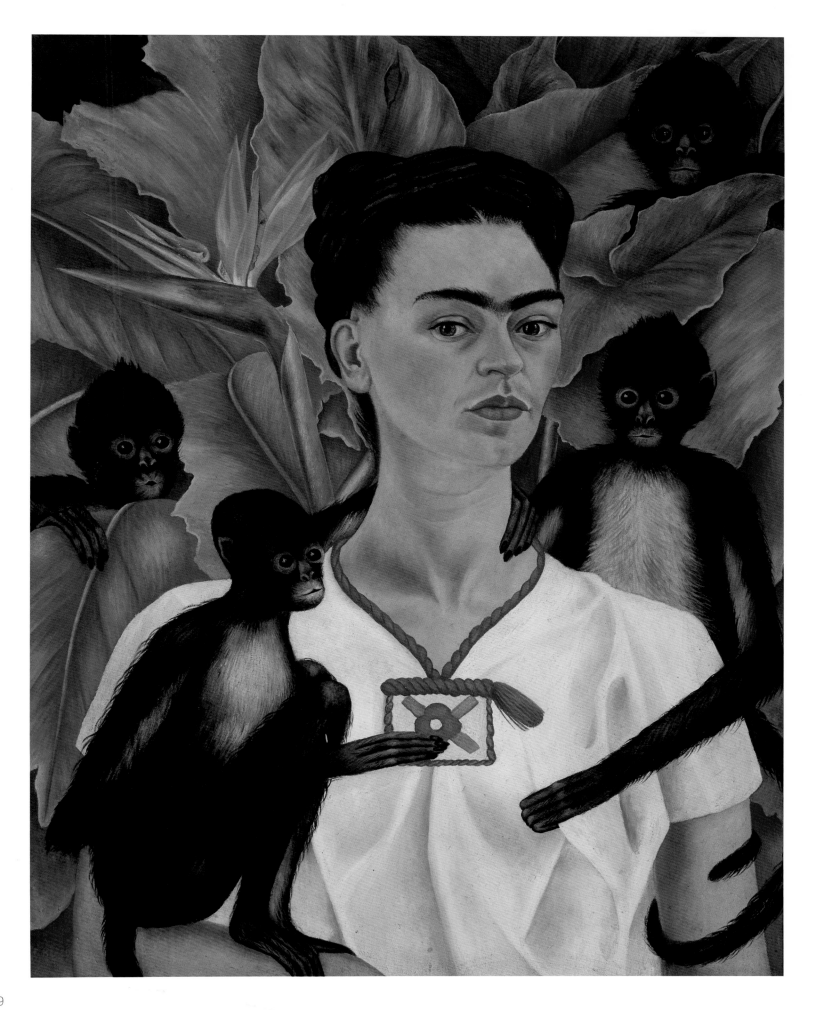

42

Self-Portrait as a Tehuana 1943
Oil on hardboard 76 x 61 cm
The Jacques and Natasha Gelman
Collection of Modern and
Contemporary Mexican Art;
The Vergel Foundation;
Fundación Cultural Parque Morelos,
Cuernavaca; Costco/Comercial Mexicana

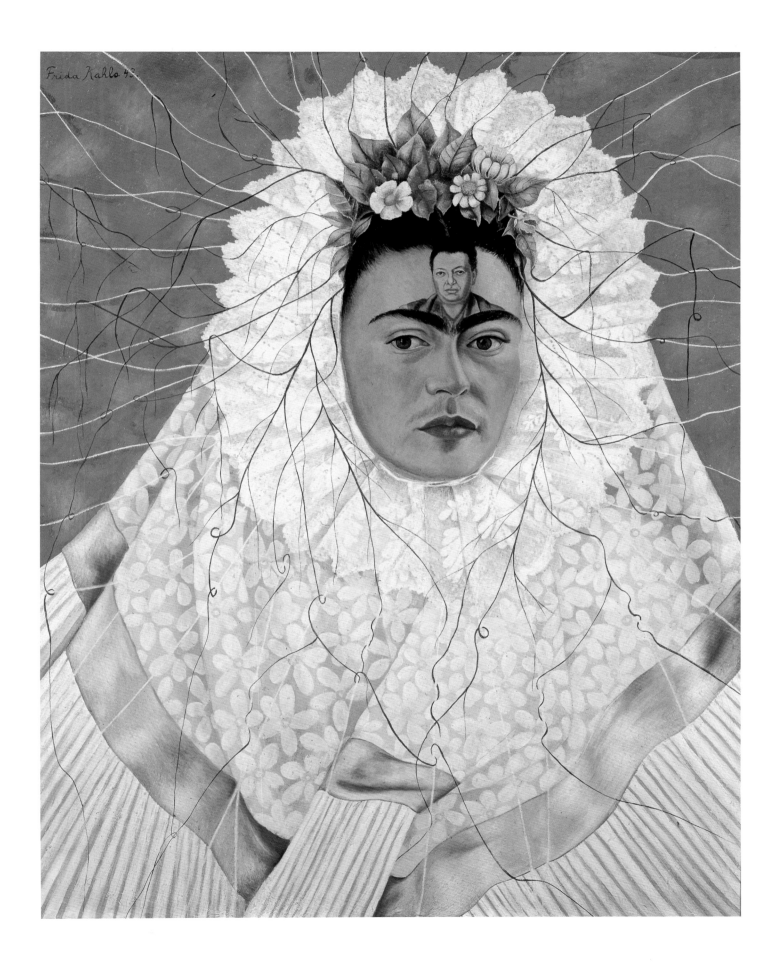

141

43
Thinking About Death 1943
Oil on canvas 44.5 x 36.3 cm
Private collection

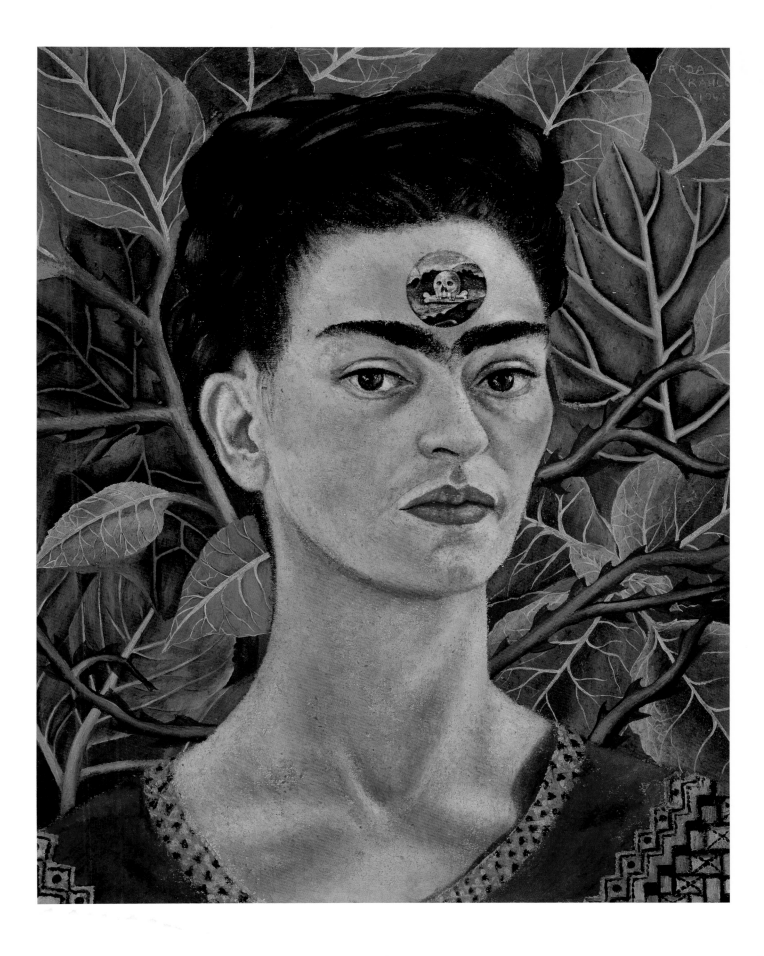

44
Self-Portrait with Small Monkey
1945
Oil on hardboard 55 x 40 cm
Museo Dolores Olmedo Patiño,
Mexico City

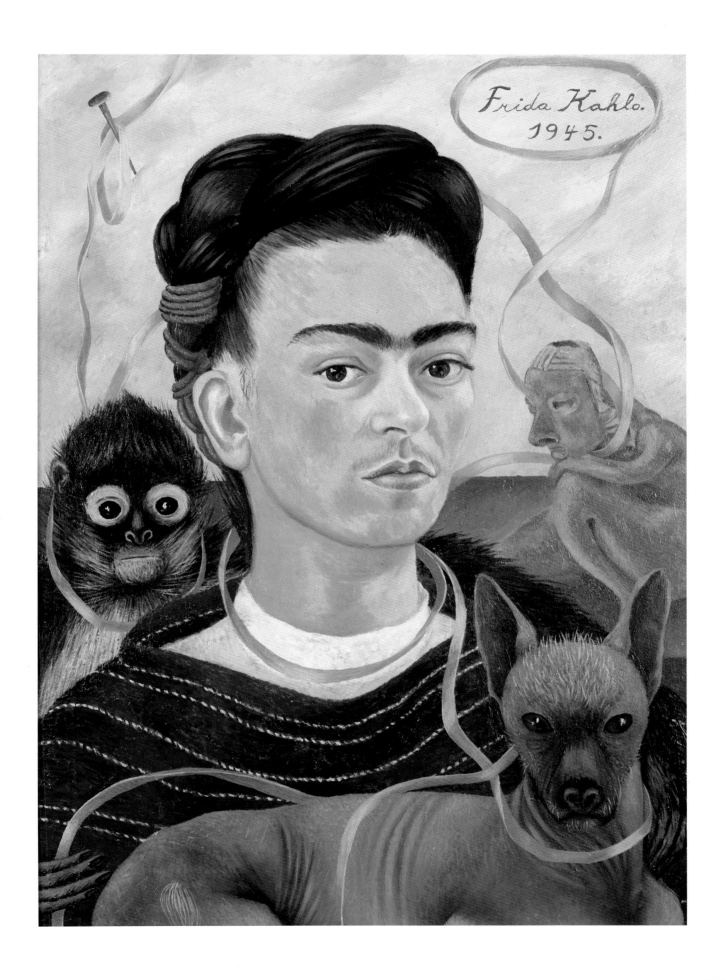

45
Self-Portrait with Loose Hair
1947
Oil on hardboard 61 x 45 cm
Private collection

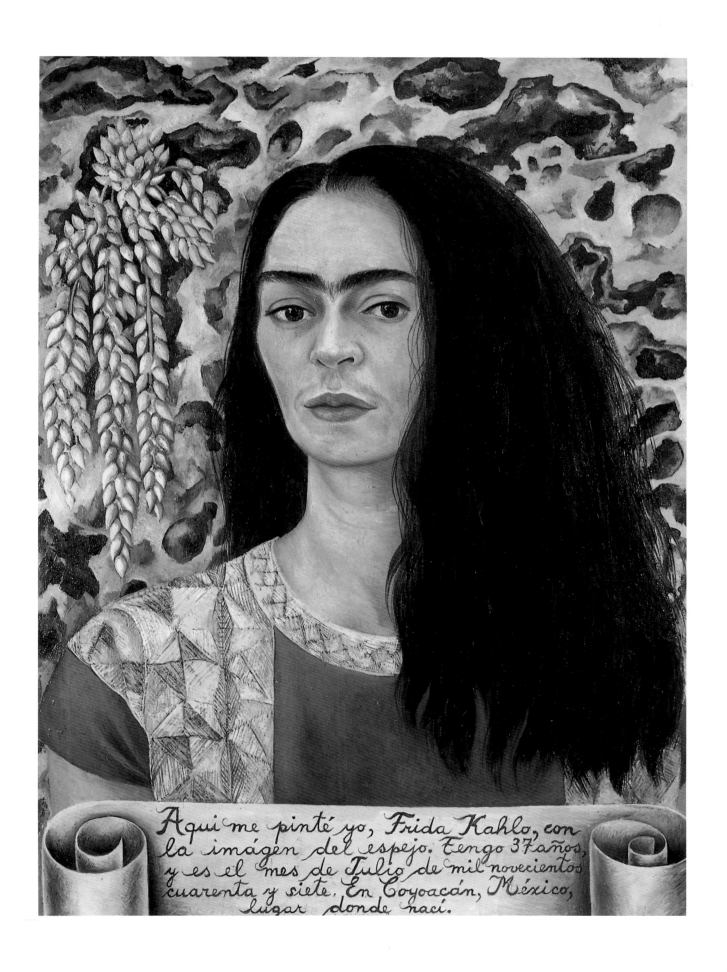

46
Self-Portrait 1948
Oil on hardboard 50 x 40 cm
Private collection

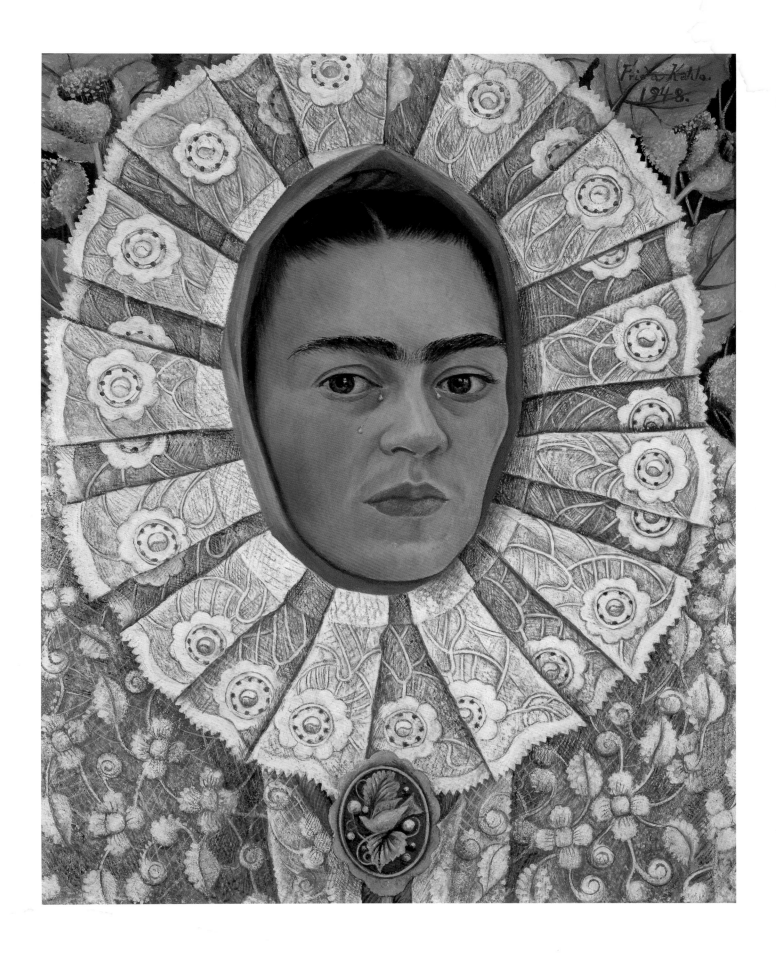

47
Diego and I 1949
Oil on canvas 28 x 22 cm
Private collection

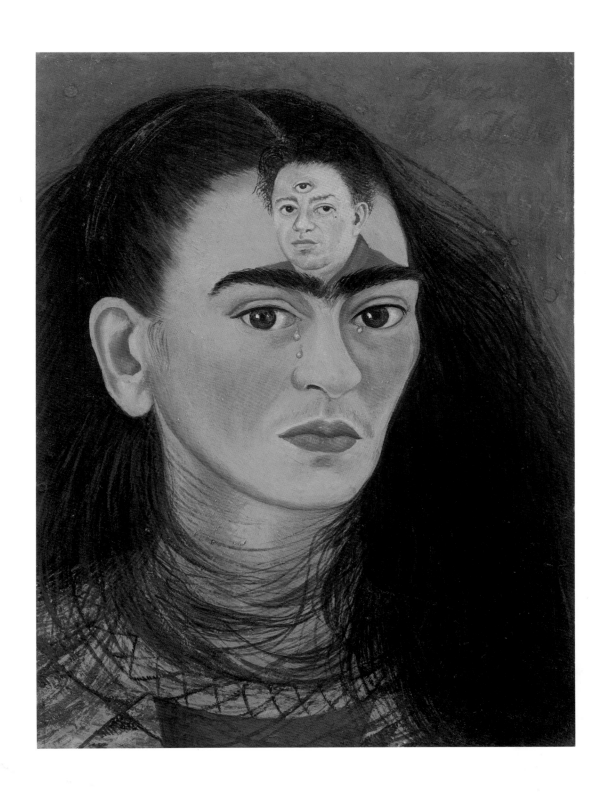

48
The Mask 1945
Oil on canvas 40 x 31 cm
Museo Dolores Olmedo Patiño,
Mexico City

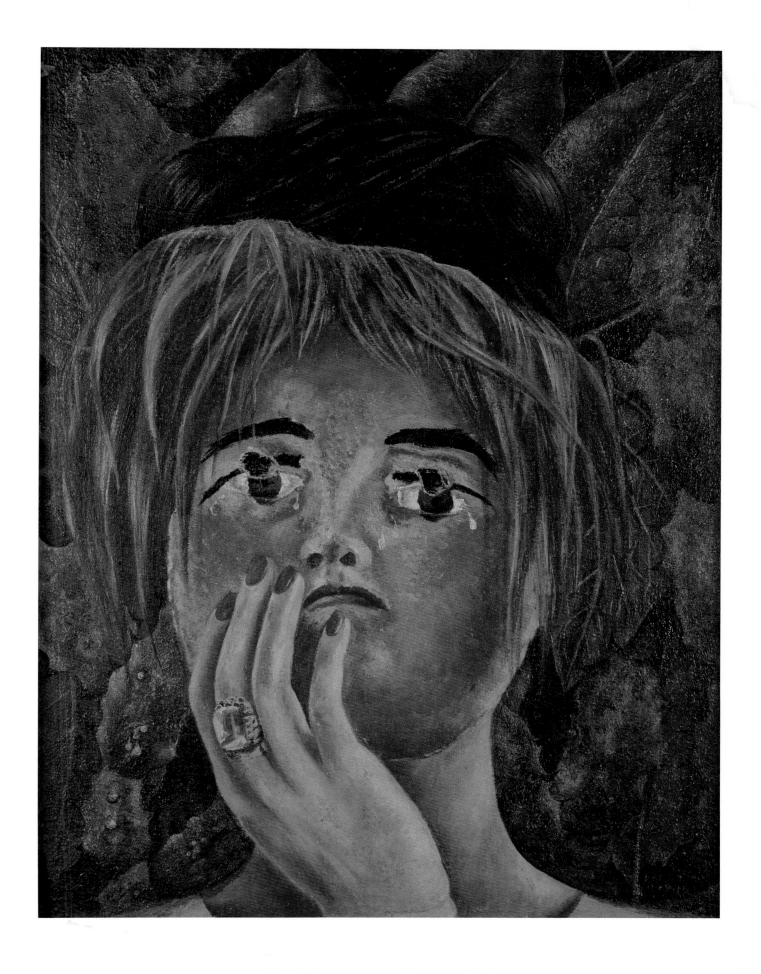

49
The Broken Column 1944
Oil on canvas 40 x 30.5 cm
Museo Dolores Olmedo Patiño,
Mexico City

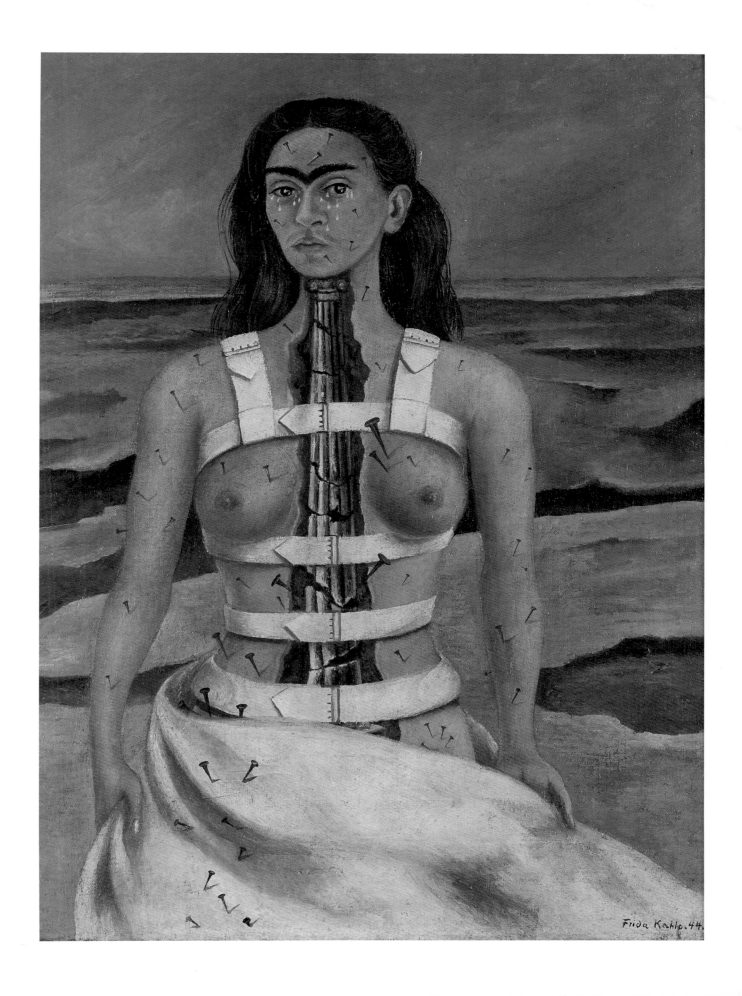

50
Roots 1943
Oil on metal 30.5 x 49.9 cm
Private collection

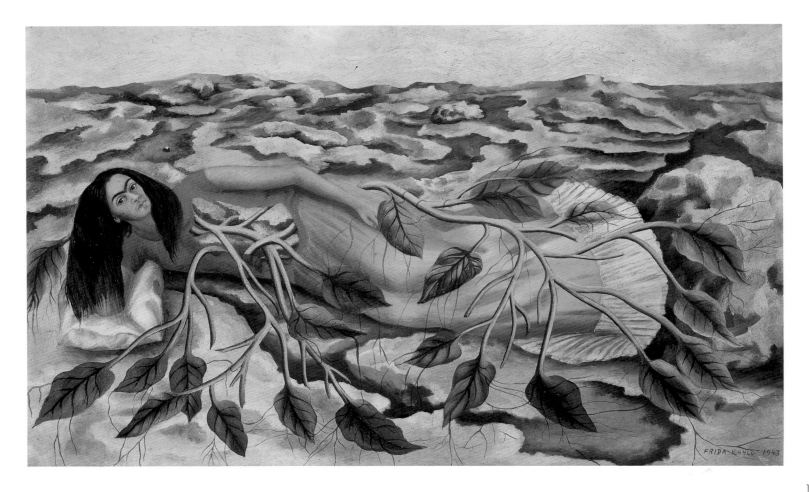

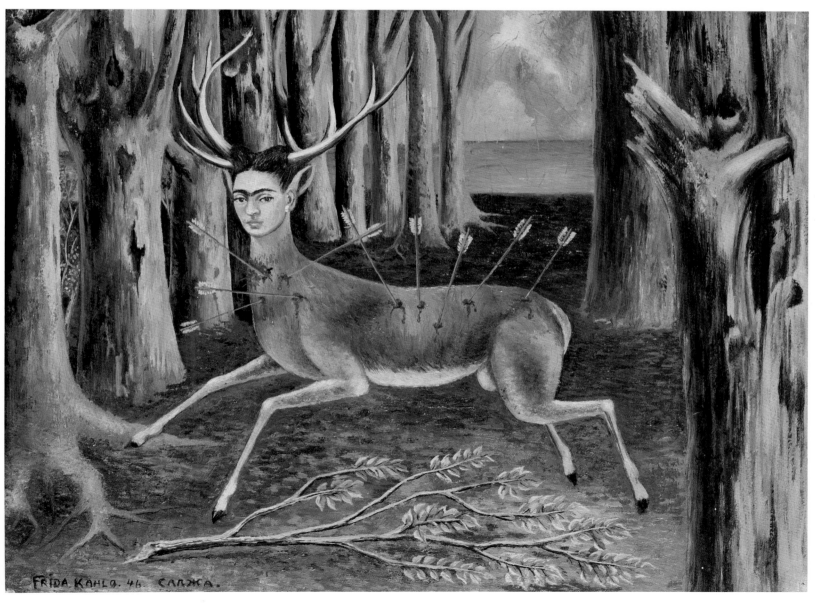

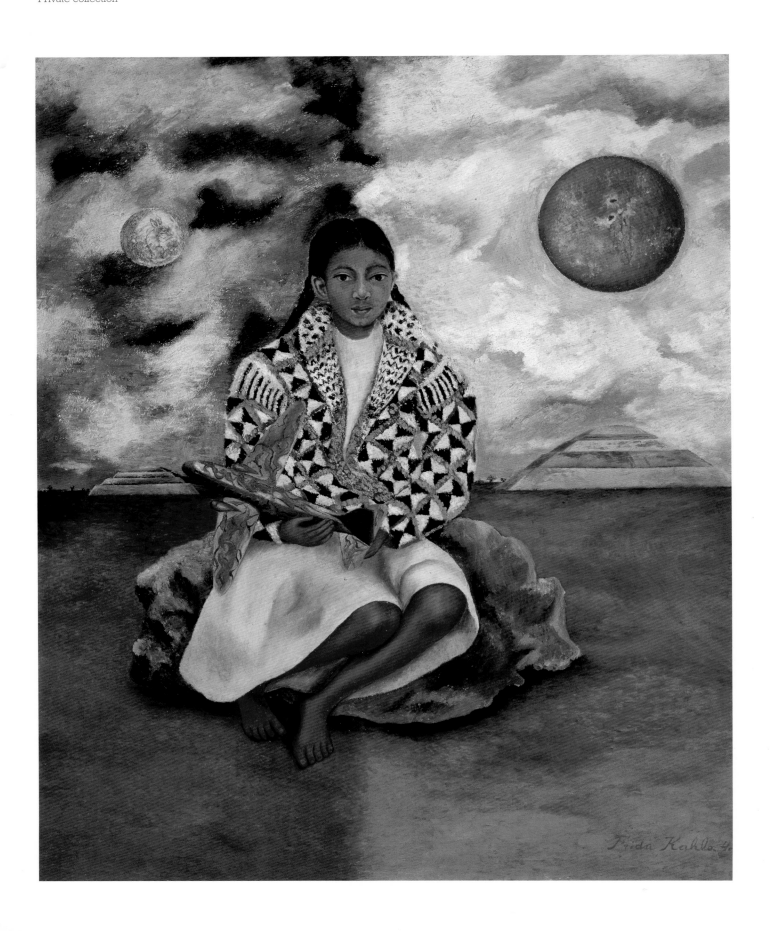

Without Hope 1945
Oil on canvas 28 x 36 cm
Museo Dolores Olmedo Patiño,
Mexico City

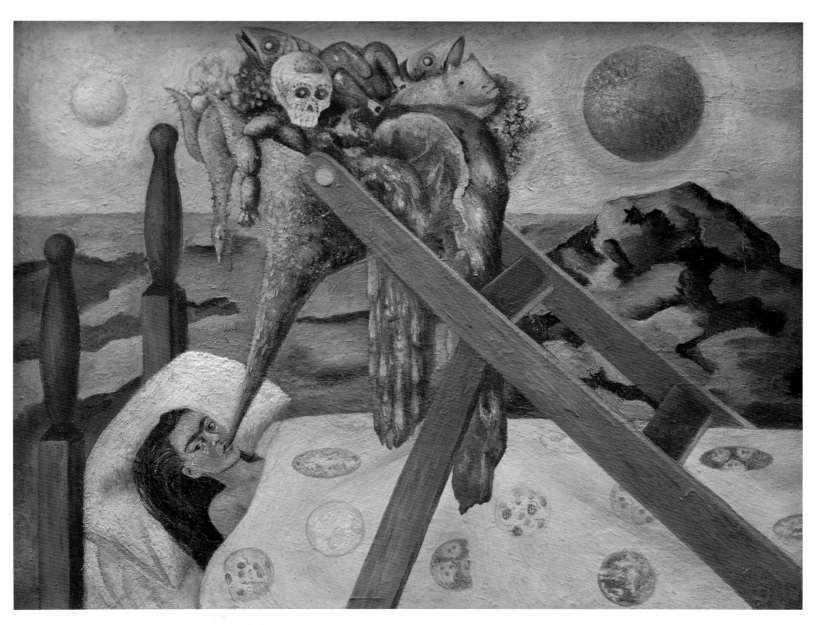

54

*Self-Portrait with Portrait
of Dr Farill* or *Self-Portrait
with Dr Juan Farill* 1951
Oil on hardboard 41.5 x 50 cm
Private collection

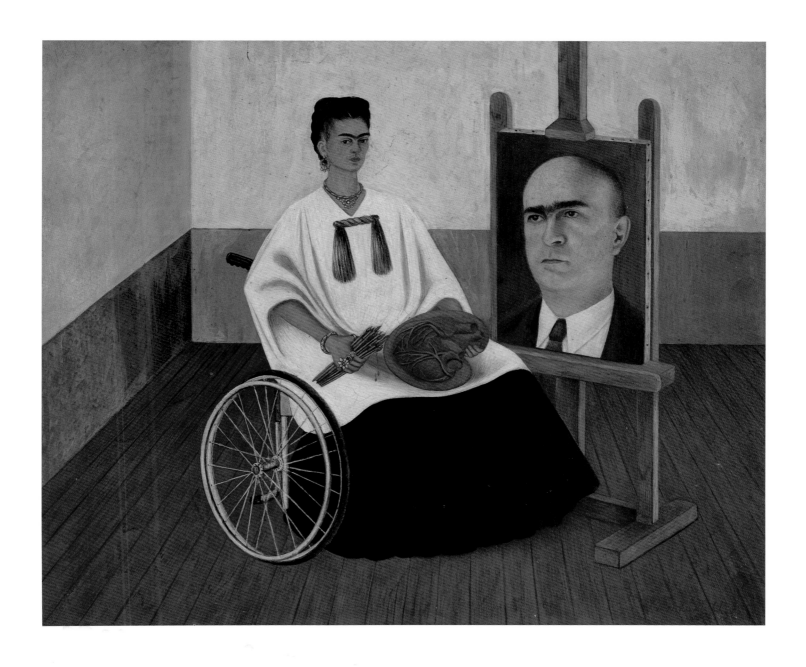

55
*Window Display in a Street in
Detroit* 1931
Oil on metal 30.3 x 38.2 cm
Mr and Mrs Abel Holtz,
courtesy of Gary Nader Fine Art,
Miami

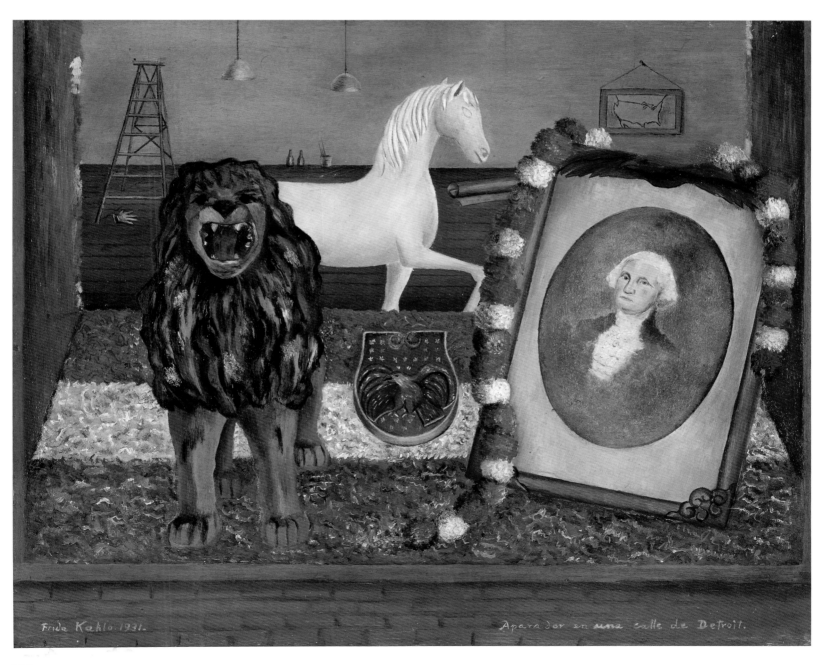

Frida Kahlo. 1931. Aparador en una calle de Detroit.

56

Fruits of the Earth 1938
Oil on hardboard 40.6 x 60 cm
Banco Nacional de México

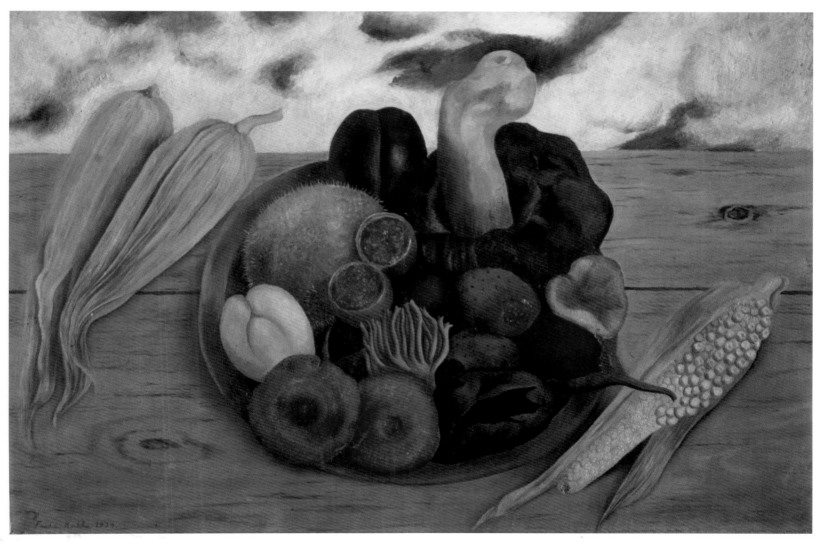

Cactus Fruits 1938
Oil on metal 24 x 18.5 cm
Private collection

58
Pitahayas 1938
Oil on metal 25.4 x 35.6 cm
Madison Museum of
Contemporary Art, Wisconsin.
Bequest of Rudolph
and Louise Langer

59
Still Life 1951
Oil on canvas 28.5 x 36 cm
Private collection, courtesy of
Galería Arvil, Mexico City

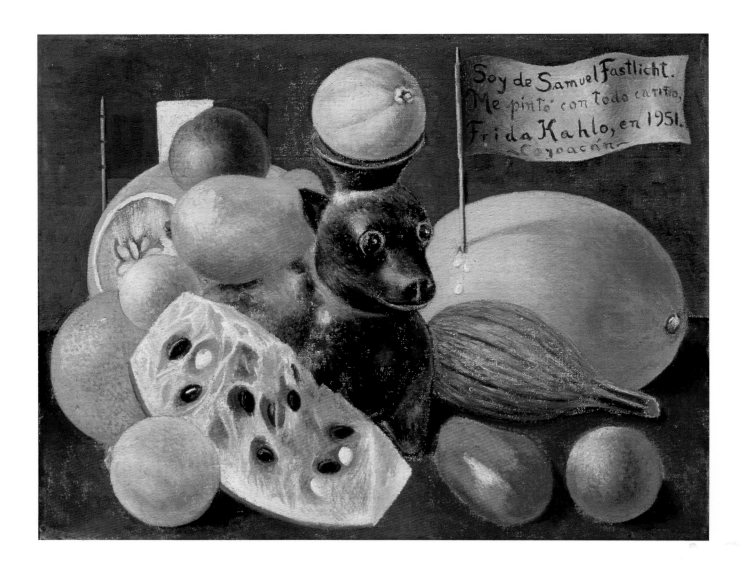

The Bride Frightened at Seeing Life
1943
Oil on canvas 63 x 81.5 cm
The Jacques and Natasha Gelman
Collection of Modern and
Contemporary Mexican Art;
The Vergel Foundation;
Fundación Cultural Parque Morelos,
Cuernavaca; Costco/Comercial
Mexicana

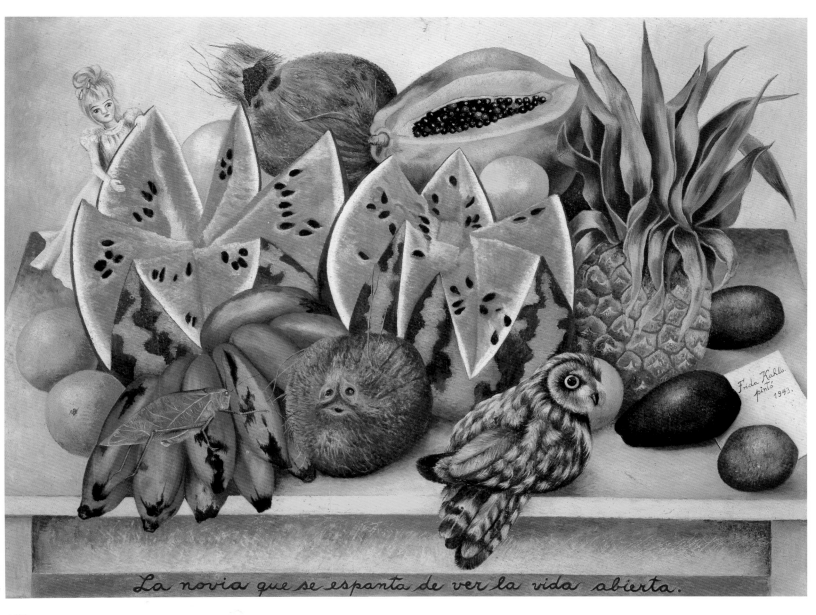

La novia que se espanta de ver la vida abierta.

61
Still Life with Watermelons 1953
Oil on hardboard 39 x 59 cm
Museo de Arte Moderno,
CONACULTA-INBA, Mexico

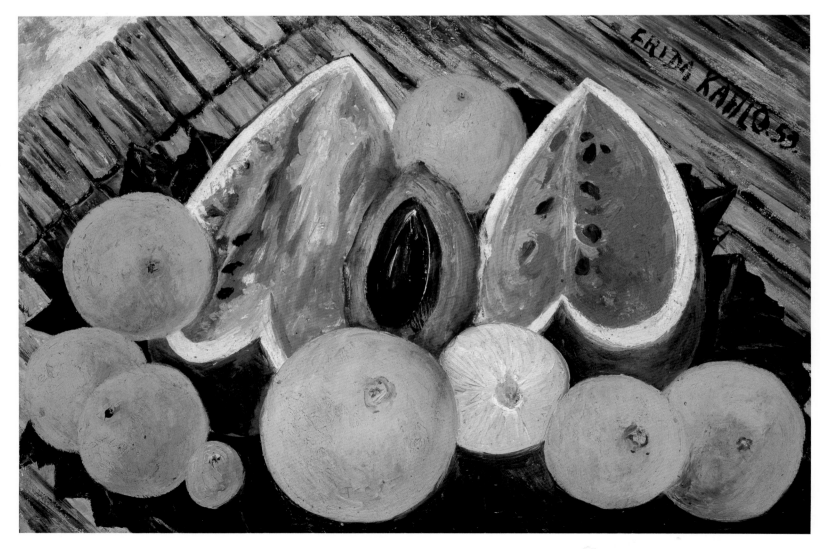

62
Still Life with Parrot and Flag
1951
Oil on hardboard 26 x 35 cm
Private collection, courtesy of
Galería Arvil, Mexico City

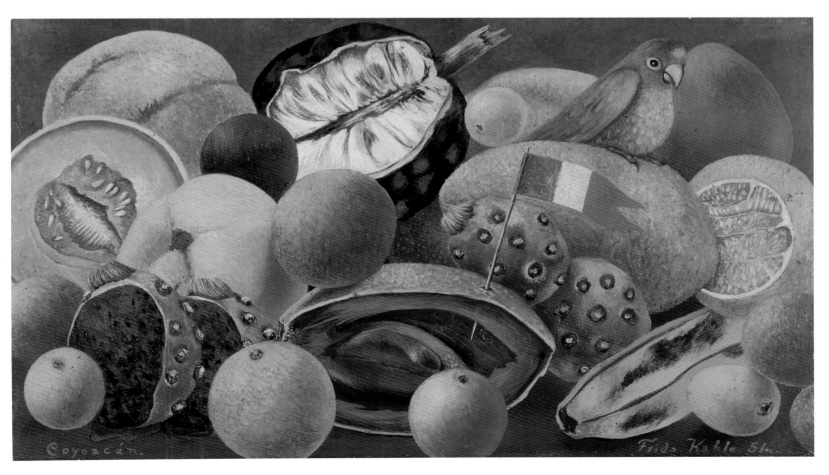

63
The Chick 1945
Oil on hardboard 27 x 22 cm
Museo Dolores Olmedo Patiño,
Mexico City

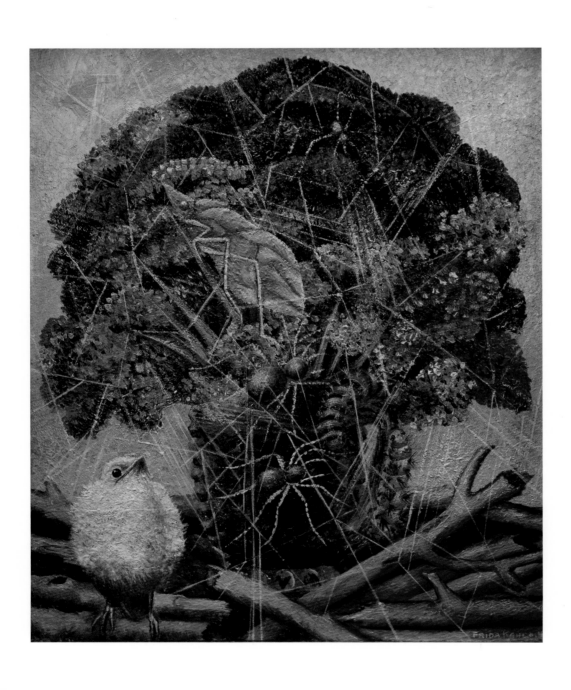

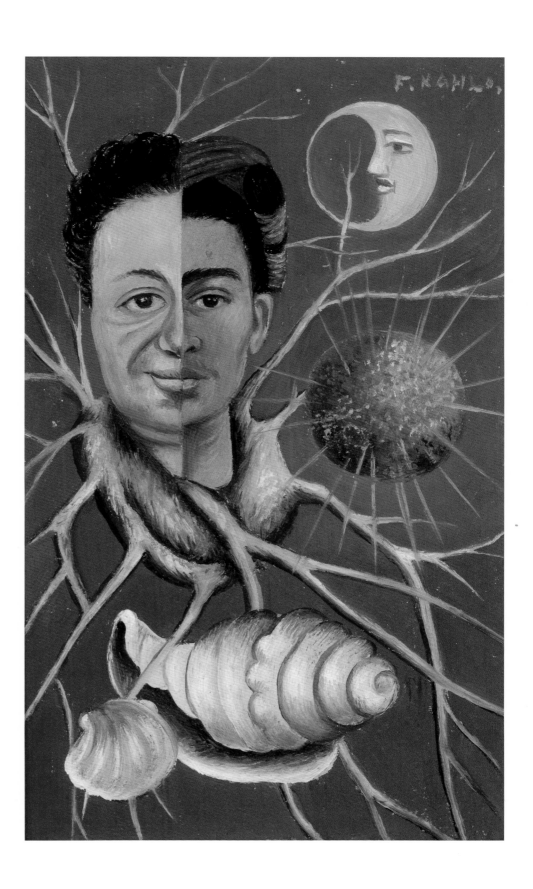

65
Still Life with Hummingbird
1941
Oil on copper 64.1 cm (diameter)
Private collection, courtesy of
Mary-Anne Martin Fine Art,
New York

67
Flower of Life 1943
Oil on hardboard
27.8 x 19.7 cm
Museo Dolores Olmedo Patiño,
Mexico City

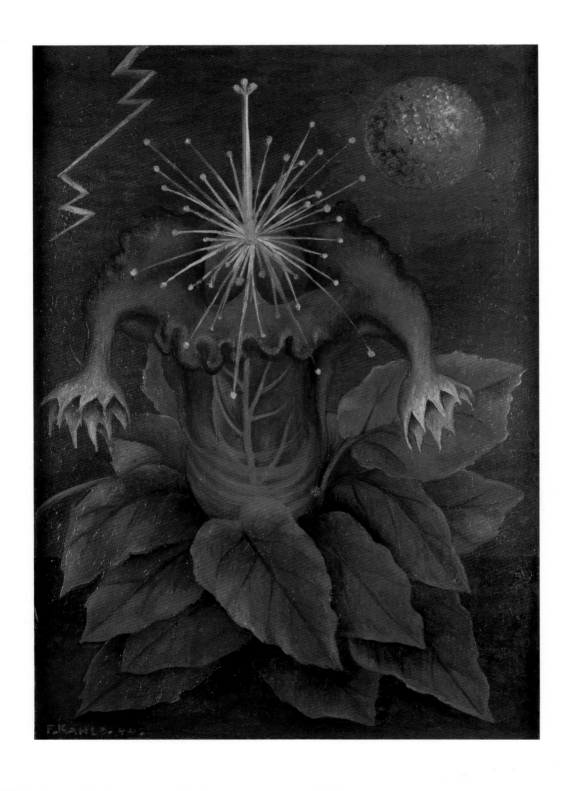

68
Sun and Life 1947
Oil on hardboard 40 x 50 cm
Private collection, courtesy of
Galería Arvil, Mexico City

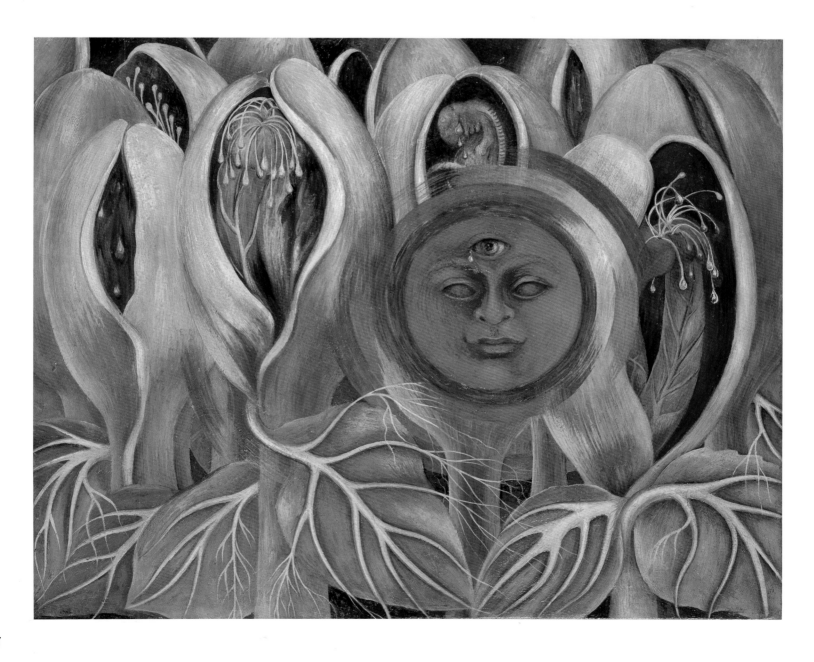

69
Moses 1945
Oil on hardboard 61 x 75.6 cm
Private collection

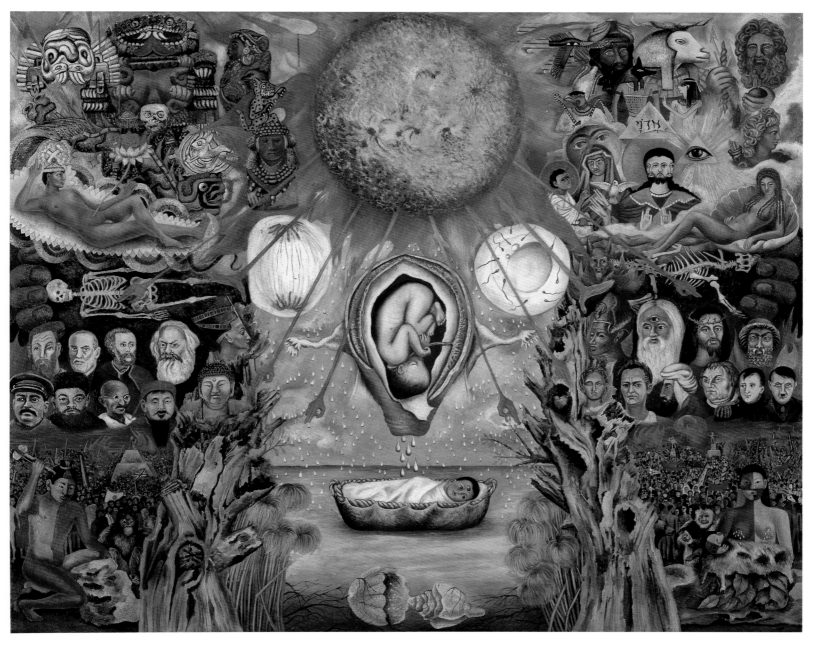

70
The Love-Embrace of the Universe,
the Earth (Mexico), Me, Diego
and Mr Xólotl 1949
Oil on canvas 70 x 60.5 cm
The Jacques and Natasha Gelman
Collection of Modern and
Contemporary Mexican Art;
The Vergel Foundation;
Fundación Cultural Parque Morelos,
Cuernavaca; Costco/Comercial
Mexicana

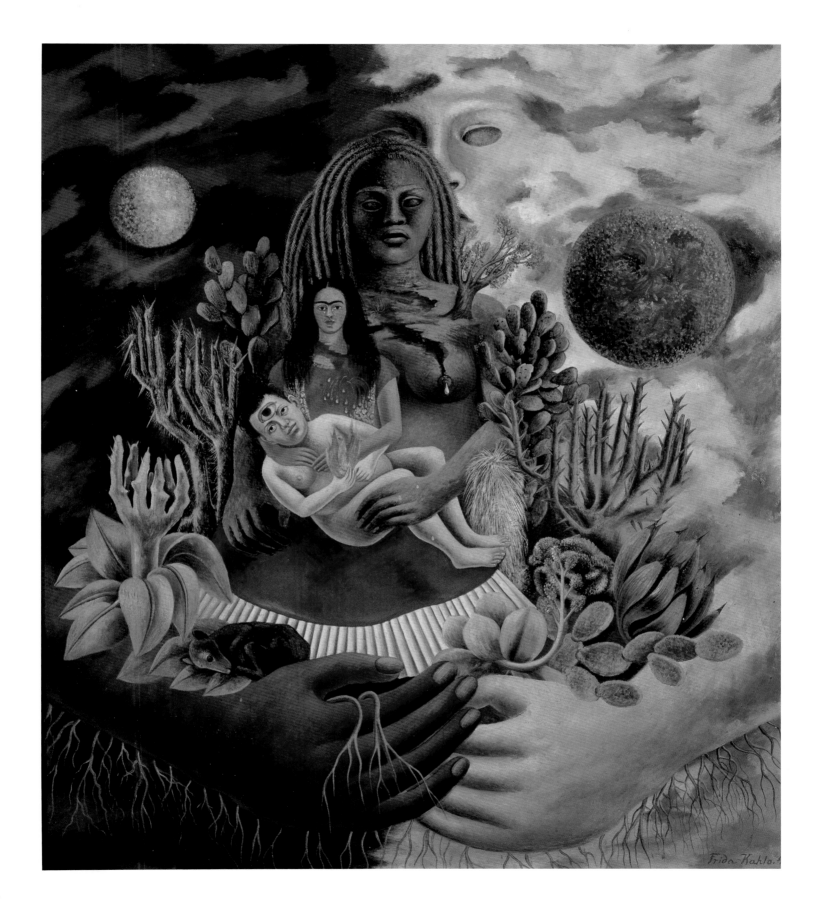

13 de noviembre 1944.
 Coyoacán.

niña de mis ojos,
Ya sabe usté cómo lo adoro,
y cómo quisiera que éste,
y todos los días, fueran
los mejores.
Bébase un vaso de vino a mi
salud. Su niña Fisita.

Pain – Love – Liberation
Frida Kahlo's Words

Raquel Tibol

The life and paintings of Frida Kahlo have been the subject of books, essays and articles published all over the world; to date, however, none of her own writings has been included in any anthology either of twentieth-century literature in general, or of women's literature in particular. Nor is she mentioned in studies focusing on the literary output of women Surrealist artists working in Mexico, such as Alice Rahon, Remedios Varo, Eva Sulzer and Leonora Carrington. References to her so-called *Diary*,[1] that highly original volume of bound papers in which, from 1944 to 1954, Kahlo blended word and image, tend to concentrate on its pictorial components (some of them outstanding) at the expense of the literary element, which is far removed from the conventional diary either as chronicle of daily events or as confessional record.

To judge by the earliest text discovered to date – 'Recuerdo' (Memory), a piece of prose poetry dating from 1922 – it may be assumed that at the age of fifteen, influenced by her nonconformist writer friends, Kahlo intended to cultivate a style that reflected her early fascination and sympathy for everything that was different and avant-garde.

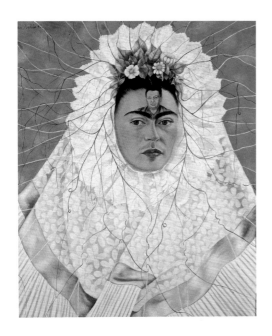

Recuerdo
Yo había sonreído. Nada más. Pero la claridad fue en mí, y en lo hondo de mi silencio.
Él me seguía. Como mi sombra, irreprochable y ligera.
En la noche, sollozó un canto …
Los indios se alargaban, sinuosos, por las callejas del pueblo.Iban envueltos en sarapes, a la danza, después de beber mescal.Un arpa y una jarana eran la música, y la alegría eran las morenas sonrientes.
En el fondo, tras del Zócalo, brillaba el río.Y se iba, como los minutos de mi vida.
Él, me seguía
Yo terminé por llorar. Arrinconada en el atrio de la Parroquia, amparada por mi rebozo de bolita, que se empapó de lágrimas.

Memory
I had smiled. Nothing more. But brightness was in me, and in the depths of my silence.
He was following me. Like my shadow, irreproachable and light.
In the night, there sobbed as song …
The Indians wound in long lines through the narrow streets of the village. Wrapped in sarapes, they moved with dancing steps, after drinking mescal. A harp and a jaran were the music, and smiling dark-skinned women were the gaiety.
In the background, behind the Zocalo, the river shimmered. And moved on, like the minutes of my life.
He was following me.
I ended up weeping. Curled up in a corner of the parish churchyard, cloaked in my *rebozo de bolita*, which was drenched with tears.

fig.105
Portrait of Miguel N. Lira 1927
(pl.6)

'Memory' was published on 30 November 1922 in *El Universal Ilustrado,* a weekly that often carried contributions from members of the Stridentist group. Stridentism, a movement largely inspired by Futurism and Dadaism, had emerged in Mexico in late 1921 and, in the words of its leading exponent, the writer Manuel Maples Arce, sought to subvert 'the reactionary principles that standardise the thinking of American youth'. The key elements of the Stridentist creed were: emotion as the wellspring of aesthetic creation; an arbitrary, fragmented and vibrant approach to art; renewal through radical opposition to entrenched ideas; a colourful, personally shaded vocabulary, inner strength, free association, verbal pyrotechnics; solidarity with the workers and the peasants, and the demand for structural change in society. In the tenth page of the *Diary,* Kahlo wrote, in ochre ink:

> Numbers, the economy,
> the farce of words,
> nerves are blue.
> I don't know why – red, too;
> but full of colour.
>
> Through round numbers
> and coloured nerves
> stars are made
> and worlds become sound.

On a later page, she wrote:

> There is nothing more precious than *laughter* and scorn. Strength lies in laughing
> and letting oneself go. In being cruel and superficial. *Tragedy* is the most
> ridiculous feature of 'Man', yet I am sure that *animals*, though they *'suffer'*,
> do not *parade* their grief in 'theatres' either *open* or 'closed' (their 'homes').

The Stridentist poet Miguel N. Lira was a close friend of Kahlo's at the National Preparatory School, where they and Kahlo's first boyfriend Alejandro Gómez Arias were members of an irreverent group known as the Cachuchas, the name deriving from the distinctive working-class cloth cap worn by its members as a badge of identity. They all loved reading, music and exchanging poems – their own and others' – and were keen to keep abreast of cultural and political developments both at home and abroad. They used to annoy the staff with such pranks as putting drawing pins on teachers' chairs and setting off small home-made bombs; one such bomb, set off by Kahlo, damaged the beautiful old school building, leading to her expulsion.

 The idea of submitting 'Memory' for publication was probably put forward by Lira (whom Kahlo nicknamed Chong Lee, Prince of Manchuria, because of his fondness for Chinese culture). Although this sort of literary venture was not to be repeated, elements of the Stridentist style were to be found in Kahlo's other writings, until they were partially displaced by, or combined with, Surrealist forms. Early on, Kahlo gave a number of drawings and watercolours to Lira (who later became a publisher and organiser of cultural activities); in 1927, she painted a portrait of him in an openly Stridentist style (fig.105), though she never saw herself as belonging to the movement. Lira was keen for Kahlo to paint him in an avant-garde style; she opted for a naive, sound-based symbolism, since the Stridentists were often dismissed as noise-makers. In the upper part of the canvas she placed a lyre (a play on his surname) and, behind, a bell ringing 'TAAAAAAAAANN'. To the right of the subject she wrote his name, 'Miguel', while to the left she painted a figure of St Michael the Archangel.

 It was not until twenty-five years after writing 'Memory' that Kahlo again wrote anything intended for publication. In 1947, at the request of the National Institute of Fine Arts, she wrote an entry about herself for an exhibition of forty-five

self-portraits by Mexican painters from the eighteenth to the twentieth centuries; the entry was included in the catalogue, and also used as the text beside her work, a portrait in oils entitled *Diego on My Mind,* painted in 1943 (fig.104). With her usual candour, Kahlo wrote:

> I really don't know whether my paintings are Surrealist or not, but I do know that they are the most honest expression of myself, taking no account of the opinions and prejudices of others. I have not painted much, and do not have the slightest ambition or desire for glory; I am determined first to please myself, and then to earn a living with my work.

In a letter written in 1939, however, she had provided a clear explanation of one of the most striking features of her work: the predominance of the self-portrait.

> Since my subjects have always been my sensations, my states of mind and the profound reactions that life has prompted in me, I have often objectified all this in figures of myself, which were the most real, most sincere thing I could do to express what I felt within and outside myself.[2]

In 1949, the Palace of Fine Arts asked her to contribute to a book-length catalogue of the great exhibition *Diego Rivera: Fifty Years of Artistic Labour*, a portrait in words of the man with whom she had lived for twenty years. The result was a piece of literature of exceptional quality.[3] Kahlo starts by describing Rivera's naked body from head to toe: 'a Buddha-like mouth with fleshy lips ... the greenish-white skin of an aquatic animal ... narrow, rounded shoulders ... feminine arms ... small hands ... marvellously sensitive Lesbian breasts ... specific, strange virility ... enormous sphere-like belly ... handsome legs like columns ... elegant movements'. She adds of this 'loveable monster' that she would like 'to hold him always in her arms like a new-born baby'.

Anticipating the comments of those who might expect complaints from her at the suffering caused by Rivera's infidelities, she warned:

> I do not believe that the banks of a river suffer by letting it flow through, nor that the earth suffers because it rains, nor that an atom suffers when it discharges its energy ... for me, everything has its natural compensations. Within my dark, difficult role as the ally of an extraordinary human being, my reward is that of a green dot in a sea of red: the reward of balance.

The 'Portrait' focused primarily on Rivera as 'revolutionary fighter ... untiring worker ... tireless researcher', a man wholly lacking in prejudices, and 'enveloped in a mobile atmosphere of love'. Kahlo imagined that Diego's ideal world

> would be a great fiesta in which each and every one of its beings would take part, from men to stones, from suns to darkness: all contributing their own beauty and creative power. A fiesta of form, colour, movement, sound, intelligence, knowledge and emotion. A spherical, intelligent, loving fiesta.

Seeing herself as his ally in the fight to build a world free of cowardice, of lies, of false foundations, Kahlo devoted much of her text to refuting accusations regarding Rivera's behaviour both in public and in private, replying with specific examples to the abuse and attacks levelled against the man and his work as painter, architect and collector of Prehispanic art:

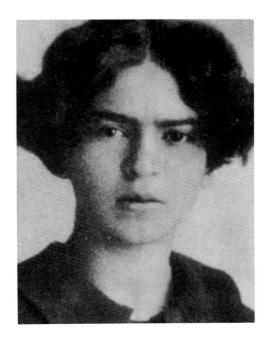

> They say he's a mythomaniac, a publicity-seeker and – most ridiculous of all – a millionaire. His alleged mythomania is directly related to his tremendous imagination; in other words, he lies just as poets do, or children who have not yet been stultified by school or their mothers ... By lying, or playing at lying,

fig.107
Card from 1926:
'LEONARDO
BORN IN THE RED CROSS
IN THE YEAR OF OUR LORD
1925 IN THE MONTH OF
SEPTEMBER AND BAPTIZED
IN THE TOWN OF COYOACÁN
THE FOLLOWING YEAR

HIS MOTHER WAS
FRIDA KAHLO
HIS GODPARENTS WERE
ISABEL CAMPOS AND
ALEJANDRO GÓMEZ ARIAS'

he unmasks some people, and he learns what drives others who, as liars, are much more naive than he is… The truth of the matter is that Diego is one of the few people bold enough to attack the very foundations, to combat – face to face and fearlessly – the so-called MORAL structure of the hypocritical society we live in …

It is incredible, by the way, that the basest, most cowardly, most foolish insults have been spat at Diego in his own home: Mexico. In the press, in barbaric acts of vandalism by those who have sought to destroy his work …

As for this business of Diego's millions, the real truth is this: because he is a craftsman, and not a wage-earner, he owns his means of production (i.e. his work), a house to live in, a few clothes and a battered van that he uses the way a tailor uses scissors. His treasure is a collection of superb sculptures, jewels of native art … that he has been collecting – not without considerable financial sacrifice – with a view to housing them in a museum that he's building.[4]

She defended his views, his 'receptive and creative mechanism', the 'crudity of his concepts', because after all 'he gives pleasure in exchange for pleasure, effort in exchange for effort'. She further argued: 'In the society in which he lives, all of us who – like him – are aware of the imperative need to destroy the false foundations of the present world, are his allies'.

Following her serious accident on 17 September 1925, Kahlo's letters became a ladder of words by which to escape her enforced confinement, to keep her friends from forgetting her, to keep love's vows from cooling. She had, however, been a keen letter-writer since adolescence; the letters collected until now (others are still to be published) date from 1922 onwards. In certain sentences, sometimes even whole paragraphs, the echoes of Stridentism can be discerned in the syntax and rhythm, in the blending of Spanish and English. The letters are a mixture of refinement and obscenity, artifice, aggression and vulgarity. An outlet for her passion, a desperate game, they are seasoned with satire and a certain earthiness, yet at the same time contain stretches of *ennui* that produce their own verbal noise. They reveal her anxiety about the family's reduced circumstances following the outbreak of revolution in 1910, and also hint implicitly at a precocious but unsatisfied sexuality; they speak openly of the physical and psychological effects of her personal tragedy. This is evident in a letter to Gómez Arias dated 29 September 1926[5]:

Why do you study so hard? What secrets are you searching for? Life will reveal them to you, all at once. I know everything now, without reading or writing. Not long ago, just a few days ago, I was a child walking through a world of colours, of hard, tangible forms. Everything was a mystery of things concealed; deciphering and learning were an enjoyable game. If only you realised how terrible it is suddenly to know everything, as though the world were lit by a flash of lightning. Now I live on a painful planet, transparent as ice; nothing is concealed, it is as if I had learnt everything in a few seconds, all at once. My friends, the girls at school, have slowly become women; I aged in a moment, and today everything is flat and bright. I know that there is nothing else beyond; if there were, I would see it.

This precocious yet profound self-searching was captured in the best of her paintings, where oil paints blended with the blood of her inner monologue. Her shadowy colours became a velvety background in images that convey a highly refined and intelligent sensitivity.

186

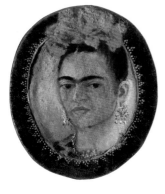

From 25 May 1953, I spent several weeks with Frida at her home in Coyoacán. I asked her to dictate her life story to me;[7] taking notes, I was surprised at first by the peculiar boldness of her language, an impression reinforced when I was allowed to read her *Diary*. She had asked me to write out the poem 'Se equivocó la paloma' (The dove was mistaken) by the Spanish poet Rafael Alberti, set to music by the Argentine composer Alberto Ginastera, which I had sung for her and a group of friends. That page, together with eighteen others, was torn out of the *Diary* at some stage after the opening of the Museo Frida Kahlo in Coyoacán in 1958; I know that the *Diary* was complete when it was placed under glass, because I leafed through it on a number of occasions. Several of the remaining pages were altered. In the internationally circulated edition, the magical key to her palette no longer includes all the words it contained when I copied it out in the 1950.[8] It runs as follows:

> **green** a good warm light.
> **solferino** Aztec *Tlapali* [the Aztec or Nahuatl word for colour]. Old prickly-pear blood. The oldest and brightest.
> **coffee** colour of *mole* [chile sauce], of fading leaves. Earth.
> **yellow** madness, sickness, fear. Part of the Sun and of happiness.
> **cobalt blue** electricity and purity. Love.
> **black** nothing is black, really nothing.
> **leaf green** leaves, sadness, science. The whole of Germany is this colour.
> **greenish yellow** more madness and mystery. All ghosts wear clothes of this colour, or at least underwear.
> **dark green** the colour of bad news and good business.
> **navy blue** distance. Tenderness can also be this blue.
> **magenta** blood? Well, who knows!

These poetic 'correspondences' show that, for Kahlo, colours were not to be perceived simply as colours, but as a starting point for discovering new horizons, for giving free rein to the imagination. It is worth noting, too, that on 30 June 1948 the renowned psychiatrist Alfonso Millán performed a Rorschach psychodiagnostic test which drew attention to the highly developed combinative and fantasy-related aspects of Kahlo's intelligence.

I published parts of the *Diary* in 1956, in the review of a tribute to Kahlo, held two years after her death at the gallery run by her friend Lola Álvarez Bravo,[9] who had organised a solo exhibition in April 1953. In 1974, Gómez Arias allowed me to publish, for the first time, some of Kahlo's letters to him.[10] My decision to focus on Kahlo as a writer rather than just a painter was stimulated by this growing contact with an imaginative language through which she laid bare her soul and her innermost thoughts. At the same time – through constant switching of styles – she sought both to conceal extreme suffering and to give free rein to a certain flirtatiousness, treating casual encounters as if they were the love of her life (painters as intelligent as Ignacio Aguirre and José Bartolí were taken in). I started to collect letters, notes, messages, confessions, acknowledgements, ballads, applications, protests, expressions of gratitude, and pleas.[11] The following texts, from three different decades, may give a flavour of her writing. From a letter to Gómez Arias, 25 December 1924:[12]

> Sometimes at night I feel very frightened and I would like you to be with me, to stop me being so frightened and to tell me that you love me just as much as you did before, as much as last December, even if I'm an 'easy thing', aren't I, Alex? You have to start liking easy things … I'd like to be even easier, a tiny little thing that you could just carry around in your pocket for ever and ever …

From a letter to Ella and Bertram D. Wolfe, dated 18 October 1934, after finding out about Rivera's affair with her sister Cristina:[13]

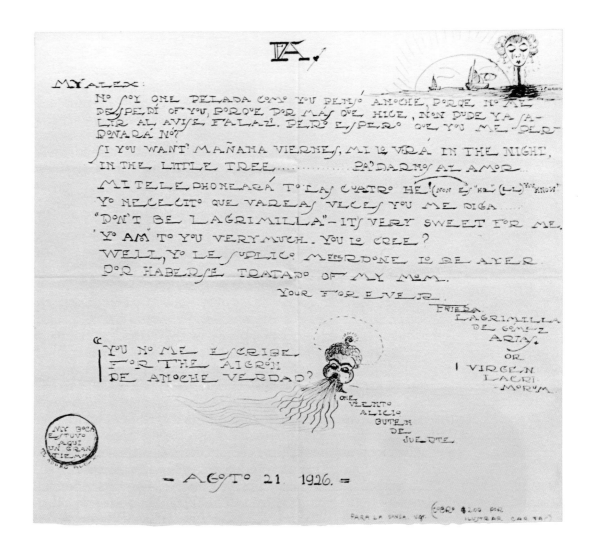

It is a twofold grief, if I may explain it like that. You know, better than anyone, what Diego means to me in all senses, and, at the same time, she was the sister I loved best, and whom I tried to help as much as I could … Of course, this is not just silly sentimentality on my part; it affects my whole life and that's why I feel lost, and nothing can help me to react intelligently. Here in Mexico I have no one, I only had Diego and my family at home, who are taking a Catholic approach to the matter, and their conclusions are so alien to my own that I can't rely on them for anything. My father is a wonderful person, but he reads Schopenhauer day and night, and is no help to me at all … The life we live is false and full of nonsense that I can't cope with any more. He [Diego] has his work, first and foremost, which spares him from many things; then his affairs, which he enjoys. People seek *him* out, *not me* … I have nothing, because I don't have him. I never realised that he meant *everything* to me, and that without him I was worthless.

In August 1945, the well-known businessman José Domingo Lavín, who had commissioned *Moses* (pl.69), invited Kahlo to explain the painting to a gathering of friends at his home. Among other things, Kahlo said:[14]

What I wanted to convey most intensely, most clearly, was that the reason people need to invent or imagine heroes and gods is pure *fear.* Fear of life and fear of death. I started painting the figure of Moses as a child. I painted him as he is described in many legends, abandoned in a basket and floating along a river. In artistic terms, I tried to make the open basket, covered with an animal hide, as reminiscent as possible of a womb, because – according to Freud – the basket is an exposed womb, and water signifies the maternal spring from which the child is born. To highlight this, I painted a fully developed human foetus surrounded by placenta, and hand-like Fallopian tubes stretching out towards the world. On either side of the child, I placed the elements of his creation – the fertilised ovum and the dividing cell.

The collecting together of this material into a single volume, first published in 1999 as *Escrituras de Frida Kahlo*, had two major results. First, it created an implicit autobiography, a first-person discourse wholly free of interpretation and over-interpretation, untainted by the ethical, aesthetic or psychological views of others; Kahlo as seen by Kahlo, torn between sincerity and manipulation, veering between complacency and sharp self-criticism, her lacerating vitality quickened by sparks of humour. It testifies to her insatiable need for love, to the unbridled erotic passion that led her into lesbian encounters with Georgia O'Keeffe[15] and episodes of masturbatory elation with the renowned homosexual poet Carlos Pellicer;[16] it provides powerful evidence both of her self-awareness and of her extreme humility.[17] The second result was this: in view of all she wrote, and how she wrote it, it became clear to me that Kahlo deserves to be accorded, at long last, her rightful place in twentieth-century Mexican confessional literature.[18] With this end in mind, I asked Antonio Alatorre, a respected philologist and literary critic, to write a Foreword to the third edition of the collected writings. In this introduction, Alatorre observed:[19]

> The first thing that struck me was the naturalness of her language, her fondness for Mexican slang. I feel as if Frida were chatting to me in private; I cannot help smiling at her picturesque idioms … She clearly loves them, and is fully aware of their expressive force. Every one of them clicks perfectly into place in the text … I noted earlier that I was struck by the *naturalness* of her language. Now I would add that this very naturalness is largely the product of 'artifice', of conscious manipulation.

The 'artifice' noted by Alatorre may to some extent reflect Kahlo's growing addiction to drugs and alcohol,[20] which probably inspired the more hallucinatory and poetic passages of her writing, both in the *Diary* and elsewhere. On 12 October 1934, she wrote to Gómez Arias:[21]

> My head is full of microscopic spiders, and innumerable tiny vermin … I can't get anything straight inside the *big realité* without moving directly onto a collision course; either I have to hang my clothes from thin air, or I have to bring distant things perilously, fatally close. You'll sort it out with your ruler and compass.

One day in 1938 she pleaded:[22]

> Respond to my love with a mighty epistle, that will cheer the saddened heart that beats for you from here, louder than you could ever imagine. Just listen to it: TIC-TAC TIC-TAC TIC-TAC TIC-TAC! Literature is hopeless at portraying things, at conveying the full volume of inner noises, so it's not my fault if instead of my heart you hear only a broken clock.

fig.112
Thinking About Death 1943
(pl.43)

Two pieces of prose poetry from the 1950s offer bitter proof of a desperation
that had dragged her to the brink of an abyss; to avoid falling, she clung to her
motherly-daughterly feelings for Rivera:

I

Diego my love
Pure farce, not even Freud would be interested.
Why did I start drawing this, if it pushes me to destroy?
I want to build. But I am just an insignificant though important part of a whole
that I am not yet aware of. There is nothing new inside me. Just the stupid old
things my parents left me.
What is happiness?
Creation upon discovery.
To know others
is an empty heritage
When one has talent and ambition it's better to make oneself scarce
and let the others 'have a try'
NOTHING
SHIT
Everything can have beauty, even the most horrible things.
Better to keep quiet.
Who knows anything about chemistry?
" " " " biology?
" " " " life?
" " " " building things?
How wonderful it is to live with Frida.[23]

II

in saliva
in paper
in an eclipse.
In all the lines
in all the colours
in all the paint pots
in my breast
outside, inside –
in the inkwell – in my inability to write
lines of sun (the sun has no lines) in
everything. Just saying in everything is stupid and magnificent.
Diego in my urine – Diego in my mouth – in my
heart, in my madness, in my sleep – in the
blotting paper – in the pen nib –
in the pencils – in the landscapes – in
food – in metal – in my imagination.
In diseases – in glass cases –
in his lapels – in his eyes – in his mouth.
In his lies.[24]

The literary element of the *Diary* cannot be viewed as an organic whole, but
rather as a series of fragments welded together by heartbreak and loneliness.
It is remarkable for its verbal probing, for certain confidences conveyed with
poetic intensity and supported by the magical visions through which she sets free
her libido, imagines a physical release despite her confinement, holds madness
and looming grief at bay. These visions are at times highly specific, blending the

rational and irrational, turning her ever in upon herself in search of ecstasy.
Although Frida Kahlo never planned to have a place in twentieth-century literature,
she must be hailed as a writer who developed new linguistic usages to express
her own existential and aesthetic tensions. In pushing her sincerity to its limits,
she wrote a key chapter in confessional literature; her words created a highly
sensitive interaction between art and life.

Kahlo's political militancy has been so distorted and exaggerated by various
writers, that it might usefully be charted in her writings. The last pages of
the *Diary* contain an 'Outline of my Life', full of deliberate errors. She claims
to have been born in 1910, rather than in 1907; that she was four (she was
actually five and a half) on 9 February 1913, at the outbreak of the military
rising known as the Tragic Ten Days.[25] The rising ended with the seizure of
power by Victoriano Huerta and the assassination, on 22 February, of President
Francisco Ignacio Madero and Deputy President José María Pino Suárez.
We can believe Kahlo's assertion:

> I saw with my own eyes the clash between Zapata's peasants and the forces
> of Carranza … The bullets just screeched past then, in 1914. I can still hear
> their extraordinary sound. They used to drum up support for Zapata in
> Coyoacán marketplace, with songs published [she probably meant illustrated]
> by [José Guadalupe] Posada. Cristi and I used to sing them, hiding in a big
> wardrobe that smelled of walnut.

As a child, she used to sing folk-songs, indeed, she sang them throughout her life,
and even wrote occasional ballads in an appropriate style. By contrast, there is
no documentary evidence to support her claim: 'My clear, precise emotional
memories of the "Mexican Revolution" were the reason why, at the age of thirteen
[she was actually sixteen in 1923] I joined the Communist Youth movement.' Her
Communist Party membership card, issued in 1953, is on display at the Museo
Frida Kahlo in Coyoacán; the *Diary* entry for that date reads: 'I have understood
dialectical materialism for many years.'
 Frida Kahlo's political views and social concern are more clearly apparent
in her letters. In 1927, General Álvaro Obregón, who had been the President of
the Republic from 1920 to 1924, stood for re-election; on 22 July of that year, Kahlo
wrote to Gómez Arias: 'Sensational! The Mexican Revolution: re-electionists,
anti-reelectionists. Interesting candidates José Vasconcelos and Luis Cabrera.'[26]
In reality, the visible anti-reelection candidates were Francisco Serrano and Arnulfo
R. Gómez, who was later to be executed for sedition. The subject crops up again
on 2 August 1927: 'In the papers, I only read the "editorial" and what's happening
in Europe. Nothing is known yet of the revolution over here; right now, Obregón
seems to be the most likely bet, but no one knows anything.'[27] News was soon
to be forthcoming: Obregón was assassinated shortly after his re-election in 1928.
Two events in 1927 must have had an impact on Kahlo: the arrival, in January that
year, of the attractive, refined Alexandra Kollontai as the Soviet Union Ambassador,
and the broad-based campaign in support for Nicola Sacco and Bartolomeo
Vanzetti (Italian workers unjustly accused of murder, who had already been
sentenced to death)[28] which involved numerous groups nationwide. This might
explain why, in August of that year, she urged Lira to 'Sing the *Internationale*
because its body belongs to the whole world, like the wave of socialism!',
which she describes as 'the howling of all men in the universal minute'.[29]
 In July 1929, a month before he married Kahlo, Rivera was expelled from
the Mexican Communist Party – which he had joined in 1921 – because of his
support for the leftist opposition movement within the Third International.[30]
In March 1930, another Mexican artist, David Alfaro Siqueiros, was also expelled

because his activities within the workers' movement were held to be incompatible with orthodox Mexican Communist Party views. Though increasingly sympathetic to Trotskyism, Siqueiros's deep-seated Stalinist faith led him to publish a vitriolic article entitled 'Rivera's Counter Revolutionary Road' in the 29 May 1934 issue of the New York review *New Masses.* In the face of this attack, Frida displayed unwavering support for Diego, as she made clear in a letter to Ella Wolfe, written on 11 July:[31]

> Just imagine! The other day I bumped into that pig Siqueiros at Misrachi's house. He had the nerve to say hello to me even after writing that bloody article in the *New Masses;* I just looked straight through him, and didn't answer. Diego did worse: Siqueiros said to him: 'How's it going, Diego?', and Diego got out his handkerchief, spat in it and put it back in his pocket; he didn't spit in his face because there were a lot of people around and it would have caused a scandal, but I can tell you that Siqueiros was totally crushed, and slunk off with his tail between his legs. What did you think of the article? To my mind, the pig deserves to be roasted alive. Don't you think? Diego doesn't want to write a reply, because it would only make the idiot look more important, but I'm going to tell him to write it, just to show him where he gets off. There's no reason why the s.o.b. should get away with it ...

At Kahlo's insistence, Diego decided to publish an unsigned pamphlet, *Defence and Attack against the Stalinists*, in which he argued that: 'To attack Rivera for producing paintings which, like any *objet d'art* under the capitalist régime, may eventually be used for speculative purposes by their purchasers – paintings which, according to Siqueiros, Rivera sells at high prices – is as stupid and antimarxist as accusing a jeweller or a shoemaker of being a counter-revolutionary because the rich buy his products.' But the dispute between Rivera–Kahlo and their Trotskyist opponents did not end there; in a letter to Ella Wolfe in March 1936,[32] Kahlo refers to the American intellectual Harry Block, married to the Mexican Malú Cabrera:

> [Diego] had a serious argument with Harry Block, and told him to go to hell – just imagine, in the end he turned out to be just another of Stalin's bootlickers, hoping to play politics here in favour of the C.P. [Communist party], using the disgusting, stupid methods that all Stalinists use; so as it turns out, we would have done better to stop being friends with Harry and Malú at the time of the Siqueiros affair.

By 1952, Kahlo had not only forgotten her Trotskyite fervour, but also recanted in the pages of her *Diary*, claiming:

> I am a communist being. I have read the History of my country, and of almost all nations. I know all about their class struggles and their economic conflicts. I have a clear understanding of the dialectical materialism of Marx, Engels, Lenin, Stalin and Mao Tse. I love them as the pillars of the new Communist world. I understood Trotsky's error as soon as he got to Mexico. I was never a Trotskyist. But at that time – 1940 – I was only Diego's ally *(personally)* (a political error). I was of no use to the Party. Now, in 1953, after 22 operations, I feel better and from time to time I'll be able to help my Communist Party. I am just a cell in the complex revolutionary mechanism of the people's movement for peace.

In fact, Kahlo was Rivera's best ally at a time when – from within the world peace movement – he was seeking to rejoin the Communist Party. This change of heart had begun in 1939, when Rivera renounced Trotskyism and even lent some support to the failed attack launched by Siqueiros's group on Trotsky's house

fig.113
Kahlo, 2 July 1954, at the
demonstration against CIA
involvement in Guatemala

in Coyoacán. Rivera's political fickleness plunged Kahlo into the depths of bitter despair, expressed in the saddest of her many letters (11 June 1940) to Rivera.[33] It wounded something she could not and would not renounce: her loyalty. It was he who, in November 1939, asked for the divorce (they remarried on 8 December 1940), not telling her that his reason was to prevent her suffering any repercussions resulting from his indirect involvement in the attack on Trotsky. Rivera left her a power of attorney so that she could deal with his affairs, but failed to add that he planned to ask the actress Paulette Goddard to approach the US immigration authorities with a view to speeding up the granting of his entry visa. Kahlo was deeply offended, and in that letter of 11 June 1940 gave vent to her indignation:

> Please convey to Mrs Goddard my deep gratitude for such splendid and timely assistance, and in particular for her punctuality and the 'coincidental' departure time of her plane. She must be clairvoyant … If I was considered *untrustworthy* in certain matters, right up until the last minute, and she was favoured with total confidence, there must have been reasons. I, unfortunately, was wholly unaware that I had been reckoned among the *cowards and suspects*. Now, all too late, certain things have become clear.

The sudden change in her situation prompted some people to shun her. The letter reveals her fury:

> The rest have been treating me like dirt ever since I lost the honour of belonging to the famous artists' elite, and especially since I stopped being your wife … all the 'decent folk' in Mexico, all the ladies at their charitable functions, shameless tarts working the streets, don't deign – since I am in poor health – to speak to me when we meet, for which I am very grateful and perfectly satisfied. I don't see anyone, and above all I shan't see any more of those snobbish, bootlicking pigs.

In the midst of this gloomy state of affairs, the question of financial dependence, which had long worried Kahlo, resurfaced:

> When I found out that you had kept the first self-portrait I painted this year, or last year – I don't remember – which I had naively taken to Misrachi's[34] house so that it could be delivered to the buyer … and that you and Misrachi had deceived me, gently, charitably, and when I saw that it had not even been unwrapped, which might have made the deceit rather more forgivable, since you claim you switched my painting for one of yours so as not to be left without my portrait, I finally understood a lot of things … you sold it to Kaufmann so that he could give me the money, and that was all I had to live on last year and this year. In other words, your money. I've still been living off you, and cherishing other hopes. My conclusion is that I have done nothing but fail. As a kid, I wanted to be a doctor, and I was flattened by a bus. I lived with you for ten years, and in short I was nothing but a nuisance; I started painting, pictures that no one but me likes, and that you have to buy knowing that nobody else will. Now that I would have given my life to help you, it turns out that other women are your real 'saviours'. Maybe I'm only thinking about this now because I'm fed up and lonely, and especially overwhelmed by inner weariness … I don't feel the slightest bit like working, even if I could summon up the enthusiasm. I'll go on painting only so that you will see my work. I don't want exhibitions or anything. I'll pay my way with painting, and then – even if I have to swallow shit – I'll do whatever I fancy, whenever I fancy.

Always faithful to herself, Kahlo did exactly as she had promised. One of the experiences that most annoyed her was the time she spent in Paris with a number of Surrealists; in February and March 1939, she took part in an exhibition

193

January. — 1940

Nick darling,

I received the hundred bucks of this month, I don't know how to thank you. I couldn't write before because I had an infeccion in the hand which didn't let me work or write or any thing. Now I am better, and I am working like hell. I have to finish a big painting and start small things, to send to Julien this month. The 17th it will be a show of surrealist painting, and every body in Mexico has become a surrealist because all are going to take part on it. This world is completly cockeyed, Kid!! Mary wrote to me and sayed that he hasn't seen you for a long time. What are you doing? It seems to me that you treat me now only as a friend you are helping, but nothing more. You never tell me about yourself, and not even about your work. I saw "Coronet" and my photo

its the best of all. The other wenches are OK too, but the one of myself is a real F. W. (Do you still remember the translation? "forking wonder") I think Julien will sell for me this month or next a painting to the Arensberg (Los Angeles). If he does, I told him to pay back to you the money you send me. because it is easier to pay little by little than to wait till the end of the year. Don't you think so? You can't have any idea of the strange feeling I have owing you money. I wish you would understand. How is Arija? and Lea? Please tell me things of yourself!!! Are you better of your sinus trouble? I feel lousy. Every day worse and worse. Any way I am working. But even that I don't know how and why? Do you know who came to Mexico? That awful wench of Ione Robinson I imagine she thinks that the road is clear now!..... I don't see any body. I am almost all day in my house. Diego came the other day to try to convince me that nobody in the world is like me! Lots of crap, kid! I cant forgive him — and that is all

My love to mam.

Your mexican wench
Frida.

fig.115
Sheet with drawings
'To feel my own pain the pain
of all those who suffer and
inspire me in the need to
live in order to struggle
for them Frida'
Copy in the collection
of Martha Zamora

of Mexican art organised by André Breton, with the assistance of Marcel Duchamp, for the Renou et Colle gallery. She was totally disgusted by the behaviour of the Surrealists (with the exception of Duchamp, of whom she was very fond), and made this clear in a letter, written in English, on 16 February 1939 to Nickolas Muray,[35] perhaps the dearest of her lovers:

> You have no idea the kind of bitches these people are. They make me vomit. They are so damn 'intellectual' and rotten that I can't stand them any more. It is really too much for my character. I rather sit on the floor in the market of Toluca and sell tortillas, than to have anything to do with those 'artistic' bitches of Paris. They sit for hours on the 'cafés' warming their precious behinds, and talk without stopping about 'culture', 'art', 'revolution' and so on and so forth, thinking themselves the gods of the world, dreaming the most fantastic nonsenses, and poisoning the air with theories and theories that never come true.
>
> Next morning – they don't have anything to eat in their houses because *none of them work* and they live as parasites of the bunch of rich bitches who admire their 'genius' of 'artists'. *Shit* and only *shit* is what they are. I never seen Diego or you wasting their time on stupid gossip and 'intellectual' discussions, that is why you are real *men* and not lousy 'artists' – gee weez! It was worthwhile to come here only to see why Europe is rottening, why all this people – good for nothing – are the cause of all the Hitlers and Mussolinis. I bet you my life I will hate this place and its people as long as I live. There is something so false and unreal about them that they drive me nuts.

Despite visits to Mexico by Antonin Artaud, André Breton, Wolfgang Paalen, César Moro, Benjamín Péret, Rahon, Varo and Carrington, there was never really a fully wrought Mexican chapter of the Surrealist movement. Any affinities were sought by art critics and historians, rather than by the artists themselves. Moreover, Mexican artists who worked in a similar style, or who felt some affinity towards Surrealism, had never formed groups. This is particularly unusual since surrealism or surrealist-like practices had appeared in Mexican art prior to the arrival of the founders and militants of the European movement. In short, there was no Mexican Surrealist movement, although there was Mexican surrealist art. In 1938, Breton welcomed Kahlo into his kingdom, writing an article entitled 'Frida Kahlo de Rivera', which – following publication in French for the catalogue of Kahlo's solo show at the Julien Levy Gallery in New York and in several reviews – appeared in the enlarged and corrected edition of Breton's *Le Surréalisme et la peinture* (1965). The New York show was held from 1 to 15 November 1938. Twelve of the twenty-five paintings exhibited were sold, which pleased Kahlo as much as the positive reviews in *Vogue, Life* and other publications. Afterwards, Rivera encouraged her to try her luck in Paris, with Breton's assistance. He probably felt that there would be some return for their earlier hospitality in inviting the Surrealist leader and his wife to stay at Kahlo's San Angel house. Breton and his wife, while not refusing, hardly appeared enthusiastic.[36]

Undoubtedly, both Kahlo and the Surrealists saw art as the key to a better understanding of the reality around them; but, having had to overcome constraints of all sorts in order to work, she found unacceptable something that Péret had asserted as an incontrovertible historic truth: that Surrealism originated in Paris, from the heated café debates of idle artists.

Translated by Paul Edson

Notes

1 The *Diary* is kept on show, under glass, at the Museo Frida Kahlo, Coyoacán, Mexico City. A facsimile edition can be found in *The Diary of Frida Kahlo: An Intimate Self-Portrait*, with an Introduction by Carlos Fuentes, and essays by Caren Cordero, Olivier Debroise, Sarah M. Lowe and Graciela Martínez-Zlace, Mexico City 1995.

2 Letter to her friend the composer Carlos Chávez, who was helping her apply for a Guggenheim Fellowship; despite many letters of recommendation, she was not awarded the Fellowship.

3 'Retrato de Diego', in *Diego Rivera: Homenaje a los 50 años de su lobor artistica*, exh. cat., Palacio de Bellas Artes, Mexico City 1949.

4 The Anahuacalli Museum, which contains over 50,000 pieces of Prehispanic art, was donated by Rivera to the people of Mexico. The museum building, located in the Los Pedregales area of Mexico City, was erected and decorated by the artist himself.

5 First published in Adelina Zendejas, 'Frida Kahlo', in 'El Gallo Ilustrado', supplement to the newspaper *El Día*, 12 July 1964.

6 The *Miniature Self-Portrait* was one of several presents given by Kahlo to her lover José Bartolí (1910–1995), a Catalonian painter, caricaturist and political cartoonist, who in 1936 had founded and presided over the Catalonia Cartoonists Union. He fought on the Republican side during the Spanish Civil War, and was afterwards interned in concentration camps in France and Germany. He fled to Mexico in 1942. In 1946, he visited the United States, where he became involved in a passionate affair with Kahlo; on 29 August of that year she wrote to him: 'Bartolí – last night I felt as though countless wings were stroking me all over, as though your fingertips were lips that kissed my skin. The atoms of my body are yours, and they vibrate together so that we can love each other. I want to live and be strong to love you with all the tenderness you deserve, to give you all the good there may be in me … I love you just as you are, I am in love with your voice, with everything you say, everything you do, everything you plan. I feel as if I always loved you, ever since you were born … I could write to you for hours and hours, I'll learn stories to tell you, I'll invent new words, and use them all to tell you that I love you more than anyone.' His widow, Dr Berenice Bromberg, auctioned the miniature together with some other items bearing amorous dedications, but she has refused to disclose around twenty love-letters that Kahlo wrote to Bartolí.

7 I published 'Fragmentos para una vida de Frida Kahlo' in 'México en la Cultura', supplement to the newspaper *Novedades* (Mexico), 7 March 1954.

8 I subsequently published the original version in my books *Frida Kahlo. Crónica, testimonios y aproximaciones,* Mexico City 1977, and *Frida Kahlo: An Open Life*, trans. Elinor Randall, Albuquerque 1993 (first published as *Frida Kahlo. Una vida abierta,* Mexico City 1983).

9 'Frida en el segundo aniversario de su muerte', in 'México en la Cultura', supplement to *Novedades*, 15 July 1956.

10 'Frida Kahlo a veinte años de su muerte', in 'Diorama de la Cultura', supplement to *Excélsior* (Mexico), 14 July 1974.

11 I set them out in chronological order, added the essential explanatory notes, and in 1999 persuaded the Universidad Nacional Autónoma de México to undertake the first publication of *Escrituras de Frida Kahlo;* new texts were added for the second edition in 2001, and further passages – bringing the total to 250 – were included in the 2004 edition published by Plaza y Janés, Mexico City.

12 First published in Hayden Herrera, *Frida: Una biografía de Frida Kahlo*, Mexico City 1984.

13 Bertram Wolfe Collection of the Hoover Institution Archives, Stanford, California.

14 'Hablando de un cuandro mío de cómo pertiendo de una sugestión del ingeniero José D. Lavín y una lectura de Freud, hice un cuadro de Moisés' (Speaking of one of my paintings, of how, starting from a suggestion by José D. Lavín and a text by Freud, I made a picture of Moses), *Así*, 18 August 1945.

15 In a letter dated 11 April 1933 (collection Martha Zamora), to the English sculptor Clifford Wight who worked with Rivera on the San Francisco and Detroit murals, Kahlo wrote, in English: 'O'Keeffe was in the hospital for three months, she went to Bermuda for a rest. She didn't make love to me that time.'

16 In November 1947 Kahlo wrote to the poet Carlos Pellicer: 'Can one invent verbs? Here is one for you: I *sky* you, meaning that my wings stretch wide open in boundless love for you. I feel that we have always been together since the start, that we are made of the same material, the same waves, that we have the same sense within us … thank you for being alive, for letting me yesterday touch your most intimate light.' (Letter, collection of Carlos Pellicer López, poet's nephew).

17 In a letter of 15 March 1941 to her doctor and close friend Leo Eloesser, she remarked: 'I have the feeling that the most important thing for everyone in Gringoland is to be ambitious, to get to be ''somebody'', and frankly, I don't have the slightest ambition to be anybody, I've not time for ''airs'',

and I'm not in the least interested in being the "big shit". (First published in Teresa del Conde, *Frida Kahlo: La pintora y el mito*, Mexico City 1992.)

18 Confessional, or private, literature uses a confidential tone to express the individual's thoughts and inner feelings; it has been practised by a number of writers. It should be constantly stressed that Kahlo's writings – like Kafka's diaries – were not intended for publication, and are thus valuable as revealed secrets.

19 Antonio Alatorre, 'Prólogo' in Raquel Tibol, *Frida Kahlo: Escrituras*, Mexico City 1999, p.7.

20 In 1938, she wrote to Ella Wolfe, the wife of Rivera's biographer Bertram D. Wolfe: 'You can tell Boit that I'm behaving myself, in the sense that I don't have as many "copious cups" … teardrops … of brandy, tequila, etcetera … I regard that as another step towards the liberation of the oppressed classes. I drank to drown my sorrows, but the little devils learnt to swim.' (First published in Herrera 1984.)

21 First published in Raquel Tibol, *Frida Kahlo: una vida abierta*, Mexico City 1983.

22 Extract from letter to Ella Wolfe cited note 19 above.

23 Written on an X-ray plate; copy, collection Ignacio M. Galbis, Santa Monica, California.

24 Collection Juan Coronel Rivera.

25 The term 'Tragic Ten Days' refers to the events that took place in the Mexican capital from 1 to 9 February 1913. A group of generals loyal to the ousted President Porfirio Díaz staged a rising, led by Bernardo Reyes (father of the famous writer Alfonso Reyes), who died in the attempt to storm the National Palace. Victoriano Huerta, commander of the government forces, met secretly with the new leader of the insurgents, Félix Díaz, at the US Embassy. The two, with the connivance of the US Ambassador, Henry Lane Wilson, decided to order the arrest of elected President Madero and Vice-President Pino Suárez. Both were executed shortly after Huerta became President. The similarity between these events and the coup d'état in Chile in 1973 has led to parallels being drawn between Madero and the Chilean President Allende, and between Victoriano Huerta and Augusto Pinochet.

26 Letter donated to the author by Isabel Campos.

27 Letter donated to the author by Isabel Campos. The issue of whether the President of the Republic could stand for re-election was one of the main causes of the Mexican Revolution. General Álvaro Obregón had occupied the Presidency from 1920 to 1924. By 1927, he remained a powerful figure in national politics, so much so that Congress voted to modify Article 83 of the Constitution, in order to allow him to stand for re-election. Obregón was duly re-elected on 1 July 1928; however, on 17 July, whilst celebrating his victory at a restaurant, he was assassinated in somewhat confused circumstances.

28 Nicola Sacco and Bartolomeo Vanzetti were executed by electrocution on 23 August 1927, in Dedham, Massachussetts, after a trial lasting seven years. Falsely accused of robbing and murdering two employees of the Slater & Morrill Shoe Company, in South Braintree, Massachussetts, the defendants were condemned to death for a crime they had not committed. What they *had* done was to openly criticise US police torture of immigrant workers who organised fellow-workers to protest against exploitation. The two innocent men received enormous international support.

29 Copy of original letter is in the archive of Raquel Tibol.

30 The Sixth Congress of the Communist International, which ended in Moscow on 1 September 1928, declared petty-bourgeois militants to be the most dangerous enemies of the workers' movement. A few days later, on 27 September, Trotsky was expelled from the Comintern, a move opposed by Rivera, who was in Moscow at the time, and by other members of the October group, whose motto was: 'Culture needs a new revolution, a new October'.

31 Bertram Wolfe Collection of the Hoover Institution Archives, Stanford, California.

32 Ibid.

33 Archives of the Centro Nacional de Investigación de Artes Plásticas/INBA-CENIDIAP, Mexico City.

34 Alberto Misrachi Samanon (born at Monastir) was the owner of the Librería y Galería Central de Arte (Bookshop and central art gallery), founded in 1932 opposite the Palacio de Bellas Artes in Mexico City. He successfully sold Rivera's paintings for several years.

35 Nickolas Muray Papers in the Archives of American Art, Smithsonian Institution, Washington, DC. Muray (1892–1965), photographer, ballet critic, aviator and fencing champion, started an affair with Kahlo in 1931, which grew more intense when she came to New York in 1938 for her first solo show at the Julien Levy Gallery; she even referred to him as: '*my lover, my sweetest*, my Nick – my life –, *mi niño*, I adore you.'

36 Breton was in Mexico in April and August 1938. Kahlo arrived in Paris in January 1939.

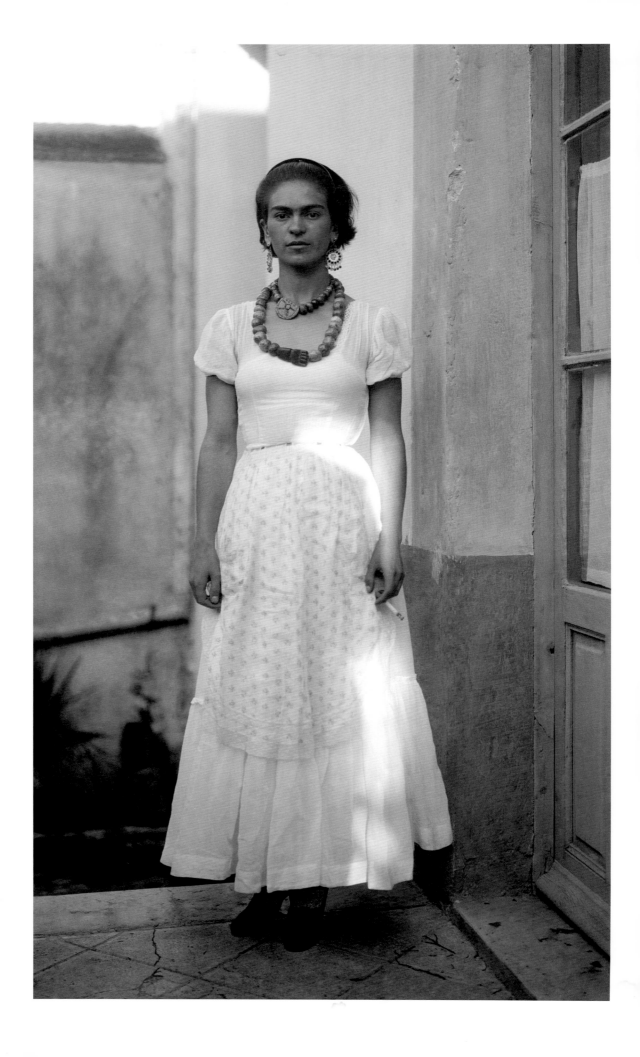

The Life of Frida Kahlo

Christina Burrus

> One day when my half-sister María Luisa was sitting on her pot, I pushed
> her and she fell backwards, taking the pot with her. Furious, she said
> 'You are not my mummy's daughter, and you are not my daddy's daughter:
> they picked you out of a dustbin!' Cut to the quick, I became a completely
> introverted child.[1]

Magdalena Carmen Frieda Kahlo Calderón was born on 6 July 1907 in Coyoacán,
on the outskirts of Mexico City. Her father, Wilhelm Kahlo, born in Baden-Baden of
Hungarian parents, moved to Mexico as a young man with the financial support of
his father, a jeweller. He changed his name from Wilhelm to Guillermo and married
a Mexican girl, María Cardeña, who gave him a first daughter, María Luisa, and died
giving birth to a second, Margarita. He then married Matilde Calderón y González,
born in Oaxaca of a Spanish mother and a father of Indian ancestry, taking over the
latter's shop and business as a photographer. Four daughters were to be born of
this union: Matilde, Adriana, Frida, and Cristina.

Frida did not enjoy an easy childhood, living among her sisters and
half-sisters in the house built by her father a few years before her birth, 126 Avenida
Londres in Coyoacán (later known as the Casa Azul). It was, like all Mexican houses,
closed in around a patio, but it was also closed in by the discipline and bigotry of
a mother (called *el Jefe* – the Chief – by Frida) who was more inclined to religious
effusions than to gestures of maternal affection: after her eldest daughter, Matilde,
fled the family home she refused to speak to her again for twelve years. She was,
on occasion, a friend to Frida nonetheless, although it was better never to raise
the question of religion with her since she could easily become hysterical.

When Frida was six, an attack of polio forced her to stay in bed for nine
months. After she had recovered, she could no longer walk without a limp, and her
classmates at the German College in Mexico City nicknamed her *Frida, pata de palo*
('Frida, peg leg'). It was her father's decision to give her this Germanic education,
which would serve as her backbone in later life. He was a very loving but fragile
parent, whom she helped with the careful retouching of his photographs and nursed
through his epileptic fits. Like any cultivated European in the Mexico of the time,
he owned a carefully selected collection of books. These were mainly German
works: Goethe, Schiller and many philosophical writings. Above his desk hung a
portrait of Schopenhauer, the dominant proponent of a vision of life that he transmitted
to his daughter, teaching her at an early age that 'philosophy makes people prudent
and helps them to assume their responsibilities'.

In 1922 Frida entered the National Preparatory School of the University
of Mexico. She was one of thirty-five girls recently admitted among the two thousand
students, thanks to the policy of opening up the education system that was being
implemented by the new Minister of Education, José Vasconcelos. She wanted to
study medicine and was interested in social sciences, biology and botany. Soon she
became one of a close group of seven boys and two girls, known as the Cachuchas
after the caps they all wore. More interested in poetry and literature than in politics

fig.118
Portrait of Frida Kahlo
aged eighteen, 1926
Photograph by Guillermo Kahlo
Courtesy of Throckmorton Fine Arts,
Inc., New York

fig.119 (right)
Frida in Coyoacán c.1927
Watercolour on paper
18.5 x 24 cm
Government of the State of Tlaxcala,
Instituto Tlaxcalteca de Cultura,
Museo de Arte de Tlaxcala

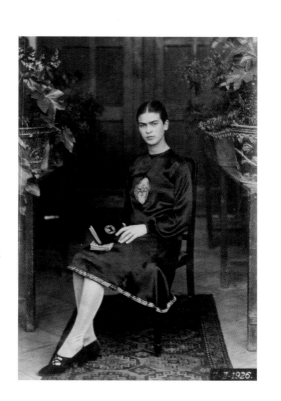

(although all except Frida would eventually choose establishment professions), for the time being they shared the same quest: to enjoy this period of the reawakening of Mexico following the Revolution of 1910–20. Frida acquired in her new friends' company a taste for subversion and an instinct for rebellion against authority, along with a strong sense of loyalty and friendship that would remain with her all her life.

During her moments of leisure, when she was not working to help the ailing family finances (her father had been obliged to mortgage their house), she took drawing lessons in Fernando Fernández's studio and as a fifteen year old, observed the famous Diego Rivera at work on a mural in the amphitheatre at the Preparatory School. Her fantasy, perhaps fuelled by the theme of the fresco, *Creation*, was, as she confessed to her friends, to have a child by him.

On 17 September 1925, Frida suffered a serious accident:

> I got on the bus with Alejandro. I sat down on the edge, near the handrail, and Alejandro sat next to me. A few seconds later, the bus hit a tramway of the Xochimilco line. The tram crushed the bus against the street corner. It was a strange shock, not violent but dull, slow, injuring everyone. Me especially ... The shock threw us forwards and the handrail pierced me as the sword pierces the bull. A man, seeing the terrible haemorrhage, picked me up and laid me on a billiard table until the Red Cross arrived. I lost my maidenhead, my back went floppy, I could no longer urinate and what I complained about most was my spine.[2]

Her friend Alejandro Gómez Arias, leader of the Cachuchas, gave a baroque, almost fairy-tale account of the incident: 'A passenger was carrying a bag of gold dust. When the two vehicles crashed, the colour spread over Frida's body, mixing gold with her blood.'[3]

Diagnosing 'multiple fractures of the spine and foot, and a crushed pelvis', the doctors thought she was doomed, but she came through. This was not as the result of any miracle, but through the strength of character, humour and courageous good nature to which her correspondence with Alejandro bears witness:

> Alex *de mi vida*, you more than anybody know how sad I have been in this piggy filthy hospital, since you can imagine it and also the boys must already have told you about it. Everyone says I should not be so desperate, but they

don't know what three months in bed means for me, which is what I need, having been a *callejera* [street urchin]. But what can one do? At least the *pelona* [the bald one, the image that Frida used to symbolise death, followed here by a drawing of a small skull and crossbones] didn't take me away, right?[4]

At the hospital, Frida experienced great solitude. Her mother, suffering from shock, did not come to see her and only her eldest sister, 'Matita', the outcast, kept her company. She read a good deal: the Chinese poetry of Li Tai Po, Henri Bergson's philosophy of the 'creative impulse', Proust, Zola, Jules Renard, together with articles on the Russian Revolution and publications on Cranach, Dürer, Botticelli, and Bronzino.

Immobilised for nine months in a plaster corset, Frida returned home, where her mother had a four-poster bed installed for her, from the canopy of which she hung a small mirror. Her father gave her a box of paints. There was no longer any question of continuing her medical studies. The only education possible was the study of herself, encompassed by this tiny mirror the size of a portrait. This permanent confrontation with her own identity gave rise to the problematics relating to the very essence of art: illusion, dissociation, our relationship with death. Much more than autobiography, her self-portraits would prove to be 'images of the inner self', of a being setting out on a quest, as existential as it was aesthetic, of a young woman still in the process of formation, of an awakening conscience.

During her apprenticeship in her father's studio, she had learned how to work meticulously in small formats. Her portraits were to remain stamped with this obsession for detail, rendered with all possible realism. Her initial definition of herself was *Self-Portrait Wearing a Velvet Dress* 1926 (pl.4), which she dedicated to her first love, Alejandro Gómez Arias, and which is marked with a nobility that calls to mind the Mannerist Agnolo Bronzino, at once dignified, discreet, strong and fragile. Alejandro was sent to Germany by his family, as much to keep him at a distance from Frida as to pursue his studies; he would only return to Mexico at the end of 1927.

Freed from her plaster as if from a mould, Kahlo had to begin to earn a living, for her father was having increasing difficulty in meeting the family's expenses, which were further burdened by his daughter's medical bills. She resumed contact with her former comrades at the Prepa, who were continuing their scholarly and political development at the university and, in the wake of her friend the student leader Germán de Campo, she mixed with the artistic milieu, at the time committed to the Communist struggle. This circle included Julio Antonio Mella, a young Cuban revolutionary exiled in Mexico (assassinated a few months later), and his friend, the beautiful Italian Tina Modotti, a photo-journalist and fervent militant, with whom Kahlo became friends. She was fascinated by this circle of personalities, in the midst of which moved the aristocratic Dolores Ibárruri – later to become known worldwide as 'Pasionaria' (passion flower), her pseudonym as a revolutionary during the Spanish Civil War in 1936.

Kahlo became a member of the Mexican Communist Party in 1928 and went to meet the great man she admired, Diego Rivera, to seek advice on the possibility of an artistic career. Rivera included her in his fresco at the Ministry of Education, a red star on her breast (see fig.65 on p.61). In 1929 they were married. 'A ver que sale!' (We shall see what comes of it) wrote Modotti to the American photographer Edward Weston. They moved to the site of Rivera's work at Cuernavaca, and Kahlo, with wifely solidarity, soon resigned from the Mexican Communist Party, which had excluded her husband. She had married a monument, part of Mexican history, twenty years older than herself, twenty centimetres (nearly eight inches) taller and a hundred kilos (220 lbs) heavier.

For Rivera – her god, her son, her father, her 'second accident' as she liked to say – Kahlo was to don the colourful costume of a Tehuana as others take the veil. From his stay in the Tehuantepec isthmus he had brought back the memory

fig.121
Portrait of Frida Kahlo, Mexico,
16 October 1932
Photograph by Guillermo Kahlo
Courtesy of Throckmorton Fine Arts,
Inc., New York

fig.122 (right)
Self-Portrait: 'very ugly'
1933
Fresco 27.4 x 22.2 cm
Private collection

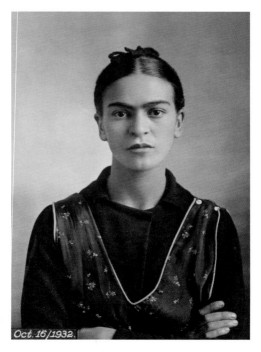

of the beauty and regal bearing (enhanced by their ornate costume and headdress) of these proud and independent women, who, it was said, had made matriarchy the law of their land. Ritually, nearly every morning until the end of her life, Kahlo decked herself out like an idol, constructing her image, establishing a style of dress whose interaction with her pictorial style rapidly became apparent. Her costume conveyed a romantic attitude, perhaps as much German as Mexican, which claimed to be an authentic 'return to nature', a rediscovery of *Mexicanidad*, the quality of being Mexican. Kahlo expressed herself in language as forthright and colourful as her paintings, ever faithful to the values that she claimed as her own: the dignity of individuals, the pride of *mestizos* and the denunciation of any lack of respect.

At the beginning of 1930 Kahlo's first pregnancy was terminated, owing to the incorrect position of the foetus. Later that year she left Mexico with Rivera, who had been commissioned to execute murals in the United States. Kahlo said of the Americans that 'their faces resemble under-cooked bread'[5] and, when the Rockefeller scandal broke,[6] that they 'shoot you down openly, whereas Mexicans knife you in the back'.[7] Faithful to their proclaimed origins, she and Rivera boycotted the good hotels that had banned Jews, voicing loud and clear their Jewishness. Similarly, a few years later, with the rise of Fascism, she would distance herself from her German origins by changing the spelling of her first name to become Frida without an 'e'.

fig.123
Kahlo, New York 1935
Photograph by Lucienne Bloch
Courtesy of Old Stage Studios

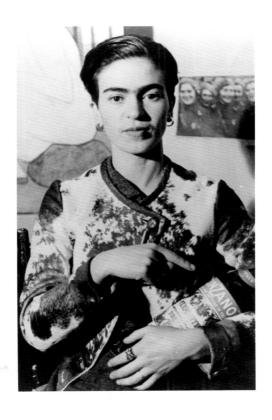

With her new identity came a new manner of painting. In 1931, using the iconography of folk art, she executed *Frieda Kahlo and Diego Rivera* (pl.12), a marriage portrait in which she depicted herself, tiny in her magnificent costume, with her hand in that of her giant husband. Then, strongly asserting her Mexican identity, she painted *Self-Portrait on the Borderline between Mexico and the United States* 1932 (pl.13), followed by *My Dress Hangs There* 1933 (pl.14).

In early July 1932 a second pregnancy ended with a miscarriage at the Henry Ford Hospital in Detroit, leaving Kahlo depressed, lacking the will to live. Lucienne Bloch, the companion of Rivera's assistant Stephen Dimitroff, gave her friendly support and Diego encouraged her to take up painting again. The painful experience of the miscarriage led to her rediscovery of a popular means of expression in Mexico: the *ex-voto* or *retablo*. As Paul Westheim suggests: 'What Frida Kahlo retained of the popular soul of the *ex-voto*, in addition to [its] vital affirmation, is the sincerity, the infantilism of the forms and the accomplishment of a truth told in such a manner that it seems to embody a lie, for there is no limit separating the world of the real, of the natural, of the objective and of invention, from that of the symbol, of the unreal.'[8] He quotes Ida Rodríguez Prampolini: 'In the *retablo* the problematic is always personal; invariably only one situation exists: the ego based on a concrete fact and its union with another world, that of the miracle.'[9]

If, in the folk-art *ex-voto*, there is always a saviour in the form of Christ, the Virgin or a saint, Kahlo replaces these figures with symbolic objects that seem to float weightlessly, as in *Henry Ford Hospital* 1932 (pl.15), or else chooses her own saviour, such as Marx in *Marxism Will Give Health to the Sick* 1954 (Museo Frida Kahlo, Mexico City) or Dr Juan Farill in *Self-Portrait with Portrait of Dr Farill* 1951 (pl.54). Concentrated in this format, and often including a banner that bears the title of the work, the drama reflects back to us an almost unbearable violence: *My Birth* 1932 (pl.16), for example, or *A Few Small Nips* 1935 (pl.20), a picture inspired by a newspaper report. For, as Rivera recognised in 1937, 'she is the first woman in the history of art to have adopted, with absolute and ruthless sincerity and, one could say, with impassive cruelty, the general and specific terms which concern women exclusively'.[10]

Kahlo and Rivera returned to Mexico in 1933, and moved to the 'twin house' in San Angel (fig.124), which had been commissioned from Juan O'Gorman, a pupil of Le Corbusier. It soon became a Mecca for the international intelligentsia: writers, painters, photographers, musicians, actors and militants met there in a bohemian atmosphere, in the midst of pets – spider monkeys, fawns, parrots and Itzcuintli dogs – and the lovers and mistresses of the moment. For Kahlo, there was one too many mistresses – Rivera was having an affair with her younger sister, Cristina. This caused her to leave San Angel for several months in 1935. She rented a flat in Mexico City and began a relationship with the sculptor Isamu Noguchi. Subsequently she went to New York to cheer herself up in the company of her friends Anita Brenner and Mary Schapiro before her return home.

The mood in Mexico at this time was oriented towards political activism. On 18 July 1936, the day the Spanish Civil War broke out, Kahlo became a member of the commission responsible for collecting funds abroad for the Republican cause. Later, sharing her husband's admiration for Trotsky, she joined the Fourth International. The Casa Azul, enlarged by Rivera, became a fortress for two years to ensure the asylum and safety of Trotsky and his wife. The political leader was not indifferent to the beauty of his hostess, then approaching her thirtieth birthday, a beauty that can be seen in her self-portraits of the period: *Fulang-Chang and I* 1937 (fig.49 on p.49), *Itzcuintli Dog and Me* 1938 (pl.30) and *Souvenir of an Open Wound* 1938 (destroyed). As her relationship with Trotsky testifies, she was in full possession of her powers of seduction – although she never lost her longing for motherhood and often sought refuge in drink. Her painting, however, became more assertive and refined. In *My Nurse and I* 1937, *Four Inhabitants of Mexico City* 1938 and *What the Water Gave Me* 1938 (pls.17, 22, 26) whether as the result of introspection or of a new perception of her relationship with the world, she dared to expose her psyche in all its complexity.

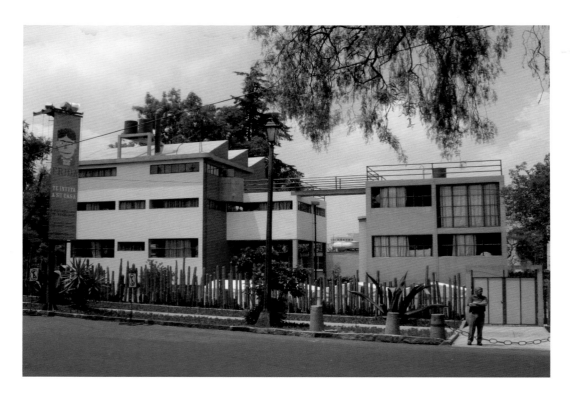

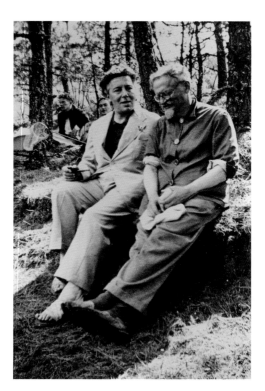

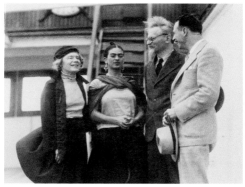

Her sources of inspiration came not only from her inner self, but from a wide range of outside influences: her father's portraits, pre-Columbian statues, *ex-votos* of the past two centuries, José Guadalupe Posada's prints, Goya's *danses macabres* or the folk dances meticulously depicted by Brueghel, together with the visions of Bosch and Magritte. These diverse sources fed into her depictions of specific events of her life. A fair interpreter of her own work, she said as much herself: 'I paint myself … because I am the subject I know best.'[11]

'A ribbon around a bomb', wrote André Breton of Kahlo's work after he had discovered it during a stay in Mexico[12]; he was so enthusiastic that he proposed she should exhibit it in Paris. Kahlo embarked first for New York, where a solo show at Julien Levy's gallery was dedicated to her work in November 1938. It was a great success: much to her astonishment, twelve of the twenty-five works were sold, in spite of the Depression. She continued her journey on to Europe and exhibited her work for the first and last time in Paris, at Galerie Renou et Colle in March 1939. Kandinsky and Duchamp were the first to congratulate her, and the Louvre acquired *Self-Portrait 'The Frame'* c.1937–8 (fig.1 on p.9). In 1938 Picasso admitted to Rivera: 'Neither Derain nor myself, nor you, are capable of painting a head like those of Frida Kahlo.'[13]

She was, however, too free-spirited to allow herself to be confined by Surrealism. Far beyond its evident intention to shock the bourgeoisie, her work expressed an imaginary daily life in Latin America and she was incapable of submitting to any law dictated by Breton and his friends. 'The problem with *el señor* Breton', she sighed, 'is that he takes himself very seriously'.[14] From Paris, finally exasperated and giving free rein to her anger, she wrote (in English) to her lover, the American photographer Nickolas Muray: 'You have no idea the kind of bitches these people are. They make me vomit. They are so damn "intellectual", and rotten that I can't stand them any more … *Shit* and only *shit* is what they are'.[15]

After yet another stay in hospital, in Paris, she returned to Mexico via New York. Kahlo's sister was still a part of Rivera's life. At the end of 1939 Kahlo and Rivera divorced, and Kahlo moved back to the Casa Azul. As an emblem of the split, she painted *The Two Fridas* 1939 (pl.28). She also cut her hair and depicted herself, scissors in hand, wearing masculine clothing, an androgyne in exile from her life as a woman, in *Self-Portrait with Cropped Hair* 1940 (pl.29). She gazed deeper still into the mirror and again depicted herself surrounded

fig.127
Kahlo and Diego Rivera
at the English Hospital in Mexico, 1950
Photograph by Juan Guzmán

fig.128
Kahlo wearing a plaster corset
decorated with hammer and sickle,
Mexico, c.1941
Photograph by Florence Arquin
Courtesy of Throckmorton Fine Arts, Inc.,
New York

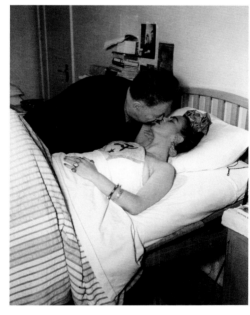

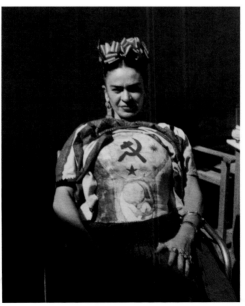

by her pets, like so many agents for her dreams of rebirth, her erotic desires, or her martyrdom. Intoxication and drugs were now part of her daily life.

Ill and, moreover, harassed by the police after Trotsky's assassination, after an eighteen-month separation she finally joined Rivera in San Francisco in September 1940, yielding to his entreaties and to those of Dr Eloesser, her old friend, confidant and medical advisor, who was responsible for her treatment there. She remarried Rivera a few months later, once they had redefined their respective territories. The couple moved back to the Casa Azul, Rivera keeping San Angel as a studio and bachelor flat. Kahlo watched over him like a mother; she had his meals carried to him wherever he was working, in pretty baskets with love notes enclosed. So life went on beside her double and opposite. As did her pain: her father died in 1941.

Increasingly, Kahlo's participation was requested for group exhibitions in Mexico and in 1946 she received a national prize for her painting *Moses* 1945 (pl.69). With the arrival of public recognition she began to attract collectors. She was also offered a job at La Esmeralda. Not an academic professor, she whisked her pupils off to improvised studios: her house, her garden or a *pulquería*, aspiring only to transmit to her 'Fridos', as they called themselves, *life*, or a way of looking at life.

In 1943 Rivera paid homage to Kahlo's art in the *Boletín del Seminario de Cultura Mexicana*[16]:

> Frida's art is collective-individual. There is such monumental realism in her space that everything possesses *n* dimensions: at one and the same time she paints both exterior and interior, everything of herself and of the world ... although her painting is not spread over the great surfaces of our walls, its content in terms of intensity and depth makes it more than equivalent to our quantity and quality; Frida Kahlo is the greatest of the Mexican painters and her work is destined to be multiplied through reproductions. And if she does not speak from walls, she will speak from books to the whole world. Her art is among the best and greatest visual documents and the most intense human records of our times. For tomorrow's world its value will be inestimable.

By June 1946, Kahlo could no longer remain either seated or standing, and after having tried a series of orthopaedic corsets she went to New York for a bone-graft operation on her spine. A work of that year shows her magnificently dressed in her Tehuana costume, sitting on the trolley next to another, post-operative Frida, a corset in her hand, presenting the motto that gave the picture its title: *Tree of Hope, Keep Firm* (fig.51 on p.51).

Kahlo is depicted at this time, both by Rivera and herself, as a maternal figure in their relationship. In Rivera's *Dream of a Sunday Afternoon in Alameda Park* 1947 (Museo Mural Diego Rivera, Mexico City), she shelters his silhouette as a little boy, whilst in her own *The Love-Embrace of the Universe, the Earth (Mexico), Me, Diego and Mr Xólotl* 1949 (pl.70) she depicts herself as the daughter of the earth and of the universe, in the embrace of successive arms, but holding in her own arms a Rivera naked as a baby, bearing on his forehead the eye of knowledge.

The New York treatment finally proving unsuccessful, at the beginning of 1950 Kahlo was hospitalised for nine more months in the English Hospital in Mexico. She was operated on by Dr Farill, whose praises she sang in *Self-Portrait with Portrait of Dr Farill* 1951 (pl.54). She depicted herself in a wheelchair, holding paintbrushes in one hand, and in the other a heart for a palette. On the easel beside her rests the portrait of the doctor of whom she said: 'Dr Farill saved me. He gave me back the joy of life.'[17] Nonetheless, the wheelchair, infirmity and depression again led her to take further drugs not prescribed by the doctor, and her hand no longer always shared the steadiness of her will. In her *Portrait of My Father* 1952 (fig.83 on p.68) Kahlo imbues the eyes with the same haggard look

fig.129
Kahlo being greeted
at the opening of her exhibition
at the Galería de Arte
Contemporaneo, 13 April 1953

fig.130
Kahlo at a rally protesting
against CIA involvement
in Guatemala, with Diego Rivera
standing behind her, 2 July 1954

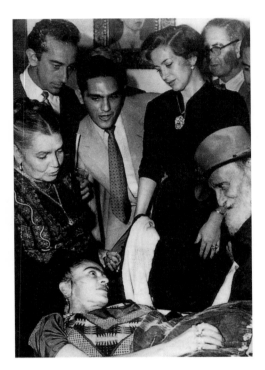

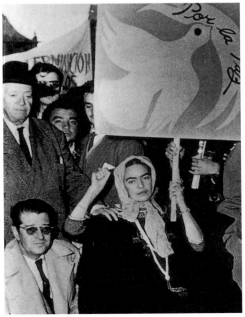

that was sometimes her own at this time. As often as not lying down to work, she collected the fruits and other objects in her vocabulary of symbols to form still lifes, calling the last *Long Live Life* 1954 (Museo Frida Kahlo, Mexico City).

Living up, at the end of her life, to the full sense of her German name – *Friede* means 'peace' – she called on her last shreds of strength to commit herself to working for peace. She distributed tracts, and collected signatures for the Stockholm Appeal against nuclear tests by the great imperialist powers, while Rivera painted his *Nightmare of War, Dream of Peace* 1952 (whereabouts unknown). In *Marxism Will Give Health to the Sick* 1954, she asserted her almost utopian belief in that political philosophy, while *Frida and Stalin* 1954 expressed it in more romantic terms (both works now in the Museo Frida Kahlo, Mexico City). At her death, she left on her easel a dirty and unfinished portrait of the latter (see fig.19 on p.27) – the result of a final doubt or of terminal weakness?

In the spring of 1953 Kahlo received her first solo exhibition in Mexico, at Lola Álvarez Bravo's gallery. Kahlo wrote the invitation like a love letter:[18]

> With friendship and love
> Born from the heart
> I have the pleasure of inviting you
> To my humble exhibition.

Rivera had her four-poster bed moved into the middle of the gallery and, after a dramatic arrival in an ambulance, she lay there, joy triumphing over pain, to receive the homage of those who crowded around her, and to accept their tokens of friendship (fig.129). A few months later her right leg was amputated. 'Feet what do I need them for if I have wings to fly?', she asked her diary, which was studded with angels (see fig.76 on p.65).

In a photograph taken at her last public appearance, on a demonstration against CIA intervention in Guatemala in 1954, Kahlo sits in her wheelchair alongside Rivera, raising up with a tired hand a placard bearing the dove of peace (fig.130). One cannot but read in her sad but determined eyes, her last words in her diary: 'I hope the leaving is joyful – and I hope never to return.'

Frida Kahlo died on 13 July 1954, at home at the Casa Azul.

A version of this text was first published in *Diego Rivera – Frida Kahlo*, exh. cat., Foundation Pierre Gianadda Martigny, Switzerland/Foundation Dina Vierny, Musée Maillol, Paris 1998.

Notes

1 As told to Raquel Tibol by Frida Kahlo, in Raquel Tibol, 'Fragmentos para una vida de Frida Kahlo',
in 'México en la Culture' supplement to the newspaper *Novedades*, Mexico City, 7 March 1954, reprinted
in Raquel Tibol, *Frida Kahlo*, Frankfurt 1980; translation by Christina Burrus.

2 Ibid., pp.23–4.

3 Cited ibid.

4 Letter to Alejandro Gómez Ariaz, 13 October 1925; trans. in Hayden Herrera, *Frida: The Biography
of Frida Kahlo*, New York 1983, p.51.

5 Letter to Isabel Campos, San Francisco, 3 May 1931, donated to Raquel Tibol by Isabel Campos.

6 Rivera had been commissioned by Nelson Rockefeller to create a mural in the Rockefeller Center,
New York, for which Rockefeller himself had set the theme: 'Men at the Crossroads Looking with Hope
and High Vision to the Choosing of a New and Better Future'. Rockefeller was initially enthusiastic
about Rivera's design, but then it was denounced in the press as Communist propaganda. Rivera
was physically forced to quit the building, and the unfinished work was covered over. A public outcry
followed, with a group of artists and intellectuals supporting Rivera, but nine months later the mural
was chipped off the wall at Rockefeller's instruction. Described in Diego Rivera, *My Art, My Life,*
New York 1960, p.126.

7 Ibid.

8 Paul Westheim, 'Frida Kahlo, una investigacion estética', *Mexico en la Cultura,* 10 June 1951, p.3.

9 Cf. Ida Rodríguez Prampolini, *El surrealismo y el arte fantastico de Mexico,* Mexico 1969.

10 In Raquel Tibol, 'Artista de Cenio', *La Prensa*, Buenos Aires, 12 July 1953.

11 Quoted in Herrera 1983, p.74.

12 André Breton, 'Frida Kahlo de Rivera' (1938), reprinted in Laura Mulvey and Peter Wollen, 'Introduction',
in *Frida Kahlo and Tina Modotti*, exh. cat, Whitechapel Art Gallery, London 1982, p.18, pp.35–6

13 Letter from Pablo Picasso to Diego Rivera after the exhibition in Paris.

14 From a private interview with a friend of Kahlo's who wished to remain anonymous, quoted in Herrera
1983, p.262.

15 Letter to Nickolas Muray, 16 February 1939: Nickolas Muray papers in the Archives of American Art,
Smithsonian Institution, Washington, DC. For a longer extract from this letter, see p.195, above.

16 In Diego Rivera, *Ecrits sur l'art,* Neuchatel 1996, p.276.

17 Entry from Frida Kahlo's diary, quoted in Herrera 1983, p.392.

18 Quoted in Herrera 1983, p.406.

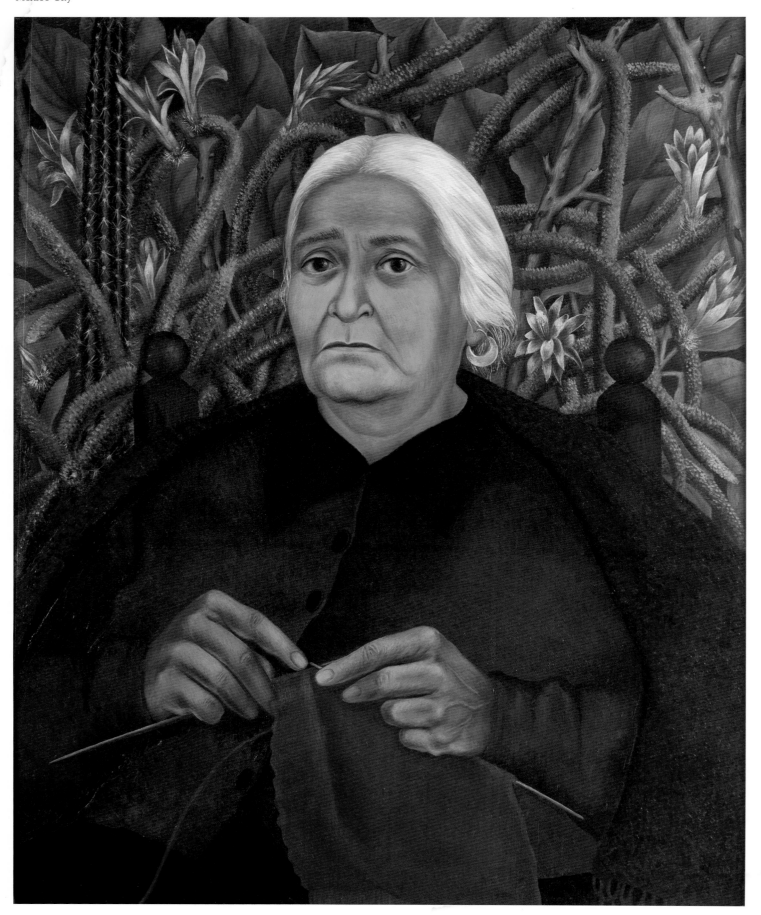

People

The people connected with Frida Kahlo were a diverse group of celebrities, patrons, artists, politicians, friends and doctors. Some of those who were professionally and personally closest to Kahlo became the subjects of her paintings and were often given works or self-portraits as gifts of goodwill. The following is a selection of these personalities and explains the relationship of each to the artist.

Lola Álvarez Bravo (1907–1993) Mexican photographer and friend of Kahlo. She began photographing in the 1930s, her work showing the influences of Edward Weston and Tina Modotti. She married influential photographer Manuel Álvarez Bravo, and organised Kahlo's first solo exhibition in Mexico City at her Galería de Arte Contemporáneo in April 1953. Kahlo was seriously ill at the time of the opening, but was carried in on a stretcher and hosted the opening from her bed (see p.206).

Manuel Álvarez Bravo (1902–2002) Self-taught photographer who became renowned in Latin America and Europe. Married to Lola Álvarez Bravo. In 1929, he met Rivera through Tina Modotti, and became friends with both Rivera and Kahlo, sharing their political beliefs. André Breton admired his photographs and subsequently published a selection in an edition of *Minotaure*. Breton also included Álvarez Bravo's work, along with that of Kahlo, in the 1939 exhibition *Mexique* at the Galerie Renou et Colle, Paris.

Lucienne Bloch (1909–1999) Photographer and close friend of Kahlo. The daughter of Swiss composer, Ernest Bloch, she met Rivera at a banquet in Manhattan. When Rivera and Kahlo moved to Detroit, Rivera asked her to move in and care for Kahlo, who was suffering from health problems. Kahlo became godmother to Bloch's child. Bloch's photographs of Kahlo have become widely known (see pp.22, 203). She was also the only person to have photographed Rivera's mural in the Rockefeller Center before its destruction.

André Breton (1896–1966) French writer and poet, and founder of the Surrealist movement in Paris. In 1938, he travelled to Mexico with his wife, Jacqueline Lamba (see p.204), and stayed with Lupe Marín, Rivera's ex-wife. He characterised Kahlo's work as 'Surrealist' and wrote the catalogue essay for her solo exhibition at the Julien Levy Gallery in 1938. He subsequently offered to organise an exhibition of her work in Paris. The show *Mexique* was eventually staged at the Galerie Renou et Colle, and included photographs by Manuel Álvarez Bravo as well as Breton's own collection of Mexican popular arts. Breton famously described Kahlo's work as 'a ribbon around a bomb'.

Luther Burbank (1849–1926) Groundbreaking horticulturalist, who lived and worked in California. Burbank sought to improve the quality of plants in order to increase the world's food supply and is known for creating hybrid fruits and vegetables such as the Shasta daisy, the Santa Rosa plum, and the Burbank potato. Kahlo painted *Luther Burbank* 1931 (pl.9) while living in San Francisco, although she never met him, as he had died five years earlier. In her painting, Burbank himself becomes a hybrid between a man and a tree, rooted in the soil, a gesture towards the natural cycle of life. Kahlo painted Burbank's portrait while Rivera was working on a mural for the San Francisco Stock Exchange, which also included a portrait of Burbank.

Marcel Duchamp (1887–1968) French artist, affiliated with Cubism, Dada, and Surrealism, who worked in Paris and New York. He conceptualised the 'readymade', which fundamentally redefined the nature of the art object in the twentieth century. In 1939, Kahlo travelled to Paris for an exhibition curated by Breton. Upon her arrival, she was outraged to learn that Breton had not yet secured a gallery for the exhibition, nor cleared her paintings through Customs. Duchamp assisted by retrieving the paintings and arranging for the exhibition to be held at the Galerie Renou et Colle. She stayed with him and Mary Reynolds after being discharged from hospital and believed Duchamp was the only Surrealist with 'his feet on the earth'.

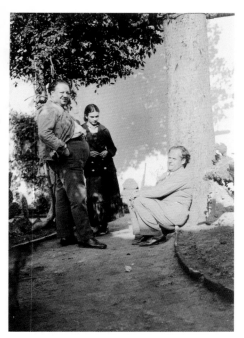

fig.132
Sergei M. Eisenstein, with Diego Rivera
and Frida Kahlo, Mexico City, August 1931
Photograph attributed to Lola Álvarez Bravo
Olivier Debroise, Mexico City

Sergei M. Eisenstein (1898–1948)
Leading Russian film-maker
(*Battleship Potemkin* 1925, *October*
1927). Rivera met him in Moscow in
1927 and Kahlo became acquainted
with him while he was in Mexico
filming *¡Que viva México!* (1931,
unfinished). She later attended the
screening of the uncompleted film
in New York in 1933. Eisenstein was
photographed together with Rivera
and Kahlo on the steps of their patio
in Coyoacán.

Dr Leo Eloesser (1881–1976)
Chief of Service at San Francisco
General Hospital, professor of
surgery at Stanford School of
Medicine, and thoracic surgeon
specialising in bone surgery. Kahlo
first consulted him in 1930 and
he would become her most trusted
doctor and life-long friend. In 1931
she painted his portrait and in 1940
dedicated a self-portrait to him, with
the inscription 'I painted my portrait
in the year 1940 for Dr. Eloesser,
my doctor and my best friend.
With all love, Frida Kahlo' (pl.36).

Dr Juan Farill (1902–1973) Leading
orthopaedic surgeon. First treated
Kahlo in order to correct an

unsuccessful operation on her spine.
Kahlo consulted him repeatedly in
later life, and he recommended the
amputation of her lower leg a year
before she died. In 1951 she painted
Self-Portrait with Portrait of Dr Farill
(pl.54), substituting the space
typically reserved for a holy icon in
an *ex-voto* painting for her doctor's
portrait. She gave him a still-life
painting in 1953.

Sigmund Firestone (1877–1964)
American engineer and art
collector. He met Kahlo and Rivera
in 1939 while on a business trip to
Mexico along with his two daugh-
ters, Alberta and Natalie. In 1940 he
commissioned Kahlo and Rivera to
paint companion self-portraits, of
identical dimensions, to commemo-
rate their friendship and hospital-
ity. Kahlo painted her self-portrait
(pl.35) during her separation from
Rivera and finished it in the same
year. Rivera finally began his self-
portrait in 1941 while working in
the studio of Frances Rich, who
was sculpting a bust of him. Rich
was so taken with his self-portrait
that she convinced him to sell it to
her. Rivera then painted a second
self-portrait, which he dedicated
and gave to Firestone (fig.102).

Eva Frederick (dates unknown)
American woman about whom little
is known, who is presumed to have
become a friend of Kahlo while
she was in San Francisco from
November 1930 to June 1931.
During this time, Kahlo painted
Portrait of Eva Frederick (pl.8).

Alicia Galant (dates unknown)
Became friends with Kahlo in 1924
at the National Preparatory School.
In 1927, Kahlo painted *Portrait
of Alicia Galant* (pl.3), one of her
earliest attempts at portraiture
based on European styles.

Jacques (1909–1986) and **Natasha
Gelman** (1911–1998) Jacques
Gelman, a Russian film producer,
and Natasha Zahalka met in Mexico
and married in 1941. The two

amassed a significant collection
of modern and contemporary
international art. While their
European paintings were
bequeathed to the Metropolitan
Museum of Art, New York, their
Mexican collection is currently
displayed at the Fundación
Cultural Parque Morelos in
Cuernavaca, and contains a number
of works by Kahlo and Rivera. Both
artists painted portraits of Natasha
Gelman in 1943.

fig.133
Paulette Goddard featured on the front cover
of *Picturegoer*, September 1940

Paulette Goddard (1910–1990)
US movie star, married to Charlie
Chaplin; briefly lived across the street
from Rivera's studio in San Angel. Is
believed to have had an affair with
Rivera; later also a friend of Kahlo's.
When Rivera came under suspicion
for the attempted assassination of
Trotsky in 1940, she watched from
her window as the police cordoned
off his studio, and tried to warn him.
In 1941, Kahlo painted *Still Life with
Hummingbird* (pl.65) as a gift to her
for assisting Rivera's entry into the
US. She appears holding Rivera's hand
while embracing the tree of love and
life in *Pan American Unity* 1940 (City
College of San Francisco) and as
woman of the North in *Dream of a
Sunday Afternoon in Alameda Park*
1947 (Museo Mural Diego Rivera,
Mexico City).

fig.134
Portrait of Engineer Marte R. Gómez 1944
Oil on hardboard 32.5 x 26.5 cm
Private collection

Marte Rodolfo Gómez (1896–1973)
Agricultural engineer and Secretary
of Agriculture. He was Rivera's patron
and a great supporter of the muralist.
Kahlo painted his portrait as a gift
in 1944 (fig.134).

Alejandro Gómez Arias
(1906–1990) Fellow student at the
National Preparatory School where
he studied law; Kahlo's first love.
In 1925 the two were travelling
together when their bus collided
with a tram, seriously injuring Kahlo.
She painted her first self-portrait
Self-Portrait Wearing a Velvet Dress
(pl.4) as a gift for him in 1926. Soon

after, he left to study in Europe and
the two drifted apart. In his youth, he
was an inspiring orator and student
leader, organising strikes in favour
of the autonomy of the National
University. He supported the failed
presidential bid of the humanist and
philosopher José Vasconcelos in
1930 and spent the rest of his life
as a left-wing journalist, teacher and
cultural civil servant, who supported
the Cárdenas presidency.

Dorothy Hale (c.1905–1938)
Actress, Ziegfeld showgirl and friend
of Kahlo. She committed suicide in
1938. At her solo exhibition in New
York, Kahlo approached Clare
Boothe Luce (managing editor of
Vanity Fair magazine and friend of

Hale's) suggesting that she make
a *recuerdo* of Hale. Luce, wrongly
assuming a *recuerdo* meant a portrait
done from memory, thought this would
be something Hale's mother might
like, and commissioned Kahlo.
However, the painting showed Hale
falling from the building, with blood
dripping onto the frame. At the
bottom of the work, a banner read
'The Suicide of Dorothy Hale, painted
at the request of Clare Boothe Luce,
for the mother of Dorothy'. Dismayed,
Luce asked to have her name
removed from the inscription. Kahlo
altered the text, which now reads, 'In
the city of New York on the 21st of the
month of October, 1938, at six in the
morning, Dorothy Hale committed
suicide by throwing herself out of a
very high window of the Hampshire
House building. In her memory …
this *retablo* was executed by FRIDA
KAHLO.' (pl.24)

fig.135
Portrait of Lady Cristina Hastings 1931
Pencil on paper 48 x 31 cm
Museo Dolores Olmedo Patiño, Mexico City

Francis John Clarence Westenra
Plantaganet Hastings (Earl of
Huntingdon from 1939) (1901–1990)
English aristocrat, artist, politician,
and radical. Met Rivera and Kahlo
in San Francisco while travelling from
Tahiti to Mexico and became Rivera's
assistant. He is depicted in Rivera's

mural *The Making of a Fresco Showing the Building of a City* 1931 at the San Francisco Art Institute. He assisted Rivera with his murals at the Detroit Institute of Arts. His first wife, Cristina Casati, became a friend of Kahlo, who drew her portrait in 1931 (fig.135). He presented a large drawing by Rivera, a study of the head of the figure of 'California' from the mural at the San Francisco Stock Exchange, to the Tate Gallery in 1958. His own murals can be found at Buscot Park in Oxfordshire.

Cristina Kahlo (1908–1964) Frida Kahlo's youngest sister, with whom she was very close. They fell out when Cristina had an affair with Rivera in the 1930s, but they were later reconciled and remained companions until Frida's death in 1954. Frida was very fond of Cristina's children, Isolda and Antonio, and the two appear in *The Wounded Table* 1940 (whereabouts unknown).

Jacqueline Lamba (1910–1993) French artist and participant in Surrealist movement between 1934 and 1947, married to André Breton. In 1938, she and Breton went to Mexico, where they stayed with Lupe Marín and with Kahlo and Rivera in San Angel. Lamba and her daughter, Aube, became closer to Kahlo when they visited her again in 1943.

Julien Levy (1906–1981) Prominent New York gallery owner from 1931 to 1949, and collector. He held the first Surrealist exhibition in the US, showing work by Eugene Atget, Marcel Duchamp, Max Ernst, Man Ray, Alberto Giacometti, Joseph Cornell, Constantin Brancusi, Salvador Dalí, and Naum Gabo. He organised Kahlo's first solo exhibition in 1938, which drew large crowds of influential artists, critics, writers and collectors (including the Rockefellers). Twenty-five paintings were exhibited, twelve of which were sold. Levy had a brief affair with Kahlo and took a series

of intimate photographs of her. He commissioned artist Joseph Cornell to create one of his famous boxes containing effects belonging to Kahlo.

Miguel N. Lira (1905–1961) Kahlo's life-long friend and fellow member of the *Cachuchas* at the National Preparatory School. Kahlo nicknamed him Chong Lee because of his love of Chinese poetry. He graduated from the National University in 1928, where he later taught. He became a lawyer and Stridentist poet. In 1927 Kahlo painted *Portrait of Miguel N. Lira* (pl.6).

Guadalupe (Lupe) Marín (1897–1981) One of Rivera's models for his murals, they married in 1922 and had two daughters, Lupe and Ruth. She became jealous of Rivera's many mistresses and they eventually divorced when he became involved with Tina Modotti. When he later married Kahlo, the couple remained in close contact with Marín. Kahlo painted her portrait in 1929.

Leo Matiz (1917–1998) Colombian photographer. Moved to Mexico in 1940, where he lived for approximately ten years, collaborating with other artists such as Manuel Álvarez Bravo and David Alfaro Siqueiros. He took various photographs of Kahlo, including a series of her in the Casa Azul in Coyoacán. He later worked in New York as a photo-journalist for *Life* magazine.

Tina Modotti (1896–1942) Italian-American photographer, artist and actress, born Assunta Adelaide Luigia Modotti. She moved to the USA in 1918 and travelled to Mexico in 1923 with Edward Weston, who taught her photography. She was actively involved in communist politics and was hired by Rivera and Orozco to document their murals. She later gave up photography in order to devote herself to politics. One account holds that Rivera and Kahlo met for the first time at a party

at Modotti's home, although they said their initial encounter occurred while Rivera was painting a mural at the Preparatory School. Modotti was accused of being a communist spy and was deported from Mexico in 1930.

fig.136
Portrait of Engineer Eduardo Morillo Safa 1944
Oil on hardboard 39.7 x 29.7 cm
Museo Dolores Olmedo Patiño, Mexico City

Eduardo Morillo Safa (dates unknown) Mexican diplomat, agronomic engineer, art collector, friend and patron of Kahlo. In 1944, he commissioned her to make five portraits of his family members. One of Kahlo's strongest portraits is of his mother, Doña Rosita Morillo Safa (fig.131), with whom she had a special rapport. He acquired over thirty of Kahlo's works, which were later sold to Dolores Olmedo Patiño in 1956.

Nickolas Muray (1892–1965) Portrait photographer, dance critic, aviator, and fencing champion. He began working for Condé Nast in New York in 1913. In subsequent years his photography was commissioned and published by *Harper's Bazaar*, *Vanity Fair*, *Vogue*, *Ladies' Home Journal*, *The New York Times* and many others. He became known as a master of colour fashion photography using the carbro colour process and made over ten thousand portraits, many of celebrities. He was

fig.137
Nickolas Muray
Frida with Nick, Coyoacán 1939 (detail)
Nickolas Muray Archives

introduced to Kahlo in Mexico by Rosa Rolando and Miguel Covarrubias. They embarked on an affair that was probably Kahlo's most serious relationship after Rivera. Their romantic relationship continued when she arrived in New York for her first solo exhibition at the Julien Levy Gallery, but was ended by Muray in 1939. Although Kahlo was devastated, their close friendship continued (see figs.43, 53 on pp.46, 54)

Isamu Noguchi (1904–1988)
Japanese-American sculptor, designer, and architect who lived in Japan and New York. A former student of Constantin Brancusi, he designed 'lived spaces' – theatres, gardens, playgrounds, and domestic settings. He moved to Mexico City in the 1930s to work on a relief mural at the Abelardo Rodríquez Market. He had a relationship with Kahlo, which was discovered by Rivera and promptly ended.

Juan O'Gorman (1905–82)
Prominent architect and painter from Coyoacán known for adapting the International style to Mexican environments and locations. Designed connecting houses for Kahlo and Rivera in San Angel and advised on the construction of Rivera's

Anahuacalli musuem, which was only completed after Rivera's death. With Rivera and Kahlo, he protested against the US intervention in Guatemala in 1954 (see fig.130 on p.206). As a muralist, O'Gorman was known for *pulquería* (saloon) painting and controversial communist murals such as the Mexico City Central Airport commission (destroyed).

Georgia O'Keeffe (1887–1986)
American artist known for her paintings of flowers and desert landscapes of the South-Western United States. Married to Alfred Stieglitz, she lived in New York until 1929 and met Rivera and Kahlo at his exhibition opening at the Museum of Modern Art. She supported, like Rivera, the ideal of a pan-American unity. O'Keeffe later attended Kahlo's exhibition at the Julien Levy Gallery. They are rumoured to have had an affair, and she visited Kahlo twice in Mexico in 1951.

Dolores Olmedo Patiño (1908–2002)
Businesswoman, philanthropist and art lover, she was a passionate collector of the works of Diego Rivera. In 1956, after Kahlo's death (despite the fact that the two women were never friends), she purchased a substantial collection of Kahlo's works belonging to Eduardo Morillo Safa as a favour to Rivera, in order to preserve the integrity of the collection. She established a museum at her home, a former hacienda called La Noria, in Xochimilco in Mexico City, where works by Kahlo, Rivera and Rivera's first wife Angelina Beloff are now displayed alongside pre-Columbian artefacts and Mexican indigenous crafts.

José Clemente Orozco
(1883–1949) One of the three major exponents of the Mexican muralist movement alongside Rivera and Siqueiros. He used a variety of techniques, including painting, drawing, and lithography, to explore political themes and events surrounding the Mexican

Revolution, often with Christian iconography. He left for the US in 1927 when a conservative political climate led to the dispersal of the muralist painters. He returned in the 1940s and continued to engage with politics through his art.

fig.138
Kahlo and Emmy Lou Packard in the garden of the Casa Azul, c.1931
Photograph by Diego Rivera
Courtesy of Throckmorton Fine Art, Inc., New York

Emmy Lou Packard (1914–1998)
Fresco artist, photographer, and social activist, she assisted Rivera with his murals in the US and travelled to Mexico with him to continue as his assistant. She lived in the Casa Azul in Coyoacán for almost a year and was a close friend of Kahlo, maintaining contact with her during the period of separation from Rivera.

Edward G. Robinson (1893–1973)
American film actor, known for his portrayal of gangsters in the 1930s. He amassed one of the largest private art collections in the US which included four of Kahlo's paintings which he bought while visiting Mexico in 1938. These were Kahlo's first major sales and included *Self-Portrait with Necklace* 1933, *Portrait of Diego Rivera* 1937, and *Self-Portrait on the Bed* or *Me and My Doll* 1937 (pl.31).

John D. Rockefeller Jr (1874–1960)
Philanthropist and son of John D. Rockefeller (founder of Standard Oil and first American billionaire). Married to **Abby Greene Aldrich** (1874–1948). They founded the Mexican Arts Association to promote the cultural exchange between Mexico and the US. Mrs John D.

Rockefeller also played a central role in the founding of the Museum of Modern Art in New York, where Rivera was invited for a solo exhibition in 1931. She asked Rivera to replicate one of his murals on her dining-room wall, but he refused this 'decorative' commission.

Nelson Aldrich Rockefeller (1908–1979) Son of John D. Rockefeller Jr and Vice-President of the Rockefeller Center. He commissioned Rivera to paint a mural on 'human intelligence in control of the forces of nature'. Rivera included a portrait of Lenin, which he refused to remove. He was paid off and summarily dismissed, and the mural was subsequently destroyed. Kahlo believed that the Rockefellers submitted to public pressure, but were themselves supportive of the radical painting. Rivera later painted a second version in the Palace of Fine Arts, Mexico City in 1934. Rockefeller became Vice-President of the United States in 1974 under President Gerald R. Ford.

Dolores del Río (1905–1983) First Mexican actress to enjoy meteoric success in 1920s Hollywood, playing the lead in *Flying Down to Rio* 1933, with Fred Astaire and Ginger Rogers in supporting roles. Her Hollywood career petered out, and in 1942 she returned to Mexico, resuming her acting career in her native language and becoming Mexico's most famous movie star at the age of thirty-seven. She collected Kahlo's work and *Two Nudes in a Forest* 1939 (pl.27) was a gift from Kahlo to the actress.

David Alfaro Siqueiros (1896–1974) One of the three major exponents of the Mexican muralist movement. He trained at the National School of Fine Arts in Mexico City. Was politically active; serving as a sergeant in the Mexican Revolution and a lieutenant colonel in the Spanish Civil War. A committed Stalinist, his activism often led to his imprisonment; he completed many works while in jail.

In 1934 he published an article, 'Rivera's Counter-revolutionary Road', which greatly offended the Trotsky-allied Rivera and was one of their many confrontations. Siqueiros led an assassination attempt on Trotsky in 1940.

Josef Stalin (1879–1953) Russian revolutionary and Soviet leader. Influenced by Lenin and member of the Bolshevik Party before the Russian Revolution of 1917. After Lenin's death in 1924, he became Soviet dictator (1925) and forced Trotsky into exile. He sent secret police to Mexico to assassinate Trotsky. One of Kahlo's last paintings, left incomplete, was a portrait of Stalin (fig.19 on p.27), and her diary includes references to him ('Viva Stalin!'). It is said that she continued to worship him even after it had become common knowledge that he was responsible for the deaths of millions of people.

Leon Trotsky (1879–1940) Leading Russian revolutionary, participated in the 1905 Revolution. In 1917 he was persuaded to join Lenin in the Bolshevik Party and together the two men led the October Revolution. Founder of the Red Army, he was exiled from Russia and spent his last years in Mexico, where he lived with his wife Natalia (see p.204). There, he formed brief political alliances with Breton and Rivera and established the Fourth International. Perhaps in retaliation against Rivera for his affair with Cristina, Kahlo became involved with Trotsky. In 1940 he was assassinated in Coyoacán, Mexico.

José Vasconcelos (1882–1959) Lawyer, writer, philosopher and politician. As Secretary of Public Education under Álvaro Obregón's regime (1920–4), he commissioned Rivera, Orozco, and Siqueiros and others to paint murals on the walls of public buildings that would glorify Mexican history and indigenous culture, as well as starting an ambitious national programme

of school and library construction. He ran for President in 1930, but was forced into exile when his attempt failed. He returned to Mexico in 1940 to become Director of the National Library. He is known for his promotion of the idea of a 'cosmic race' which would rid humankind of economic and social strife and create universal harmony.

Pancho Villa (**Doroteo Arango**) (c.1878–1923) Mexican revolutionary leader, assassinated in 1923. Reputedly a bandit before joining the Madero revolution in 1910, he appears in Kahlo's 1927 painting *Pancho Villa and Adelita* (pl.5). Known as a rebel and freedom fighter, he forcibly redistributed land to the poor and is admired for the raids he successfully conducted in 1916 within the US territory of New Mexico, despite the best efforts of US General Pershing's troops to catch him.

Bertram D. Wolfe (1896–1977) and **Ella G. Wolfe** (1896–2000) Political activists and friends of Kahlo and Rivera. Bertram Wolfe became Diego Rivera's biographer. Together with Jay Lovestone, the couple founded the US Communist Party and published the newspaper *Workers Age*. The international Communist movement expelled Bertram Wolfe for his interpretations of the ideology. He later reversed his political views and became strongly anti-Communist. He eventually became a university professor.

Chronology

In her lifetime, Frida Kahlo was already a personality – a semi-mythic character, a legend, and an enigma. She actively courted these reputations and even perpetuated them. The various accounts of her life, including her own statements, are often contradictory and are heavily influenced by rumour and speculation. Particularly controversial areas include: the varying status of her many relationships with men and women; her attitude towards motherhood; the nature of her involvement with the Mexican Communist Party, and her father Guillermo Kahlo's ancestry. The chronology presented here has been compiled from a variety of available sources and aims to be as factual as possible.

Selected Sources

The Diary of Frida Kahlo: An Intimate Self-Portrait, Introduction by Carlos Fuentes, Essay and Commentary by Sarah M. Lowe, London 1995.
Hayden Herrera, *Frida: A Biography of Frida Kahlo*, (1983), London 2003.
Mexique-Europe: Allers-Retours 1910–1960, exh. cat., Musée d'art moderne de Lille Métropole, Lille 2004.
Helga Prignitz-Poda, Salomon Grimberg and Andrea Kettenmann, *Frida Kahlo: Das Gesamtwerk*, Frankfurt 1988.
Raquel Tibol, *An Open Life: Frida Kahlo*, trans. Elinor Randall, Albuquerque 1993.
Sharyn Rohlfsen Udall, *Carr, O'Keefe, Kahlo: Places of their Own*, London 2000.
Martha Zamora, *Frida Kahlo: The Brush of Anguish*, London 1990.

Frida Kahlo

1907

6 July, Frida Kahlo is born, Magdalena Carmen Frieda Kahlo y Calderón, in Coyoacán, Mexico. She is the fifth daughter of Guillermo Kahlo, German photographer, and the third daughter of Mexican mother, Matilde Calderón. They live in the house built by her father in 1904, known later as the Casa Azul.

At age nineteen, Diego Rivera, Kahlo's future husband, is currently studying in Spain.

1908

Guillermo Kahlo finishes a four-year project, commissioned by José Ives Limantour, Secretary of the Treasury, to photograph Mexico's cultural patrimony.

1909

1910

Kahlo later claimed 7 July 1910 as her birthday, although her birth certificate states that she was born in 1907. It is thought that she changed the date in recognition of the revolution.

Rivera returns briefly to Mexico to present an exhibition organised by President Díaz's wife, then leaves again for Europe in 1911.

Mexican and World Events

Porfirio Díaz is in his seventh term as President of Mexico, having ruled for over thirty years since 1877. His regular re-elections are not openly democratic. The period known as the 'Porfiriato' is characterised by social conservatism, class stratification and enforced technological modernisation. Despite a positivist attitude and steady growth, the economic climate in Mexico remains similar to that of the Spanish colonial days, controlled by few landowners ('hacendados') and dominated by foreign investment. By 1907, Mexico falls into an economic crisis as it incurs large amounts of foreign debt, experiences industrial overproduction, and is influenced by the financial Panic of 1907 in the US. Discontent among the working class and anti-Díaz opposition continues to increase. Artistic and cultural production emulates European influences to the detriment of indigenous forms of cultural expression. Artists and writers such as Diego Rivera and José Clemente Orozco escape from the conservative artistic climate and seek new influences in Europe and the US.

Díaz declares that he will not seek re-election in 1910 giving hope to liberals and dissidents that a regime change is possible. Francisco I. Madero, a political idealist from Coahuila, is nominated to run in the upcoming election.

Díaz reneges on his declaration and continues to openly violate the civil liberties established in the 1857 constitution using his army to suppress his opponents. Madero forms the National Anti-Reelection Party in a bid to run for the presidency.

Díaz wins the election by imprisoning opposing voters (including Madero) and rigging the results. Madero makes public his *Plan de San Luis Potosí*, which calls for an armed uprising against the Díaz dictatorship. The Mexican Revolution starts to break out across the country driven by the fight for workers' rights, the failure of the entrepreneurial middle class to conform to industry restrictions, confiscation of farmers' land by the wealthy, and the exploitation of factory, mine and 'hacienda' workers.

1911

The Kahlos face economic hardship following the fall of Díaz's government and the subsequent civil war. They are forced to sell their furniture and take in paying house guests at times in order to survive.

Widespread revolt grips the country with guerrilla armies staging uprisings led by Pascual Orozco and Pancho Villa in the north (Chihuahua) and Emiliano Zapata in the south (Morelos). The Revolution will cost over one million lives and is the first social revolution of the twentieth century, foreshadowing Russia's. Díaz goes into exile in France and Madero assumes the presidency.

1912

Madero loses control of his government and is himself accused of conservatism.
The Balkan Wars (1912–14) begin.

1913

Kahlo attends primary school in Coyoacán. She later recalls her mother offering aid to Zapatistas travelling past their house.

Madero's own General, Victoriano Huerta, overthrows him and establishes his own dictatorship during 'the Tragic Ten', a *coup d'etat* that lasts ten days. American Ambassador, Henry Lane Wilson, is implicated.

1914

At six years old, Kahlo contracts poliomyelitis, which permanently damages her right leg.

Huerta's rule is short-lived as he faces resistance from coalitions within Mexico and from the US army, who occupy the Port of Veracruz; he is forced to resign.
Archduke Franz Ferdinand is assassinated in Sarajevo, leading to the First World War. The Panama Canal opens.

1915

Guillermo considers Frida to be his most intelligent child and throughout her younger years, educates her about literature, nature, archaeology, art, and photography.

Mexico falls into civil war with four separate coalitions claiming leadership.

1916

Angelina Beloff, Russian painter and Rivera's first wife, gives birth to their only son, Dieguito.

Venustiano Carranza, chief of the north coalition, emerges as the victorious military commander. Pancho Villa raids New Mexico, killing seventeen US citizens and evades capture by General John J. 'Black Jack' Pershing.

1917

Dieguito dies of meningitis.

A new Constitution is passed, which sets a limit on the presidential term, with no re-election. It also guarantees agricultural reform, freedom of religion, free and obligatory public education, labour guidelines, and the right to strike. Carranza is elected President, and introduces an independent judiciary, greater decentralisation of power, and land reforms. He still fails to satisfy leftist proponents of the Revolution.
The US enters the First World War on the side of the Allies. Leon Trotsky joins the Bolsheviks in Russia, who gain power during the October Revolution.

1918

In the years following Kahlo's childhood illness, her father introduces her to various sports and outdoor activities, a rare opportunity for a young girl in Mexico at the time.

Civil unrest continues in Mexico, with significant resistance from Zapata in the south and Villa in the north.
The Armistice is signed at Compiègne in France, effectively ending the First World War.

1919

The Mexican Communist Party (PCM) is founded and affiliated with the Communist International, but is never recognised as an official political party. Zapata is assassinated.

Germany and the Allies sign the Peace Treaty of Versailles. Benito Mussolini founds the Fascist Party in Italy.

1920

Alvaro Obregón, Secretary of War, differs from Carranza in his support for leftist ideas. Obregón overthrows Carranza and the Constitutionalists to become President. Obregón balances foreign investment and domestic private enterprise, but also distributes more than ten times more land to peasant farmers than Carranza had. He maintains a neutral stance on religion. Philosopher and writer José Vasconcelos becomes Director of the National University.

Women obtain the right to vote in the US.

1921

Rivera and Beloff separate and he returns to Mexico.

A strong believer in education, Obregón creates a new Department and appoints Vasconcelos as Secretary of Public Education. An ambitious programme of establishing schools and libraries is launched. Mexico undergoes an artistic renaissance, which includes the revaluation of indigenous crafts and folk art. Pre-Columbian myths, histories, and languages become central in redefining Mexican identity. Mexico City becomes fertile ground for the development of free-thinking ideas and artistic representation.

1922

Kahlo enters the National Preparatory School, planning to pursue medical studies. She is the only child in her family to attend secondary school and is one of thirty-five girls in a school of two thousand students. She and eight pupils form a group called the Cachuchas, after the unique style of caps they wear. She falls in love with another member of the group, Alejandro Gómez Arias.

Rivera is commissioned to paint murals at the National Preparatory School and meets Kahlo for the first time. He marries Lupe Marín.

Vasconcelos commissions Diego Rivera, José Clemente Orozco, David Alfaro Siqueiros, and others to paint murals heroicising the common people, starting the artistic movement known as 'muralismo'.

Benito Mussolini becomes Prime Minister of Italy. Josef Stalin is appointed General Secretary of the Communist Party in the Soviet Union.

1923

Tina Modotti and Edward Weston arrive in Mexico. Modotti and Kahlo become friends.

Secretary of Finance Adolfo de la Huerta is not nominated for the upcoming election and unsuccessfully attempts to overthrow President Obregón. He is exiled. Pancho Villa is assassinated.

Miguel Primo de Rivera leads a military coup to become the dictator of Spain.

1924

Churches of Mexico is published featuring photography by Guillermo Kahlo.

Plutarco Elías Calles, Secretary of Government, is elected President of Mexico. He works toward improving infrastructure, eliminating public debt and is in favour of public education and workers unions. He is also fiercely anti-clerical, which brings Mexico into religious crisis.

Lenin dies and Stalin begins to gain control of the Soviet Union. André Breton publishes *The First Surrealist Manifesto* and the Surrealist movement flourishes between the World Wars.

1925

At age eighteen, Kahlo begins an engraving apprenticeship with printer Fernando Fernández. 17 September: Kahlo is riding the bus with Alejandro Gómez Arias when a tram crashes into it. She is severely injured and spends a month in the Red Cross hospital.

President Calles establishes the Banco de México. The PCM periodical *El Machete* is founded by Rivera and Siqueiros.

1926

Kahlo paints her first oil, *Self-Portrait Wearing a Velvet Dress* (pl.4), as a gift for Gómez Arias.

Led by the Archbishop of Mexico, the Cristero Wars (1926–9) begin as the Roman Catholic Church and partisans unsuccessfully attempt to overthrow the Mexican government to restore church privileges. During repairs to a wing of the National Palace in Mexico City, the ruins of the Great Pyramid of Tenochtitlan are found.

1927

Kahlo paints *Pancho Villa and Adelita* (pl.5).
 Rivera and Marín divorce.

The School of Applied Carving is founded in Mexico City.
 Leon Trotsky is thrown out of the Bolshevik Party in the Soviet Union. The Agrarian Revolution begins in China. Augusto Cesar Sandino conducts raids against occupying US troops in Nicaragua.

1928

Obregón is re-elected President of Mexico in violation of the 'no re-election' law established in the 1917 Constitution, but is assassinated before taking office. Calles abides by the law by nominating Emilio Portes Gil as interim President. However, Calles maintains his powerful influence over Mexican politics during the next six years known as the 'Maximato'.

1929

Kahlo marries Rivera in Coyoacán. Rivera begins working on murals in Cuernavaca. He is expelled from the Mexican Communist Party because of ideological differences. Kahlo witnesses the killing of Germán de Campo, a young revolutionary orator, who is publicly shot by the military.

Calles, now Secretary of War, establishes the National Revolutionary Party (PNR), Mexico's first nationalised political party. The PCM is declared illegal and is forced underground. The National University students strike against the Portes Gil government and are forcibly suppressed. Julio Antonio Mella, a Cuban revolutionary exile, Communist party activist and Modotti's partner is assassinated in Mexico City.
 The Museum of Modern Art opens in New York. Breton publishes the *Second Surrealist Manifesto*.

1930

Kahlo and Rivera live in Cuernavaca and Rivera paints murals at the Palace of Cortés, commissioned by Dwight W. Morrow, American Ambassador. Kahlo's first pregnancy is terminated for medical reasons. Both artists leave Mexico and move to San Francisco. There, Kahlo completes six paintings and meets Imogen Cunningham and Edward Weston.

Largely orchestrated by Calles, Pascual Ortiz Rubio and the PNR defeat José Vasconcelos in the presidential election; fraud is suspected. Calles orders a near halt to land redistribution to maintain agricultural productivity over equity. Modotti is accused of being a communist spy and of involvement in the assassination attempt on President Ortiz Rubio and is deported.

1931

In San Francisco, Kahlo paints *Frieda Kahlo and Diego Rivera* (pl.12). She becomes friends with Dr Leo Eloesser and paints his portrait. Kahlo and Rivera return to Mexico briefly before going to New York for Rivera's solo exhibition at the Museum of Modern Art. Kahlo meets Nickolas Muray and they become involved in an affair that lasts eight years.

Having strayed too far from the control of Calles, Ortiz Rubio is replaced by Abelardo L. Rodríguez, who serves as Mexican President for the final two years of the 'Maximato'. This government oppresses communists and priests, institutes compulsory socialist teaching, and suppresses the labour unions. Sergei Eisenstein arrives in Mexico to begin filming *¡Que viva México!*, which is never finished.

Julien Levy opens a gallery in New York and holds the first exhibition of Surrealism in the US.

1932

Kahlo and Rivera go to Detroit, where Rivera paints murals at the Detroit Institute of Arts and Kahlo paints *Self-Portrait on the Borderline Between Mexico and the United States* (pl.13). She suffers her second miscarriage at the Henry Ford Hospital four months into her pregnancy. She paints *Henry Ford Hospital* and *My Birth* (pls.15, 16). Kahlo urgently returns to Mexico because her mother is gravely ill. She dies on 15 September. Afterwards, Kahlo returns to Detroit.

The Rodríguez adminstration establishes Mexican Petrol (PEMEX), the Mortgage and Public Works Bank, and sets a minimum wage. Calles comes under fire from his own PNR party for his intolerant policies. To avoid a party split, he nominates Lázaro Cárdenas for the presidency, a popular state governor and former revolutionary military officer.

1933

Kahlo and Rivera go to New York where Rivera begins a mural at the Rockefeller Center, which is cancelled soon after. Kahlo paints *My Dress Hangs There* (pl.14). They return to Mexico and move into their new twin houses in San Angel, designed by Juan O'Gorman.

Years of government corruption take their toll and Mexico falls into economic depression. Cárdenas gains popularity for the upcoming election by distancing himself from Calles's elitism.

US President Franklin D. Roosevelt launches the New Deal programme to create jobs and stimulate the economy.

1934

Kahlo's third pregnancy is terminated, she has surgery on her right foot, and does not complete a single painting during the year.

Rivera paints a revised version of the Rockefeller mural at the Palace of Fine Arts. He has an affair with Kahlo's younger sister, Cristina. Kahlo briefly visits New York with friends.

Lázaro Cárdenas is elected president of Mexico and rebrands the PNR as the Mexican Revolutionary Party (PRM). Cárdenas is known for his honesty and leftist ideas. He promotes labour organisation, empowers workers and farmers, eases tensions with the clergy, and introduces various social institutions. The PCM is able to publicly re-emerge under the more liberal Cárdenas administration. The Palace of Fine Arts, Mexico City, is completed and inaugurated after twenty-nine years of construction and delays.

Augusto Cesar Sandino, guerrilla leader, is executed by the Nicaraguan National Guard.

1935

Kahlo and Rivera temporarily separate and Kahlo moves into an apartment in Mexico City. She paints *A Few Small Nips* (pl.20), has an affair with Isamu Noguchi, and travels to New York with friends. Kahlo and Rivera later reunite in San Angel and she terminates another pregnancy. The Treasury Department commissions Rivera to paint *Mexico Today and Tomorrow* in the National Palace.

Cárdenas distributes more than twice as much land as all his predecessors combined. His administration's policy towards the arts equally supports populist and elitist circles.

Stalin calls for a Popular Front of leftist governments to unite in the struggle against fascism. Mao Zedong gains control of the Communist Party in China.

1936

Kahlo has another operation on her foot. She and Rivera become involved in providing aid to Republicans fighting the Spanish Civil War. She paints *My Grandparents, My Parents, and I* (pl.18).

President Cárdenas finally breaks entirely from Calles by sending the latter into exile. Cárdenas establishes the nation-wide Confederation of Mexican Workers (CTM) and breaks up all of the haciendas.

Rivera joins the International Communist League, as tensions heighten between Trotskyites and Stalinists around the world.

The Spanish Civil War begins. The American Artists' Congress is founded in New York to oppose war and fascism.

1937

Kahlo paints *My Nurse and I* (pl.17) and *Fulang-Chang and I* (fig.49 on p.49), the first of her self-portrait busts. Leon Trotsky and his wife Natalia arrive in Mexico and live in the Casa Azul. Trotsky and Kahlo have a brief affair.

The Mexican railway system is nationalised.

1938

Breton and Jacqueline Lamba arrive in Mexico. Breton is impressed by Kahlo's work and he, Rivera, and Trotsky write the *Manifesto for an Independent Revolutionary Art*. Kahlo paints *Self-Portrait with Monkey* (pl.33), *Fruits of the Earth* and *Pitahayas* (pls.56, 58). She sells her first paintings and travels to New York for her first solo exhibition at the Julien Levy Gallery. Breton writes the catalogue essay 'Frida Kahlo de Rivera'. Kahlo becomes briefly involved with Levy. Rivera falls out with Trotsky.

President Cárdenas continues to bring populist reform to Mexico and expropriates foreign oil companies, solidifying the national industry and eventually leading to greater economic independence. He establishes the National Peasant Confederation (CNC).

1939

Kahlo travels to Paris. She exhibits in the exhibition *Mexique*, organised by Breton and Marcel Duchamp at the Galerie Renou et Colle. The Louvre purchases *Self-Portrait 'The Frame'* 1937–8 (fig.1 on p.9). She stays with the Bretons, becomes hospitalised, then stays with Duchamp. Back in Mexico, Kahlo and Rivera divorce. Sigmund Firestone commissions companion self-portraits from both artists.

The National Action Party (PAN), a right-wing official party, is founded.

Francisco Franco declares the end of the Spanish Civil War and becomes Spain's dictator. Germany invades Poland, precipitating the Second World War.

1940

Kahlo exhibits *The Two Fridas* (pl.28) and *The Wounded Table* (wherabouts unknown) in the International Exhibition of Surrealism at the Galería de Arte Mexicano, Mexico City. Kahlo goes to San Francisco where she and Rivera participate in the *Art in Action Show* at the Golden Gate International Exposition. There, she also receives treament from Dr Leo Eloesser and paints a self-portrait dedicated to him. Trotsky is assassinated in Mexico City. Rivera comes under suspicion owing to their political differences. Kahlo is also a suspect and spends two days in jail. Rivera and Kahlo are remarried and move into the Casa Azul.

As the presidency of Cárdenas comes to an end, he supports the modernising of the country through industrialisation, ending the agricultural revolution. Manuel Ávila Camacho, Secretary of Defence, controversially wins the election. He is a moderate and combats illiteracy, separates the church and military from the state, and oversees a period of general socio-economic stability. Mexico experiences an economic boom due to the increased need for raw materials during the Second World War.

1941

Kahlo's work is shown at the Institute of Contemporary Arts in Boston. Her father dies of a heart attack and she returns to Mexico.

Japan bombs Pearl Harbor and the US enters the war under President Franklin D. Roosevelt.

1942

Rivera designs the Anahuacalli Museum, which will hold his pre-Columbian collection. Kahlo is appointed professor of painting at La Esmeralda by Antonio Ruíz, and supervises a group of her students in the painting of the Pulquería La Rosita murals, which are unveiled in Coyoacán. She shows work in New York at the *First Papers of Surrealism* and *20th Century Portraits* exhibitions.

La Esmeralda, the National School for Painting, Sculpture, and Graphics, is founded. The Seminar of Mexican Culture is founded and Kahlo is appointed its first Secretary.

Germany sinks two Mexican civilian ships, and President Ávila Camacho leads Mexico into the Second World War against the Axis powers. Peggy Guggenheim opens the Art of This Century gallery in New York, a hub for European and American artists during the war.

1943

Kahlo participates in an exhibition at Peggy Guggenheim's gallery. Rivera publishes the article 'Frida Kahlo and Mexican Art', in the journal of the Seminar of Mexican Culture.

Mexico collaborates with US efforts in the war.
 Mussolini is removed from power by his government in Italy.

1944

Kahlo begins keeping a diary. She paints *The Broken Column* and *Diego and Frida 1929–1944 (II)* (pls.49, 64) as a fifteenth wedding anniversary portrait. Kahlo also paints portraits of her patrons including Doña Rosita Morillo (fig.131 on p.208). She attends Picasso's exhibition at the Modern Art Society A.C. in Mexico City.

1945

Kahlo paints *Without Hope, Moses,* and *The Mask* (pls.53, 69, 48).

As one of the fifty member countries, Mexico signs the United Nations Charter.
 German forces surrender to the Allies. The US drops atomic bombs on Hiroshima and Nagasaki, Japan effectively ending the Second World War. Gabriela Mistral, Chilean poet, wins Latin America's first Nobel Prize for literature.

1946

Kahlo is awarded a prize for *Moses* in the category of 'Public Education' at the Palace of Fine Arts National Exhibition. She travels to New York to undergo surgery on her spinal column; paints *The Little Deer* (pl.51) and *Tree of Hope, Keep Firm* (fig.51 on p.51).

President Ávila Camacho rebrands the PRM as the Institutional Revolutionary Party (PRI), marking the shift away from military-based leadership. Miguel Alemán Valdés, PRI Secretary of the Interior, is elected President. He is a lawyer and the first non-military President since Madero in 1911. His term in office is marked by large-scale industrialisation and modernisation.
 Churchill popularises the phrase 'The Iron Curtain' to warn against the expansionist tendencies of the USSR.

1947

Kahlo's work is included in an exhibition of self-portraiture held at the Palace of Fine Arts and in the displays of the new National Museum. She paints *Sun and Life* (pl.68).
 Rivera, Orozco, and Siqueiros form the Commission of Mural Paintings under INBA.

The National Institute of Fine Arts and Literature (INBA) and the National Museum of the Creative Arts are established in the Palace of Fine Arts. The Alemán Valdés administration grants women the right to vote at the municipal level.
 The Truman Doctrine is signed, in which the US pledges to assist countries threatened by communism. All twenty-one American republics sign the Rio Treaty, providing a collective defence in the Western hemisphere against external aggression.

1948

The Society for the Encouragement of Creative Arts is formed in Mexico.
 The Marshall Plan is signed, with the US offering $20 billion in post-war relief to Europe.

1949

Kahlo paints *The Love-Embrace of the Universe, the Earth (Mexico), Me, Diego and Mr Xolótl* (pl.70) for the inaugural exhibition of the Hall of Mexican Creative Art .
 The Palace of Fine Arts holds a fifty-year retrospective of 500 works by Rivera. Kahlo writes 'Portrait of Diego' for the catalogue.

The Alemán Valdés government's push to modernise Mexico stratifies the classes leading to greater social inequality. Bribery and corruption at all levels of government is on the rise.
 Mao Zedong establishes the People's Republic of China. The Julien Levy Gallery, New York closes.

1950

Kahlo is hospitalised for a period of nine months, during which she undergoes two operations on her spine.

Octavio Paz writes *The Labyrinth of Solitude* while in France and collaborates with the Surrealists. Luis Buñuel directs his Surrealist film *Los Olvidados*, set in a Mexican slum. North Korean Communist forces invade South Korea.

1951

Kahlo paints *Self-Portrait with Portrait of Dr Farill* (pl.54) and a number of still-life compositions.

The Treaty of Peace with Japan is signed by forty-eight nations.

1952

Kahlo and her assistants renovate the Pulquería La Rosita murals.

Dissatisfaction with the Alemán Valdés government allows the Secretary of Government, Adolfo Ruíz Cortines, to succeed him as President. Ruíz Cortines pledges to rid the administration of corruption, restore credibility and end excessive government overspending.

1953

Kahlo is documented as being a member of the Mexican Communist Party (PCM). Five of her paintings are included in the *Mexican Art* exhibition at the Tate gallery, London. Lola Álvarez Bravo organises Kahlo's first solo exhibition at the Galería Arte Contemporaneo, Mexico City. Kahlo attends the opening in her bed. Her right leg is later amputated below the knee.

President Ruíz Cortines and the PRI amend the constitution to allow women the rights to stand for election and to vote in national elections.
 Josef Stalin, leader of the Soviet Union, dies aged seventy-three. The UN, China, and North Korea sign an armistice to end the Korean War.

1954

Rivera is permitted to rejoin the PCM.
 Kahlo catches pneumonia and, against the advice of her doctors, participates in demonstrations against the US intervention in Guatemala. 13 July: at age forty-seven Kahlo dies of compounding health problems, in the Casa Azul. Over five hundred people attend her funeral at the Palace of Fine Arts.

The Ruíz Cortines administration devalues the peso to boost the Mexican economy.
 The CIA orchestrates the overthrow of Guatemalan president Jacobo Arbenz Guzmán.

1955

Rivera dedicates the Casa Azul to the Mexican people in honour of Kahlo. He travels to Eastern Europe.

The Warsaw Pact is signed by Albania, Bulgaria, Hungary, Germany, Poland, Romania, the USSR and Czechoslovakia.

1956

Rivera returns to Mexico and celebrations are held on the occasion of his seventieth birthday.

The Suez Crisis begins in Egypt.

1957

Three years after Kahlo's death, Rivera dies of cancer in San Angel.

Mexico celebrates the centenary of the 1857 constitution.

1958

The Museo Frida Kahlo opens to the public, housed in the Casa Azul in Coyoacán.

Adolfo López Mateos, Secretary of Labour, is elected President. He prioritises healthcare and education, nationalises industry and oversees general economic stability. He establishes National Museums of Natural History and Anthropology and the Museum of Modern Art. The population of Mexico has doubled since the 1930s to 34 million.

List of Exhibited Works

Works illustrated in this publication but not shown in the exhibition are not included in this list: please refer to the Index.

Measurements are given in centimetres, height before width. Cross-references refer to the page on which the main illustration appears.

FRIDA KAHLO
(1907–1954)

Country Girl 1925
Muchacha pueblerina
Watercolour and pencil on paper 23 x 14 cm
Government of the State of Tlaxcala, Instituto
Tlaxcalteca de Cultura, Museo de Arte
de Tlaxcala
[fig.6 on p.14]

Have Another One 1925
Échate la otra
Watercolour and pencil on paper 17.5 x 24 cm
Government of the State of Tlaxcala, Instituto
Tlaxcalteca de Cultura, Museo de Arte
de Tlaxcala
[fig.93 on p.74]

Urban Landscape c.1925
Paisaje urbano
Oil on canvas 34.4 x 40.2 cm
Private collection, courtesy of Galería Enrique
Guerrero, Mexico City
[pl.1 on p.80]

The Accident 1926
El accidente
Pencil on paper 20 x 27 cm
Juan Rafael Coronel Rivera. Promised donation
to Museo Nacional de Arte, Mexico City
[fig.24 on p.33]

Self-Portrait Wearing a Velvet Dress 1926
Autorrertrato con traje de terciopelo
Oil on canvas 79.7 x 59.9 cm
Private collection
[pl.4 on p.83]

Pancho Villa and Adelita before 1927
Pancho Villa y la Adelita
Oil on canvas 65 x 45 cm
Government of the State of Tlaxcala, Instituto
Tlaxcalteca de Cultura, Museo de Arte
de Tlaxcala
[pl.5 on p.84]

Frida in Coyoacán c.1927
Frida en Coyoacán
Watercolour on paper 18.5 x 24 cm
Government of the State of Tlaxcala, Instituto
Tlaxcalteca de Cultura, Museo de Arte
de Tlaxcala
[fig.119 on p.200]

Frida in Coyoacán c.1927
Frida en Coyoacán
Pencil on paper 18.5 x 24 cm
Government of the State of Tlaxcala, Instituto
Tlaxcalteca de Cultura, Museo de Arte
de Tlaxcala

Portrait of Alicia Galant 1927
Retrato de Alicia Galant
Oil on canvas 97 x 84 cm
Museo Dolores Olmedo Patiño, Mexico City
[pl.3 on p.82]

Portrait of Miguel N. Lira 1927
Retrato de Miguel N. Lira
Oil on canvas 106 x 74 cm
Government of the State of Tlaxcala,
Instituto Tlaxcalteca de Cultura, Museo
de Arte de Tlaxcala
[pl.6 on p.85]

Portrait of Alejandro Gómez Arias 1928
Retrato de Alejandro Gómez Arias
Oil on wood 61.5 x 41 cm
Private collection
[pl.2 on p.81]

Small Mexican Horse c.1928
Caballito mexicano
Watercolour on paper 27 x 33 cm
Private collection, courtesy of Galería Arvil,
Mexico City
[fig.18 on p.26]

The Bus 1929
El camión
Oil on canvas 26 x 55.5 cm
Museo Dolores Olmedo Patiño, Mexico City
[pl.7 on p.87]

Portrait of Virginia 1929
La niña Virginia
Oil on hardboard 77 x 60 cm
Museo Dolores Olmedo Patiño, Mexico City
[pl.10 on p.90]

Nude of my Cousin Ady Weber 1930
Desnudo de Ady Weber (mi prima)
Pencil on paper 60 x 47 cm
Museo Dolores Olmedo Patiño, Mexico City

Frieda Kahlo and Diego Rivera 1931
Frieda Kahlo y Diego Rivera
Oil on canvas 100 x 78.7 cm
San Francisco Museum of Modern Art. Albert
M. Bender Collection, Gift of Albert M. Bender
[pl.12 on p.93]

Nude of Eva Frederick 1931
Desnudo de Eva Frederick
Pencil on paper 61 x 47 cm
Museo Dolores Olmedo Patiño, Mexico City

Portrait of Eva Frederick 1931
Retrato de Eva Frederick
Oil on canvas 62 x 45 cm
Museo Dolores Olmedo Patiño, Mexico City
[pl.8 on p.88]

Portrait of Lady Cristina Hastings 1931
Retrato de Lady Cristina Hastings
Pencil on paper 48 x 31 cm
Museo Dolores Olmedo Patiño, Mexico City
[fig.135 on p.211]

Portrait of Luther Burbank 1931
Retrato de Luther Burbank
Pencil on paper 30.3 x 21.5 cm
Juan Rafael Coronel Rivera. Promised donation
to Museo Nacional de Arte, Mexico City

Portrait of Luther Burbank 1931
Retrato de Luther Burbank
Oil on hardboard 85 x 61 cm
Museo Dolores Olmedo Patiño, Mexico City
[pl.9 on p.89]

Window Display in a Street in Detroit 1931
El aparador (en una calle de Detroit)
Oil on metal panel 30.3 x 38.2 cm
Mr and Mrs Abel Holtz, courtesy of Gary
Nader Fine Art, Miami
[pl.55 on p.163]

Beauty Parlour (I) or The Perm 1932
Salón de belleza (I) o El permanente
Watercolour and pencil on paper 26 x 22 cm
Agustín Cristóbal, courtesy of Galería Arvil,
Mexico City
[fig.10 on p.18]

Birth or My Birth 1932
Nacimiento o Mi nacimiento
Oil on metal panel 30.5 x 35 cm
Madonna
[pl.16 on p.100]

The Dream or Self-Portrait Dreaming (I) 1932
El sueño o Autorretrato onírico (I)
Pencil on paper 27 x 20 cm
Juan Rafael Coronel Rivera. Promised donation
to Museo Nacional de Arte, Mexico City
[fig.31 on p.39]

With LUCIENNE BLOCH (1909–1999)
Exquisite Corpse c.1932
Cadáver exquisito
Pencil on paper 21.5 x 13.5 cm
Private collection
[fig.5a on p.12]

With LUCIENNE BLOCH (1909–1999)
Exquisite Corpse c.1932
Cadáver exquisito
Pencil on paper 21.5 x 13.5 cm
Private collection
[fig.5b on p.12]

Frida and the Miscarriage 1932
Frida y el aborto
Lithograph on paper 31.5 x 23.5 cm
Museo Dolores Olmedo Patiño, Mexico City
[fig.28 on p.36]

Henry Ford Hospital 1932
Hospital Henry Ford
Oil on metal 30.5 x 38 cm
Museo Dolores Olmedo Patiño, Mexico City
[pl.15 on p.99]

San Baba or Santa Claus c.1932
San Baba o Papá Noel
Watercolour, pencil and silver foil on paper
22 x 26 cm
Juan Rafael Coronel Rivera. Promised donation
to Museo Nacional de Arte, Mexico City
[fig.10 on p.18]

Self-Portrait on the Borderline between Mexico
and the United States 1932
Autorretrato en la frontera entre México
y los Estados Unidos
Oil on metal 31 x 35 cm
Manuel and Maria Reyero, New York
[pl.13 on p.95]

Self-Portrait with Beret (Head with Red
'Cachucha') 1932
Autorretrato con boina (Cabeza con
cachucha roja)
Pencil on paper 30 x 23.7 cm
Museo Dolores Olmedo Patiño, Mexico City

Self-Portrait, 9 July 1932 1932
Autorretrato, 9 de julio de 1932
Pencil on paper 20.5 x 13.2 cm
Juan Rafael Coronel Rivera. Promised donation
to Museo Nacional de Arte, Mexico City
[fig.23 on p.33]

My Dress Hangs There or New York 1933
Allá cuelga mi vestido o New York
Oil and collage on hardboard 46 x 50 cm
Private collection
[pl.14 on p.97]

Self-Portrait 'very ugly' 1933
Autorretrato 'very ugly'
Fresco 27.4 x 22.2 cm
Private collection
[fig.122 on p.202]

All-Seeing Eye! 1934
Ojo avisor!
Pencil on paper 21 x 30.5 cm
Juan Rafael Coronel Rivera. Promised donation
to Museo Nacional de Arte, Mexico City
[fig.3 on p.12]

A Few Small Nips 1935
Unos cuantos piquetitos
Oil on metal 30 x 40 cm
Museo Dolores Olmedo Patiño, Mexico City
[pl.20 on p.105]

Self-Portrait Lying Down or Frida Asleep 1935
Autorretrato acostada o Frida dormida
Pencil and coloured pencil on paper
20.7 x 29.7 cm
Juan Rafael Coronel Rivera. Promised donation
to Museo Nacional de Arte, Mexico City

My Grandparents, My Parents, and I
(Family Tree) 1936
Mis abuelos, mis padres y yo
Oil and tempera on metal 30.7 x 34.5 cm
The Museum of Modern Art, New York. Gift
of Allan Roos, M.D., and B. Mathieu Roos, 1976
[pl.18 on p.104]

The Deceased Dimas Rosas Aged Three 1937
El difuntito Dimas Rosas a los tres años
Oil on hardboard 48 x 31.5 cm
Museo Dolores Olmedo Patiño, Mexico City
[pl.11 on p.93]

My Nurse and I 1937
Mi nana y yo
Oil on metal 30.5 x 34.7 cm
Museo Dolores Olmedo Patiño, Mexico City
[pl.17 on p.101]

Self-Portrait Drawing c.1937
Autorretrato dibujando
Pencil and coloured pencil on paper 29.7 x 21 cm
Private collection
[fig.20 on p.31]

Self-Portrait 'The Frame' 1937–8
Autorretrato 'The Frame'
Oil on aluminium and glass 28.5 x 20.7 cm
Centre Georges Pompidou, Paris. Musée
national d'art moderne. Centre de création
industrielle
[fig.1 on p.9]

Four Inhabitants of Mexico City
or The Square Is Theirs 1938
Cuatro habitantes de la Ciudad de México
o La plaza es suya
Oil on metal 32.4 x 47.6 cm
Private collection
[pl.22 on p.107]

Fruits of the Earth 1938
Los frutos de la tierra
Oil on hardboard 40.6 x 60 cm
Banco Nacional de México
[pl.56 on p.165]

Girl with Death Mask (I) 1938
Niña con máscara de cabvera (I)
Oil on metal 14.9 x 11 cm
Nagoya City Art Museum
[pl.21 on p.106]

Itzcuintli Dog with Me c.1938
Perro Itzcuintli conmigo
Oil on canvas 71 x 52 cm
Private collection
[pl.30 on p.119]

Pitahayas 1938
Pitahayas
Oil on metal 25.4 x 35.6 cm
Madison Museum of Contemporary Art,
Wisconsin. Bequest of Rudolph and Louise
Langer
[pl.58 on p.167]

Self-Portrait c.1938
Autorretrato
Oil on metal 12 x 7 cm
Private collection, courtesy
of Galerie 1900–2000, Paris
[pl.23 on p.109]

Self-Portrait with Monkey 1938
Autorretrato con mono
Oil on hardboard 40.6 x 30.5 cm
Albright-Knox Art Gallery, Buffalo, New York.
Bequest of A. Conger Goodyear, 1966
[pl.33 on p.123]

Xochítl, Flower of Life 1938
Xochítl, Flor de la vida
Oil on metal 18 x 9.5 cm
Private collection
[pl.66 on p.175]

The Two Fridas 1939
Las dos Fridas
Oil on canvas 173.5 x 173 cm
Museo de Arte Moderno,
CONACULTA-INBA, Mexico
[pl.28 on p.127]

Two Nudes in a Forest or Earth Herself
or My Nurse and I 1939
Dos desnudos en un bosque o La tierra
misma o Mi nana y yo
Oil on metal 25 x 30.5 cm
Jon and Mary Shirley
[pl.27 on p.115]

Self-Portrait 1940
Autorretrato
Oil on hardboard 61 x 43.2 cm
Private collection, courtesy of Mary-Anne
Martin Fine Art, New York
[pl.35 on p.127]

Self-Portrait with Monkey 1940
Autorretrato con mono
Oil on hardboard 55.2 x 43.5 cm
Madonna
[pl.34 on p.125]

Still Life with Hummingbird 1941
Naturaleza Muerta con Colibrí
Oil on copper 64.1 cm (diameter)
Private collection, courtesy of Mary-Anne
Martin Fine Art, New York
[pl.65 on p.174]

Portrait of Lucha María, Girl from Tehuacán
or Sun and Moon 1942
Niña Tehuacana, Lucha María o Sol y Luna
Oil on hardboard 54.6 x 43.2 cm
Private collection
[pl.52 on p.158]

Self-Portrait with Monkey and Parrot 1942
Autorretrato con chango y loro
Oil on hardboard 54.6 x 43.2 cm
MALBA / Constantini Collection,
Buenos Aires
[pl.40 on p.137]

Flower of Life 1943
La flor de la vida
Oil on hardboard 27.8 x 19.7 cm
Museo Dolores Olmedo Patiño, Mexico City
[pl.67 on p.176]

Roots 1943
Raíces
Oil on metal 30.5 x 49.9 cm
Private collection
[pl.50 on p.156]

Self-Portrait with Monkeys 1943
Autorretrato con monos
Oil on canvas 81.5 x 63 cm
The Jacques and Natasha Gelman Collection
of Modern and Contemporary Mexican Art,
courtesy of The Vergel Foundation, Fundación
Cultural Parque Morelos (Muros), Cuernavaca
and Costco/Comercial Mexicana
[pl.41 on p.139]

Self-Portrait as a Tehuana
or Diego on My Mind 1943
Autorretrato como Tehuana
o Diego en mi pensamiento
Oil on hardboard 76 x 61 cm
The Jacques and Natasha Gelman Collection
of Modern and Contemporary Mexican Art,
courtesy of The Vergel Foundation, Fundación
Cultural Parque Morelos (Muros), Cuernavaca
and Costco/Comercial Mexicana
[pl.42 on p.141]

Thinking About Death 1943
Pensando en la muerte
Oil on canvas 44.5 x 37 cm
Private collection
[pl.43 on p.143]

The Broken Column 1944
La columna rota
Oil on canvas 40 x 30.5 cm
Museo Dolores Olmedo Patiño, Mexico City
[pl.49 on p.155]

Diego and Frida 1929–1944 (II)
or Double Portrait of Diego and I (II) 1944
Diego y Frida 1929–1944 (II)
o Retrato doble de Diego y yo (II)
Oil on hardboard 13 x 8 cm
Private collection
[pl.64 on p.173]

Fantasy (I) 1944
Fantasía (I)
Pencil on paper 24 x 16 cm
Museo Dolores Olmedo Patiño, Mexico City
[fig.68 on p.62]

Fantasy (II) 1944
Fantasía (II)
Ink and pencil on paper 24 x 16 cm
Private collection, courtesy Galería Enrique
Guerrero, Mexico City

Portrait of Doña Rosita Morillo 1944
Retrato de Doña Rosita Morillo
Oil on canvas 75.5 x 59.5 cm
Museo Dolores Olmedo Patiño, Mexico City
[fig.131 on p.208]

Portrait of Engineer Eduardo Morillo Safa 1944
Retrato del Ing. Eduardo Morillo Safa
Oil on hardboard 39.7 x 29.7 cm
Museo Dolores Olmedo Patiño, Mexico City
[fig.136 on p.212]

Portrait of Engineer Marte R. Gómez 1944
Retrato del Ing. Marte R. Gómez
Oil on hardboard 32.5 x 26.5 cm
Private collection
[fig.134 on p.211]

The Chick 1945
El pollito
Oil on hardboard 27 x 22 cm
Museo Dolores Olmedo Patiño, Mexico City
[pl.63 on p.172]

The Mask 1945
La máscara
Oil on canvas 40 x 31 cm
Museo Dolores Olmedo Patiño, Mexico City
[pl.48 on p.153]

Moses 1945
Moisés
Oil on hardboard 61 x 75.6 cm
Private collection
[pl.69 on p.179]

Self-Portrait with Small Monkey 1945
Autorretrato con changuito
Oil on hardboard 55 x 40 cm
Museo Dolores Olmedo Patiño, Mexico City
[pl.44 on p.145]

Without Hope 1945
Sin esperanza
Oil on canvas 28 x 36 cm
Museo Dolores Olmedo Patiño, Mexico City
[pl.53 on p.159]

The Little Deer 1946
La venadita
Oil on hardboard 22.5 x 30.2 cm
Dr Carolyn Farb
[pl.51 on p.157]

Miniature Self-Portrait 1946
Autorretrato en miniatura
Oil on board 4.8 x 4 cm
Cejas Collection, Miami
[fig.108 on p.187]

Self-Portrait with Loose Hair 1947
Autorretrato con el pelo suelto
Oil on hardboard 61 x 45 cm
Private collection
[pl.45 on p.147]

Sun and Life 1947
El sol y la vida
Oil on hardboard 40 x 50 cm
Private collection, courtesy of Galería Arvil,
Mexico City
[pl.68 on p.177]

Self-Portrait 1948
Autorretrato
Oil on hardboard 50 x 40 cm
Private collection
[pl.46 on p.149]

The Love-Embrace of the Universe, the Earth
(Mexico), Me, Diego and Mr Xólotl 1949
El abrazo de amor de el universo, la tierra
(México), Yo, Diego y el señor Xólotl
Oil on canvas 70 x 60.5 cm
The Jacques and Natasha Gelman Collection
of Modern and Contemporary Mexican Art,
courtesy of The Vergel Foundation, Fundación
Cultural Parque Morelos (Muros), Cuernavaca
and Costco/Comercial Mexicana
[pl.70 on p.181]

Self-Portrait with Portrait of Dr Farill
or Self-Portrait with Dr Juan Farill 1951
Autorretrato con el retrato del Dr. Farill
o Autorretrato con el Dr. Juan Farill
Oil on hardboard 41.5 x 50 cm
Private collection
[pl.54 on p.161]

Still Life 1951
Naturaleza muerta
Oil on canvas 28.5 x 36 cm
Private collection, courtesy Galería Arvil,
Mexico City
[pl.59 on p.168]

Still Life with Parrot and Flag 1951
Naturaleza muerta con perico y bandera
Oil on hardboard 26 x 35 cm
Private collection, courtesy of Galería Arvil,
Mexico City
[pl.62 on p.171]

Still Life with Watermelons 1953
Naturaleza muerta con sandías
Oil on hardboard 39 x 59 cm
Museo de Arte Moderno,
CONACULTA-INBA, Mexico
[pl.61 on p.170]

Little Life date unknown
Vida pequeña
Watercolour on paper 22 x 27.8 cm
Private collection

DIEGO RIVERA
(1886–1957)

Self-Portrait 1941
Autorretrato
Oil on canvas 69.9 x 41.9 cm
Private collection, courtesy of Mary-Anne
Martin Fine Art, New York
[fig.102 on p.126]

Lenders

Albright-Knox Art Gallery, Buffalo, New York
Banco Nacional de México
Cejas Collection, Miami
Centre Georges Pompidou, Paris, Musée national d'art moderne / Centre de création industrielle
Agustín Cristóbal, courtesy of Galería Arvil, Mexico City
Dr Carolyn Farb
The Jacques and Natasha Gelman Collection of Modern and Contemporary Mexican Art, vourtesy of The Vergel Foundation, Fundación Cultural Parque Morelos (Muros), Cuernavaca and Costco/Comercial Mexicana
Government of the State of Tlaxcala, Instituto Tlaxcalteca de la Cultura, Museo de Arte de Tlaxcala
Mr and Mrs Abel Holtz Collection, courtesy of Gary Nader Fine Art, Miami
Madison Museum of Contemporary Art, Wisconsin
Madonna
MALBA / Colección Costantini, Buenos Aires, Argentina
Museo de Arte Moderno, CONACULTA-INBA, Mexico
Museo Dolores Olmedo Patiño, Mexico City
The Museum of Modern Art, New York
Nagoya City Art Museum
Private collection, courtesy of Galería Arvil, Mexico City
Private collection, courtesy Galería Enrique Guerrero, Mexico City
Private collection, courtesy of Galerie 1900-2000, Paris
Private collection, courtesy of Mary-Anne Martin Fine Art, New York
Manuel and Maria Reyero, New York
Juan Rafael Coronel Rivera. Promised donation to the Museo Nacional de Arte, Mexico City
San Francisco Museum of Modern Art
Jon and Mary Shirley

Index

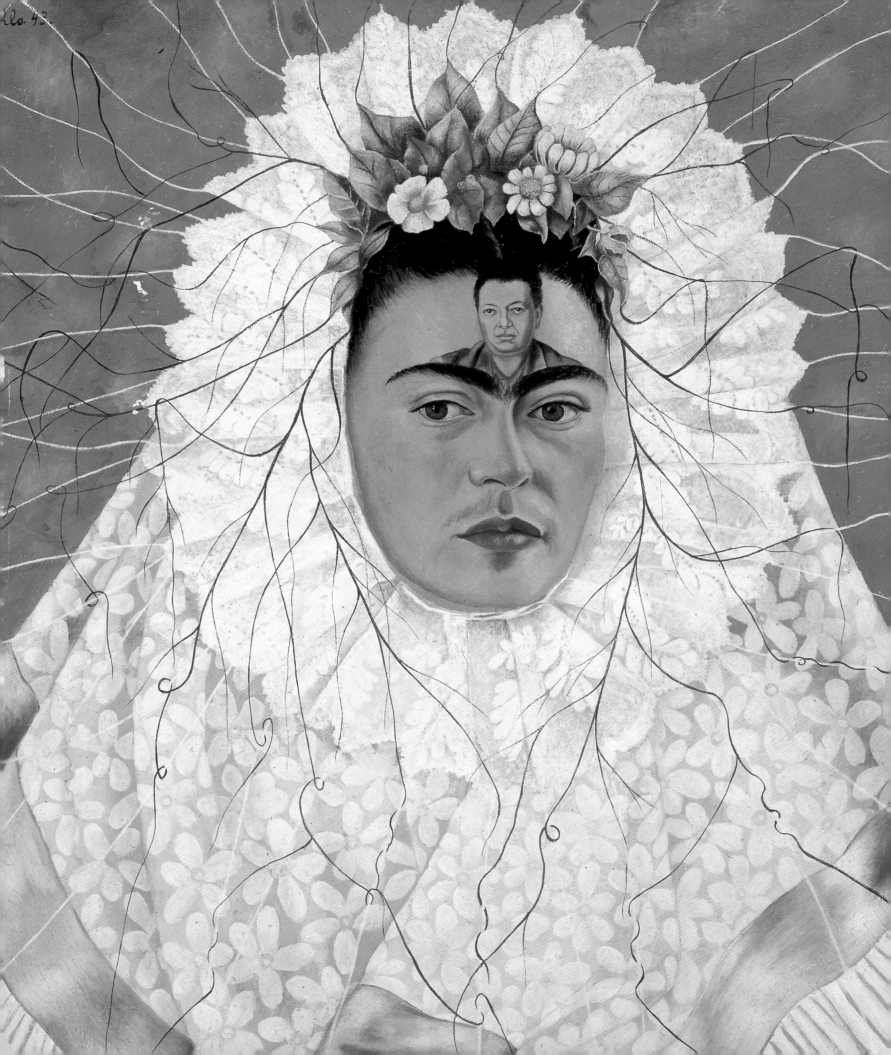

Frida

Kahlo